DREAM HOMES

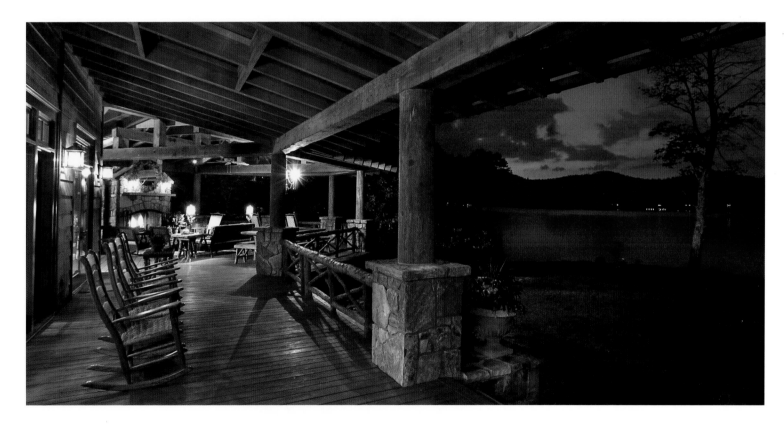

CAROLINAS

AN EXCLUSIVE SHOWCASE OF THE CAROLINAS' FINEST ARCHITECTS, DESIGNERS AND BUILDERS

Published by

PANACHE
PANACHE PARTNERS, LLC

13747 Montfort Drive, Suite 100
Dallas, Texas 75240
972.661.9884
Fax: 972.661.2743
www.panache.com

Publishers: Brian G. Carabet and John A. Shand
Executive Publisher: Phil Reavis
Associate Publisher: Kara Price
Editor: Lori Tate
Designer: Emily A. Kattan

Printed in Malaysia

Distributed by Independent Publishers Group
800.888.4741

PUBLISHER'S DATA

Dream Homes Carolinas

Library of Congress Control Number: 2006939716

ISBN 13: 978-1-933415-03-1
ISBN 10: 1-933415-03-7

First Printing 2007

10 9 8 7 6 5 4 3 2 1

Previous Page: Bob Dylewski, Bronco Contruction
See page 201 *Photograph by Tim Burleson*

This Page: Steven J. Koenig, Steven J. Koenig Construction, Inc.
See page 49 *Photograph by Rick Rhodes*

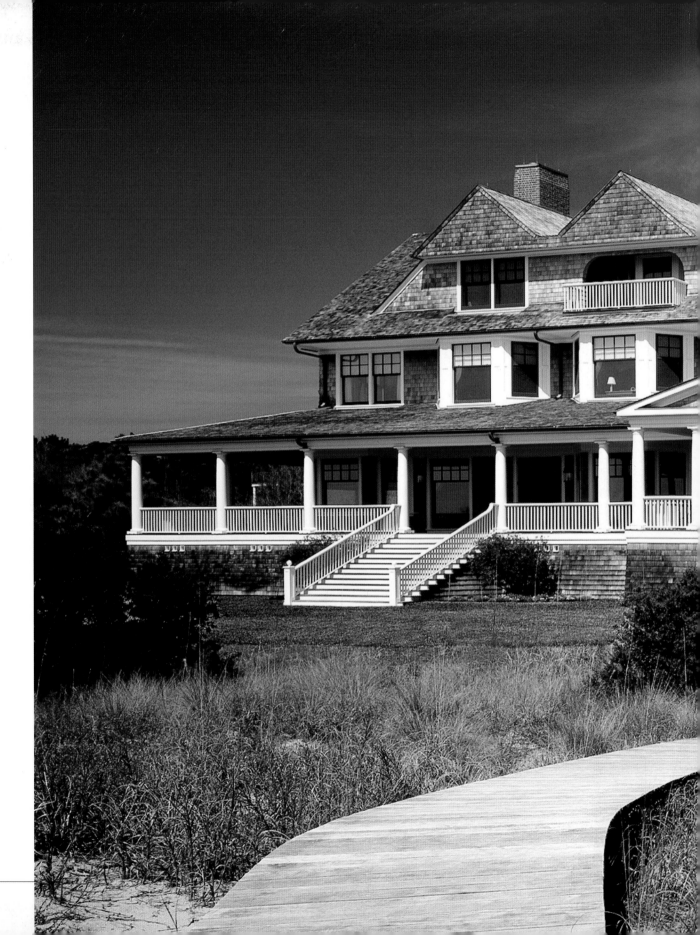

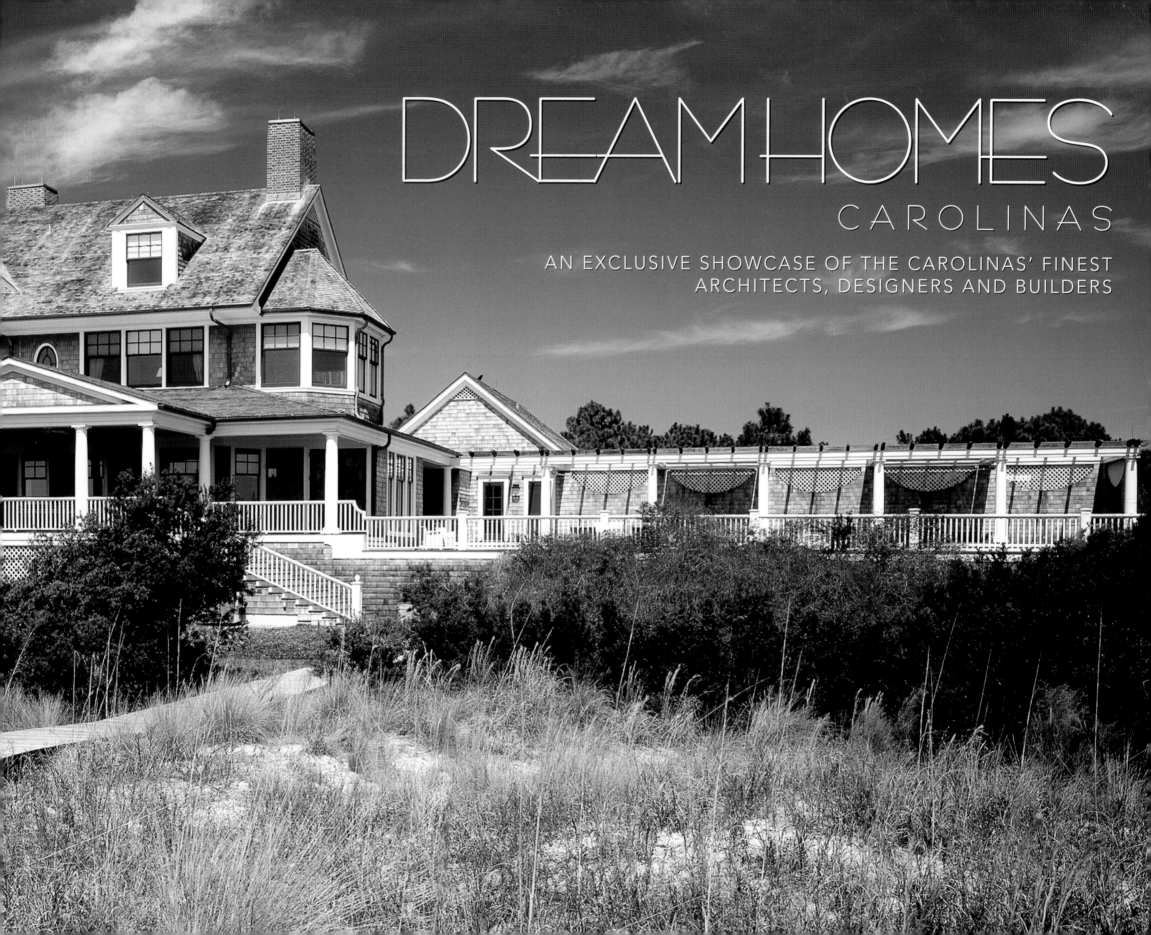

DREAM HOMES

CAROLINAS

AN EXCLUSIVE SHOWCASE OF THE CAROLINAS' FINEST ARCHITECTS, DESIGNERS AND BUILDERS

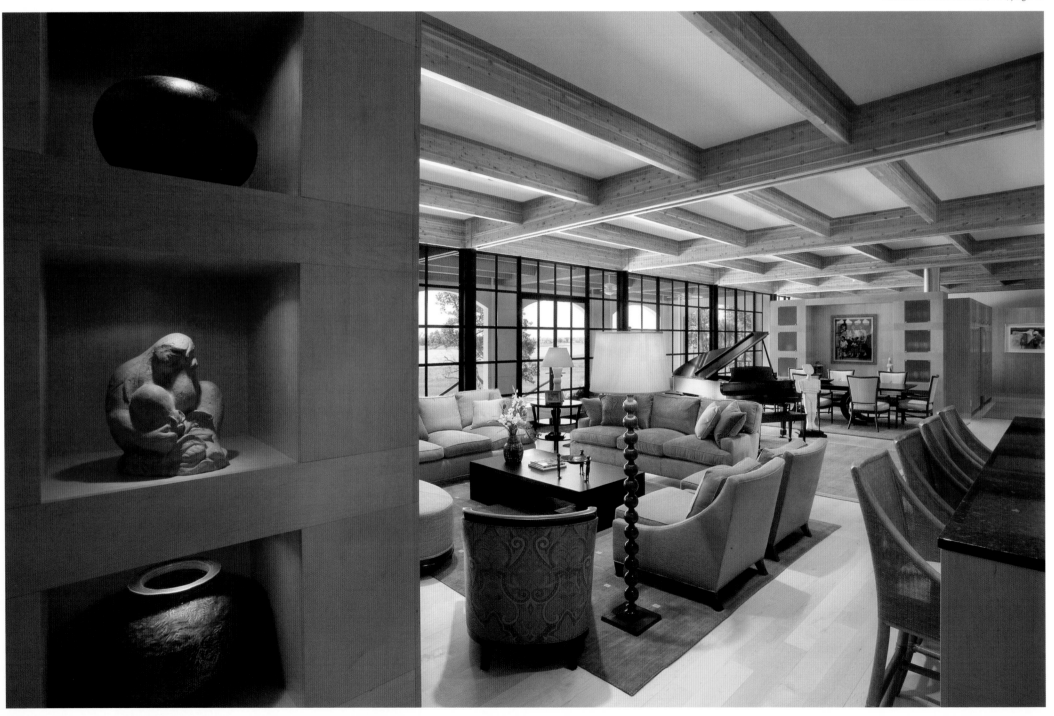

INTRODUCTION

Creativity abounds in the scenic region of the Carolinas. The profusion of architectural opportunities, not to mention the breathtakingly beautiful and diverse landscape, has lured creative minds at the top of their profession.

Dream Homes Carolinas is a brilliant assemblage of the work and philosophies of highly respected architects and builders. The design professionals featured on the pages that follow were selected for their talent, artistry and command of craft. From coastal cottages and low country dwellings to traditional Southern estates and rustic mountain lodges, these magnificent homes display thoughtful, sophisticated designs that epitomize their residents' lifestyles and stylistic proclivities. Each has evolved from its creator's vast historical and cultural knowledge, strict attention to detail and innate aesthetic sensibility coupled with hard work and a genuine passion for fine architecture.

From small additions to elaborate renovations, restorations and, of course, new construction projects, the architects and builders of *Dream Homes Carolinas* are interested and well-versed in a wide range of styles—from Classical to Modern and everything in between. Though their ideas and approaches vary, all are bound by the quest to create unique works of architecture that acknowledge their surroundings, possess pleasing proportions and evoke delight.

Whether patrons wish to work with a boutique-sized firm or prefer to draw on the capabilities of a residential specialty studio within a large, general practice firm, there are plenty of excellent professionals from whom to choose. The beautiful homes on the pages that follow display the architects and builders' immense talents, yet above all, the men and women of *Dream Homes Carolinas* measure their success through the happiness of their clients.

Kara Price

Kara Price
Associate Publisher

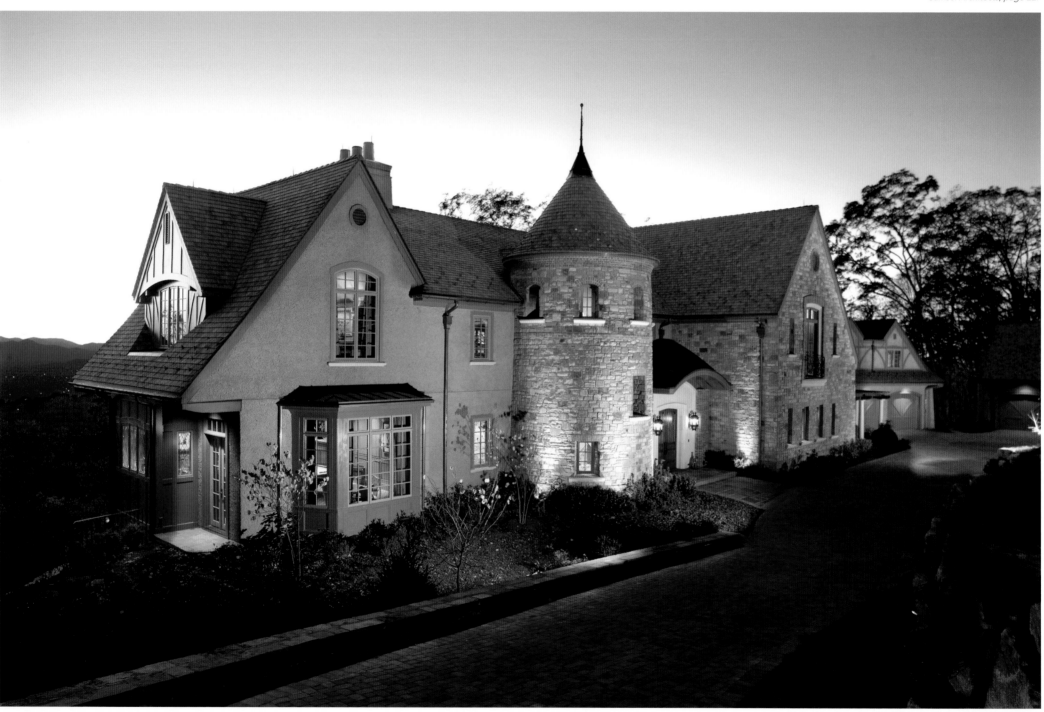

TABLE OF CONTENTS

Schmitt Walker Architects, Inc.; *page 89*

Robert Morgan Fine Homes; *page 53*

Camens Architectural Group; *page 11*

THE COAST

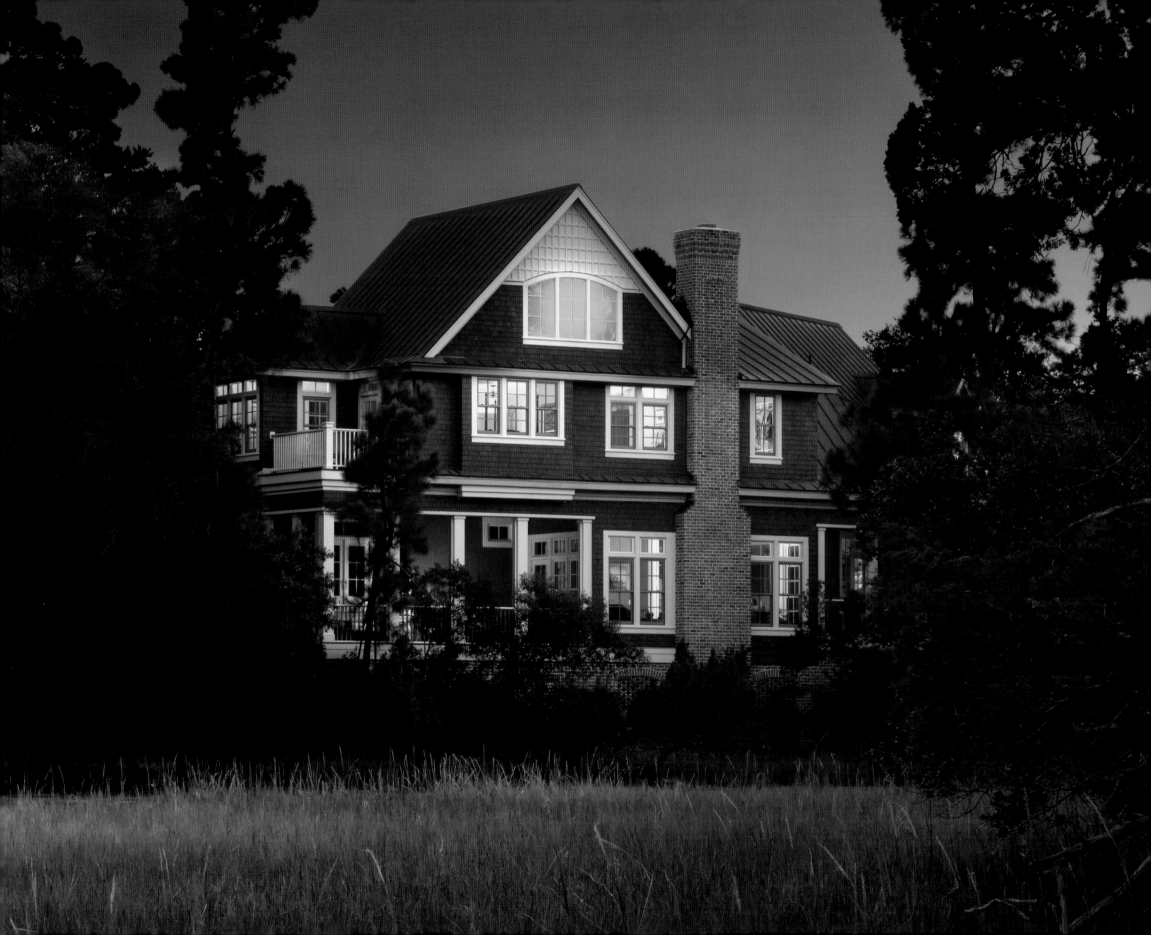

Marc Camens
Camens Architectural Group

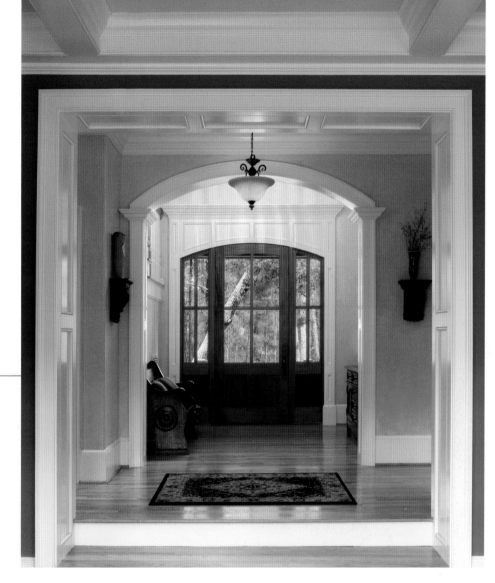

Above: The warm and inviting front entrance hall of this Blue Heron Pond Road residence welcomes owners and visitors alike.
Photograph by Dickson Dunlap

Facing Page: The rear marsh view of a Blue Heron Pond Road residence.
Photograph by Dickson Dunlap

After taking a five-week vacation to Seabrook Island in 1998, Marc Camens sold his 18-year-old architectural practice in the Adirondacks and moved to the low country. "In New York I developed strong relationships with my clients because I listened to them," explains Camens, who is the owner of Camens Architectural Group on Johns Island. "What made me successful in the Adirondacks I anticipated would make me successful here."

Turns out his logic was right, as Marc's architectural designs now pepper Kiawah Island, James Island, Sullivan's Island, and Daniel Island. "We're definitely a client-driven practice," says Marc of his six employees. "Our mantra is, 'Listen to your dreams, and we will listen to you.'"

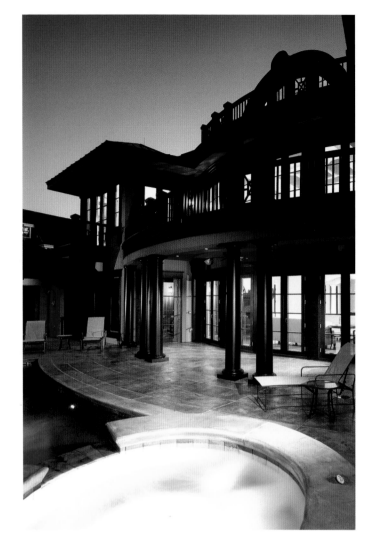

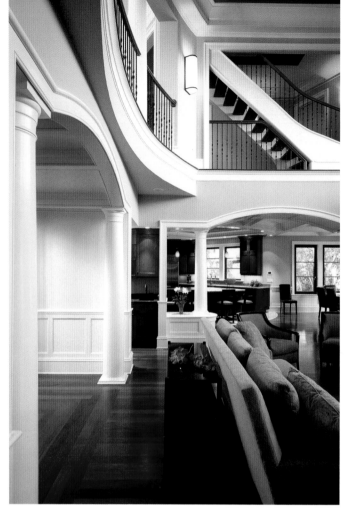

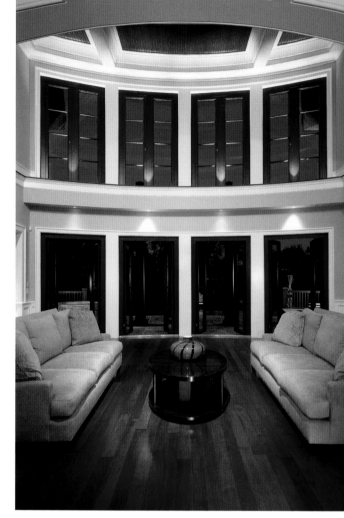

Listening to the site is also important to Marc when he designs a home. "The site is going to tell you what's happening on this property and where the potential lies, where the views are," he says. "It will also tell you what kind of constraints exist, what the neighborhood is like, where privacy is needed, and what the interplay of all of the elements are."

A graduate of Kent State University, Marc gathers as much information from his clients as possible during the initial phases of the design process. He looks at photographs of architectural details that they like. He talks with them about how they live,

how they cook, and how they envision living in their home. "I try to gather up everything I can so we can jointly create a philosophical statement of what home is about," he says. "Then I wrap the building around their lifestyle. I meld everything the site and the client is describing to me, and I build the plan from the inside out."

As he designs, Marc pays particular attention to the light and flow of a structure. "The light inside the building is the life force of the building," he says. "The flow allows you to move within the spaces and experience them freely."

Above Left: The exterior pool deck at night; Otter Island residence.
Photograph by John McManus

Above Middle: The impressive two-story main living area; Otter Island residence.
Photograph by John McManus

Above Right: Another perspective of the same Otter Island residence's main entrance, which leads into the main living area.
Photograph by John McManus

Facing Page: Main living area view of the kitchen; Otter Island residence.
Photograph by John McManus

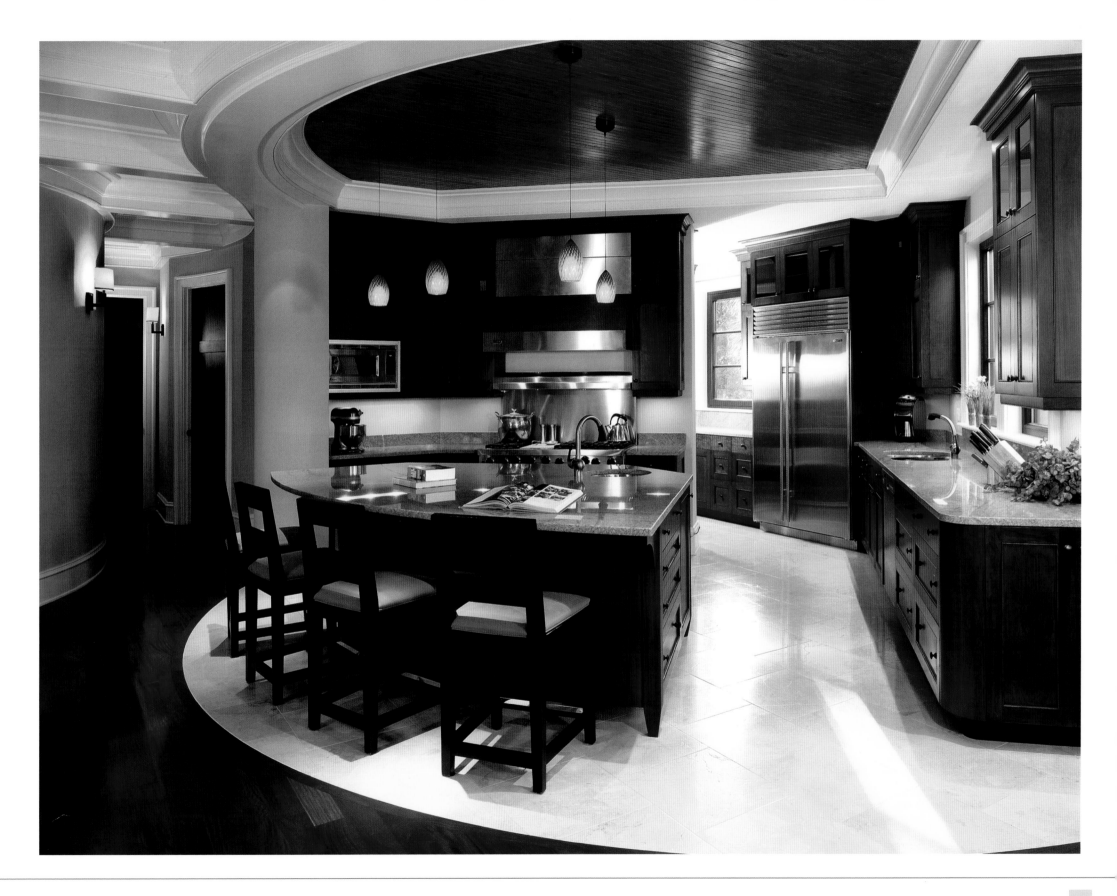

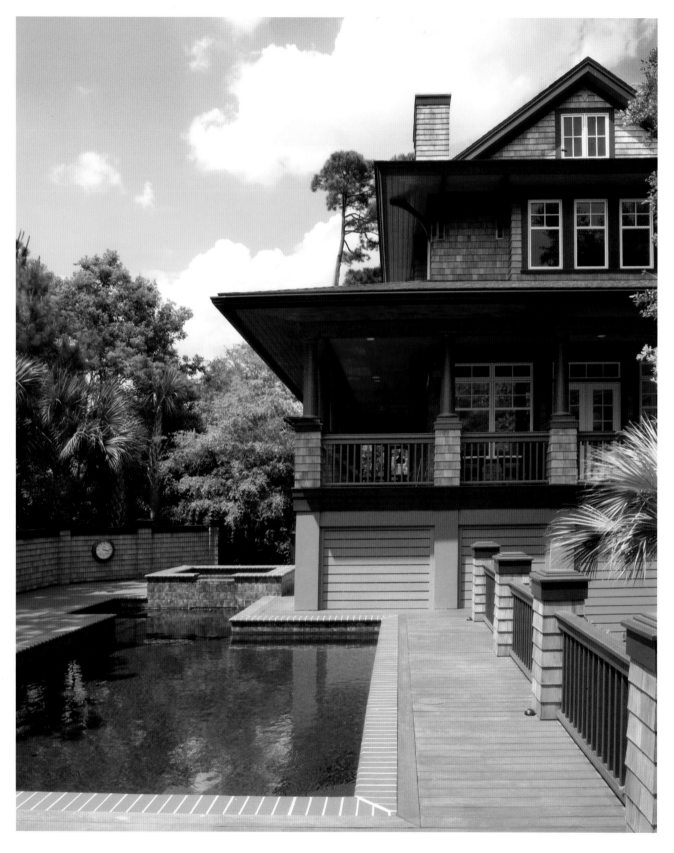

Fond of the creative process, Marc enjoys sitting down with a blank piece of paper and sketching the homes of people's dreams. "I've designed more houses on airplanes and other places because I just go into my design process and focus and drown out the world and drown out the clock," he says. "I love that part of it."

As the son of a developer, Marc worked on his father's crews as an apprentice carpenter and later had his own design/build firm in Alabama. Throw in the fact that Marc has also built his own home, and it is easy to see why he has such a strong penchant for construction.

Left: Private view of pool deck; Ballybunion residence.
Photograph by Dickson Dunlap

Facing Page Left: Interior view of a bright, airy great room with impressive cathedral ceilings; Ballybunion residence.
Photograph by Dickson Dunlap

Facing Page Right: Interior view of the entrance hall from the great room; Ballybunion residence.
Photograph by Dickson Dunlap

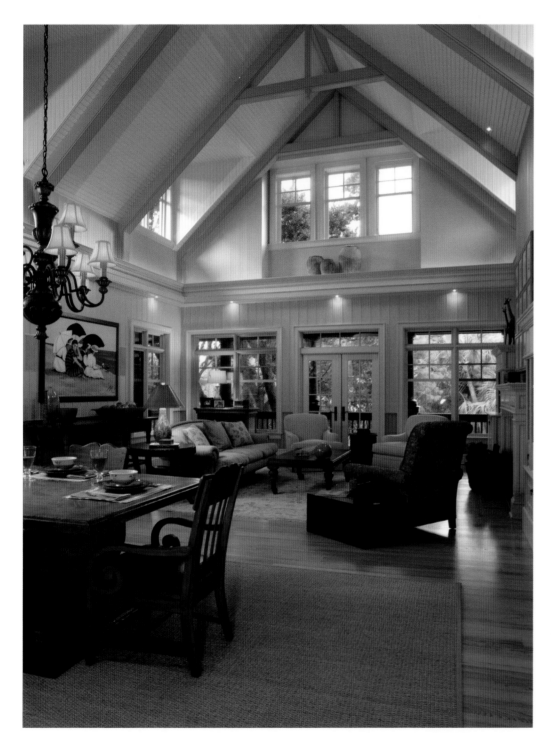
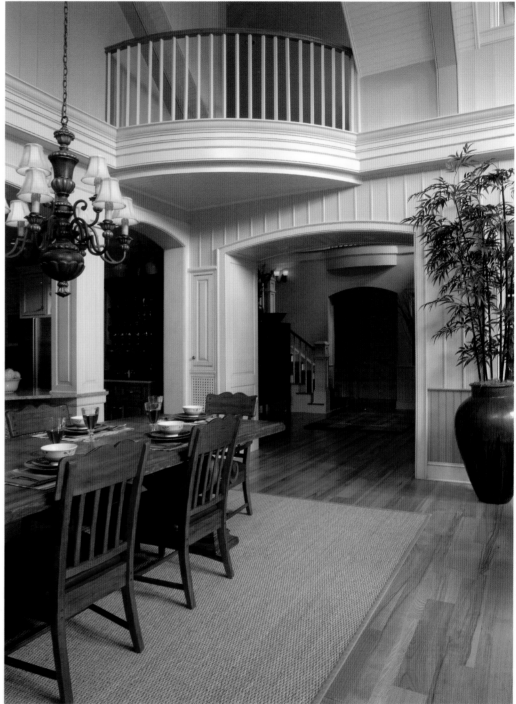

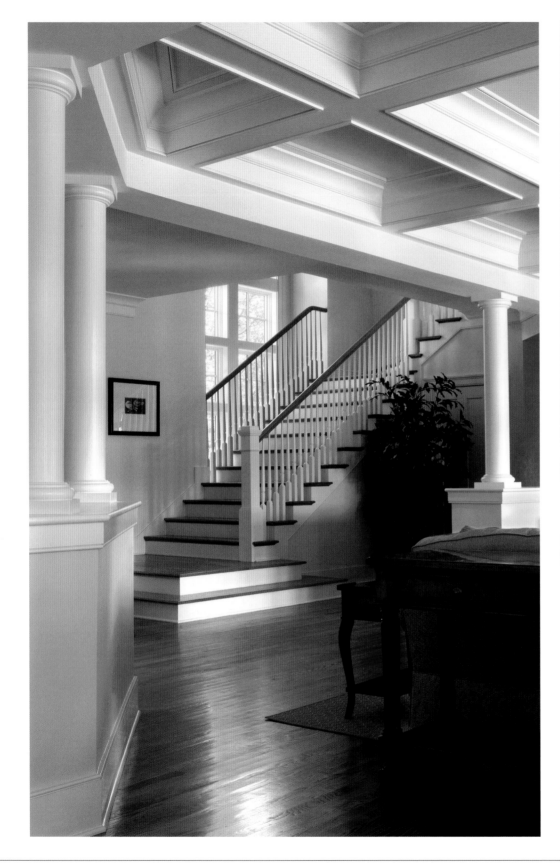

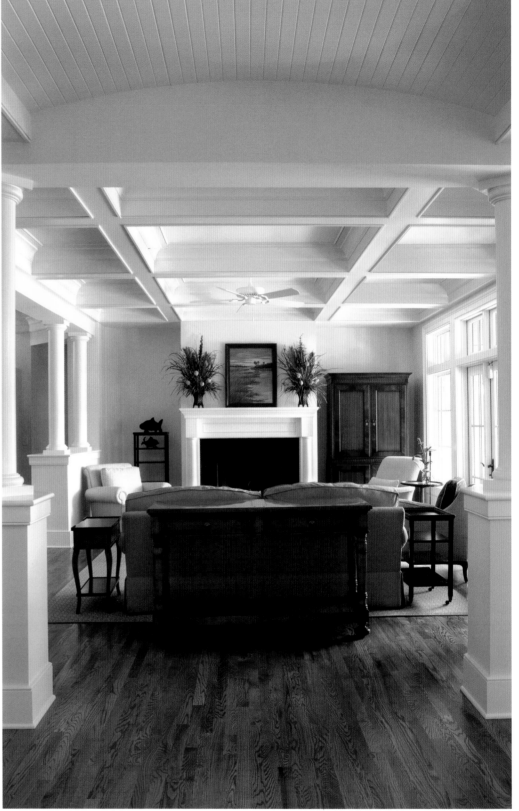

"I try to solve problems from a buildability side and an aesthetic side. I try to merge them," explains Marc. "My success is my ability to work, listen and communicate with clients and contractors. I am not the guy who walks on job sites and says, 'I know everything, do it my way.' I think the project only becomes better if you allow things to happen on site."

Marc, who has been known to climb on the roof to talk to a subcontractor about framing, believes that everyone from the client to the tile installer is part of the synergy of a home. Everyone's point of view is important to him, and it is through this open line of communication that the structure truly becomes all that it can be. The main goal for him is to always create a home that has a wholeness to it that feels right to everyone who experiences it. "It's important for me to try to create things that are interesting but yet have balance and are whole."

Right: View of front entryway and guest house nestled within the giant live oak; Kiawah Island Club residence.
Photograph by Dickson Dunlap

Facing Page Left: Interior view of stairwell and window wall; Kiawah Island Club residence.
Photograph by Dickson Dunlap

Facing Page Right: Kitchen view into living area with detailed coffered ceiling; Kiawah Island Club residence.
Photograph by Dickson Dunlap

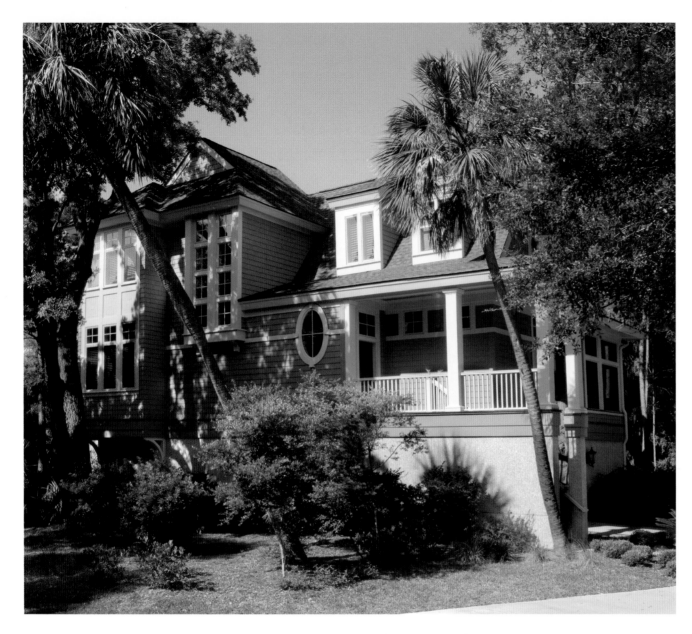

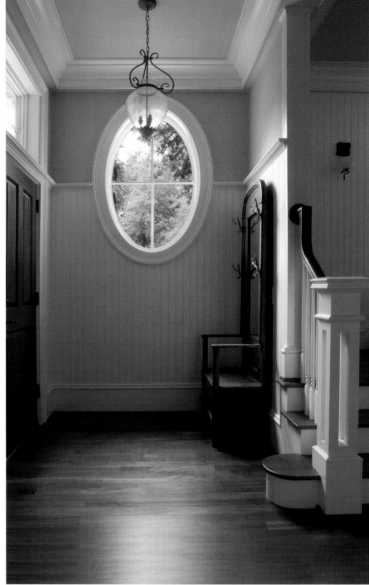

Designing approximately eight to 12 homes a year, Marc has a high referral rate and often does repeat projects for clients. "The award our firm seeks is our client's satisfaction. If someone likes what we have done for them so much that they want us to do more, that is the highest compliment they could give us," he says. "You listen to what the clients desire, and you give it back to them with the craft and they give it back to you."

Above Left: The front exterior of a Burroughs Hall residence.
Photograph by Dickson Dunlap

Above Right: Entry hallway; Burroughs Hall residence.
Photograph by Dickson Dunlap

Facing Page: Pool courtyard and exterior facade; Burroughs Hall residence.
Photograph by Dickson Dunlap

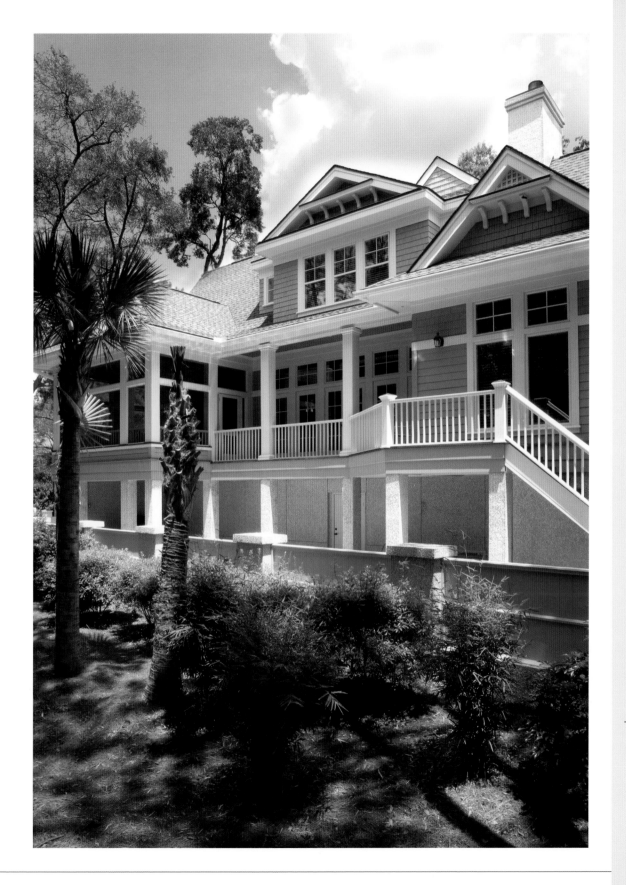

WHAT DO YOU LIKE ABOUT DOING BUSINESS IN THE LOW COUNTRY?

It's just a great place. The environment is so phenomenal. Every setting is unique. Working in the South is wonderful because the people are nice to work with, and the pace is right—it's just a little slower.

WHAT IS THE MOST UNIQUE PROJECT YOU HAVE DONE?

I've designed a lot of churches, but the most unique project I've done is a cheese plant.

ARE MOST OF THE HOMES YOU DESIGN SECOND HOMES?

The homes we're designing are for great clients who want a wonderful home. The budgets are great. We're not doing shoestring kind of things, but we're not over the top either. This is mainly a second home market with people thinking about retiring to their second home. Most of these people are my peers so we have had a lot of similar experiences.

DO YOU STILL DESIGN HOMES FOR THE ADIRONDACKS?

I still get calls from past clients and new clients in the Adirondacks.

Camens Architectural Group

Marc Camens
3461 Maybank Highway
Johns Island, SC 29455
843.768.3800
Fax: 843.557.0101
www.camensarchitecturalgroup.com

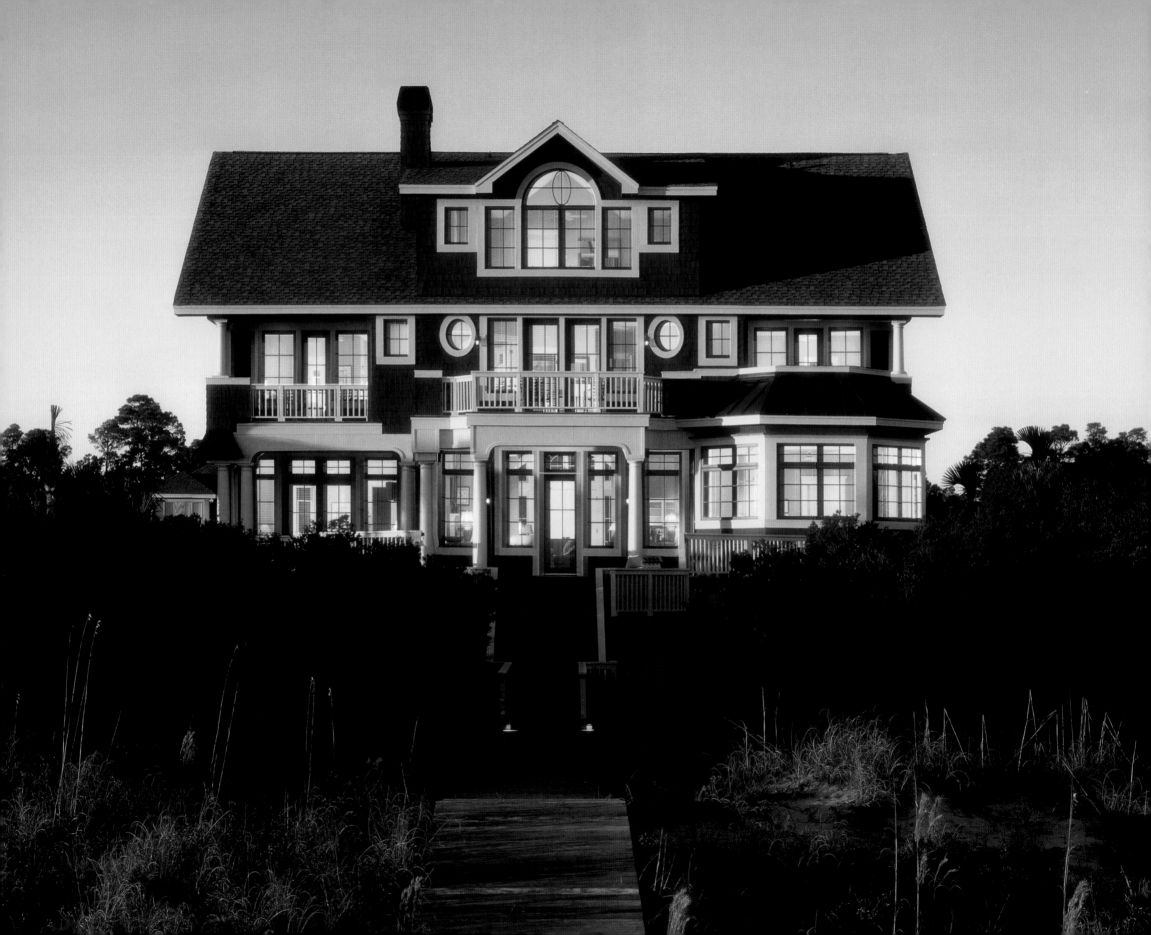

Farris Cowart

Osprey Construction Company, Inc.

Above: A peaceful spot on the rear porch where Jackie and Farris Cowart have light meals while enjoying the gentle marsh breezes and Seabrook Island sunsets.
Photograph by Warren Lieb

Facing Page: Constructed by Osprey with the utmost care, this breathtaking oceanfront home is just a short walk down a private boardwalk to the world-renowned Kiawah Island beach.
Photograph by Dickson Dunlap

Farris Cowart has been building homes in the Southeast for more than 40 years. Starting his career in his native Georgia, Farris moved to Charleston in 1989 and founded Osprey Construction Company two years later. He named his company after the osprey, which is a powerful and graceful raptor that flies South every year to escape the cold temperatures of the North.

"Most of our clients come to Kiawah and Seabrook Islands because of the natural beauty of our beaches, marshes and sea forests in addition to our great weather," says Farris, president and owner of Osprey Construction Company on Johns Island. "Like the osprey, many of our homeowners only spend part of the year with us. We build a lot of vacation homes and future retirement homes for clients from all over the United States and Europe."

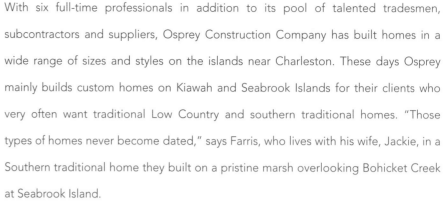

With six full-time professionals in addition to its pool of talented tradesmen, subcontractors and suppliers, Osprey Construction Company has built homes in a wide range of sizes and styles on the islands near Charleston. These days Osprey mainly builds custom homes on Kiawah and Seabrook Islands for their clients who very often want traditional Low Country and southern traditional homes. "Those types of homes never become dated," says Farris, who lives with his wife, Jackie, in a Southern traditional home they built on a pristine marsh overlooking Bohicket Creek at Seabrook Island.

With lots of windows for natural light and lots of outdoor porches for exterior living, his 3,900-square-foot home won the 1997 PRISM Award from the Charleston Trident Home Builders Association for "Best Design for a Resort/Island Home over 3,500 Square Feet." Osprey has also won five other PRISM Awards in addition to having its work featured in *Builder/Architect, South Carolina Homes & Gardens* and *Charleston Home Design* magazines.

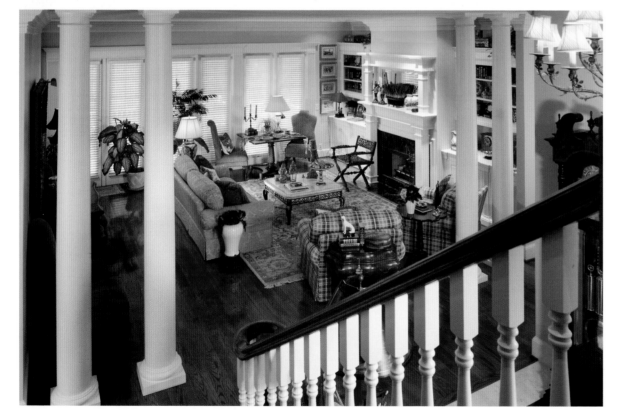

Farris says that Osprey's main goal is to develop and maintain lasting relationships with clients by earning their respect every day—before, during and long after the building process is complete. After all, his clients will become his neighbors. Throughout his career Farris has learned that absolute client satisfaction can only be achieved by focusing on several key criteria: 1. Using reliable subcontractors who are top in their field. 2. Closely managing the entire process from inception to completion. 3. Completing houses on budget and on time with no surprises. 4. Accomplishing every project with a close-knit team who is passionate about achieving the common goal of customer satisfaction.

Top Left: The Cowart kitchen is a model of beauty and efficiency. The cherry island—with custom-stained glass light box overhead—lends a striking contrast to the white cabinetry. Stained Glass Artist: Susan Suffel.
Photograph by Warren Lieb

Bottom Left: A sophisticated living room with two sets of Tuscan twin columns and luxurious appointments invites the owners to relax in front of the custom-designed double mantel fireplace.
Photograph by Warren Lieb

Facing Page: Surrounded by the beauty and serenity of Seabrook Island, Farris and Jackie lovingly incorporated their ideas and tastes into their Southern traditional home, best described as "quietly elegant."
Photograph by Warren Lieb

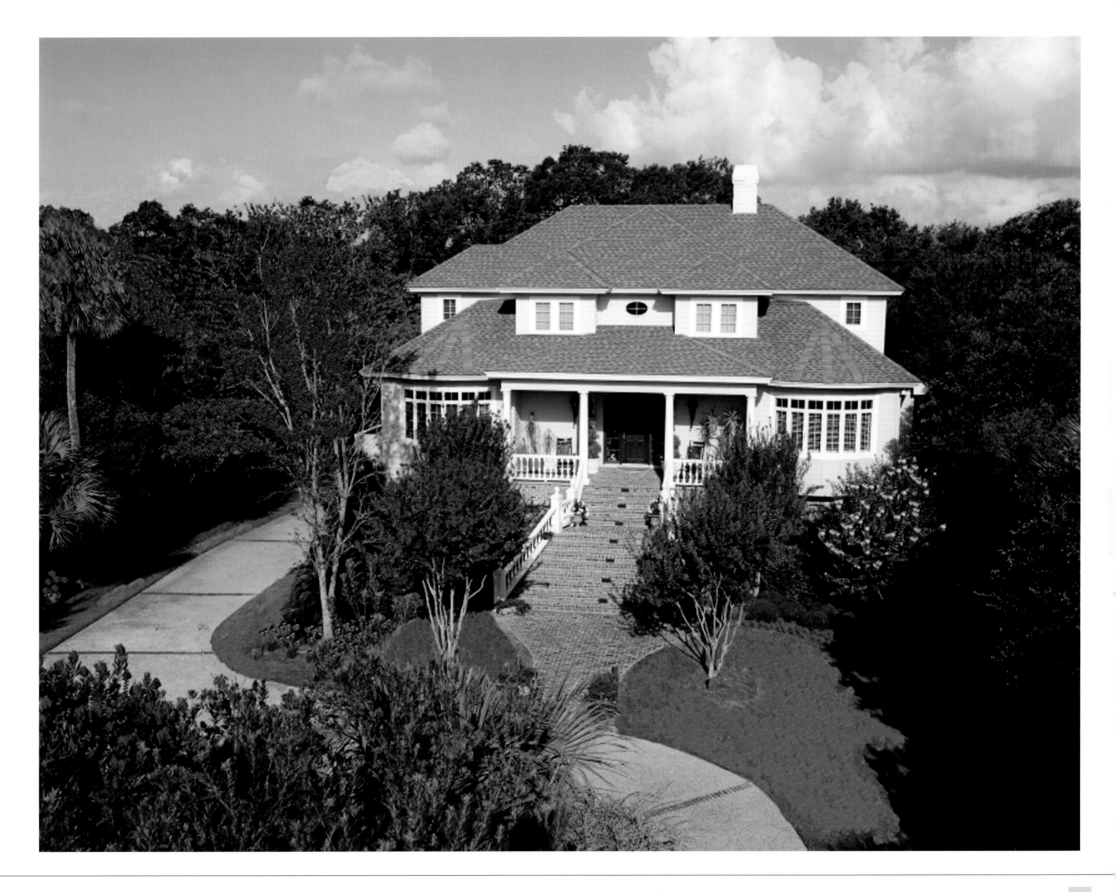

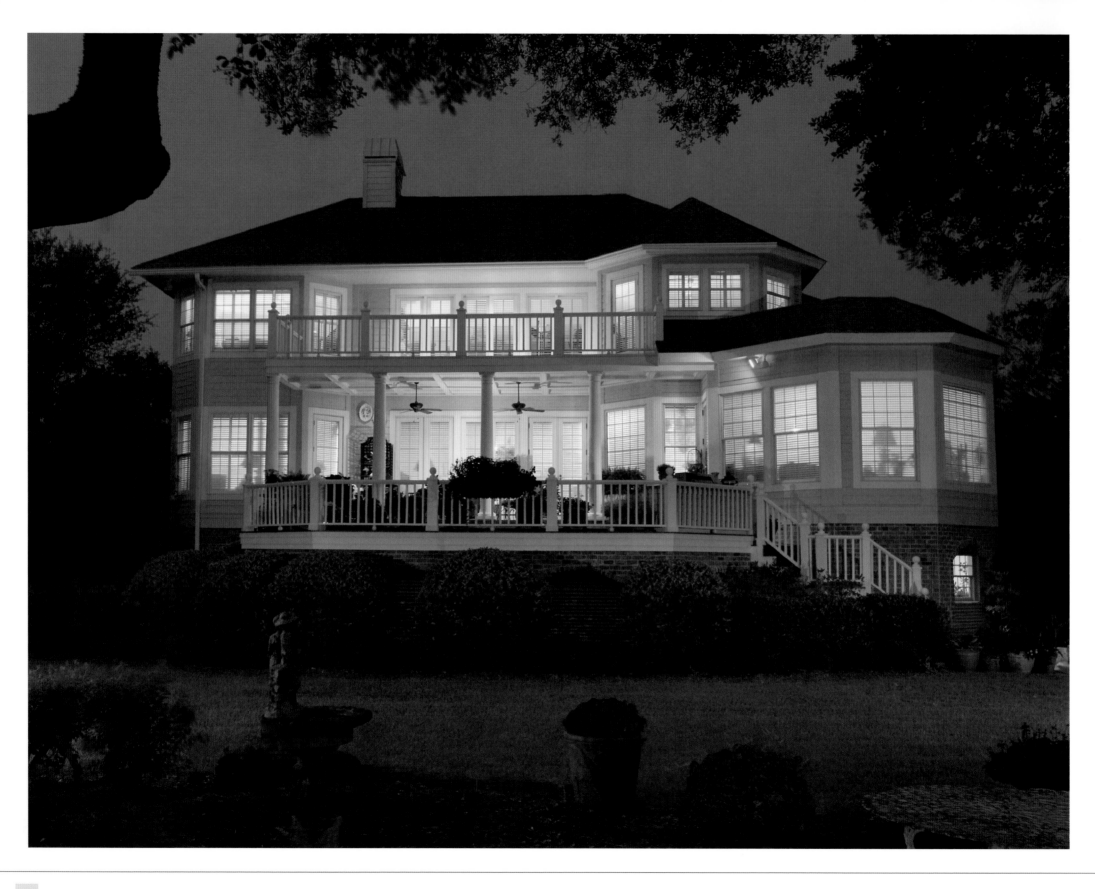

"We shoot for consistency and quality. I really don't compare myself to other builders. I just do the best I can to give clients what they're looking for," says Farris, who has built more than 1,000 homes in the low country areas of South Carolina and Georgia. "We usually wind up being friends once their home is complete."

On Kiawah and Seabrook Islands, homes must be designed by an architect. Over the years, Farris has worked with a wide range of architects, both local and from other areas around the country. "We have excellent relationships with a number of local architectural firms but we also welcome clients to choose their own architect. In addition to his financial responsibilities, Farris personally cost estimates every job and broadly oversees the building progress of each home along with a very talented project management team.

Through our marketing department, we reach out to potential clients throughout the United States and Europe. Once a client indicates interest, we communicate with them in a variety of ways depending on their preference. "When face-to-face meetings are appropriate, we find them to be very useful, but we have built homes for clients who have met with us only once and then returned when it was time for them to move into the house," says Farris. "On average, during the construction phase, we probably meet with clients three to four times at their convenience and one to three times pre-construction."

Osprey Construction Company, Inc. builds five to seven homes a year starting from under one million dollars to well over that figure. Osprey homes range in size from around 2,500 to 6,000 square feet. "I enjoy the challenge of building a unique home. I enjoy taking a client's ideas and delivering them the home they have often dreamed of for many years," says Farris.

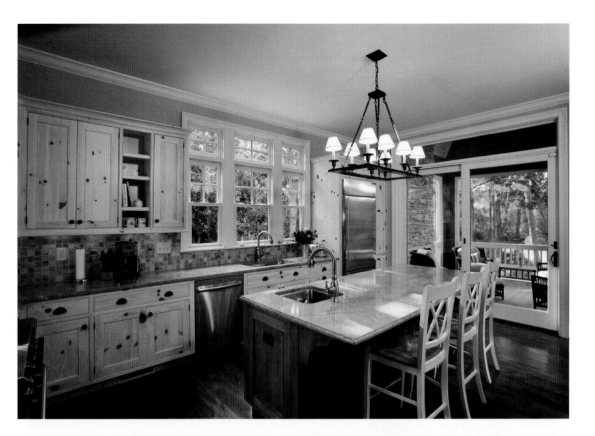

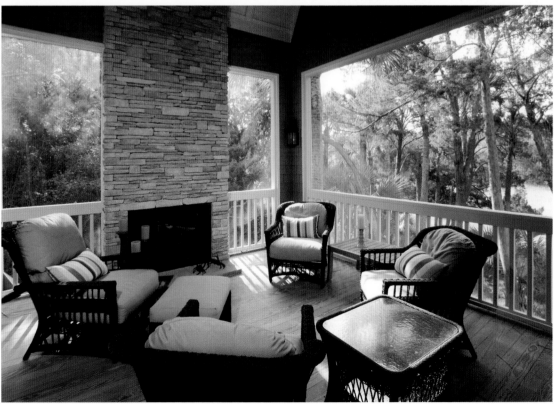

Top Right: White-glazed knotty pine cabinetry, designed by the William Pritchard Company, forms a striking contrast with the verde portofino granite-topped elder island and the walnut stained floors.
Photograph by Warren Lieb

Bottom Right: This spacious screened porch with vaulted ceiling and stacked cultured stone fireplace provides additional gathering space in the Kiawah Island home of a young Atlanta family.
Photograph by Warren Lieb

Facing Page: With almost all rooms enjoying panoramic views from the double tier of rear decks, the stunning Cowart family home stands illuminated against the summer sky at dusk.
Photograph by Warren Lieb

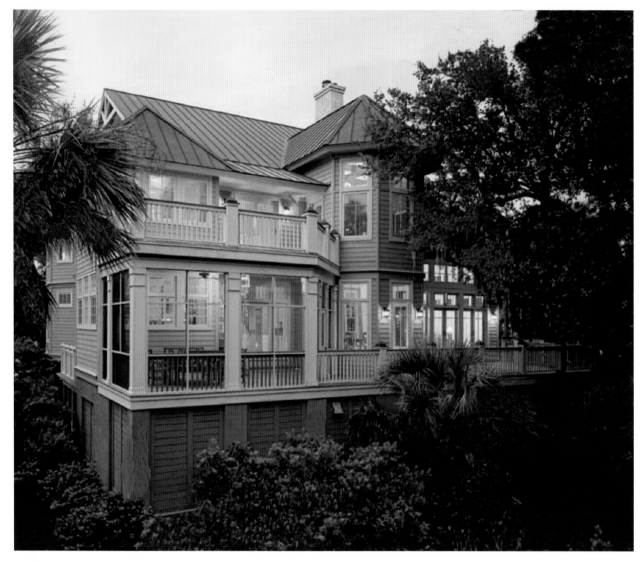

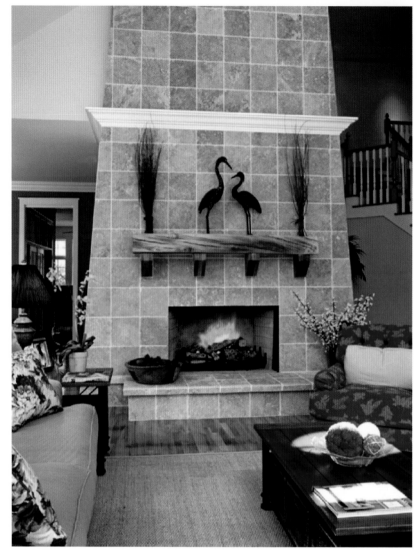

Farris knew he wanted to be a builder when he was in elementary school as he always enjoyed constructing things. In his spare time, he practices woodworking and makes cabinets, furniture and bookcases. He has found that his hobby often influences his work. "When you're building furniture and cabinets you must have an eye for detail and think a lot about what you're going to do, how the product will appear when it's finished and what you might do to improve on that end product. The same is true when you're building a home," he explains. "Using these skills, when I am out in the field overseeing jobs I can often see things that can be done to improve aesthetics and/or functionality with little or no cost increase."

Farris runs his company by a simple building philosophy, "Build the house right the first time and the client will be happy." He believes in giving people what they want in a custom home so they can enjoy it for years to come. Says Farris, "I think

I'm one of the few home builders who actually loves the work he does. It never gets boring when you work with great clients and an excellent staff."

Above Left: Blending gracefully into the natural surroundings, this spectacular 4,500-square-foot Kiawah Island home serves as a beach and golf retreat for an active family from Texas.
Photograph by ©Rick Rhodes

Above Right: This Austin white limestone fireplace rises close to 30 feet to a vaulted ceiling. A mantel of rough-sawn heavy timber was shipped from the owners' Texas ranch.
Photograph by Dickson Dunlap

Facing Page Top: An expanse of the casually elegant living/dining space, easily accessible to the rear deck with pool, exemplifies the relaxed island lifestyle enjoyed by Osprey's clients.
Photograph by Warren Lieb

Facing Page Bottom: This brightly painted media room with sumptuous leather seating provides a family from Illinois with a place to kick back. The wall of windows provides plenty of light.
Photograph by Warren Lieb

Facing Page Far Right: After a busy day at the office, Farris relaxes with his wife, Jackie. Their home was carefully designed to capitalize on "the most dramatic sunsets in all of the low country."
Photograph by ©Rick Rhodes

Q&A
more about Farris ...

WHO HAS HAD THE BIGGEST INFLUENCE ON YOUR CAREER?

My father. He was a very hard worker and a great role model.

WHAT IS THE BEST THING ABOUT BEING A BUILDER?

Creating a quality home for a client so that they can live out their dreams.

WHAT DO YOU LIKE ABOUT DOING BUSINESS ON KIAWAH AND SEABROOK?

I like the uniqueness of the construction here and the different challenges that come with it. I also love meeting the interesting people who come here from all over the country and Europe to vacation or retire.

IF YOU COULD ELIMINATE ONE DESIGN/ARCHITECTURAL/BUILDING TECHNIQUE OR STYLE FROM THE WORLD, WHAT WOULD IT BE?

Poorly designed and poorly constructed "cookie cutter" homes.

Osprey Construction Company, Inc.

Farris Cowart

Island Center, Suite 2B

3690 Bohicket Road

Johns Island, SC 29455

843.768.4150

Fax: 843.768.4152

www.ospreyinc.com

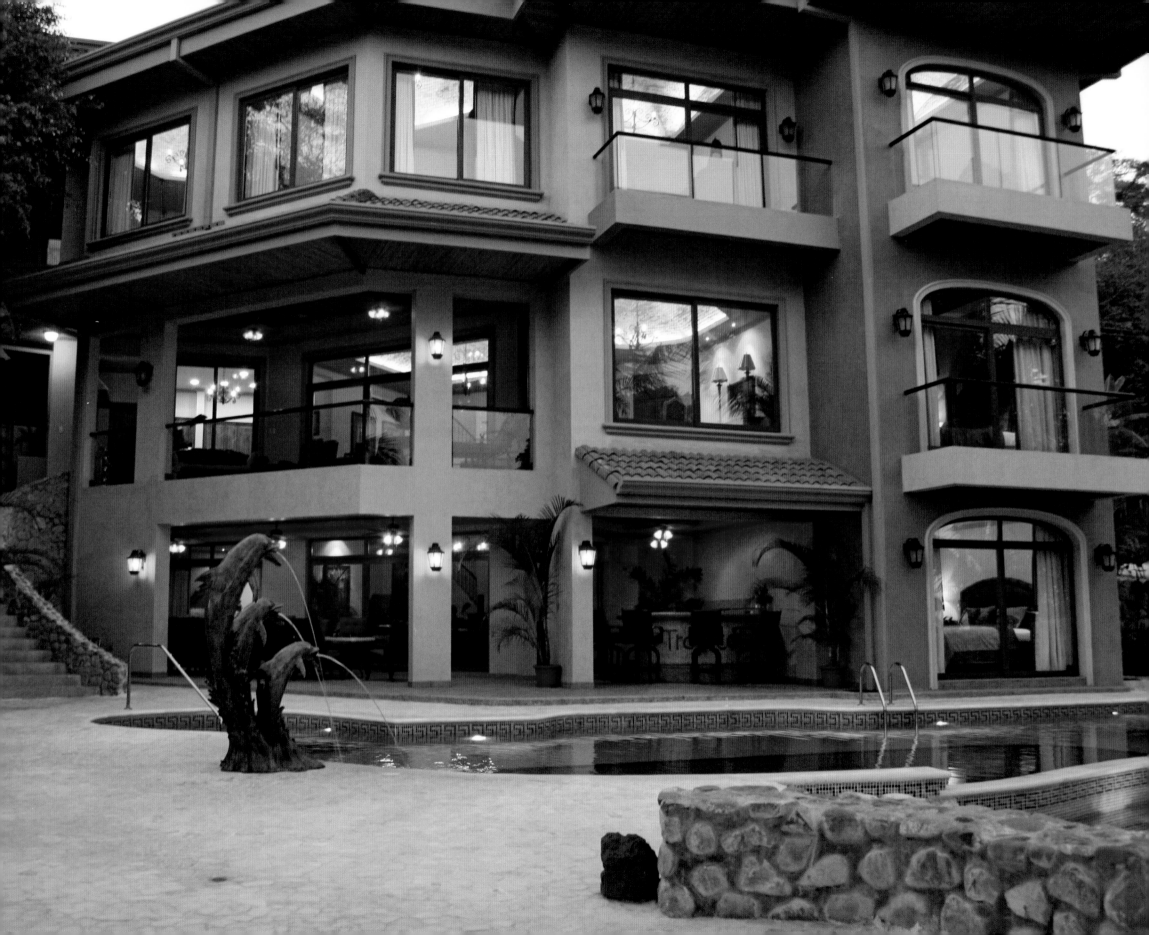

Frank Guidobono

Cambridge Homes, Inc.

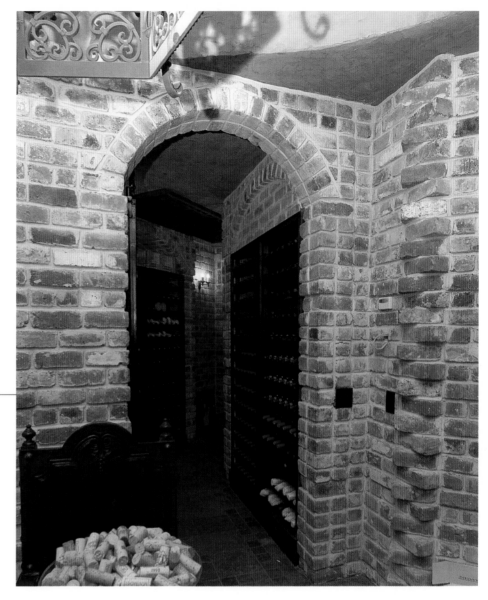

Above: This one-of-a-kind wine cellar—with its beautiful brick and tile, abundant rack space and temperature controlled environment—is a wine collector's dream come true.
Photograph by Brackett Photography

Facing Page: Every bedroom in this fabulous home has a beautiful view of the unique pool area as well as breathtaking ocean views.
Photograph by Cambridge Homes, Inc.

In the early 1980s, not long after earning a degree in building construction from Michigan State University, Frank Guidobono left the frigid winter temperatures of his native state and ventured south to explore the opportunities in sunny Hilton Head Island. One successful house led to another and, in 1982, Frank launched Cambridge Homes; today, more than 500 homes later, his company is the leading residential construction firm on the island.

"Our mission is to custom-build our clients' dream homes from top quality materials and the highest construction standards in the industry," says Frank, who serves as president of the company and holds building contractor licenses in South Carolina, Georgia and Florida.

When asked for Cambridge's guiding philosophy, Frank declares, "The customer's needs and desires are at the heart of everything. Our task is to make the entire home-building experience as painless as possible, from the design to the construction to the actual finished product." Frank and his team are adamant that they do not put their own ideas ahead of what the client wants. They are equally resolute about ensuring that clients do not feel the custom-build process is a hassle, no matter how complex the job.

Cambridge specializes in challenging projects. Most people want to exploit the view, but some lots have odd shapes with little of the overall perimeter facing the prime viewing area. The team designs the house to radiate from the center of the view and chooses materials to maximize sightlines. "We focus so carefully on the design of a difficult project that we often end up with not just a passable home but a masterpiece," says Frank. The Cambridge team takes pride in crafting a unique solution to each particular puzzle.

Frank first encourages a client to craft a wish-list with no limits. "There's nothing that we can't add or change or make work with their plans in the design stage," he declares. Frank guides his client through the design, serving as liaison to the architect and making sure that what the client desires is infused throughout the finished blueprint. Cambridge designs approximately 60 to 70 percent of the homes the company builds; the remainder is designed by the clients' own architects.

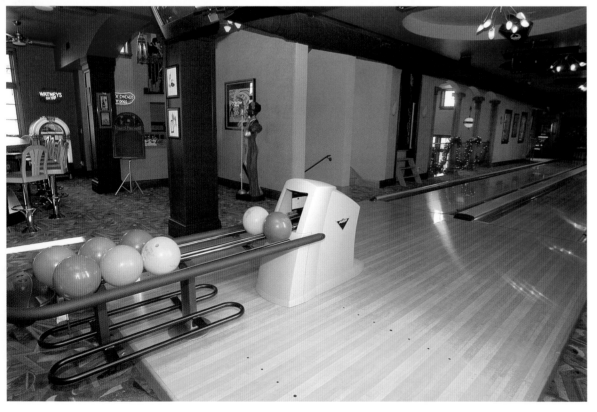

Top Left: The wood trim coffered ceiling with recessed lighting accents the stone fireplace and arched windows to make this room an inviting place for the family to gather.
Photograph by Brackett Photography

Bottom Left: This game room bowling alley is a great illustration of how Cambridge Homes encourages their clients to realize that their ultimate dream home is within reach with those perfect personalized touches.
Photograph by Brackett Photography

Facing Page: This beautiful balcony library is just one of the many reasons Cambridge Homes received a Pinnacle Award from the South Carolina Home Builders Association for this home.
Photograph by Brackett Photography

Ken Crast, Cambridge's Vice President of Construction, executes the plan from start to finish—but his expertise is not limited to overall management. Ken is a master custom woodworker who once owned his own millwork studio. He designs and personally implements many of the intricate interior details to ensure that the client's aesthetic sensibilities are reflected in the artistic design of the complete dwelling. "No facet of the process is too small to be worth my attention," Ken asserts. "The difference between a nice house and a phenomenal one is often in the details."

Ken is just one example of the quality staff at Cambridge; the best tradesperson is one who has the breadth and depth of experience to visualize how his or her one piece of the puzzle will contribute to the finished home.

Above: A cozy niche in this beautiful wood-trimmed library makes for a perfect place for reading or a quiet game of chess.
Photograph by Brackett Photography

Facing Page: Custom built-ins and exquisite details combine with the beautiful wood floors and coffered ceiling to make this office a complete pleasure in which to work.
Photograph by Brackett Photography

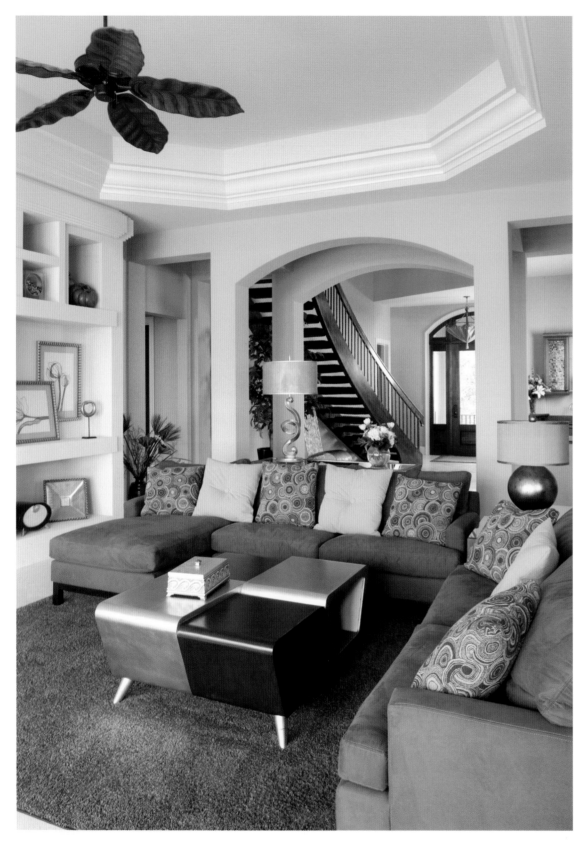

A Cambridge home is built to stand the test of time, both physically and aesthetically. This is especially important when homes are built on oceanfront property; sand, salt spray, erosion, and the occasional hurricane can cause considerable damage to both the structure and the look of a home. The collective experience of the Cambridge staff and its talented subcontractors results in very few warranty callbacks even under harsh coastal conditions.

The average Cambridge home is between 4,000 and 5,000 square feet, though dwellings have ranged in size from 1,000 to 15,000 square feet over the years. Recently, the company built a nearly 9,000-square-foot vacation rental on the ocean in Costa Rica, complete with a private chef and maid. The exquisite home rents for as much as $40,000 per week and is rumored to attract a celebrity clientele, though Frank declines to verify any names.

The Cambridge team particularly enjoys being involved with projects that are forging novel styles and marrying the old to the new. Frank frequently visits Italy to soak in his Italian heritage and study the highly discriminating and elegantly detailed Roman architecture. He also takes advantage of the rich architectural history of nearby Charleston and Savannah to garner ideas for homes with Old World style and modern sensibilities.

Left: The curved staircase in the front foyer and the double-arched entryway lead into a spectacular contemporary living room with beautiful crown moulding and custom display niches for the owner's collections.
Photograph by J.S. Gibson Photography

Facing Page: Everywhere you look in this spectacular kitchen you will find a feature that delights the eyes from the unique ceiling design to the granite countertops and Art Deco lighting.
Photograph by J.S. Gibson Photography

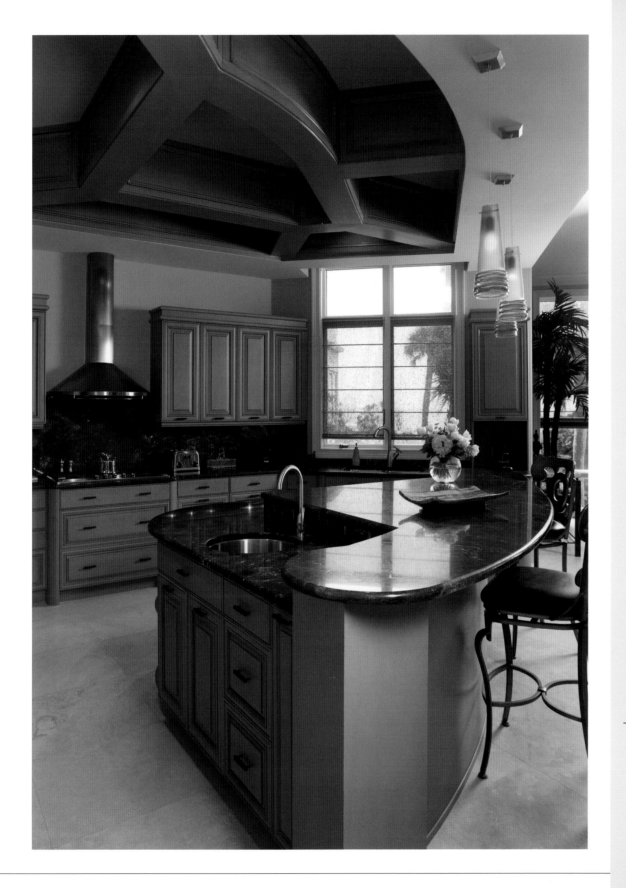

WERE YOU ALWAYS INTERESTED IN DESIGN AND CONSTRUCTION?

When I was growing up in Michigan I remember shoveling sand through a six-inch basement window in 98-degree weather. When I finished one load of sand, the next one would pull up. I was out there sweating when the builder would pull up in a Cadillac with a cigar in his mouth. He rolled down his window slightly so the air conditioning wouldn't escape and said, "Hey kid, have your dad give me a call when he comes back." That's when I decided I wanted to be on the other side of the glass.

WHAT IS THE PHILOSOPHY OF CAMBRIDGE HOMES?

Quality construction, individualized service and competitive pricing.

DO YOU DO COMMERCIAL WORK?

Yes, Cambridge has built more than 50 commercial structures.

WHAT DO YOU LIKE BEST ABOUT DOING BUSINESS IN HILTON HEAD?

It's a great place to live. You can work year 'round because there are no "down" seasons like there are in Michigan where you have to shut down for the winter. You meet world-class people here. We've had the opportunity to meet a lot of industry leaders, celebrities and even inventors. Those are the kind of people who seem to migrate here for retirement. We've made some neat acquaintances through the building process.

Cambridge Homes, Inc.

Frank Guidobono

19 Bow Circle

Hilton Head Island, SC 29928

843.341.2444

Fax: 843.341.2446

www.cambridgehomeshhi.com

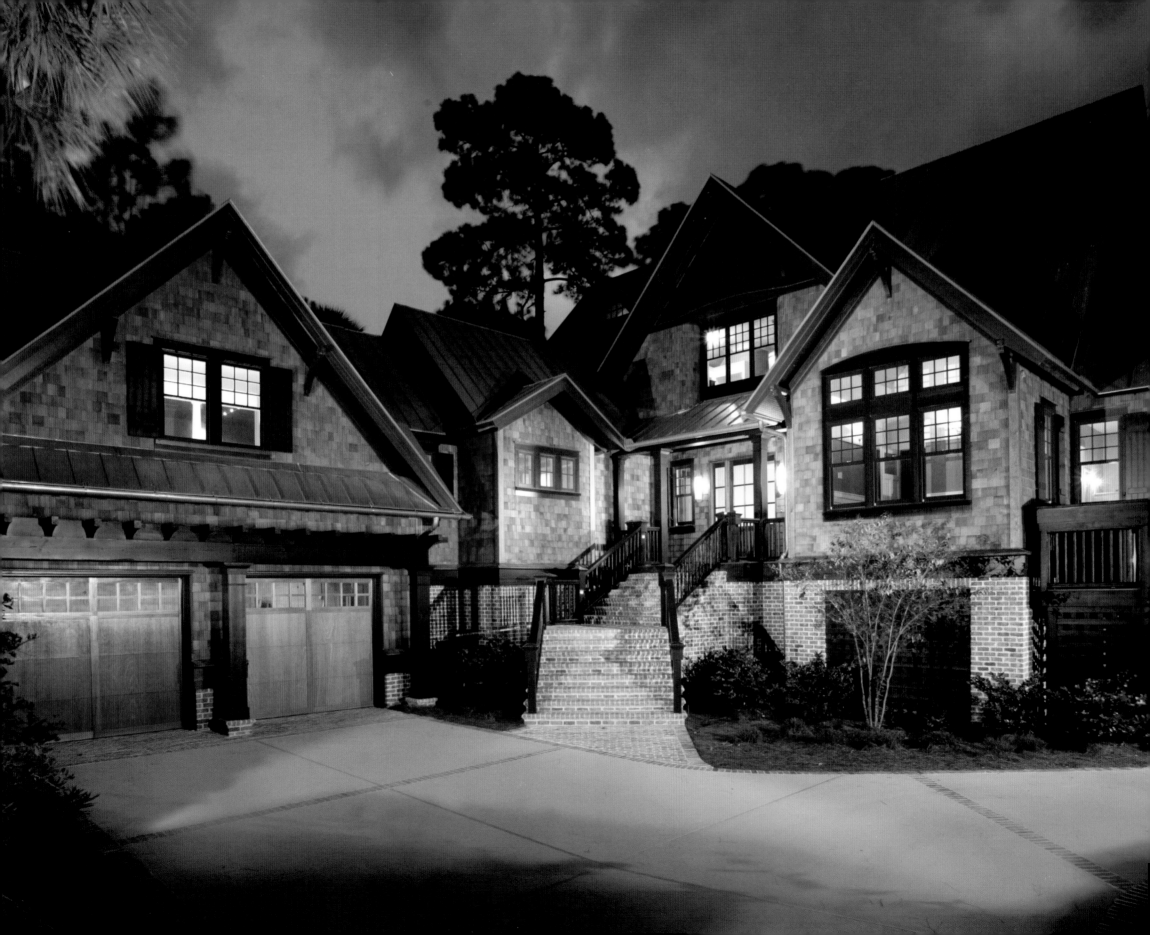

Stephen Herlong

Stephen Herlong & Associates Architects

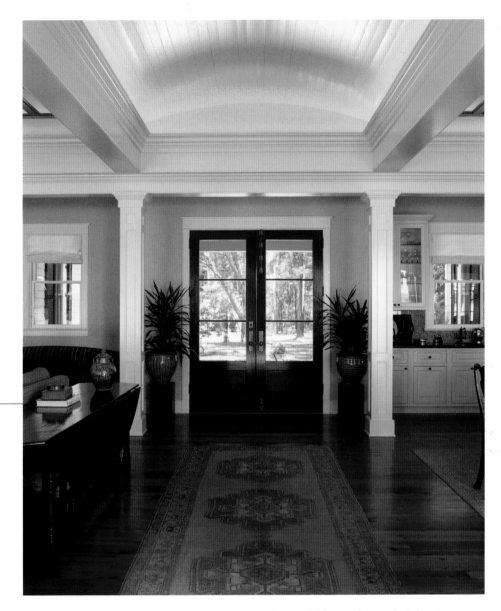

Above: Appropriately detailed columns, beams and ceilings provide a casual definition of this creekside home's open spaces, and create an easy transition from the main entry to the waterfront setting beyond.
Photograph by Tripp Smith

Facing Page: Natural materials used throughout the home work in harmony with playful articulation of exterior forms.
Photograph by Warren Lieb

Architect Stephen Herlong leads a talented team of professionals in creating exceptional homes that reflect timeless quality, which in turn relates to the natural beauty of South Carolina's islands, rivers and coastal regions. When discussing his team's design philosophy Steve states, "We use traditional materials and forms. We respect the surrounding land and water, but most importantly, we respond to the specific needs and lifestyles of our clients."

As Steve and his team move through the design process, they engage their clients by listening to their ideas, asking how they live and how they will use their home. "We design to meet their unique needs and expectations as we incorporate the aspects of design that will best relate to the surrounding

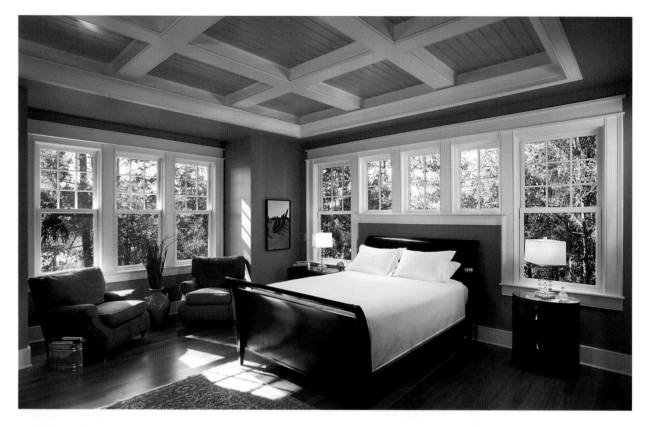

environment. We recognize the distinctive shapes, elements, colors and light patterns found throughout nature and the influence it has on our homes," he explains.

A native South Carolinian and graduate of Clemson University, Steve began his architectural practice in 1991 and later formed Stephen Herlong & Associates. Although he finds inspiration from the beauty of the Carolina's coastal landscape, Steve's philosophy of timeless design heralds back 20 years when he sailed his 37-foot sailboat along the coastlines of the Mediterranean.

"Sailing into the harbors and experiencing the uniqueness of the villages and islands of France, Italy and Greece, I saw firsthand how the gift of beautiful, natural land can be incorporated into design with purpose. Those ancient coastal villages represent architecture at its best—defining place, home and community," he adds.

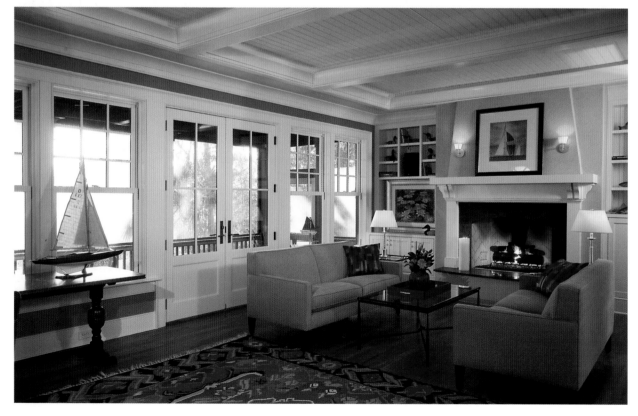

Steve's architectural practice has grown to include a team of architects and interior designers who share his passion for design excellence. Their homes embrace the landscape of the Carolinas' islands, rivers and coastal regions. His firm's personal attention to timeless detail has resulted in its work being featured in magazines such as *Coastal Living, Charleston Home* and *Southern Living*. Recently, Stephen Herlong & Associates was awarded five Robert Mills Design Awards from the South Carolina American Institute of Architects in recognition of design that encompasses traditional southern elements, forms and materials.

"Many of our clients have worked a lifetime to realize their dream home on an exquisite spot of land on or near Carolina's coastal waters," explains Steve. "With every home, it is our work and our passion to fulfill the dreams of our clients. We focus our talents, artistry and expertise on creating a home that will delight for decades and shape memories for future generations."

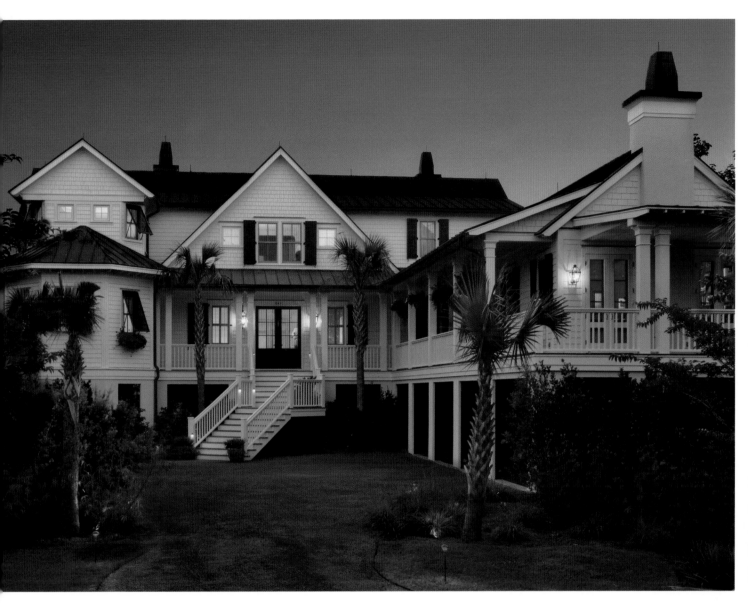

Above Left: Overlooking the Charleston harbor, this home was designed to fit the smaller scale streetscape of a barrier island community, while taking full advantage of the expansive harbor views. Materials are classic and timeless, built to withstand the sands of time and delight for generations.
Photograph by Dickson Dunlap

Above Right: The home fronts the oceanside with porches, decks and large overhangs to buffer the heat and glare from the sun and sea. The façade was broken into smaller parts and carefully articulated to provide numerous views.
Photograph by Dickson Dunlap

Facing Page Top: The spacious master bedroom was designed to create a comfortable relationship between the home and its peaceful landscape.
Photograph by Warren Lieb

Facing Page Bottom: Creative lighting design and abundant glazing in the great room free the ceiling from distractions and create an elegant, yet casual, place to both relax and gather among friends and family.
Photograph by Warren Lieb

Stephen Herlong & Associates Architects

Steve Herlong

103 Palm Boulevard, Suite 3-A

Isle of Palms, SC 29451

843.886.9199

Fax: 843.886.9198

www.herlongarchitects.com

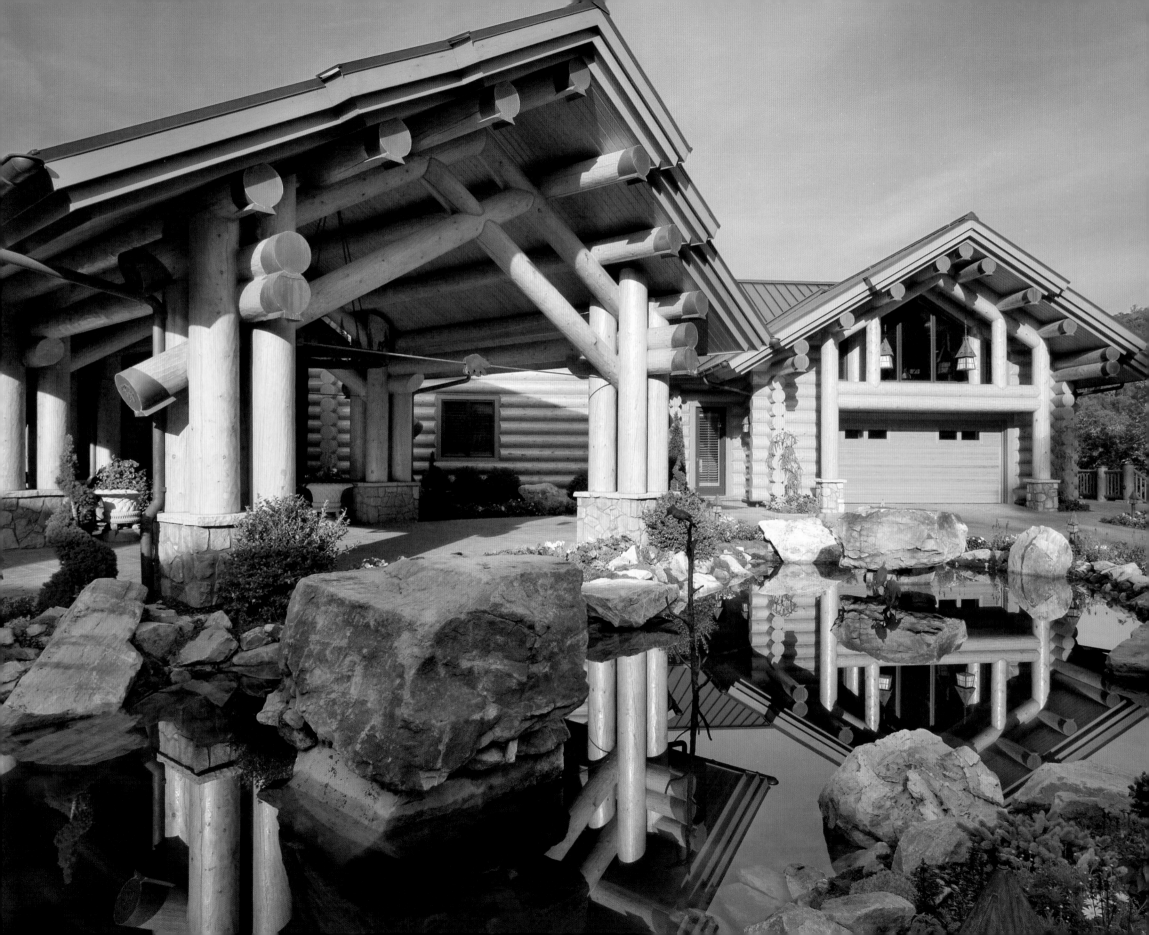

Henry Johnston
Ian Johnston

Johnston Architecture LLP, AIA

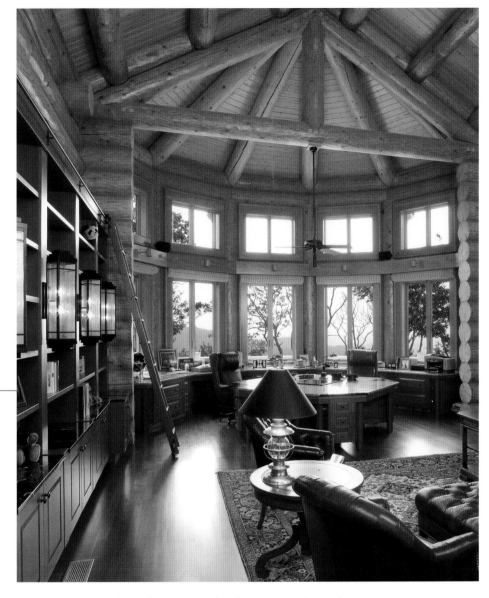

Above: This Black Bear study provides a scenic view from the expansive windows inside.
Photograph by Tim Buchman

Facing Page: A view of a Black Bear porte cochere and lodge.
Photograph by Tim Buchman

When Henry Johnston founded Johnston Architecture in 1976, he was practicing a modern, contemporary approach to design that marries the natural elements of a building site with the program of the client's need. A modern architect like Henry is a purist, initiating the design process in situ where the environment anchors the home to its setting—coastal, rocky or treed—and the floor plan evolves organically, crafted from the available light, surrounding views and the client's requirements for space.

Henry's earliest work unfolds like a catalog of environmentally sensitive dwellings that respond to the remote North Carolina coast of Figure Eight Island where he designed homes around groves of ancient live oak trees and sited for views of the open savannah, Banks Channel and the Atlantic Ocean.

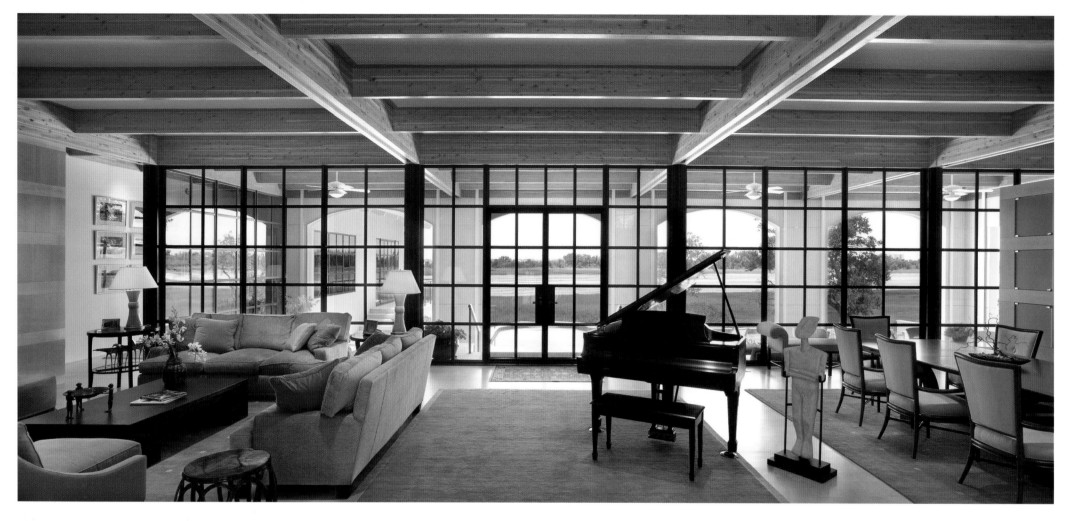

"We start with the client's objectives, the site, as well as the interior, and do a lot of careful planning in terms of function, furniture groups, natural light and expansive views," Henry says. "Our homes are a synthesis of all those things."

In 1991, Henry welcomed his son, Ian Johnston into the family practice. In the 16 years since then, the father-son architectural firm has created dynamic, permanent homes of integrity for North Carolina families—from the mountains to the sea.

They believe the essence of successful collaborations is listening for the client's unspoken desire: "What they don't say is as important as what they do say," Henry explains. Finding that one characteristic that elevates a house into a home and mirrors the client's personality is among the many challenges the Johnstons relish.

"A client's program can change during the design process, but the site doesn't," Henry says. "The site is the one fixed component. We try to make sure the design takes full advantage of it." Executing the design plan through the use of precise drawings, solid details, emerging building materials and state-of-the-art technology has become a hallmark of their style in the trade. The result, whether the house is a year-round residence or a second home, is an integrated design that fits the client's lifestyle like a well-tailored suit.

Above & Facing Page: A wall of windows with access to the loggia beyond makes this Landfall home's great room a naturally sunny and welcoming space.
Photographs by Tim Buchman

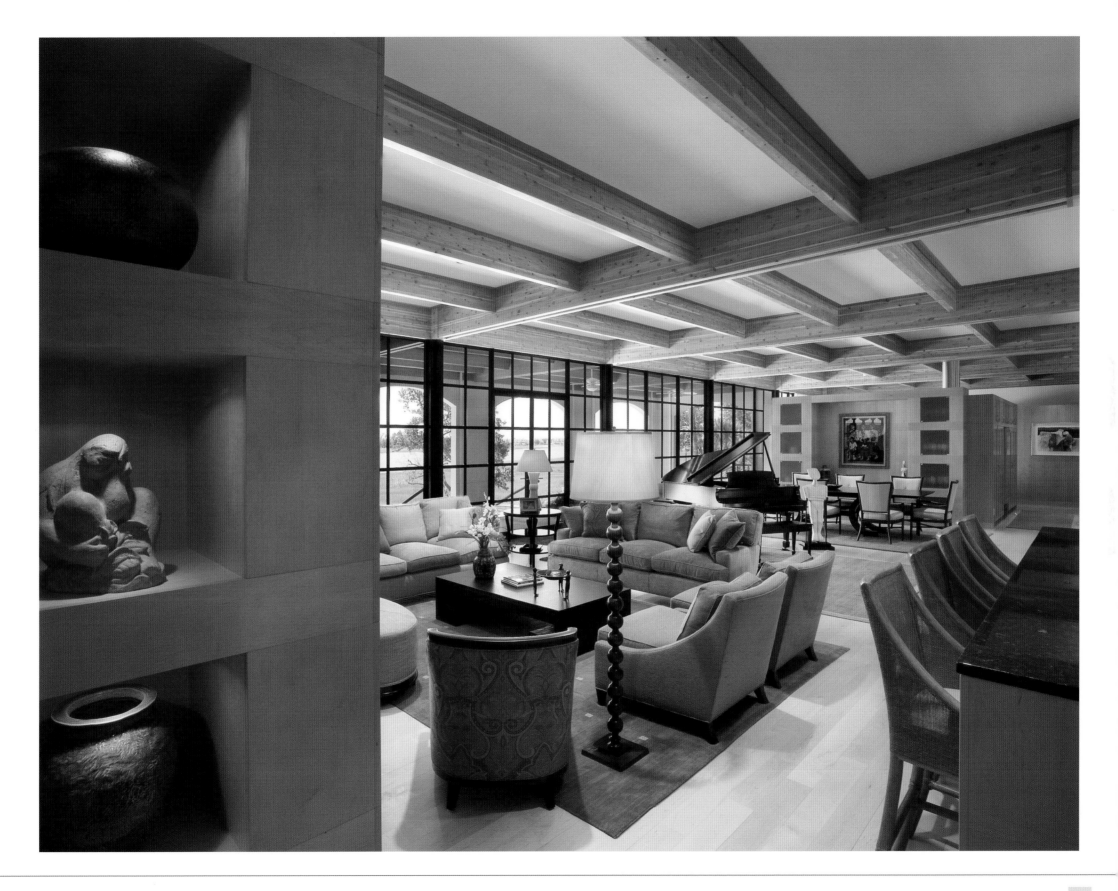

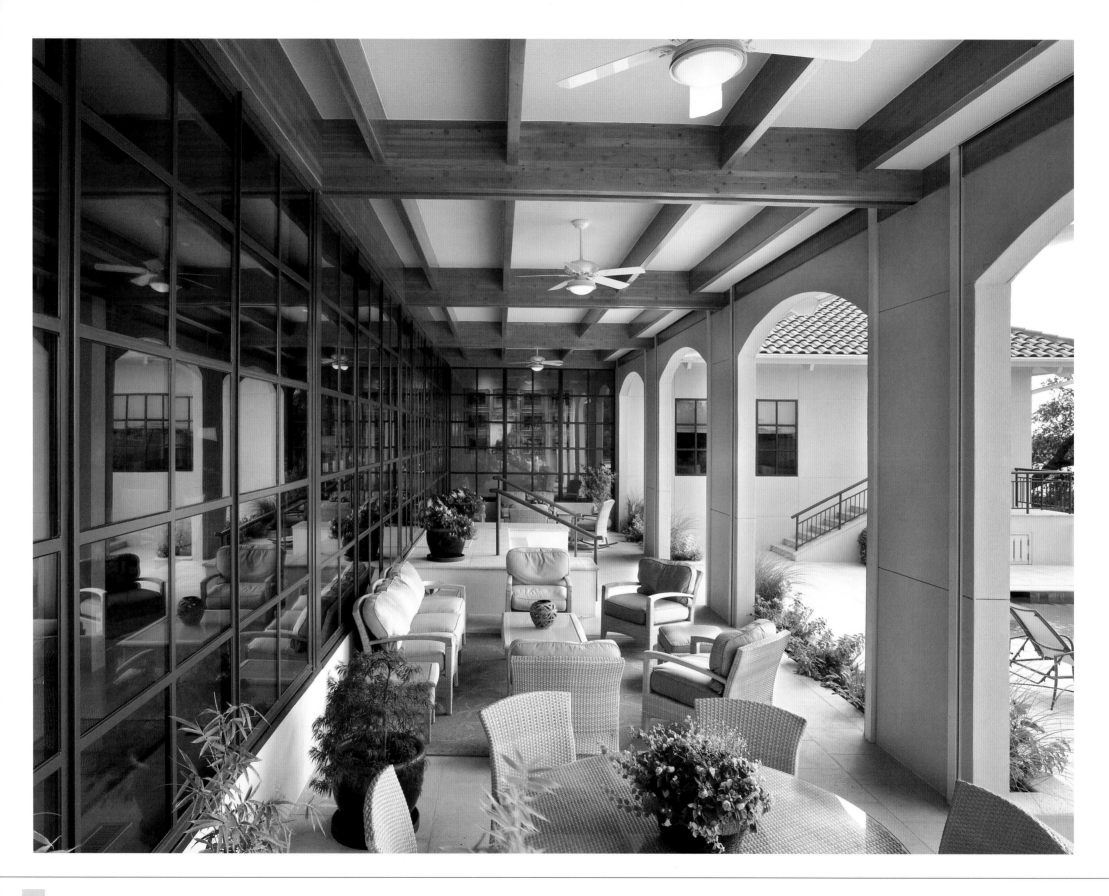

Johnston Architecture was one of the first firms in North Carolina to use a Computer Aided Design (CAD) System to develop comprehensive construction plans. Among builders and contractors, they are known for accurate, thorough and coordinated building documents. "Our homes are cutting-edge in terms of technical details and systems, and we pay a great deal of attention to the design of them," Ian says. "We've been told that our drawings are the best," Henry adds. The Johnstons share projects and take the lead by turns, approaching each project holistically. "I think some of the most challenging sites we've worked upon," Henry starts, "have bred the most innovative solutions," Ian finishes.

A stunning example of the Johnston method is a summer home located 4,530 feet above sea level on a 12-acre site near Linville, North Carolina. The client's wish for a genuine log home was matched to the grandeur of the surrounding views and a contemporary open floor plan.

"The home is a combination of traditional log stack walls, and the great room is a post-and-beam structure open to the southern light and mountain views. The entire roof frame is made with working log trusses and concealed connections," Ian says. "We also integrated an 80-foot-long, 20-foot-high wall of glass into the log frame."

That framed view of the Blue Ridge Mountains is an architectural triumph, so is the creation of an authentic log home in a mountain setting, with rigid site limitations and numerous structural considerations, such as waterproofing and wind engineering to insure permanent sustainability. "That's probably one of the most unusual projects we've done," Ian says, "but we enjoyed it thoroughly because it was such a challenge."

One of the best examples of their collaborative work is near sea level, on the Intracoastal Waterway in Landfall, Wilmington's premiere waterfront community. "This home is simply good design," Henry says. "It's thoroughly executed all the way through with a high level of elegance and refinement."

Top Right: Expansive windows, again, bring interest and natural light into this Landfall home's kitchen.
Photograph by Tim Buchman

Bottom Right: A spectacular view of the Intracoastal from a covered porch.
Photograph by Tim Buchman

Facing Page: The poolside loggia of a Landfall home.
Photograph by Tim Buchman

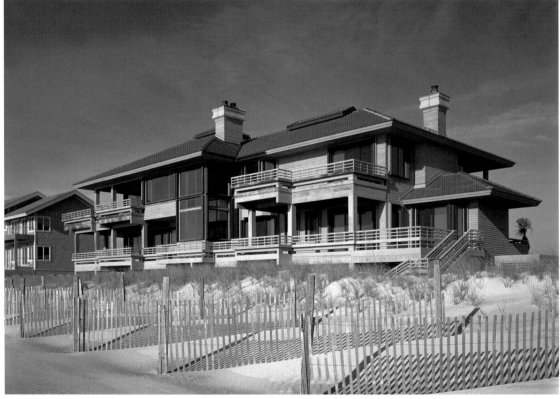

The Johnston's wed the client's desire for a Mediterranean style exterior with an understated, sophisticated, contemporary interior. The living and dining area features a 90-foot-long by 10-foot-high wall of glass that delivers dramatic views of the waterway. Reinforced with structural steel columns integrated, to maximize views, the deep green framing, glazed with tinted green glass, mirrors the natural foliage, spartina cordgrass, and live oak trees indigenous to the site. Green glass tiles blend the dwelling with its environment. Leading from the great room to the pool terrace, a sunken loggia creates a covered outdoor space for relaxing and entertaining family and friends. "There's a rhythm and continuity to this house," Ian says. "The home is designed with a series of repetitive structural elements, patterns in the window frames and interior woodwork and cabinetry that flow from room to room."

As a general policy the Johnstons follow their designs through inception to the conclusion of the construction process. "You want to insure you're building a home that will last. We advocate for the client, and we're very involved in evaluating the quality of the construction," Henry explains. "You don't find many architects climbing scaffolding, scaling roofs or in the crawl space. We do all of that to make sure the home is being built properly."

The Johnstons design only two or three significant homes a year. "Being a small firm allows us to be extremely responsive to our clients," Ian says, adding that they have designed as many as seven homes for one extended family and multiple homes for many others.

"We create homes that embrace the uniqueness of the site and the lifestyles of our clients," Ian says, "designed to be enjoyed by generations to come."

Top Left: The back deck of a Figure Eight Island oceanfront home.
Photograph by Tim Buchman

Bottom Left: A front façade view of an engaging Figure Eight Island oceanfront home.
Photograph by Tim Buchman

Facing Page Top: The same Figure Eight Island home surrounded by a live oak grove.
Photograph by Tim Buchman

Facing Page Bottom: A closer view of the Figure Eight Island home illustrates the natural grandeur of the live oak grove.
Photograph by Tim Buchman

more about Henry and Ian ...

WHAT DO YOU ENJOY MOST ABOUT BEING ARCHITECTS?

Aside from problem solving, we enjoy expressing the uniqueness of each client and creating places for families to gather. Seeing the project through until the client calls it home is a rewarding experience.

DESCRIBE YOUR STYLE OR DESIGN PREFERENCES.

Style often brings preconceptions to a project so we don't favor a particular style. Our work typically embodies the stylistic inspirations from our clients combined with the openness and flow of contemporary design.

WHAT SEPARATES YOU FROM YOUR COMPETITION?

The combination of the quality of our design work and our technical abilities sets us apart. All the contractors we have worked with have remarked on the quality of our construction documents in terms of accuracy, coordination and thoroughness, and many have in turn recommended us to clients. In addition to this, we've both built buildings with our hands. Having worked as carpenters, we understand the way a building goes together and how important attention to detail and craftsmanship are.

WHAT DO YOU LIKE BEST ABOUT WORKING IN NORTH CAROLINA?

North Carolina offers such a broad range of beautiful natural environments. We enjoy designing homes on water-related and mountainous sites because of the opportunities to display the environment's natural beauty from the interior of the home. We feel fortunate to have created 30 years of diverse and unique homes for our clients.

Johnston Architecture LLP, AIA

Henry Johnston
Ian Johnston
3967 Market Street
Wilmington, NC 28403
910.763.5739
Fax: 910.763.5767
www.johnstonarchitecture.com

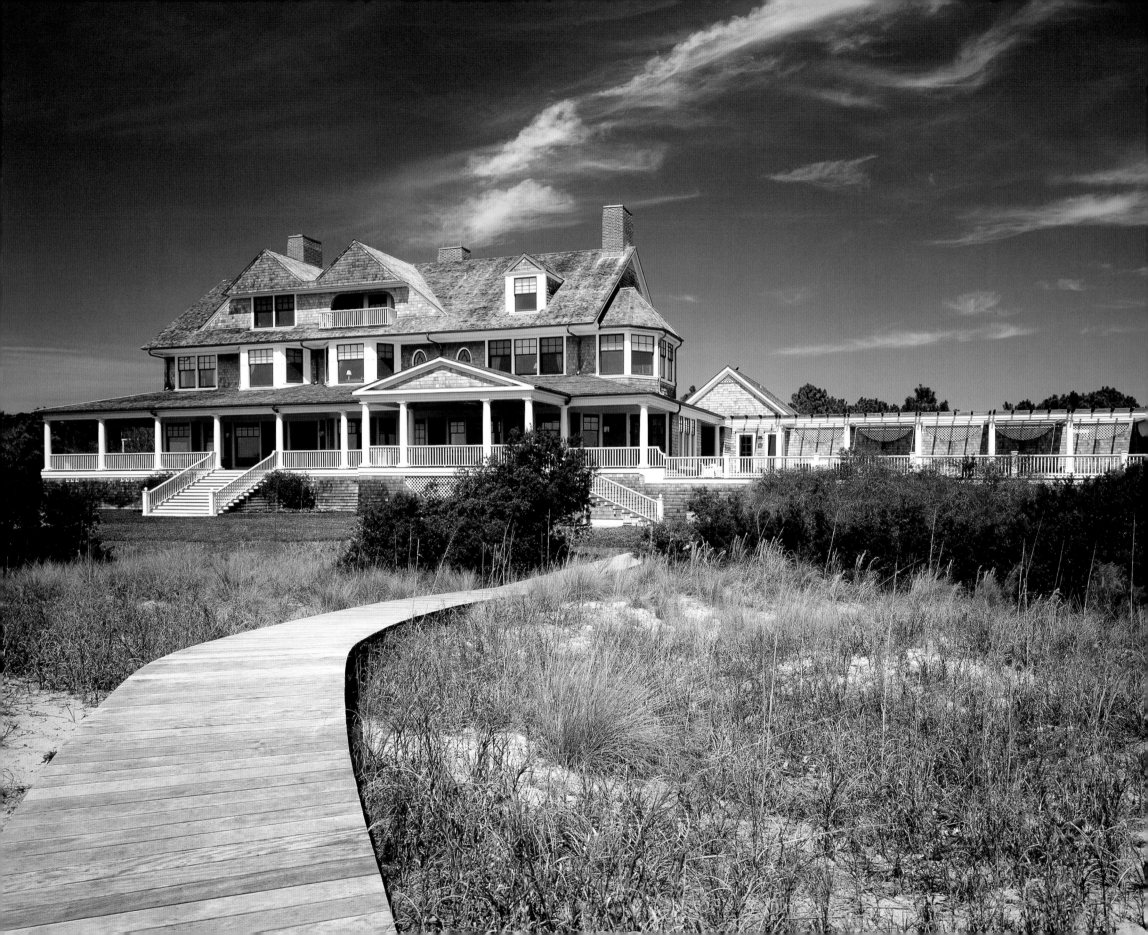

Steven J. Koenig

Steven J. Koenig Construction, Inc.

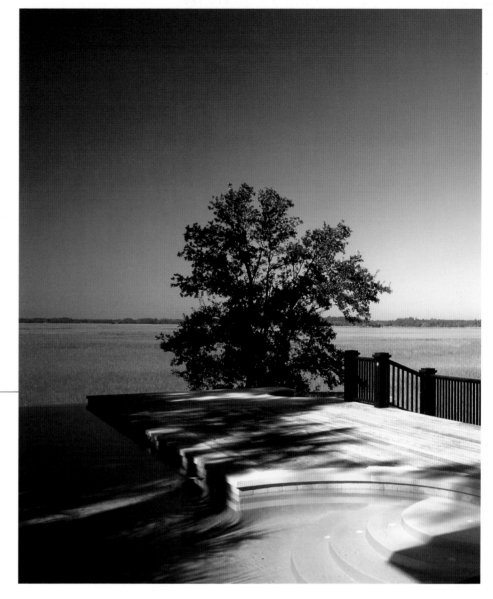

Above: Marsh views, overlooking Kiawah River, can be enjoyed from the negative-edge pool and spa.
Mark Finlay Architect.
Photograph by Steven Brooke

Facing Page: A serene Kiawah beach home designed by Robert A. M. Stern.
Photograph by Rick Rhodes

In 1978 Steve Koenig quit his corporate management job with Union Carbide to pursue his dream of starting a construction business. Seven years later he moved his business from West Virginia to Kiawah Island and has since built more than 100 homes on Kiawah and Seabrook Islands. "I think clients come to us with a built-in level of trust due to our reputation," says Steve. "They depend heavily on us for our input in most cases."

Steve built the only home on Kiawah Island designed by the legendary Robert A. M. Stern and also frequently works with architect Mark P. Finlay. "In the process of designing a home, I work heavily with the architectural team and with our team in the engineering of the house and also the pricing of it," says Steve, who has undergraduate and graduate degrees in industrial engineering. "I'm involved with every project in many ways."

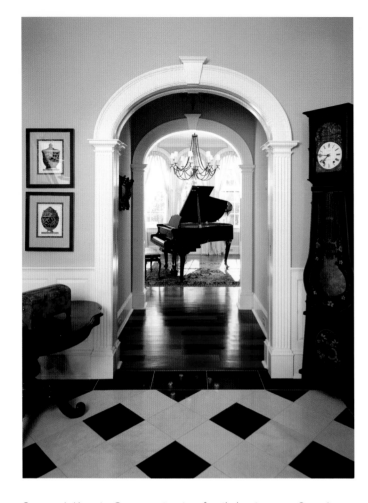

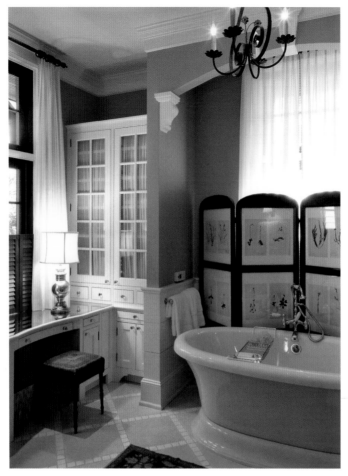

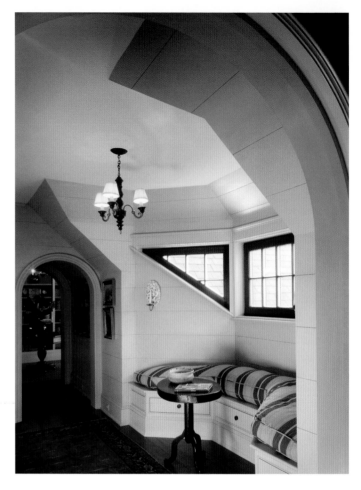

Steven J. Koenig Construction is a family business as Steve's son and daughter both work for the company. Steve's brother, Paul, and his two sons are also part of the business. With a dedicated team of employees, suppliers and subcontractors, Steve is able to offer his clients the highest quality in construction.

"We have a very talented workforce in the Charleston area because of the restoration work that goes on downtown. There are good craftsmen and tradespeople here to handle the kind of high-end homes that we like to build," says Steve, who throughout his career has developed criteria for building on the islands that surpasses standard methods of construction in many ways.

"We build relationships with our clients. That's our motto," explains Steve. "We have such good friends. I can go anywhere on Kiawah, go to one of the clubs, go to dinner, and there's always somebody sitting there that comes up and says, 'Hi.' It's very gratifying."

Steve's latest endeavor is Briar's Creek, a 915-acre private golf retreat on the Kiawah River. With 120 home sites featuring marsh and golf course views, Steve has found this a wonderful place to build the quality custom homes for which he is known. In fact, one of the first homes built there was his. "We don't see an end to our building opportunities here," says the Wisconsin native. "Half of the homes we build are vacation homes, and the rest are

either immediate retirement homes or will be in the near future. We surround our clients with a team rather than an individual. There are typically three or four people working with every client on almost a daily basis. I think that differentiates us from most construction companies."

Above Left: A formal double-arched case opening entryway leads into a bright and cozy breakfast room. Located on Kiawah Island. Mark Finlay Architect.
Photograph by Rick Rhodes

Above Middle: This elegant lady's master bath features a large oval air bath, custom-built linen cabinets and stone floors. Mark Finlay Architect.
Photograph by Steven Brooke

Above Right: Intricate woodwork, creative design and built-in window seats, as well as ample natural sunlight, create the perfect reading nook. Custom wall panels and mahogany windows add to the charm. Mark Finlay Architect.
Photograph by Steven Brooke

Facing Page Top: This porte cochere, which softens the home's front elevation, leads guests into this stunning Kiawah home. Mark Finlay Architect.
Photograph by Steven Brooke

Facing Page Bottom: Upon entering this formal Kiawah residence entry hall, the long gallery opens to a step-down foyer featuring a bridge-walk on the second floor. Mark Finlay Architect.
Photograph by Steven Brooke

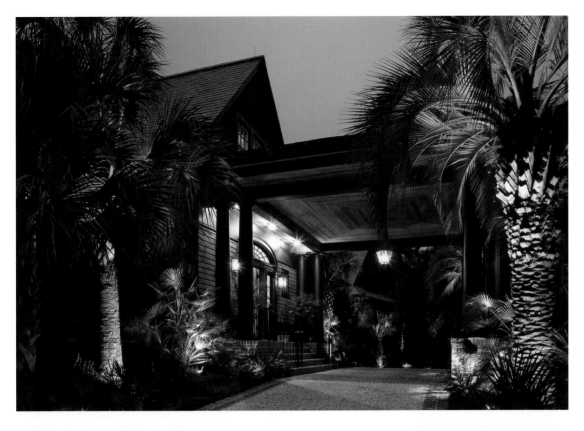

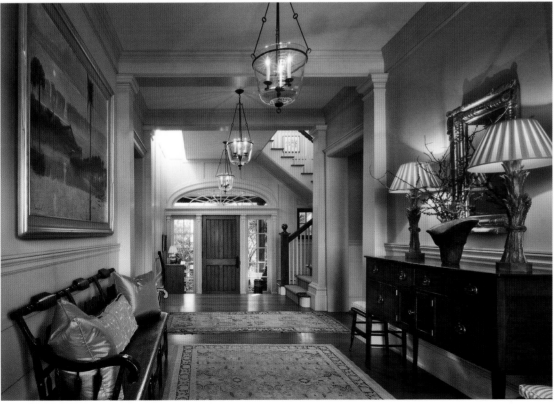

more about Steven ...

DID YOU ALWAYS KNOW YOU WANTED TO BE A BUILDER?

Yes, I did. I built my first fort when I was four years old. Growing up I built houses out of hay whenever they mowed the field in my hometown. I built an underground house until it flooded. When I was a kid I helped frame garages and helped work on buildings with my mother's brothers, who were all very talented. I even helped my grandfather build his summer home up on one of the lakes in Wisconsin when I was eleven. It was in my blood.

WHAT IS YOUR BUILDING PHILOSOPHY?

I always remind my staff that 50 years from now, if someone were looking at one of our homes, we would want them to consider renovating it instead of tearing it down. Everything needs to be done correctly and done to the same standard you'd want someone to do it for you.

WHAT DO YOU ENJOY MOST ABOUT BEING A BUILDER?

There are certain things I enjoy about the process, for instance I love the framing of a home because a structure goes up so quickly. I also love the complexity of a home because I'm good at complexity. An industrial engineering degree is really a problem-solving degree. Anyone could build if it were easy. We like to take on the jobs that are more difficult. That's what separates us from other people.

Steven J. Koenig Construction, Inc.

Steven J. Koenig
3690 Bohicket Road, Suite 4-B
Johns Island, SC 29455
843.768.0842
888.664.6387
Fax: 843.768.0894

www.koenigconstruction.com

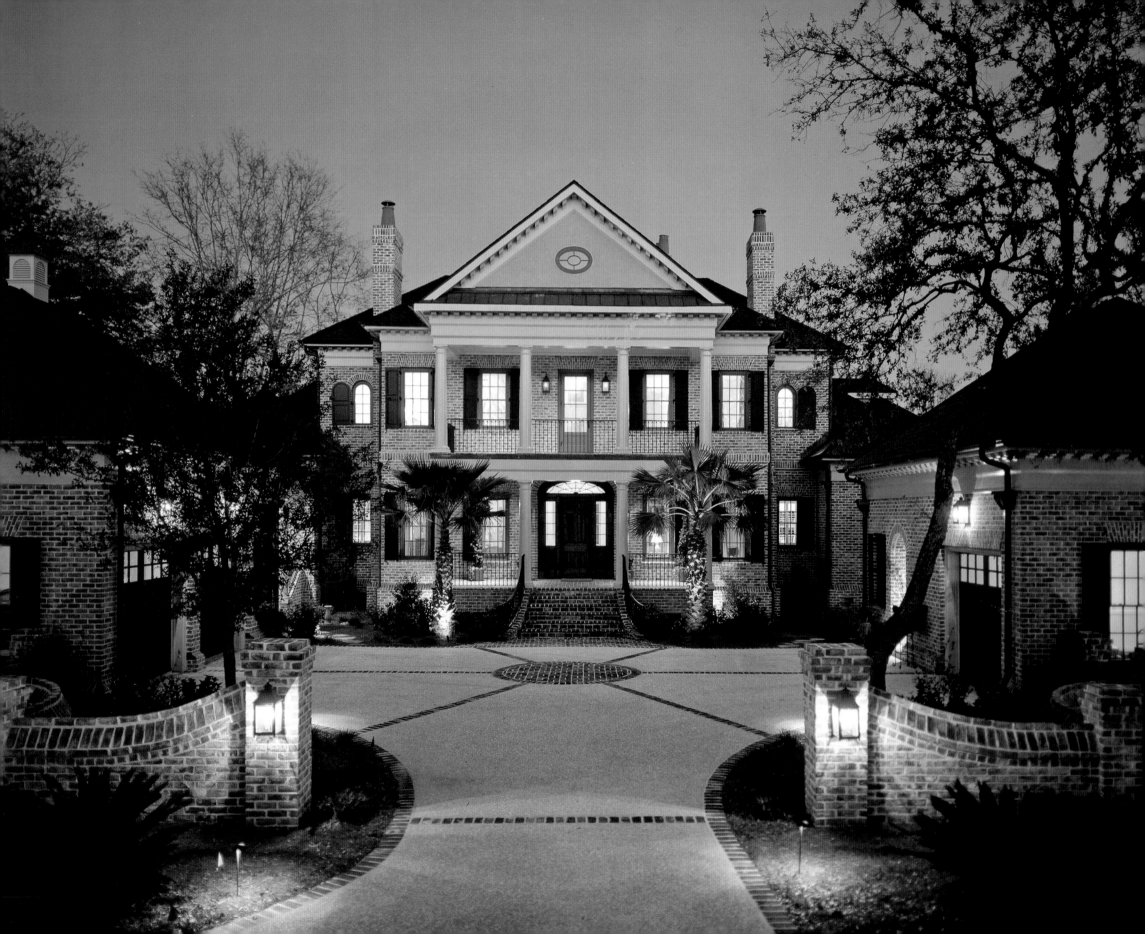

Bob Lee

Robert Morgan Fine Homes

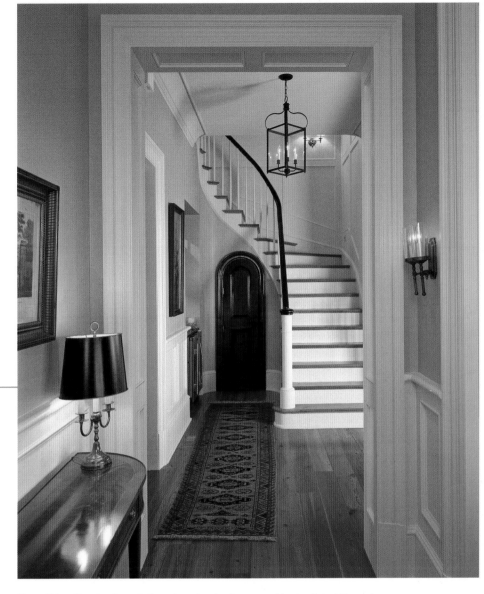

Above: This striking view from a hallway shows that details are everything in a Robert Morgan home.
Photograph by ©Rick Rhodes Photography

Facing Page: Outdoor living spaces and dramatic architecture create a stunning rear exterior of this home on Daniel Island, South Carolina.
Photograph by ©Rick Rhodes Photography

Bob Lee began his construction business, Robert Morgan Fine Homes, in Charlotte in 1976 after working for Cameron Brown Mortgage Company. His philosophy of building has always been that there is a right way and a wrong way to do things. Bob has consistently chosen the right way, even if it has proven to be more costly. He believes, "More important than anything is your reputation."

Developing loyalty among the subcontractors is also crucial in the building business, and Bob says his subs had been with him an average of 15 years in the Queen City. The element that creates a better builder is his sub base: "They need to know what to expect from you, and what you expect from them."

In Charlotte, Bob built a variety of styles in a number of different communities. He is also responsible for St. Serrant, an elegant condominium building in Myers Park featuring an imported limestone façade from Italy. Occasionally, he still builds in Charlotte and the northern North Carolina mountains.

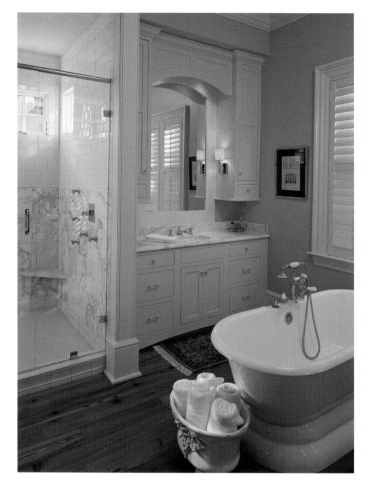
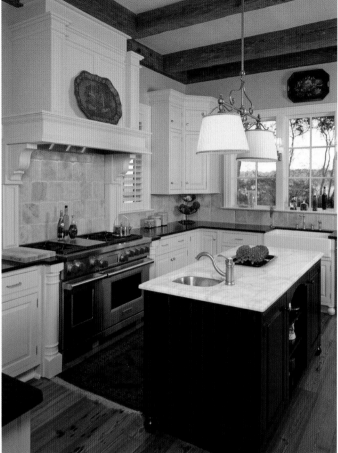
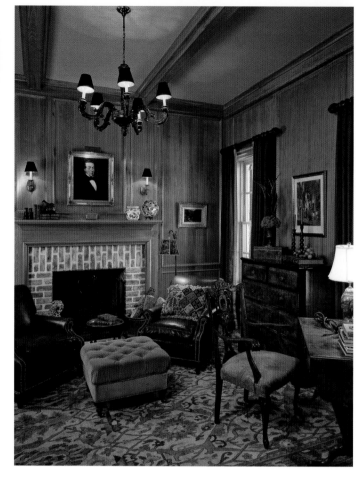

Three years ago Bob relocated his primary business to Charleston, South Carolina. Traditional architecture is preferred in that area, where Bob focuses on Charleston traditional, Georgian traditional, and New England cottage-style homes ranging in size from 4,500 to 9,000 square feet. Creating living space outside is essential in the low country. He incorporates outdoor fireplaces in practically every one of his Charleston homes as they make wonderful spaces for friends to congregate during the fall, winter and spring months. Porches are also a must for this city that catches a sea breeze almost every summer afternoon.

Building four to 10 homes a year, Robert Morgan Fine Homes won two 2005 PRISM Awards from the Charleston Trident Home

Builders Association for "Best Product Single Family Custom Homes for Resort Islands" in the $2.5 to $5 million category and in the $1.5 to $2.5 million category.

Bob's Construction Manager, Dennis Haigler, who has been with him for 15 years, manages the sites in Charleston and Charlotte. Superintendent David Garris works in Charleston, along with Bob's wife, Catherine, and daughter, Angela Byrd. Dian Seegers has been with the company for 30 years, and she manages the Charlotte office. Together, they take the stress out of building a custom home by breaking the process into segments. By offering impeccable organization, this family business guides clients through the building process so they don't become

overwhelmed. "There are a lot of personal decisions to be made when building a custom home," says Bob. "We work with our clients closely so that it's a pleasant process."

Above Left: This master bath on Daniel Island includes a freestanding tub, marble shower with body sprays, and marble vanity countertops.
Photograph by ©Rick Rhodes Photography

Above Middle: A kitchen with an exquisite water view includes a beamed ceiling, top-of-the-line appliances and marble countertops.
Photograph by ©Rick Rhodes Photography

Above Right: Study with beamed ceiling, cypress paneling on the walls and a masonry wood-burning fireplace.
Photograph by ©Rick Rhodes Photography

Facing Page Top: A view from the third floor shows the beautiful detail of the staircase.
Photograph by ©Rick Rhodes Photography

Facing Page Bottom: This master bedroom has a spectacular water view on Daniel Island.
Photograph by ©Rick Rhodes Photography

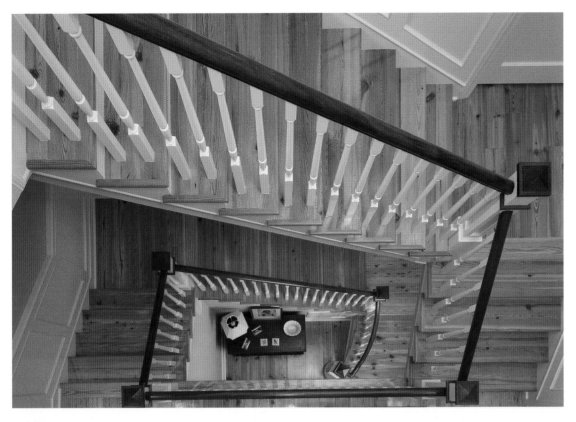

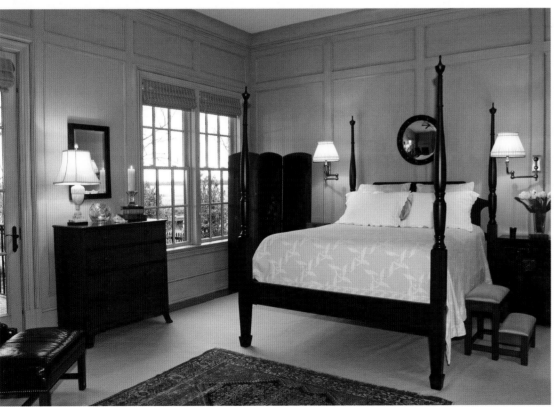

WHAT COLOR BEST DESCRIBES YOU AND WHY?

Any bright color. I always look on the bright side.

WHAT SEPARATES YOU FROM THE COMPETITION?

My clients are getting added value when they buy a Robert Morgan Home. There are items and materials you can select for a house that will give you a return. When my clients move into their new home, I want them to have equity in their home because of how well we built it.

WHAT ARE SOME OF YOUR FAVORITE PROJECTS?

It's difficult to say because many times it depends on the individual. It's wonderful for a client to tell you how pleased they are once they move into their new home.

WHAT DO YOU LIKE ABOUT DOING BUSINESS IN CHARLESTON?

People choose to be here. There's just a great attitude about living in Charleston.

Robert Morgan Fine Homes

Bob Lee

672 Marina Drive, Building E, Suite 201

Charleston, SC 29492

843.284.0316

Fax: 843.284.0318

6805-B Fairview Road

Charlotte, NC 28210

704.366.1619

Fax: 704.365.3982

www.robertmorganfinehomes.com

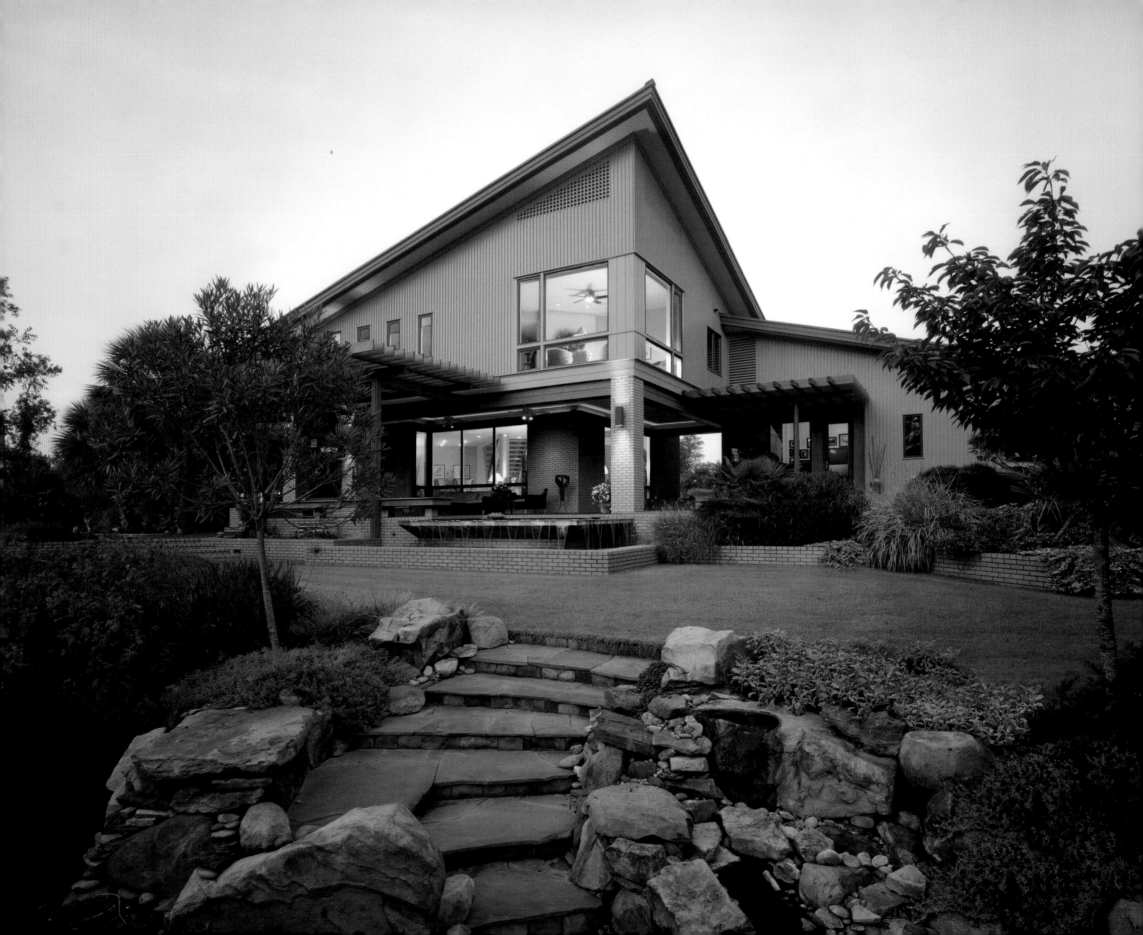

Michael Moorefield

Michael Moorefield Architects

Above: Root Residence.
Photograph by Jerry Blow

Facing Page: Root Residence.
Photograph by Jerry Blow

We typically think of architecture as a positive creative act. Yet, any act of design inevitably, often unintentionally, modifies our world; a beautiful tree is cut, a vista is lost or a subtle contour is graded. Michael Moorefield, principal of Michael Moorefield Architects in Wilmington, North Carolina, designs residences for some of the most beautiful land in the state so it is imperative that he understands the impact of his designs on the environment and the human experience.

"My ambition is to feel I have given back something that respects what was taken or changed. With architecture you are always altering nature so we should always strive to give something back, adding something new, a space, a use, a meaning … that enhances our experience in some positive way," says Michael. "The value and final judgment of these designed enhancements are grounded in human experience. To me, the excitement of architecture is to take our present resources, meld them with our

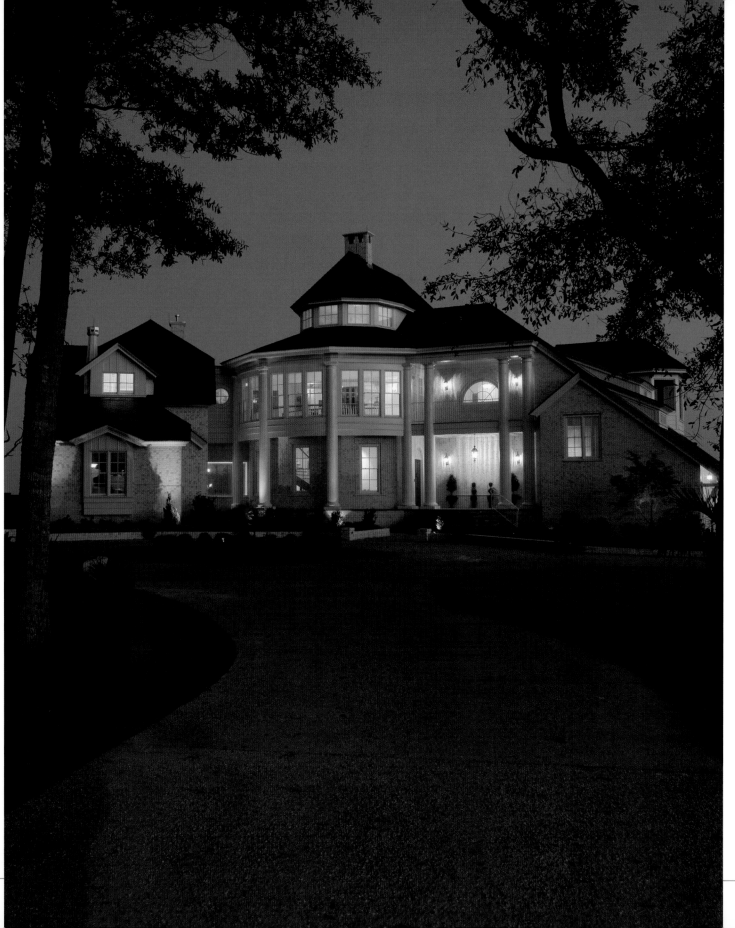
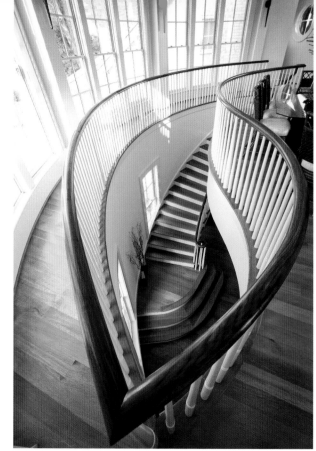
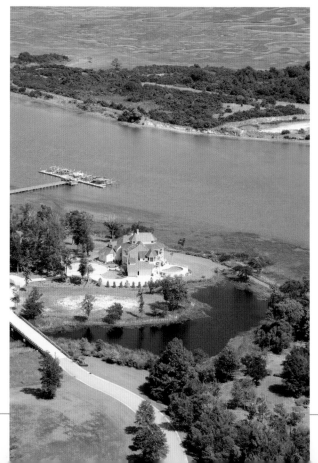

traditions and memories, and transform them, by design, into a future vision that both preserves our heritage and nurtures a meaningful and promising future."

One of Michael's favorite projects is Three Bridges, a home designed for property on the Atlantic Intracoastal Waterway. A significant center portion of the site was a low wetlands basin. Rather than risk damage to this sensitive land area, a design concept evolved that designated the wetlands as garden space. The house was divided into three smaller building units positioned on the higher portions of the site outside of the wetlands areas. The three buildings were connected by bridges that spanned without adversely affecting the wetland. "We used the wetlands as the inner-soul of the house" recalls Michael. "A beautiful natural garden, the wetland areas determined to a great extent as to how we started to think about the house."

Right: The Addison's residence's expansive bay window.
Photograph by Jack Davis

Facing Page Left: Addison residence at dusk.
Photograph by Jack Davis

Facing Page Top: Addison's staircase.
Photograph by Chris Lang

Facing Page Bottom: Addison's aerial view.
Photograph by Jack Davis

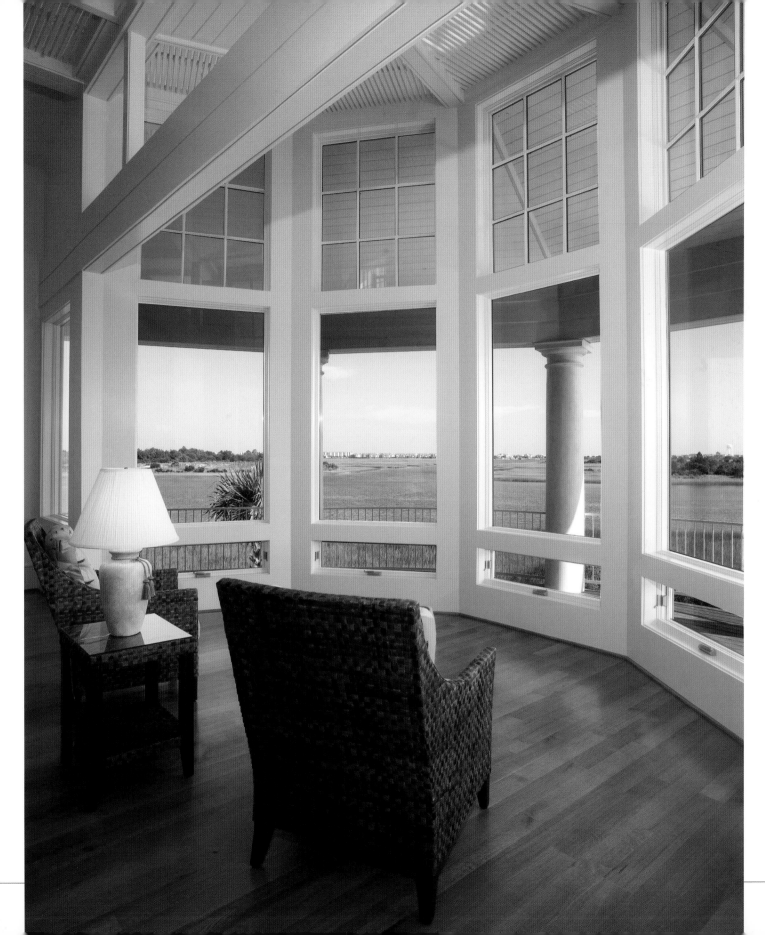

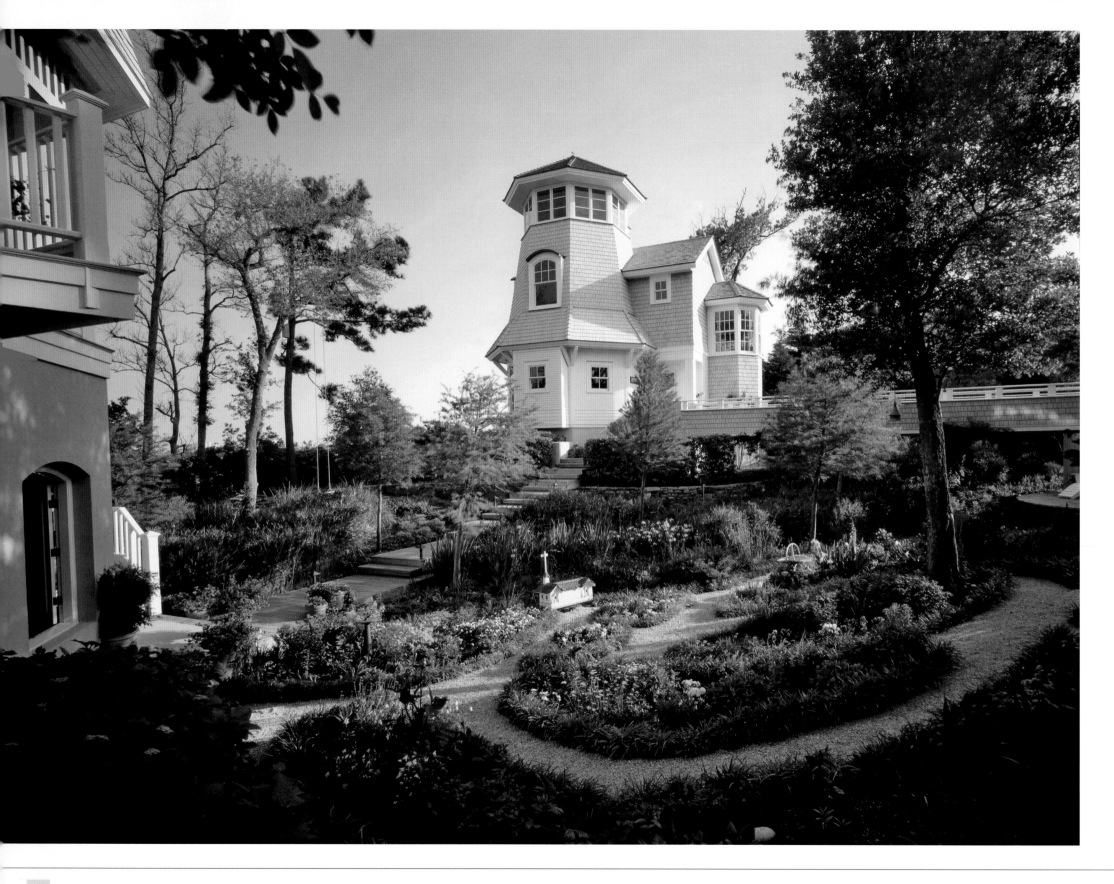

Although the average size of one of Michael's designs is between 5,000 and 8,000 square feet, his firm has also designed an 18,000-square-foot residence and several smaller 1,300-square-foot infill houses in Wilmington's historic district. A large number of his projects are on the coast, but he has designed homes as far away as the foothills of North Carolina.

One of his projects involved designing a contemporary home in a golfing community that did not have many contemporary residences. Michael designed a low-pitched green copper roof for the home in an effort to create an organic form that related to the landscape. The ground-hugging roof effortlessly blends into the rolling hills of the green golf course, while the back of the house is extremely contemporary with an abundance of windows that overlook a lake. The site is successful in that the clients got the contemporary environment they desired without being obtrusive to their neighbors.

With nine employees, Michael Moorefield Architects tackles each design holistically including interior design, landscaping and site planning in the initial design thinking. Michael says his clients' interior and landscape interests are the fundamental starting points of his architectural design process. People tend to buy property that is important to them in a personal way. A meaningful design will evolve from and build upon this attachment. Clients also have ideas about the interiors of their homes in terms of color, wood, light and openness. These are all matters of lifestyle, taste and heritage. Michael studies all of these components, harvesting connections and revelations that lead to promising design ideas.

Top Right: The Phillips' residence, "Three Bridges" kitchen.
Photograph by Jerry Blow

Bottom Right: The Phillips' residence, "Three Bridges" guest house view.
Photograph by Jerry Blow

Facing Page: The Phillips' residence, "Three Bridges."
Photograph by Jerry Blow

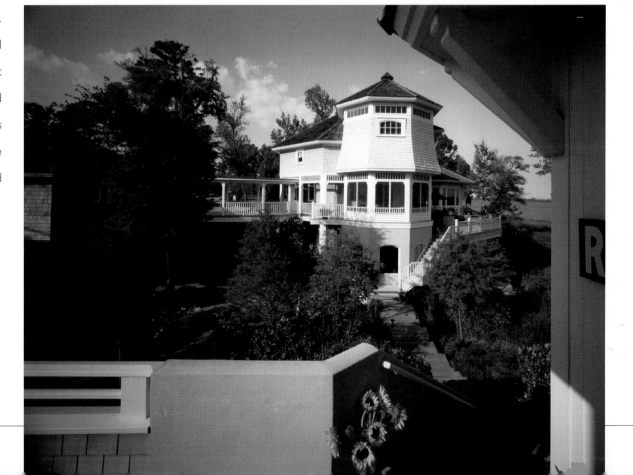

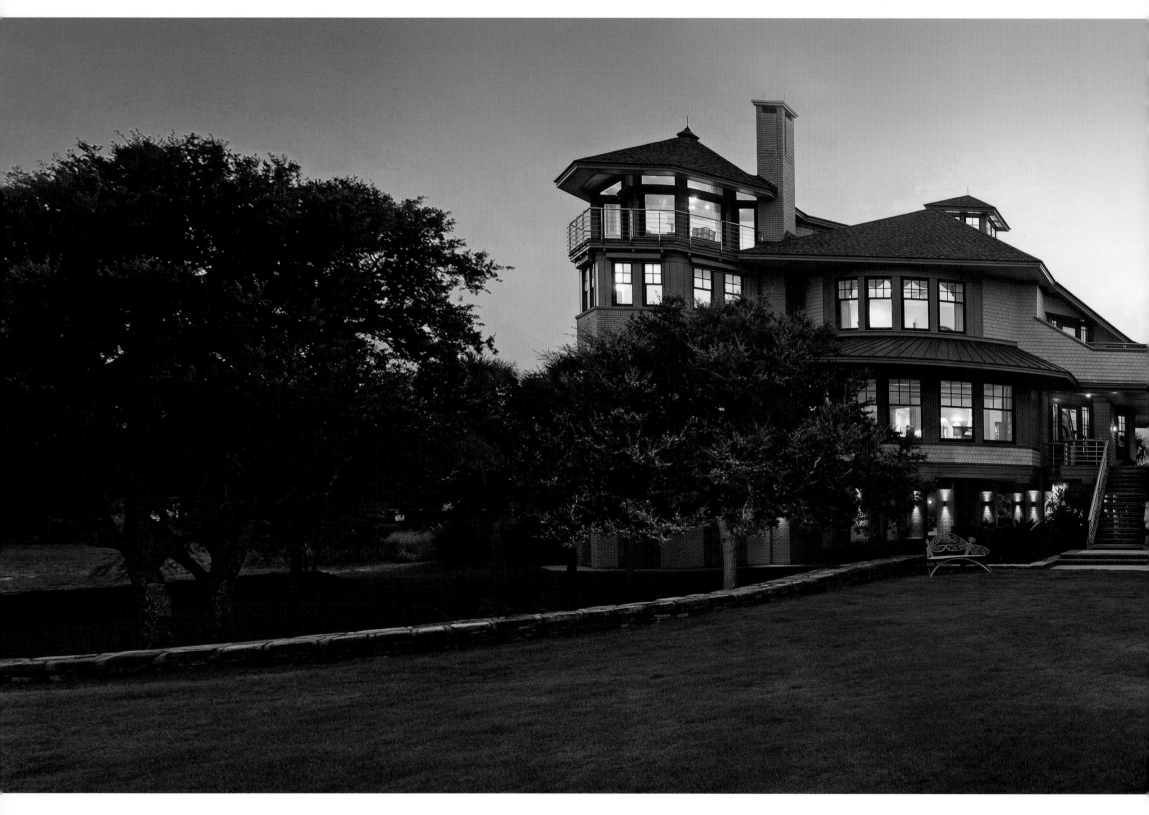

Above: The Stahl residence, inlet view.
Photograph by Brownie Harris

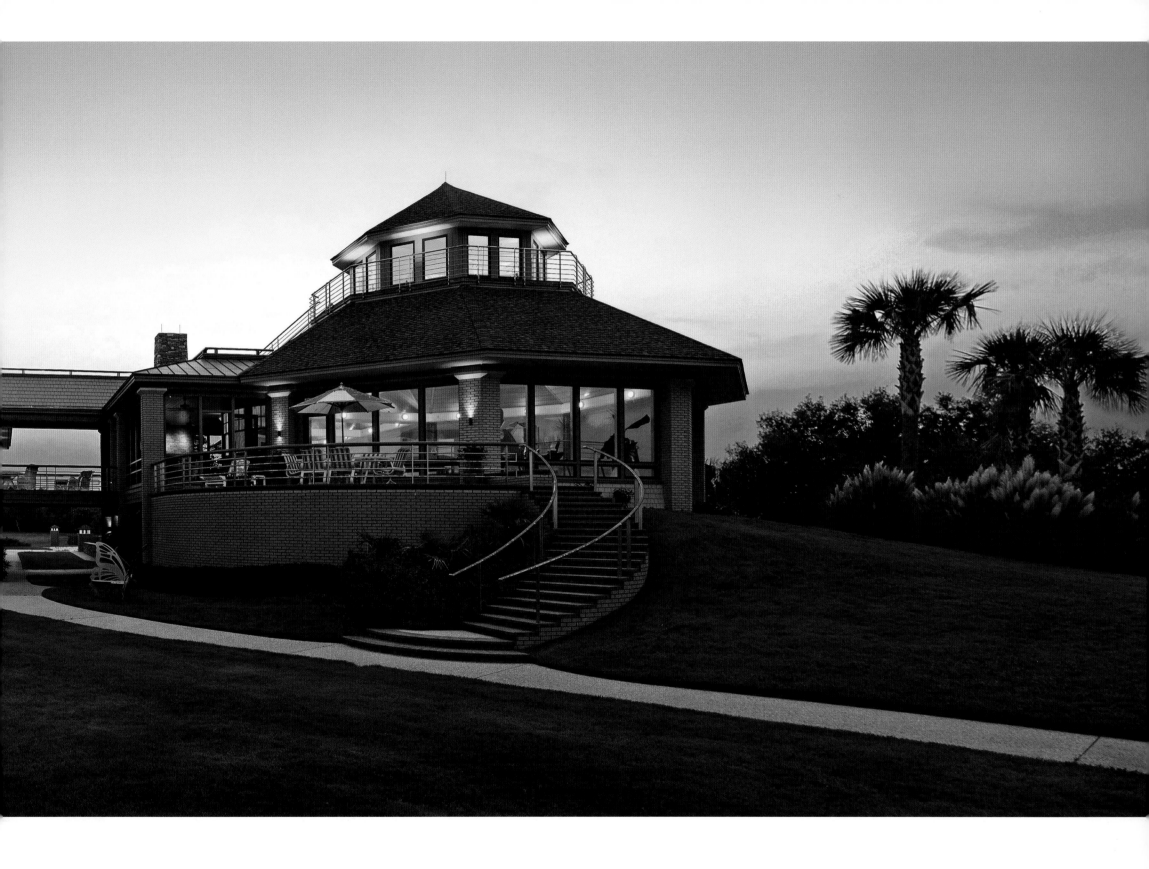

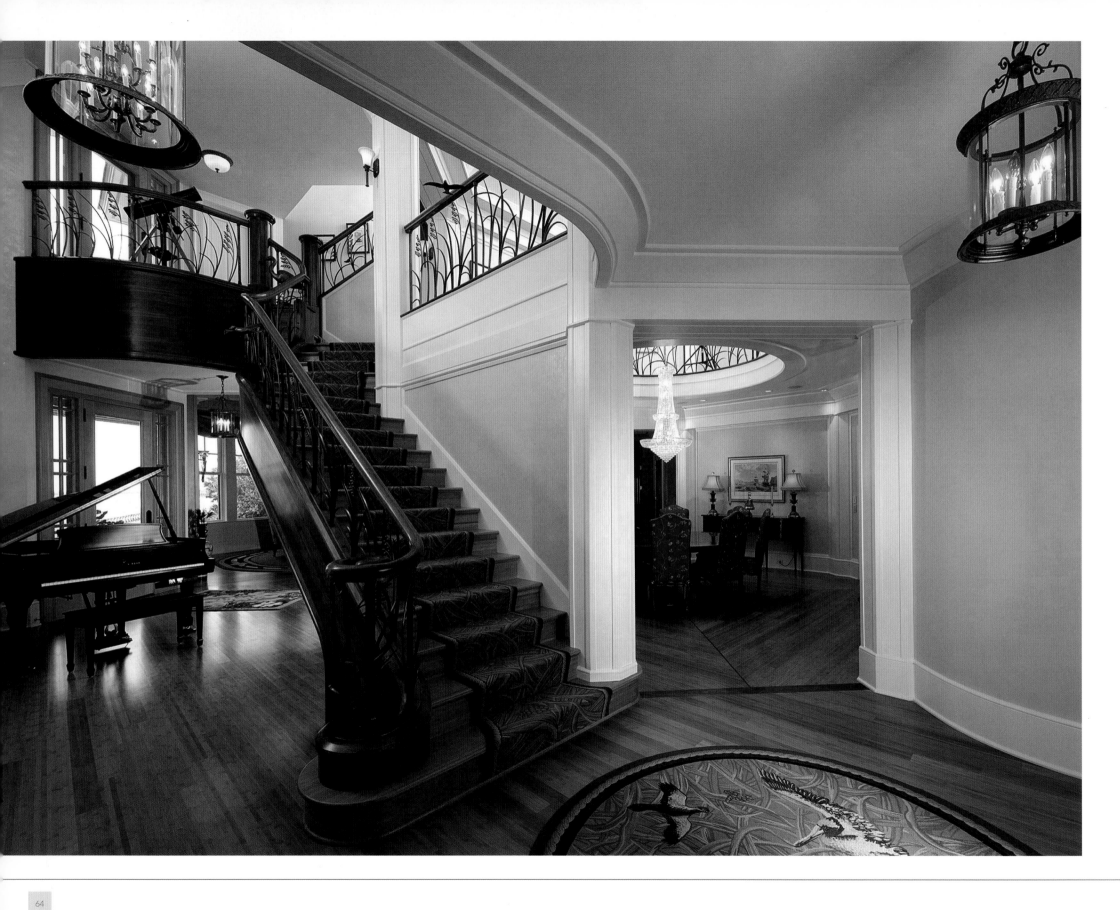

"It's kind of an interesting approach: the interiors and landscape are such an integral part of what we do," explains Michael. "We're really strong in developing a site and making the house a part of a greater landscape concept. Our houses are unique in that we don't approach a design with a particular style in mind. Rather, we try to understand the imaginations and needs of our clients and express for them something that is both new and fresh and meaningfully grounded in their personal reality."

Michael, who studied psychology before earning his master's in architecture at North Carolina State University, says he and his staff spend a lot of time listening to what clients want. "The fact that I studied psychology and philosophy doesn't mean that I'm analyzing clients," he says. "It just means that I have a tremendous interest in what motivates people, and I take that very seriously." For me, architecture is less about bricks and mortar and more about personality, perception, symbol and experience. From this perspective I see architecture, particularly residential architecture, as a process of organizing appropriate materials in a way that authentically and aesthetically represents the personality of real people, namely, the client."

Michael says that one of the things that sets his staff apart is that they are not formalists and that they are constantly looking for the magic in a building. For instance, he prefers inconsistencies to rigid patterns. "I like things that are a little bit open-ended at times, and I think that's the way human beings are so that's

Right: The Stahl pool house.
Photograph by Brownie Harris

Facing Page: The Stahl entry.
Photograph by Brownie Harris

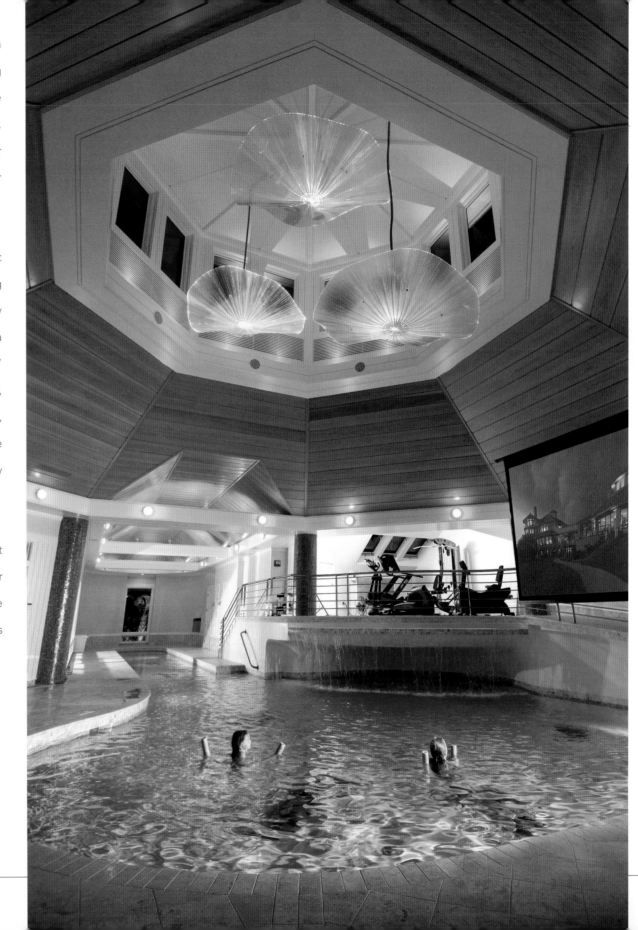

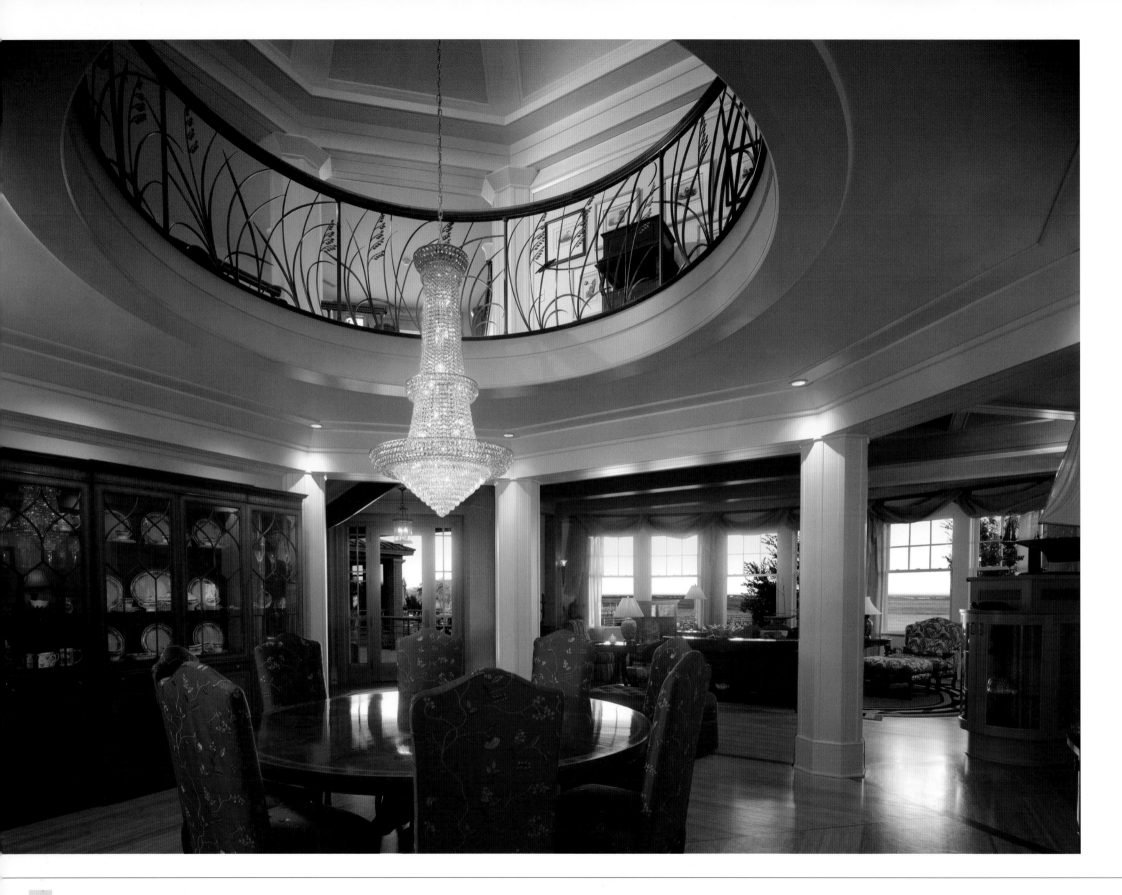

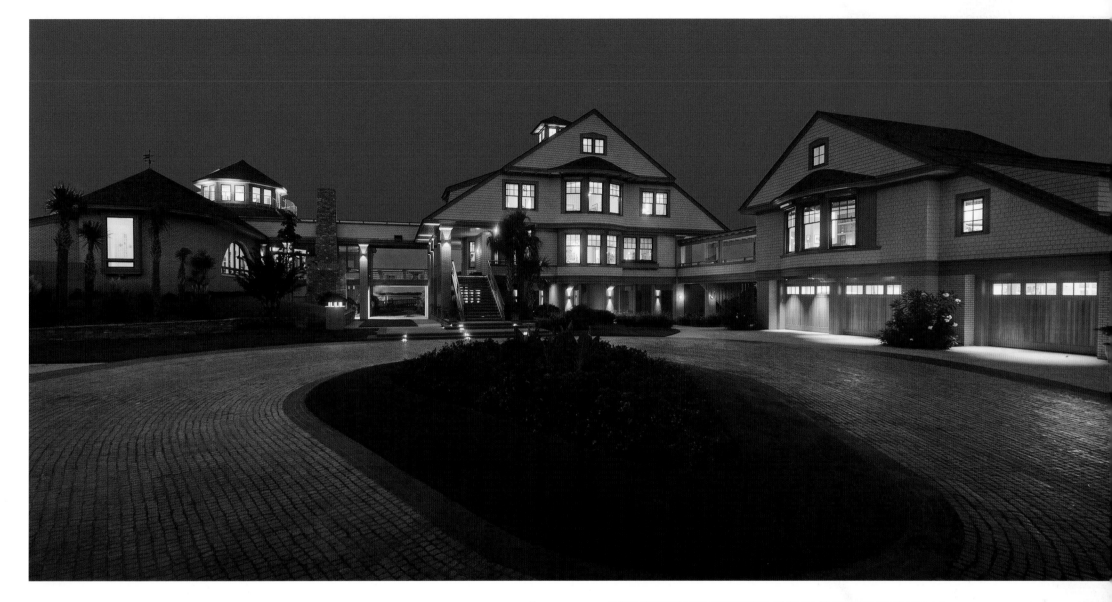

a true reflection of people." Instead of having preconceived ideas about architectural designs for homes, Michael sees himself as an advocate for the dreams of his clients.

"A dream home is called a dream home for a good reason," he says. "People are expressing something about their inner selves through their homes. What could be more interesting? What could be more challenging?"

Above: The Stahl residence at dusk.
Photograph by Brownie Harris

Facing Page: The Stahl dining room.
Photograph by Jerry Blow

Michael Moorefield Architects

Michael Moorefield
2 North Front Street, 8th Floor
Wilmington, NC 28401
910.762.6020
Fax: 910.762.7799
www.michaelmoorefield.com

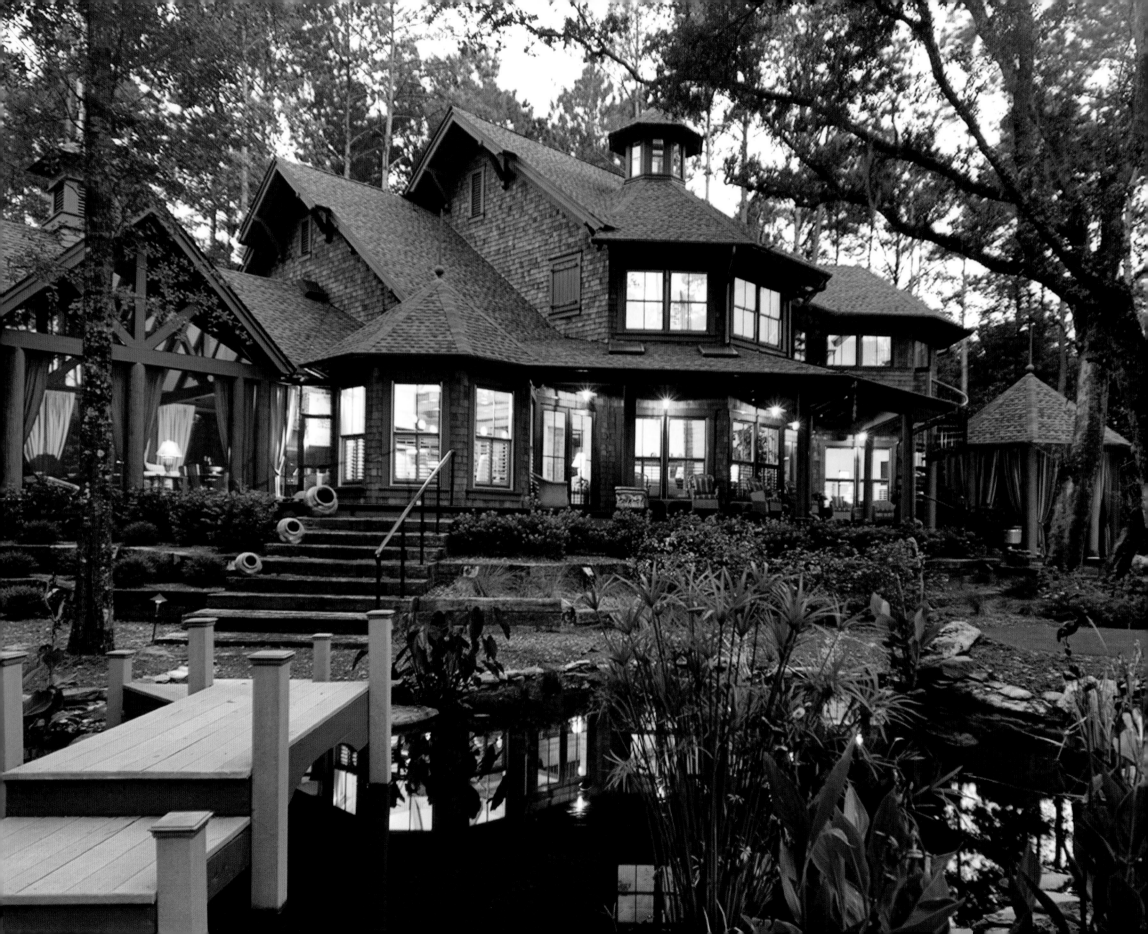

John Pittman III

Architect, John Pittman III

Above: This "Hide-and-Seek Library" provides a magical touch of whimsy through hidden passageways leading to the master suite and home theatre beyond. Hellman residence, Berkeley Hall.
Photograph by John McManus

Facing Page: "Sunset at the Marsh Lodge": As dusk settles over this marsh setting, the rear façade comes alive with the evening's activities. Hellman residence, Berkeley Hall.
Photograph by John McManus

With an undergraduate degree in architecture from Tulane University and post-graduate studies at the Harvard University Graduate School of Design, John Pittman III, AIA, NCARB, has done residential and commercial design in South Carolina and Georgia since becoming a registered architect in 1988.

John's designs range from classic Low Country to modern. Regardless of the style of the design, his homes reflect a balance of detail and proportion with sensitivity to the compatibility of the building materials, textures and color.

At an early age John was enamored with design, architecture and construction. His enthusiasm for his profession remains apparent in his work today. "I grew up in it all my life, so therefore I take an

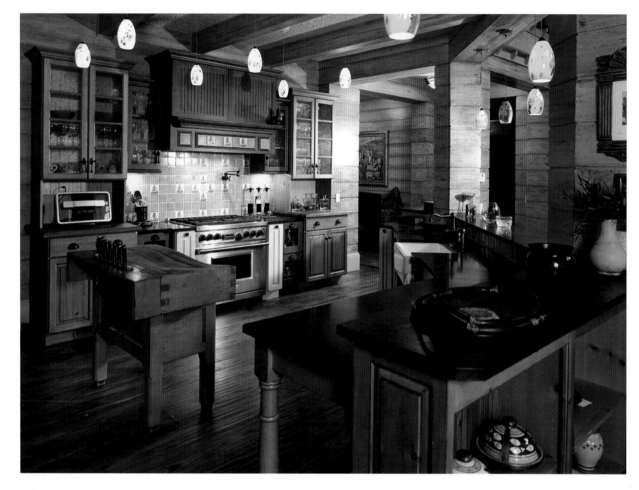

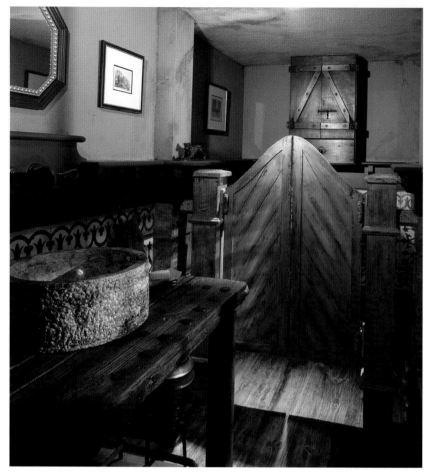

active role throughout all phases of our projects whether we are constructing them or not," John says. "We want to be involved with the owner throughout the entire process. In addition to being accomplished architects, we are also registered interior designers, so we can help the clients with those types of selections as well. We design and select everything from color schemes to final furnishings."

In 2002-2003 and again in 2004-2005, the Hilton Head Chapter of the AIA (the American Institute of Architects) recognized John Pittman III for "Excellence in Architectural Design." "There is no higher honor than to be recognized by your peers," he says.

In 2003, 2004, 2005 and 2006, John's designs were honored by the Home Builders Association of South Carolina with its coveted Pinnacle Award. In addition, his design involvement has been recognized by the local Hilton Head Island Lighthouse Builder Awards, and his work has been featured in *Low Country Home Magazine, Hilton Head Monthly,* and *South Carolina Homes & Gardens* magazine.

Lending a traditional eye to the design of comfortable, well-planned Southern architecture, John is praised for his ability to develop creative designs from a client's verbal description or "wish list." The John Pittman III design process is a collaboration with the client and builder during the design phase to assure that the project meets budget objectives and renders a "hands-on crafting" of the home during the construction phase.

Above Left: "La Cocina": A 100-year-old Spanish butcher block anchors this Old World handcrafted kitchen with furniture-inspired cabinetry. Hellman residence, Berkeley Hall.
Photograph by John McManus

Above Right: "El Baño," handcrafted powder room with ancient stone and wooden relics imported from 17th-century Spain. Hellman residence, Berkeley Hall.
Photograph by John McManus

Facing Page: "Marshside Cottage" is set along the banks of the Colleton River with a distinct Low Country flair, this cottage embodies the notion of "barefoot casual." Barbie Lancaster residence, Rose Hill.
Photograph by Wayne Corley

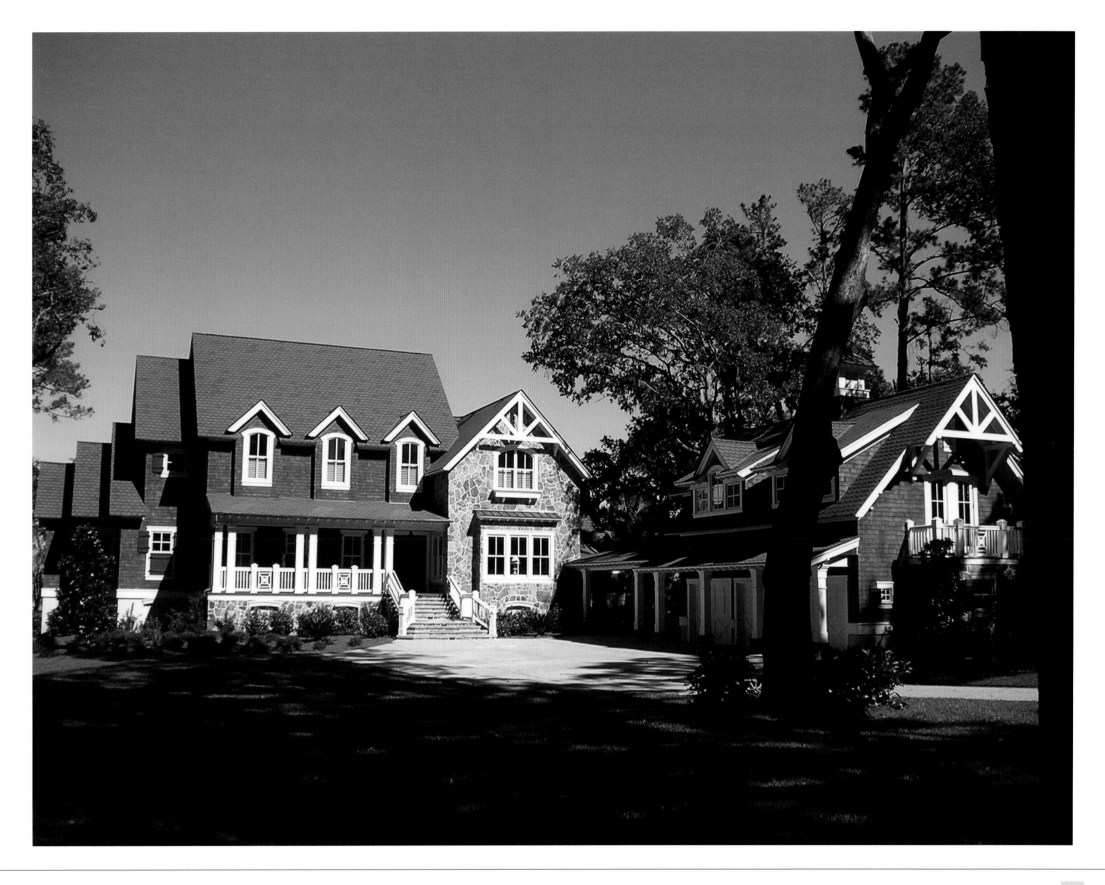

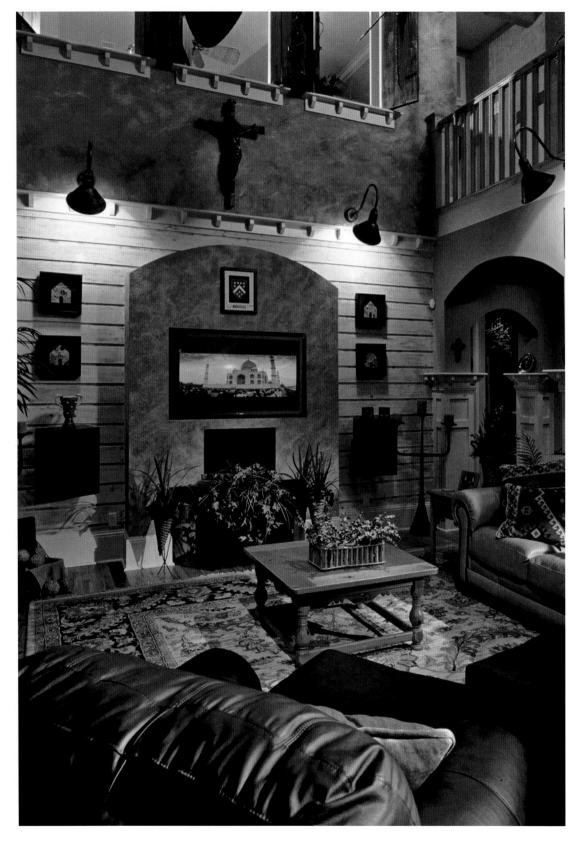

His firm's architectural services are provided as a comprehensive package, and the cost of the design package is a modest percentage of the ultimate cost of the home. Step one includes the preliminary planning consultations, which produce a site plan and floor plan. Step two is conceptual design or preliminary architectural approval by the community's governing board. Step three produces a builders' set of drawings for final architectural approval and a building permit.

The real fun begins with the commencement of construction. As John likes to say, "Most architects design homes. I receive my satisfaction from crafting homes." As construction begins, based on his interaction with the clients, John has a comprehensive vision of the completed home both inside and out. Through weekly visits to the construction site, John engages in the crafting process, making certain that every detail is finished according to his vision and on-site observation. Having also built homes, John has a unique ability to communicate with the craftsmen producing the finished product.

"My design philosophy is to make sure the client sitting in front of me ends up with a unique home that suits them. We're simply the tour guides leading them through the design and construction process," says John. "Clients are always astounded by how much of themselves they find in the solution of their home. That's why every home we design looks extremely different from the other. It's going to reflect each owner's life lessons along life's journey."

Left: "Cozy Courtyard on the Inside" describes this family gathering room in rich hues of warm earth tones. Pittman residence, Berkeley Hall.
Photograph by John Pittman III, AIA

Facing Page Top: "Fire and Water": An interesting outdoor oasis juxtaposing the screened porch fireplace and the beach scene of the plasma television. Hellman residence, Berkeley Hall.
Photograph by John McManus

Facing Page Bottom Left: "Floating Sweet Dreams," as the master suite's custom-made bed seemingly floats upon a bamboo river raft surrounded by a lush tropical lanai. Corley residence, Berkeley Hall.
Photograph by Matt Silk

Facing Page Bottom Right: "Vitruvian Man Meets DaVinci Code." This modern kitchen is complete with architectural Fibonacci Code and Golden Section mural. Corley residence, Berkeley Hall.
Photograph by Matt Silk

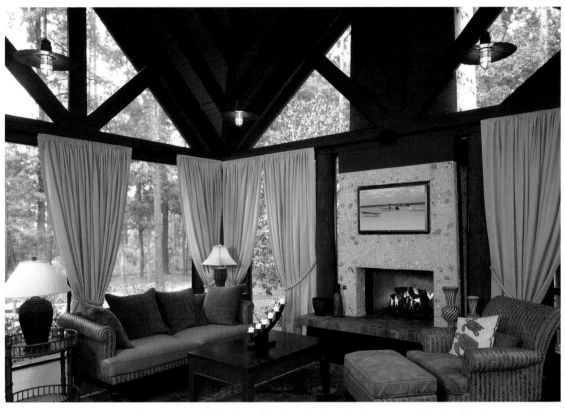

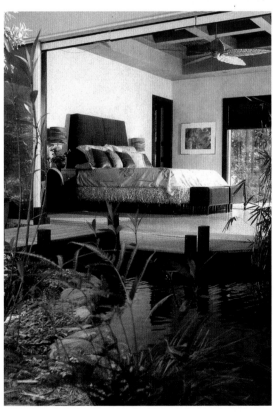

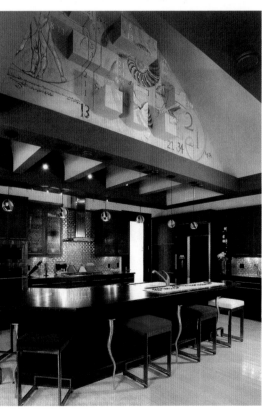

WHAT IS THE AVERAGE SIZE OF ONE OF YOUR CUSTOM HOMES?

They're usually 2,800 to 5,600 square feet or more.

WHAT DO YOU ENJOY MOST ABOUT BEING AN ARCHITECT?

I'm an architectural medium in the way I work with clients. I take the owner's dreams and wishes and make them a reality in the built world through careful tailoring and crafting.

WHAT ABOUT YOUR THREE-LEGGED STOOL THEORY?

Successful residential design is a collaboration between the architect, owner and builder, guided by a sensitive balance of site considerations, budget objectives, and the owners' expectations mixed with a dash of architectural magic, grace and charm.

HOW DO YOU DESCRIBE YOUR STYLE, AND WHO ARE SOME ARCHITECTS YOU ADMIRE?

The Pittman vernacular's roots and influences are shaped by architectural greats such as Frank Lloyd Wright, Louis Kahn, Mies van der Rohe, Robert A. M. Stern, Frank Gehry and others who leave their mark on the "whole" home from the basics of structural design to the details of interior furnishings and fixtures. I admire those who don't stop at the walls. As other architectural greats who have come before me have said, "God is in the details."

Architect, John Pittman III

John Pittman III, AIA, NCARB

PO Box 21295

Hilton Head, SC 29925

843.815.8155

Fax: 843.815.8156

www.johnpittmanarchitect.com

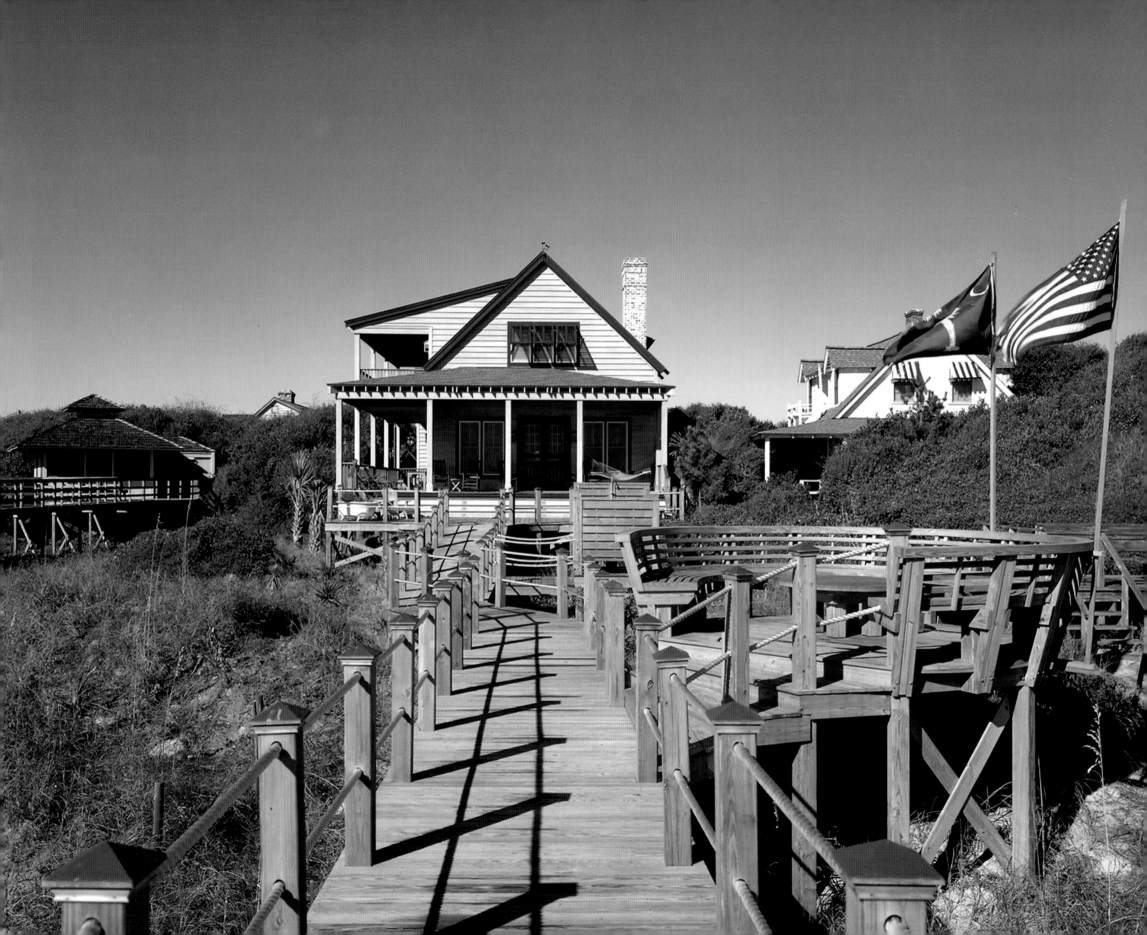

Wayne Rogers
Catalyst Architects, LLC

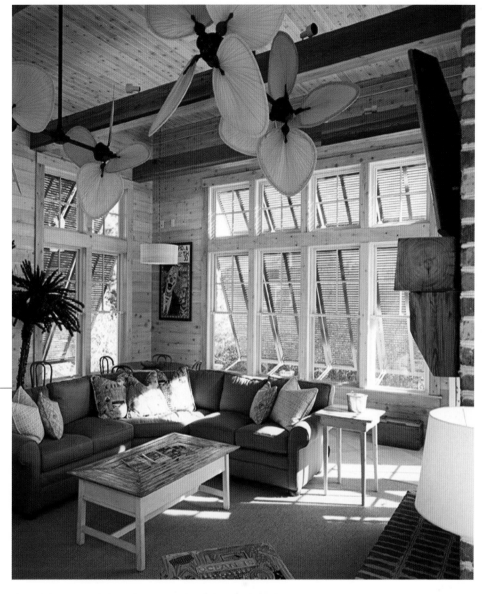

Above: Cabana, Dune Oaks residence, DeBordieu Colony, South Carolina.
Photograph by Matt Silk

Facing Page: The ocean view from a Pawleys Island beach house, Pawleys Island, South Carolina.
Photograph by Bob Mikrut

As the son of an architect, Wayne Rogers knew he wanted to design structures ever since he could walk. His passion for architecture has not wavered in the least. For almost 20 years, Wayne has been president of Catalyst Architects in Lexington, South Carolina. With six employees, including Wayne's father, Colonel Rogers, Catalyst's work is heavily concentrated in the coastal area of Georgetown, South Carolina.

"Though I live three hours from where I do most of my work, I have an intimate knowledge of the area. It is a small area of geography, and therefore you know all of the building officials, the suppliers, the vendors, the craftsmen and the contractors," explains Wayne, who has a bachelor's and a master's degree in architecture from Clemson University. "My goal when I started the firm 18 years ago was to remain a small 'hands-on' firm. I went to school to become an architect. While a lot of my colleagues

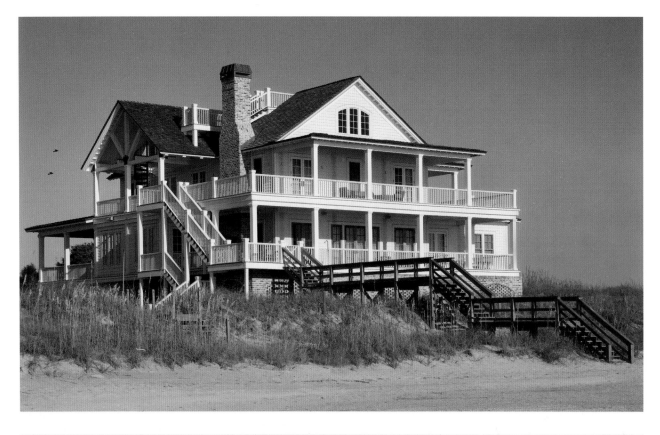

have become very good business people and managers of firms, they do not have the opportunity to remain immersed in the design process. I like to draw and design—and create the details—so I wanted a firm small enough that I could still do that and be thoroughly involved in every project."

Wayne says his team finds inspiration from being on the property and in a larger context, being in the community where a home is going to be built. "For instance, Pawleys Island has a certain image. It has a lot to do with verandas and simple materials. We are inspired by the vernacular, as well as the uniqueness of each site on which we build. We pay attention to views, where the sun is, and where the breezes are coming from, in addition to the trees and vegetation of the property."

Wayne explains that every property has its limitations, but that it is these limitations which inspire creative design. Sometimes when he meets clients on their land for the first time, they apologize for the complexity of their property. "I tell them that this will be the most exciting, the most fun project because it requires the most creative energy," says the South Carolina native. "By far the most exciting projects we do are always those that offer the most difficult sites."

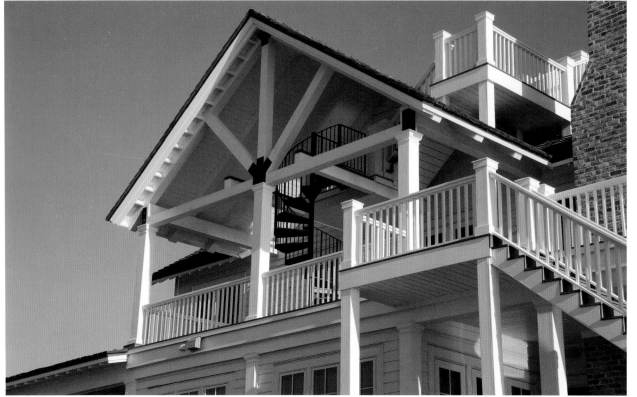

Top Left: The view of a Pioneer Place beach house from the ocean, DeBordieu Colony, South Carolina.
Photograph by Matt Silk

Bottom Left: Gable detail at south-facing porch, Pioneer Place beach house, DeBordieu Colony, South Carolina.
Photograph by Matt Silk

Facing Page: Interior of a Pioneer Place beach house, DeBordieu Colony, South Carolina.
Photograph by Matt Silk

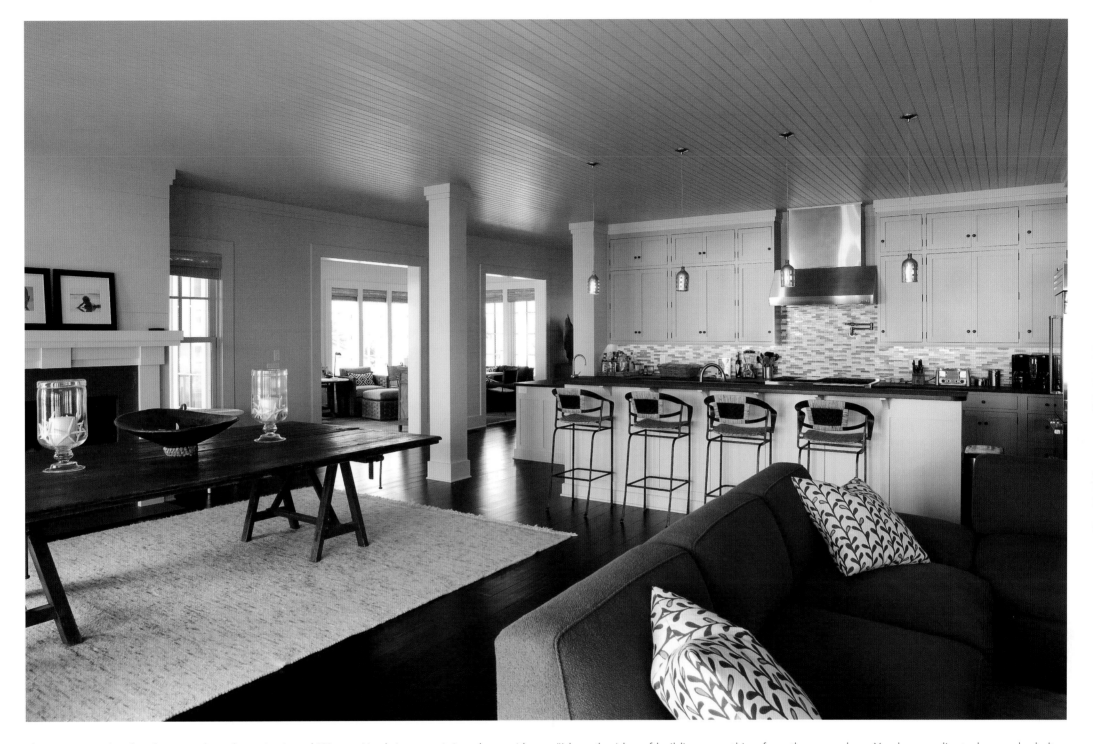

The creative side of architecture has always intrigued Wayne. He thrives on sitting down with a client to find out what is unique about them and what is unique about the location in which they are building. Just as every client is different, so too are the structures that result from their collaboration with Wayne and his team.

"I love the idea of building something from the ground up. You have a client who needs shelter, and they present you with their needs, their backgrounds, their memories, their passion and their property," says Wayne, who enjoys working closely alongside his clients and sorting through the details.

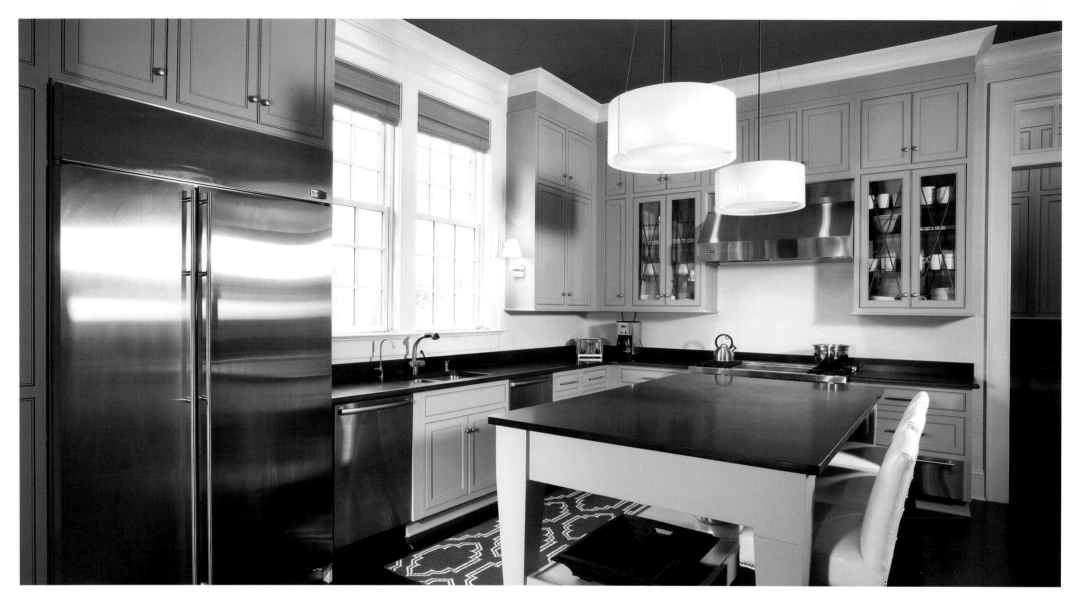

"We create lots of sketches at first that are almost thumbnail size because we try to take the whole project and boil it down to a few core issues. I don't want the house to simply be a collection of spaces linked together with nice materials."

The homes Wayne and his team design reflect the uniqueness of his clients and their sites. However, history and tradition also have a place in Catalyst's work, which has been featured in *Coastal Living* and *Custom Home* magazines and has won awards from the local chapter of the American Institute of Architects and the Historic Columbia Foundation. "The more our practice matures the more I see that there are historical and classical principles involved in our designs," says Wayne. "Tradition

instructs what we do. It informs what we do, however, it doesn't limit what we do. Our work should always be creative yet taught by tradition."

With every project, the key to success is having good clients. "Having a small firm means pursuing the right work and accepting the right work," says Wayne. "We've been fortunate to be able to work with the right kind of clients over the years."

Above: The kitchen of a Colony Point residence, DeBordieu Colony, South Carolina.
Photograph by Matt Silk

Facing Page: The exterior of a Colony Point residence, DeBordieu Colony, South Carolina.
Photograph by Matt Silk

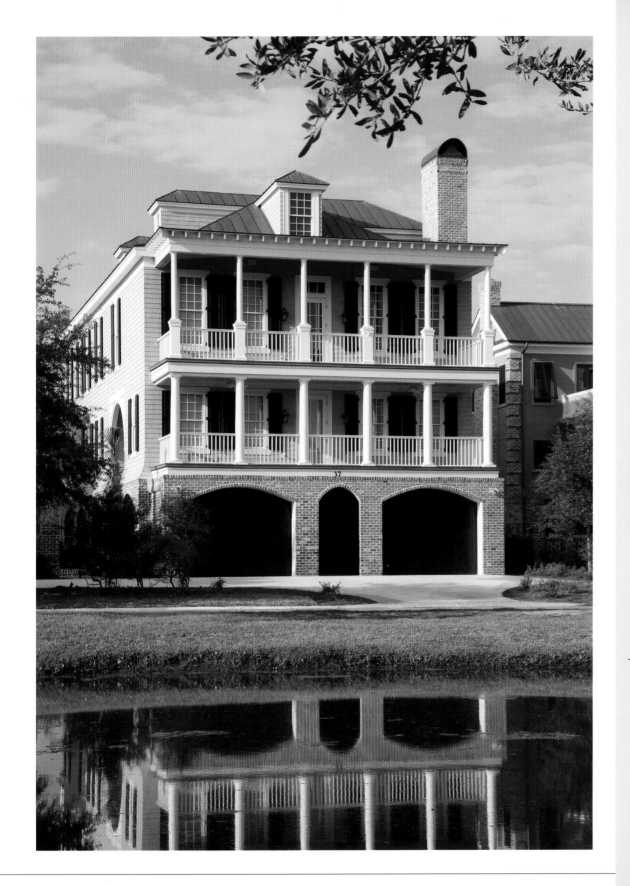

DO YOU ENJOY WORKING WITH YOUR FATHER?

One of the joys of what we do certainly is working together. The opportunity to work and create architecture together with my father is a remarkable thing.

WHAT SEPARATES YOU FROM YOUR COMPETITION?

I love what I do, and it is contagious. I think clients sense and feel that.

WHAT IS ONE OF YOUR FAVORITE PROJECTS?

It's always the projects that we're doing now that I'm most excited about because of my own passion, how I love what I do. It's also because I know that we're building on what we've done in the past.

WHO HAS INSPIRED YOUR WORK?

Certainly my father, the professors at the School of Architecture at Clemson (Yuji Kishimoto, John Jacques, Peter Lee), and studying at Clemson's Daniel Center for Building Research and Urban Studies in Genova, Italy. How can I talk about inspiration without thinking of growing up with an architect father and the early influence of faculty who shaped my understanding of design and architecture in school?

Catalyst Architects, LLC

Wayne Rogers, AIA
212 West Main Street
Lexington, SC 29072
803.358.6565
Fax: 803.358.6566

Georgetown, SC
843.520.0140
www.catalystarch.com

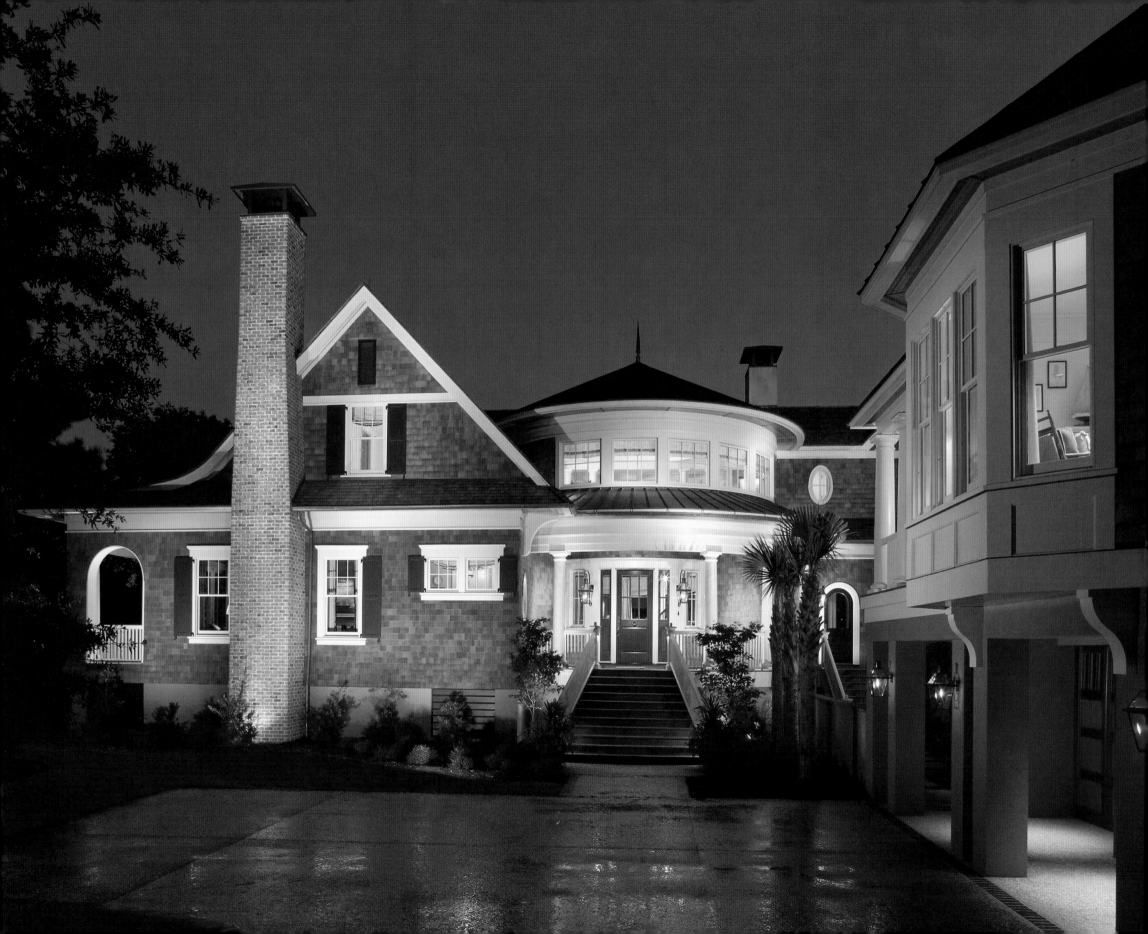

Christopher A. Rose

Christopher Rose Architects, P.A.

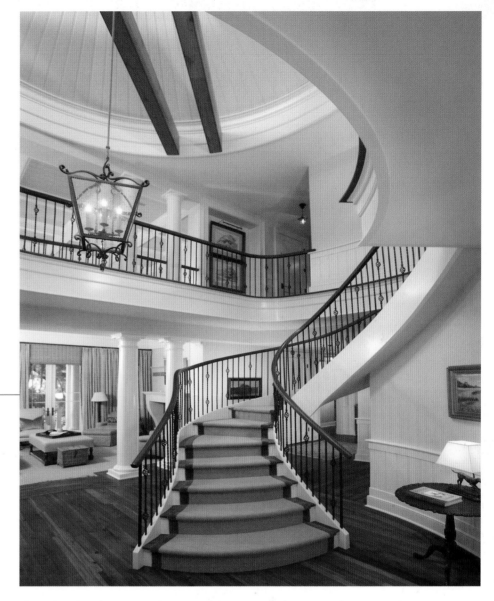

Above: The sculptural sweeping staircase gives a dramatic impact to the entry rotunda.
Photograph by Creative Sources Photography

Facing Page: This guest house over the three-car garage frames the front entry of this Shingle-style home.
Photograph by Creative Sources Photography

Christopher Rose's passion for architecture is reflected in every home he designs. As a seventh-generation South Carolinian, he has a deep appreciation of the state's architectural history and its climatic landscape and uses this knowledge to create homes his clients will enjoy for years to come.

"If I'm putting my name on a project, I want it to be something that I'm proud of," says Christopher, who earned bachelor's and master's degrees in architecture from Clemson University. While in graduate school, Christopher studied for a semester at the Charles E. Daniel Center for Urban Studies in Genoa, Italy and has since returned as a lecturer. A member of the American Institute of Architects and the American Society of Interior Designers, he is able to offer clients complete architectural services.

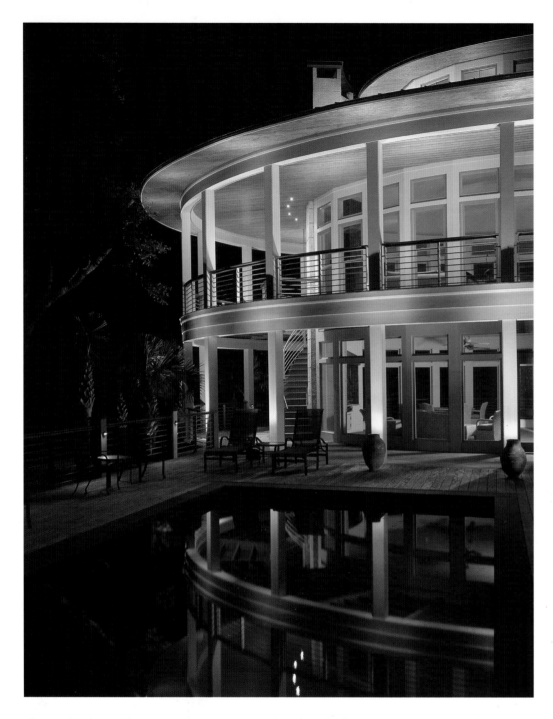

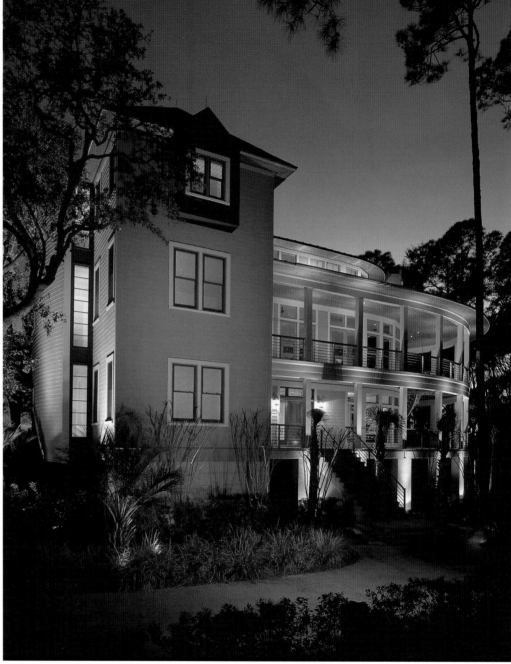

Christopher began his career doing commercial work in the hospitality and restaurant industries. However, after designing several custom homes, he soon found that residential design was his niche. "I love having a real client. In commercial work you typically don't have one owner," he explains. "Individual owners are much more willing to explore different materials. It's more personal."

Above Left: The wraparound porches extend the living area and reflect in the pool.
Photograph by Creative Sources Photography

Above Right: The front of this home speaks to the vernacular architecture of the low country of South Carolina, while reinterpreting it to the present day.
Photograph by Creative Sources Photography

Facing Page: The bronze-clad fireplace is the focal point of the living/dining area. The transoms, with double-hung windows, recall the walk-out, triple-hung windows of antebellum plantation homes.
Photograph by Creative Sources Photography

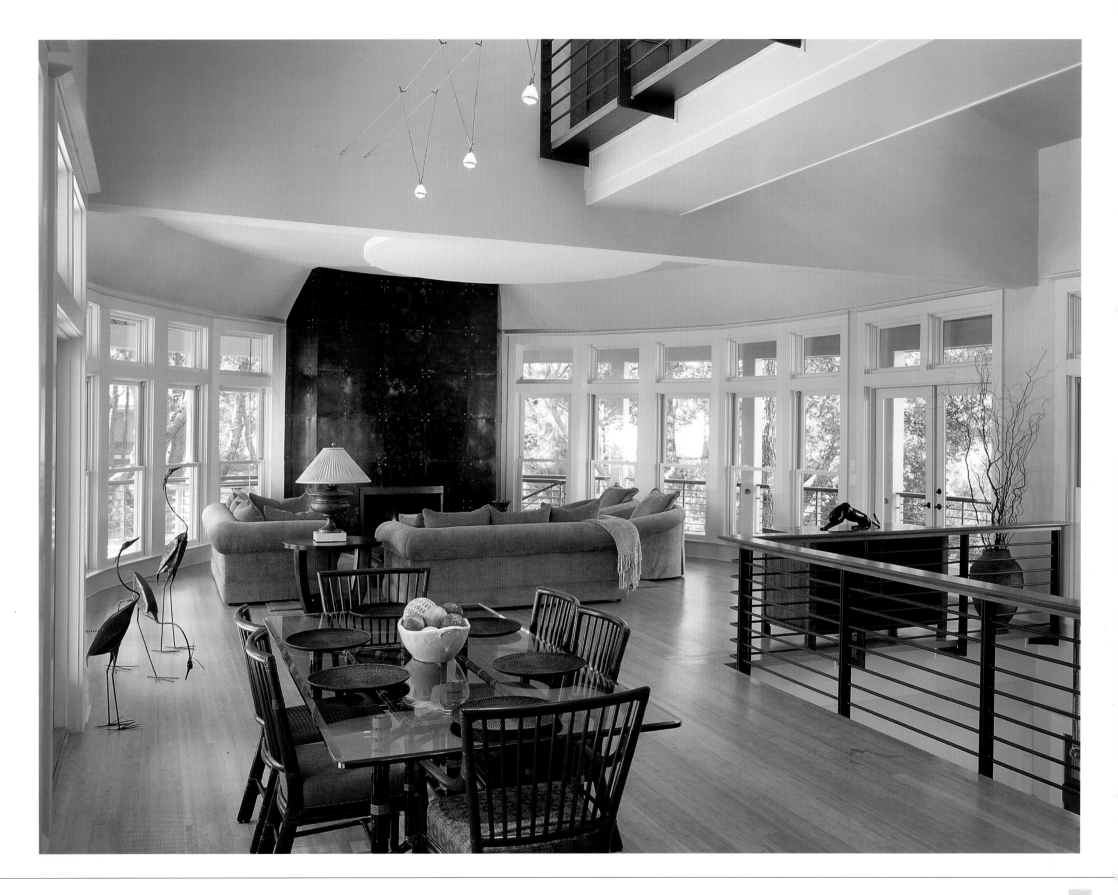

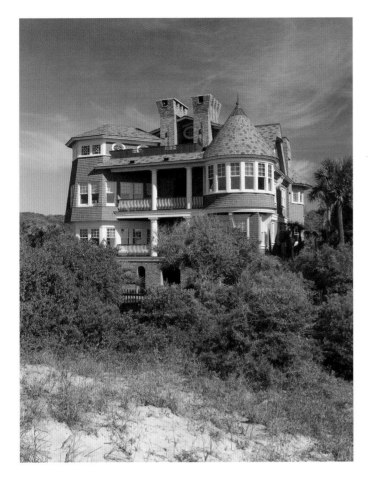

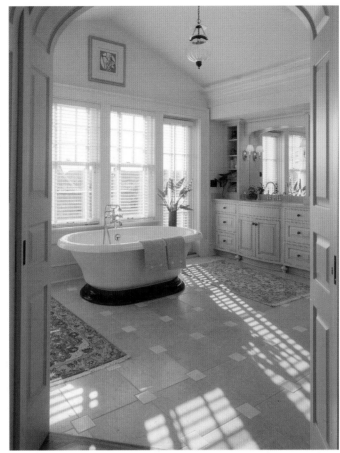

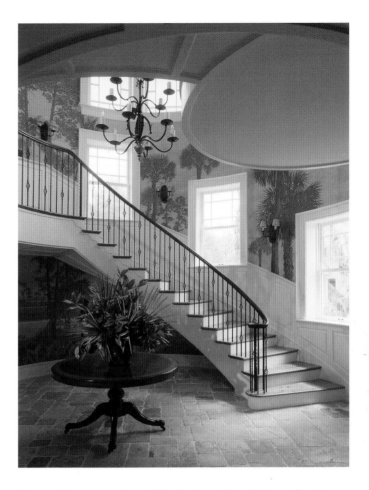

For instance, one of his clients recently purchased a chandelier for the foyer of her contemporary home and wanted the metal surround of the fireplace to match it. Christopher found a book regarding metal finishes in his firm's extensive resource library and proceeded to add a bronze finish to the surround. "We enjoy incorporating those kinds of personal details," he says.

Christopher individualizes each design to a person and place, taking everything into account from the lifestyle of the client to the prevailing breezes and views of the property. Having been in the business for more than 20 years, he and his team thoroughly understand the local environment. "We study where the breezes are. We look at solar orientation. Where do you get morning and

afternoon sun?" he explains. "We like to speak to where we are because people are coming here for the climate and the views." This extensive site analysis leads to a home where using sustainable design principles and the selection of Green products helps our clients become good stewards of the land.

No two homes are the same, as Christopher does not subscribe to one particular architectural style. "What I find that is so fascinating with this profession is that we go through the same process with everyone, but every client is different, every site is different, and the challenges are different," says the architect, who has designed contemporary and traditional homes as well as Georgian and Tuscan. "We try to reinterpret what was done in

the past for current times. We don't want to design a direct copy of a certain style."

Based on Johns Island, Christopher has designed homes for as far away as Long Island and Vancouver. He is currently working on the renovation of a French country home in Burgundy, France.

Above Left: The turret and living room wing provide privacy from the neighbors on this oceanfront Shingle-style home which evokes the memories of the homes the owners lived in during their childhood.
Photograph by Creative Sources Photography

Above Middle: The paneled elliptical top entry leads into the light-filled master bath.
Photograph by John McManus Photography

Above Right: A mural in the circular stair turret by a Charleston artist gives a hint to the waterfront view the guests will soon encounter.
Photograph by John McManus Photography

Facing Page: The porte cochère with a radial pattern stone floor welcomes the guests while providing welcome shade during the hot summer months.
Photograph by Creative Sources Photography

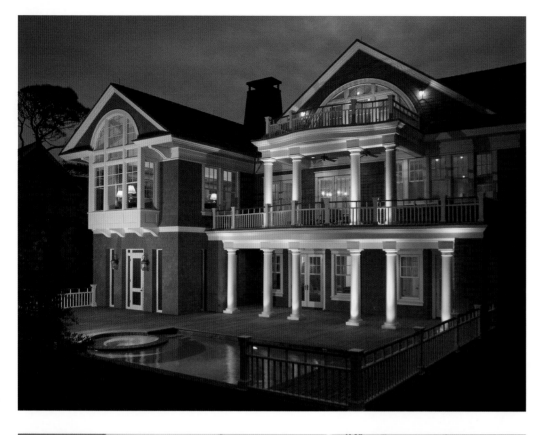

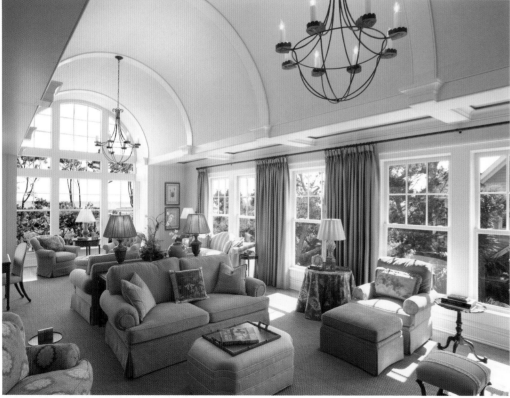

Typically he designs five to six homes a year in areas such as Beaufort, Brays Island, Fripp Island, Isle of Palms, Kiawah and Sullivan's Island. He has actively participated in the planning of several new communities including Brays Island Plantation, RiverTowne and Spring Island.

One of the things that Christopher loves about the Charleston area is the endless amount of interesting architecture waiting to be discovered. "I vowed to myself that if I wasn't working in Europe, I wanted to be the closest I could be to it," he says. "Here in Charleston you can walk down a street a hundred times and all of the sudden you'll notice an architectural detail that you've never noticed before."

Christopher's work has been featured in publications such as *Architectural Digest, Country French Decorating, Custom Builder, Custom Home, Southern Living, South Carolina Homes & Gardens,* and *Waterfront Home & Design.*

His firm has also been awarded two Platinum "Best in American Living" Awards from the National Homebuilders Association for one-of-a-kind custom homes 6,501 square feet or more in addition to several Robert Mills Residential Design Awards and PRISM Awards from the Charleston Trident Home Builder's Association. In 1991, the American Institute of Architects presented Christopher with its National Honor Award, the institute's highest recognition, for the Charleston Cottages— prototype housing for the homeless. To this day, he remains the youngest person to ever have received this award.

As president of Christopher Rose Architects, Christopher is personally involved with every project. One of the reasons he founded his own firm was so he could work with each individual client. "We pay close attention to detail as we try to create homes, not houses," he says. "It's important to be passionate about what you're doing. I think if you have passion, it shows in what you do."

Top Left: Multilevel porches encourage the interaction of interior and exterior to take advantage of the water views.
Photograph by Creative Sources Photography

Bottom Left: The barrel vault frames the ocean view from the great room.
Photograph by Creative Sources Photography

Facing Page: The arched window opening offers the master suite unobstructed ocean views.
Photograph by Creative Sources Photography

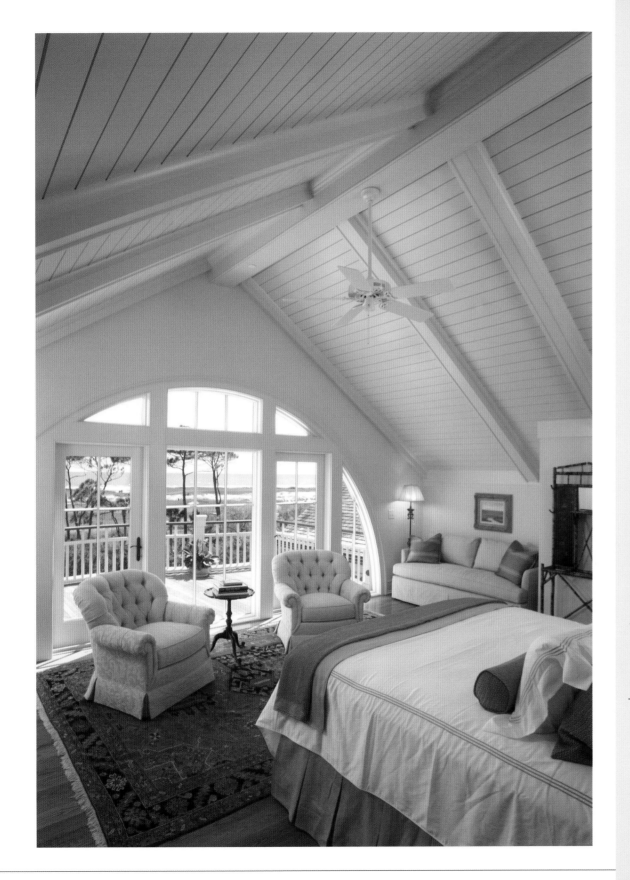

more about Christopher ...

WHAT SEPARATES YOU FROM THE COMPETITION?

Because of my commercial background, we do true construction observation. We're the clients' representatives on the site. Probably 80 percent of our clients are from out of state or out of the country so we've got to be there to send field notes and questions. We tell our clients that they can be as involved in the process as much they want to be, but we don't want to inundate them with a million decisions.

DID YOU ALWAYS KNOW YOU WANTED TO BE AN ARCHITECT?

Yes. I liked drawing when I was a child, and my grandmother and my great grandmother were artists. My mother could also draw quite well. At first I thought about being an artist, but I enjoyed building things more. When I was a small child, I built all the little miniature homes and scale models out of balsa wood for my train sets. Growing up my entertainment was walking through houses under construction.

WHAT IS YOUR DESIGN PHILOSOPHY?

Our construction methods and materials marry the tried-and-true lessons of history with the state-of-the-art techniques of today. We work closely with the client and their environment to capture the property's views and breezes. When we design a home for a particular site, we design it so that the structure could not be moved somewhere else. It is solely customized for that site. Our designs use the best sustainable practices and Green building products to realize a structure that is as good to the world as it is to the client. We want to give our clients a home that delights the senses and serves as a welcome retreat.

Christopher Rose Architects, P.A.

Christopher A. Rose, AIA, ASID, NCARB

3509 Meeks Farm Road

Johns Island, SC 29455

843.559.7670

877.559.7670

Fax: 843.559.7673

www.christopherrosearchitects.com

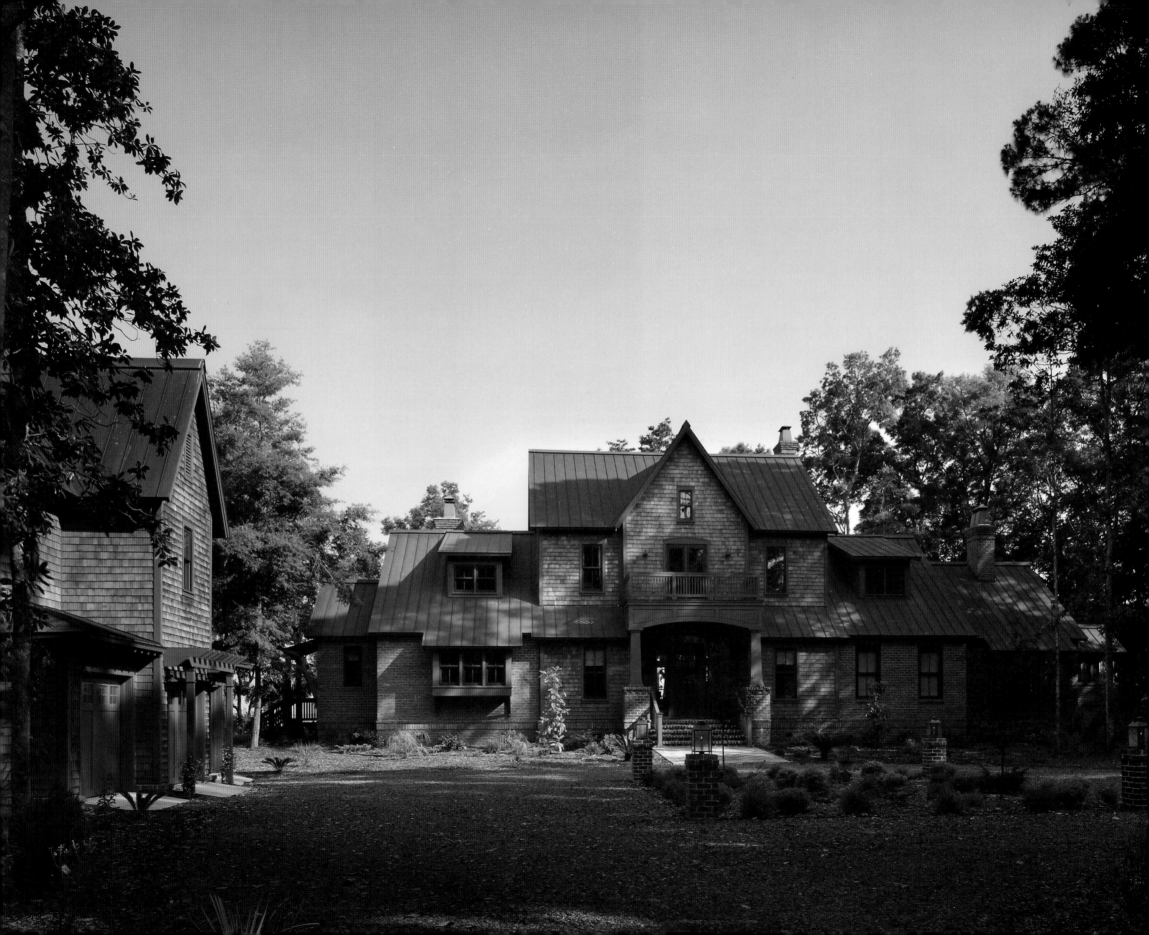

Chris Schmitt
Jimmy Walker
Michael Edwards

Schmitt Walker Architects, Inc.

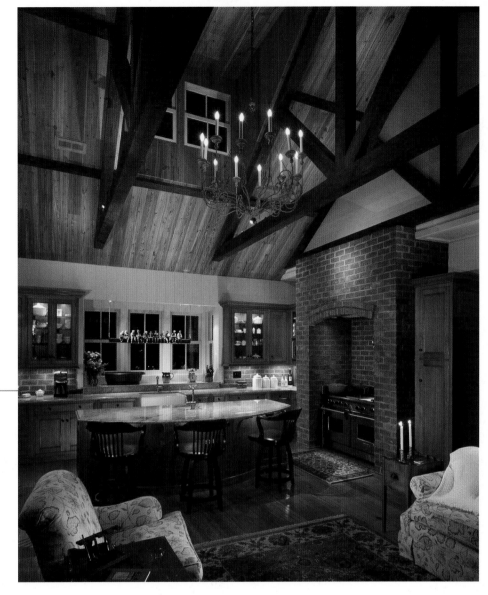

Above: Private residence, kitchen/family room in Edisto Island, South Carolina.
Photograph by © 2005 Rion Rizzo, Creative Sources

Facing Page: Private residence, entry elevation in Edisto Island, South Carolina.
Photograph by © 2005 Rion Rizzo, Creative Sources

The design philosophy of Schmitt Walker Architects is based upon appropriateness of design to context, directness and economy of means, and careful tailoring of the architectural expression to the needs of the client, the program and budget. Each of the firm's completed custom single-family homes has its own unique identity because it responds to different environmental, cultural and architectural contexts.

"When you design a building there are a lot of subtle things that you can bring into it that reflect the place," explains Chris Schmitt, the firm's founding partner. "It's very important for a building to have a sense of place and feel like it belongs where it is. People look at our work and comment on how it has a sense of timelessness and how it seems to fit its respective site."

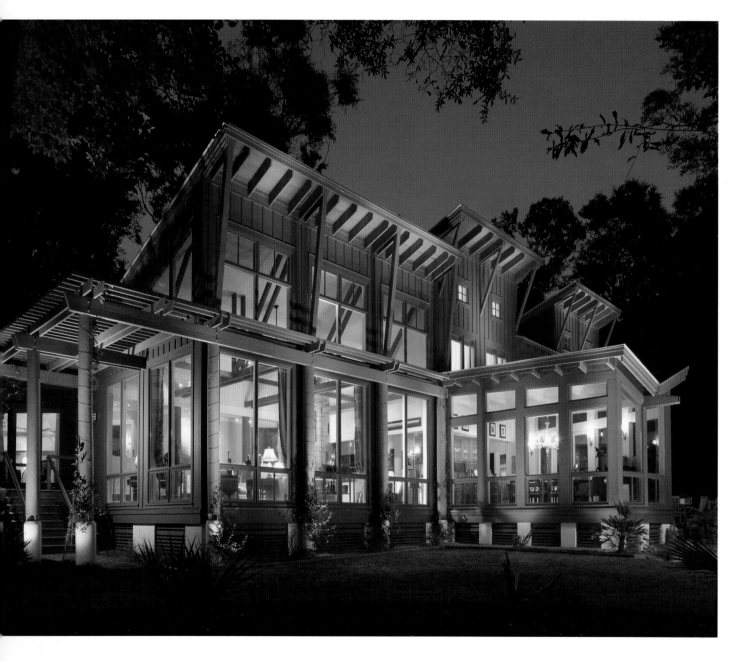

Based in Charleston, South Carolina, Schmitt Walker Architects offers its clients the complete scope of architectural services necessary to successfully complete the design and construction of a custom home. The emphasis is on communication among client, architect, consultants and contractor to insure maximum understanding, productivity, quality and creativity throughout all phases of a project. Schmitt Walker Architects is committed to creating projects of quality, elegance, durability and individuality.

With a master's in architecture from Harvard University, Chris founded Schmitt Walker Architects 20 years ago and was later elected a Fellow of the American Institute of Architects. Jimmy Walker joined the firm in 1993, and Michael Edwards joined in 2004. Both are graduates of Clemson University. Schmitt, Walker and Edwards together have helped build Schmitt Walker Architects into the successful and reputable firm that it is today, especially in their custom home and multi-family residential portfolios.

The firm has received more than 80 design awards on state, regional and national levels since it was founded. In 2006, the South Carolina Chapter of the American Institute of Architects awarded Schmitt Walker its "Firm Award," which has rarely been

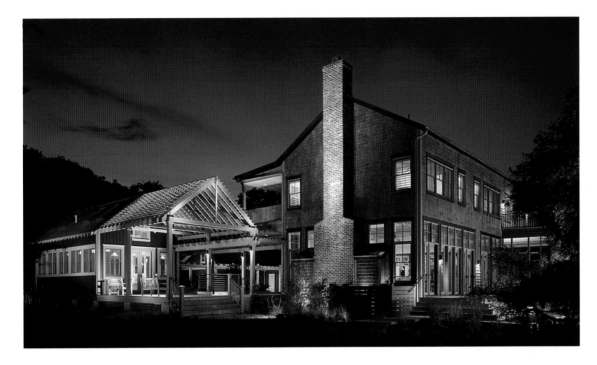

given throughout the organization's history. This award is the highest honor that can be awarded to an AIA South Carolina firm and is given in recognition of a firm's significant body of work and service that has made a lasting influence on the practice of architecture in the state. The firm's work has also been featured in *Architectural Digest, Custom Home, Coastal Living, The New York Times* and *Southern Living*.

Schmitt Walker Architects' performance is documented by the quality of its completed buildings, its impeccable record for cost control and scheduling performance, and by the long-term satisfaction of its clients. Says Chris, "Our work is a reflection of the quality of our clients."

Above: Private residence, side elevation in Brays Island Plantation, South Carolina.
Photograph by © 2005 Rion Rizzo, Creative Sources

Facing Page: Private residence, rear elevation in Spring Island, South Carolina.
Photograph by © 2005 Rion Rizzo, Creative Sources

Q & A

more about Chris, Jimmy and Michael ...

WHAT ONE ELEMENT OF STYLE OR PHILOSOPHY HAVE YOU STUCK WITH THAT STILL WORKS FOR YOU TODAY?

Timeless design is good design no matter what style it is.

WHAT IS THE AVERAGE SIZE OF ONE OF YOUR CUSTOM HOME DESIGNS?

Most of our designs are for second homes and tend to run in the range of 4,500 to 7,400 square feet. These homes typically range in price from $1.5 million to $3.5 million depending on the size and scope of the house.

WHAT IS ONE OF YOUR FAVORITE PROJECTS?

Our favorite project is the next one we are going to design because we always think we can do it better.

WHAT DO YOU LIKE BEST ABOUT BEING ARCHITECTS?

We can't imagine people who don't love what they do for a living. If we didn't love architecture so much, we would be gone tomorrow. To be able to draw, use your imagination and to have your imagination come forth in the design of someone's home that eventually gets built—that's an amazing voyage.

Schmitt Walker Architects, Inc.

Chris Schmitt, FAIA, NCARB

Jimmy Walker, AIA

Michael Edwards, AIA, NCARB

12-A Vanderhorst Street

Charleston, SC 29403

843.727.3140

Fax: 843.727.3143

www.schmittwalker.com

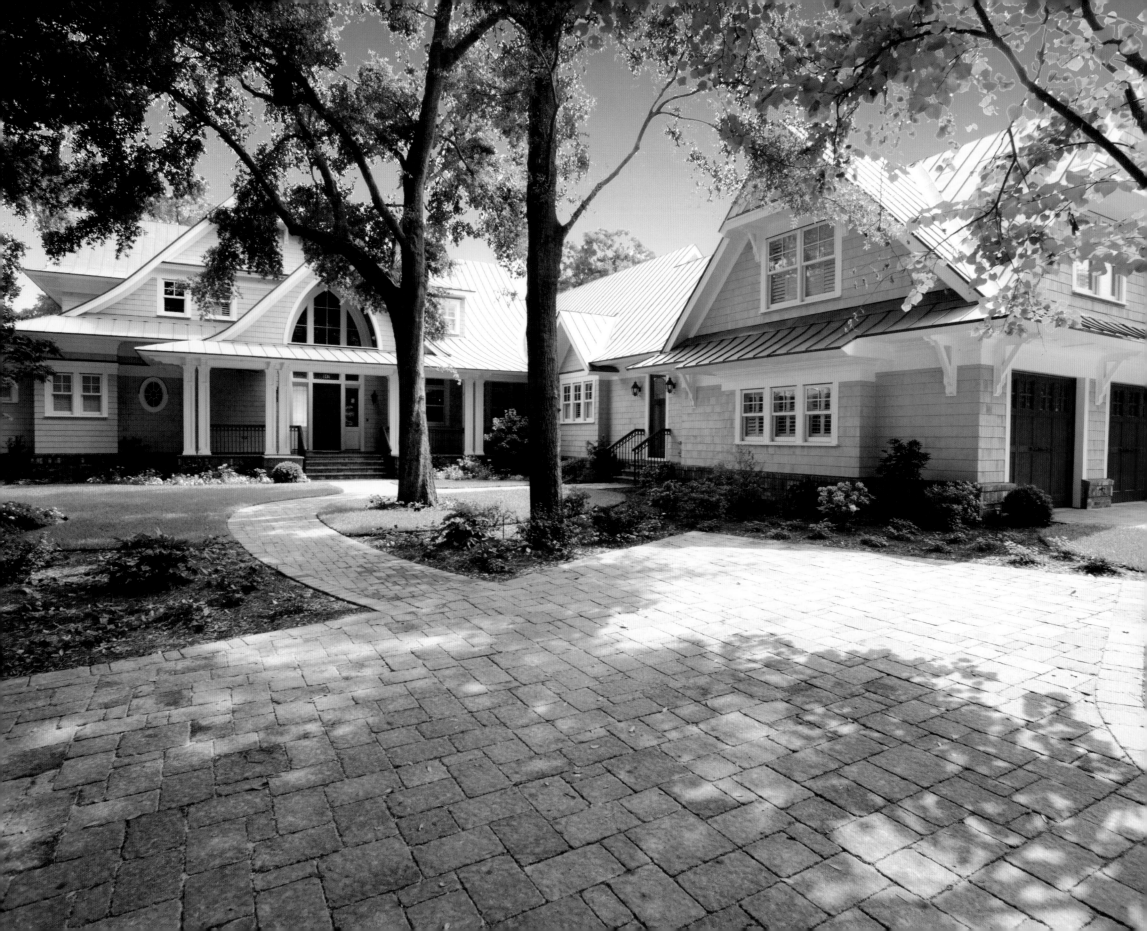

Michael W. Spivey
Grady L. Woods

Spivey & Woods Architects, LLC

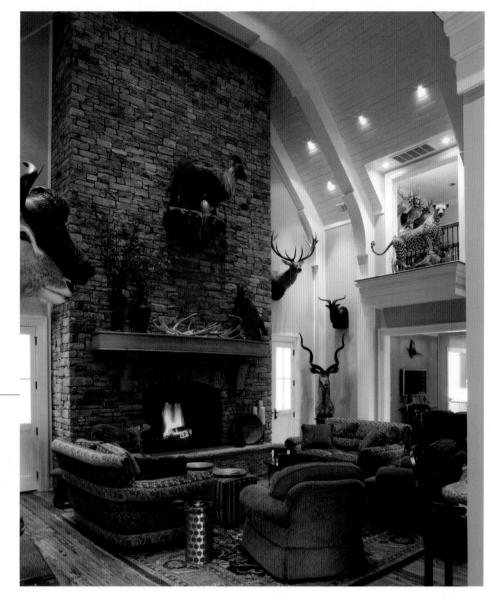

Above: Using high ceilings and specialty elements such as a cantilevered balcony, the architect created an opportunity to display the owner's collection of trophies.
Photograph by Dickson Dunlap

Facing Page: The architect used similarly colored copper standing seam roof, garage doors and brick foundation wall, which complement the cedar shingle siding and create an understated elegant and welcoming feel.
Photograph by Warren Lieb

Michael Spivey and Grady Woods merged their architectural practices in 2000 because they had a similar philosophy. They both have graduate degrees in architecture. Viewing architecture as a service business, their goal is to use their talents and education to create the homes that their clients would create if they were trained architects. The end result should always look familiar to what the client envisioned in their imagination.

Michael and Grady spend a tremendous amount of time getting to know their clients. "We want to ensure that we design a house that suits their tastes in a professional manner. We walk the site with them. We oftentimes visit their existing residence to determine what they like about it and what they don't like about it," explains Michael. "Every building has a different set of solutions. Creating individual solutions is our challenge and our motivation."

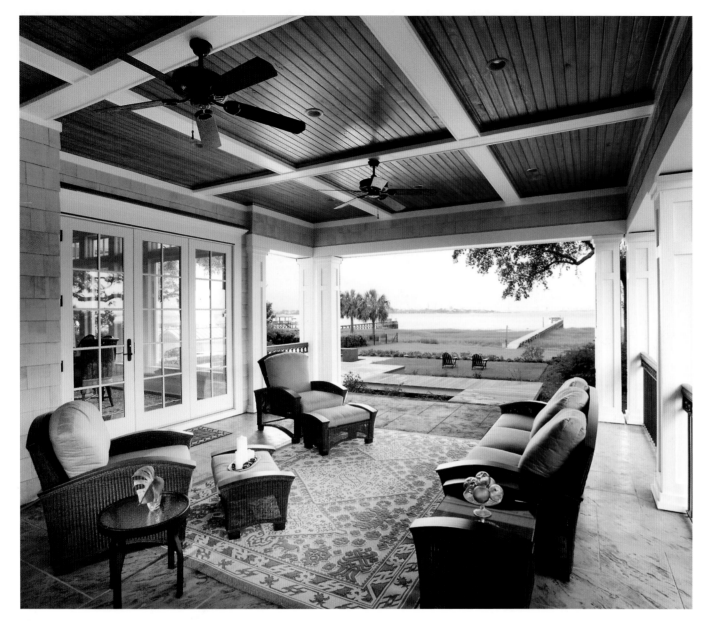

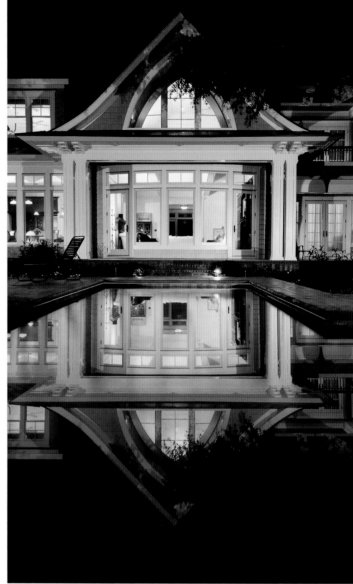

Michael and Grady truly listen and pay attention to their clients. "A lot of architects have a tendency to believe that they know better than their clients do," says Grady. "Very often they force their own individual ideas on a client. We spend a lot of time listening to our clients' ideas and dreams."

Another factor that separates Spivey & Woods from its competition is the fact that Michael still owns part of Cook Bonner Construction, Inc., a Charleston construction company he helped George Cook found in 1976. "During the first five years of my career I built everything that I designed," says Michael. "I don't know many architects who have done that, so it gives me close, intimate knowledge of the construction process. I'm very comfortable walking on site and talking with contractors."

Licensed in Georgia, Florida, North Carolina and South Carolina, Michael and Grady design approximately 12 homes a year across the region. "We're comfortable designing homes on the ocean. We're comfortable doing houses in the mountains," says Michael.

Above Left: An outdoor porch provides casual living and expansive harbor views.
Photograph by William Lieb

Above Right: The living room is reflected in this evening shot across the negative-edge pool.
Photograph by William Lieb

Facing Page: This home at Ford Plantation is presented with elegant brick detail and separate buildings for a guest house and carriage house/garage.
Photograph by William Lieb

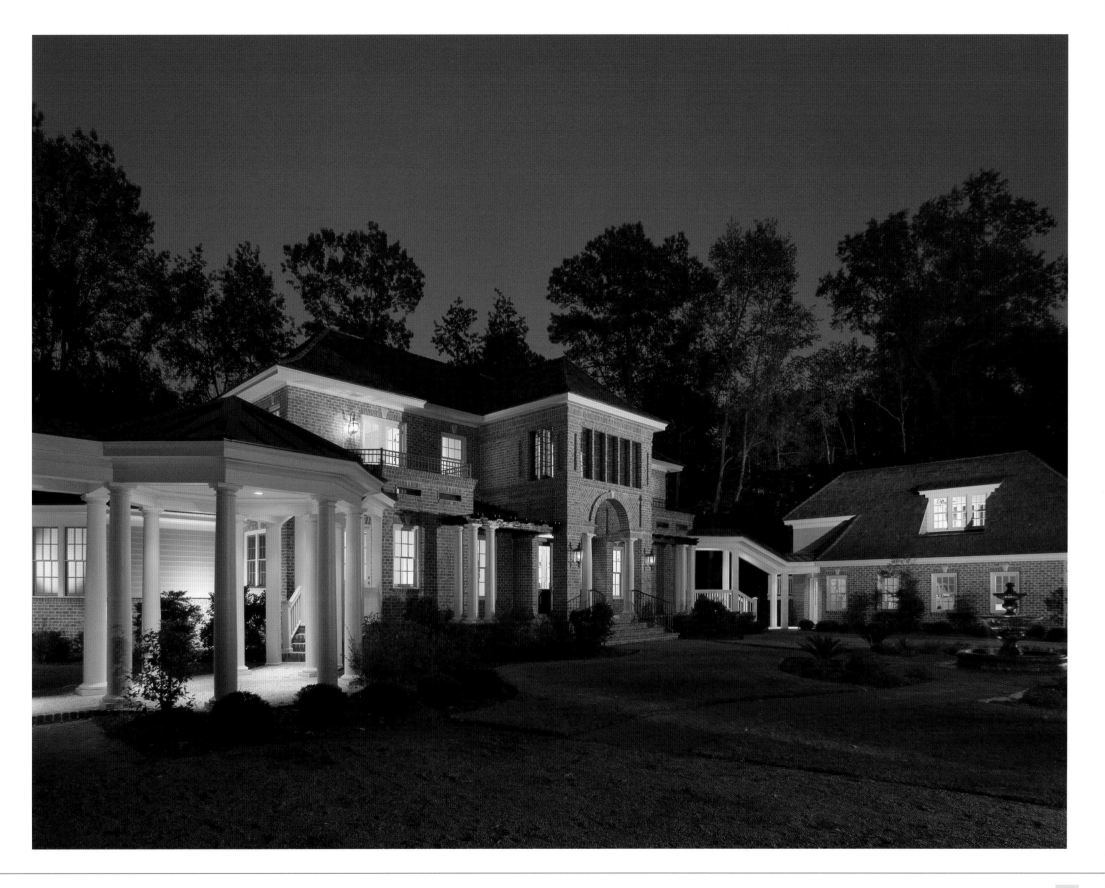

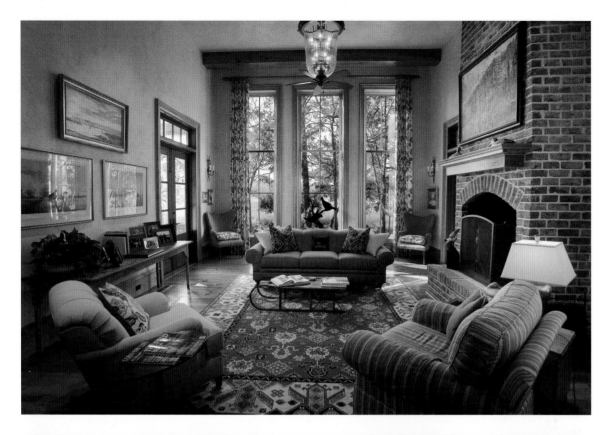

"We're comfortable doing houses in the Piedmont on lakes, rivers, whatever the case may be."

In the low country, you'll find their designs on Brays Island, Daniel Island, Deep Water Creek, The Ford Plantation, Kiawah Island, Palmetto Bluff, and other prestigious communities and neighborhoods in Charleston and Savannah, Georgia.

"I think Grady and I both do very well at design. I have a slight edge on the technical end of things, and Grady has a slight edge on the design end of things," says Michael. "It's a complementary relationship."

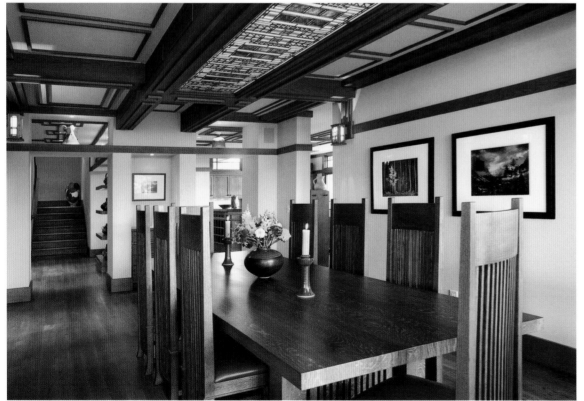

Top Left: Vertically proportioned windows anchor this room with delightful views and bring light into the extreme interior of the space.
Photograph by Warren Lieb

Bottom Left: To enhance the owner's commissioned Wright-influenced home and furniture, the architect used custom-designed ceiling treatments and light fixture designs to complete the experience.
Photograph by Warren Lieb

Facing Page: Interpretive craftsman detailing enhances this Wadmalaw Island home. Enlarged window openings provide lovely views of the water and surrounding marsh.
Photograph by Wilson Baker

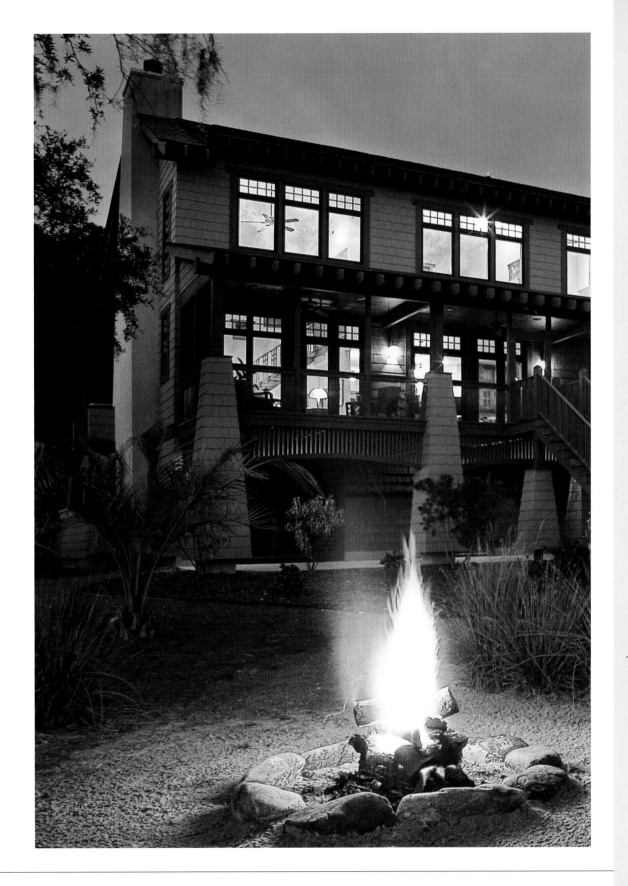

more about Michael and Grady ...

WHAT'S YOUR FAVORITE PROJECT?

Every project is unique. It's not just the project itself; it's the client that you're dealing with. We never have a repeat performance. We never have a project that's identical to the one prior to it.

ARE THERE OTHER ARCHITECTS ON YOUR STAFF?

We have three other architects aside from us, plus additional support staff.

WHAT ARE SOME UNUSUAL THINGS YOUR FIRM HAS DESIGNED?

We've had clients who have come to Kiawah Island and are enamored with the mountains and the pole construction found there. We've actually done some pole house construction on Kiawah Island, which is very unusual. It's a situation where the pilings run completely through the house from the ground through the roof. It's more or less a post-and-beam type of construction.

WHAT DO YOU ENJOY ABOUT BEING ARCHITECTS?

It's a widely varied profession with a wide range of duties and responsibilities. It requires significant knowledge and experience in a complex industry that keeps us busy. It's not static. It's constantly moving and changing. We'd be bored doing anything else.

Spivey & Woods Architects, LLC

Michael W. Spivey, AIA, NCARB

Grady L. Woods, AIA, NCARB

1216 Grays Highway	30 Hendersonville Road	147 Wappoo Creek Drive
PO Box 2143	Suite 1	Suite 304
Ridgeland, SC 29936	Asheville, NC 28803	Charleston, SC 29412
843.726.6730	828.277.8407	843.795.9370
Fax: 843.726.6735	Fax: 828.277.8408	Fax: 843.795.3532

www.swaarchitects.com

Mike Tuten

Harden Tuten Custom Homes, Inc.

A native of the low country, Mike Tuten remembers watching his grandfather trap wild hogs in what is now Sea Pines on Hilton Head Island. In 2001 he was preparing to relocate from the low country he loved so much when Joe Harden approached him about buying his residential construction company. Harden founded the business in 1989 after a long stint in the commercial construction industry. As he was preparing to retire, he wanted to pass the reigns of his business on to a younger generation. Mike, who had extensive experience in development and construction, was an obvious choice.

"It truly was an offer that I couldn't refuse," says Mike, who is now the president of Harden Tuten Custom Homes. "It was very flattering and very rewarding in that it gave me the

Left: The Byrd Residence, Windy Knoll, Bluffton, South Carolina. Winner of the 2006 South Carolina Home Builders Association "Pinnacle Award."
Photograph by Fred Clay, Lenox Lane Associates of Hilton Head LLC

opportunity to buy an existing business with an established track record and a well-known name. Joe Harden established himself in the early years of Hilton Head Island and created a great name for himself because he delivered a first-rate product. He established himself as a leader, not only in our field but also in our community. He is somebody for whom I have a lot of respect."

Today the company has 27 employees, including Mike, and works as a team to deliver a spectacular product through its attention to detail, accurate cost control measures, on-time performance and unmatched follow-up.

"While we're a home-building business, we're also in the relationship-building business. Joe Harden built quality and long-lasting relationships with his employees. I've tried to maintain that philosophy," explains Mike. "We—in turn—build relationships with our clients that exceed the typical builder/owner relationships."

Concentrating most of its work in Beaufort County, Harden Tuten builds 12 to 20 homes a year ranging in size from 2,500 to more than 7,000 heated/cooled square feet. Many of the company's homes can be found in communities and neighborhoods such as Belfair, Berkeley Hall, Brays Island, Colleton River Plantation, Long Cove, Palmetto Dunes, Sea Pines, Spring Island, Wexford Plantation, and in the near future, Palmetto Bluff. Mike says one of the best professional compliments he's received was when the owner of a high-end building company in South Florida asked him to build his personal residence.

Although Mike's favorite architectural style is Southern traditional, he says that his company builds in a variety of styles. "We'll build in any architectural style, but we do build a lot in the traditional style," he says, adding that his homes generally start at $750,000. "We also build a lot of Country French, neo-traditional, Southern traditional and transitional homes."

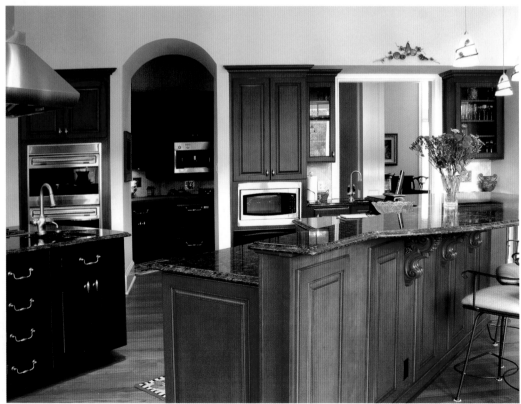

Top Left: The Byrd residence country kitchen, Windy Knoll, Bluffton, South Carolina.
Photograph by Fred Clay, Lenox Lane Associates of Hilton Head LLC

Bottom Left: The Curl residence kitchen, Leamington, Hilton Head Island, South Carolina.
Photograph by Fred Clay, Lenox Lane Associates of Hilton Head LLC

Facing Page: The Curl Residence waterway view, Leamington, Hilton Head Island, South Carolina.
Winner of the 2006 South Carolina Home Builders Association Merit Award.
Photograph by Fred Clay, Lenox Lane Associates of Hilton Head LLC

Being in the low country with its wonderful weather, outdoor living is essential. Mike took that into consideration when his company introduced what has come to be known as Carolina Lifestyle homes: In these homes, screened atriums house pools, spas, outdoor fireplaces, summer kitchens and landscaping. "It's an informal living space outside of the house, but it's enclosed so you can enjoy the outdoors twelve months a year," says Mike. "Our atriums blend in seamlessly to our homes. It's been one of my favorite products because it has become so popular."

Mike is involved with every project to make sure the end product is exactly what the client desires. "When your name is on the sign, you have to be," he says. "Throughout my entire career, trust has always been the most important factor. That's my philosophy when I deal with people in business. We work with people every day that we can trust. We pick out the contractors, subcontractors and vendors that we trust. Together we have a team approach, and it's all built on trust."

Above: The Millar residence lagoon view, Berkeley Hall, Bluffton, South Carolina.
Winner of the 2005 South Carolina Home Builders Association "Pinnacle Award."
Photograph by Rick Rhodes Photography

Facing Page Top Left: The Millar residence master bath, Berkeley Hall, Bluffton, South Carolina.
Photograph by Rick Rhodes Photography

Facing Page Top Right: The Millar residence cross gallery, Berkeley Hall, Bluffton, South Carolina.
Photograph by Rick Rhodes Photography

Facing Page Bottom: The Millar Residence kitchen, Berkeley Hall, Bluffton, South Carolina.
Photograph by Rick Rhodes Photography

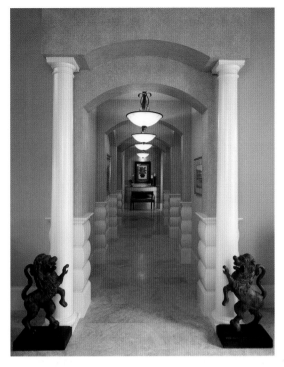

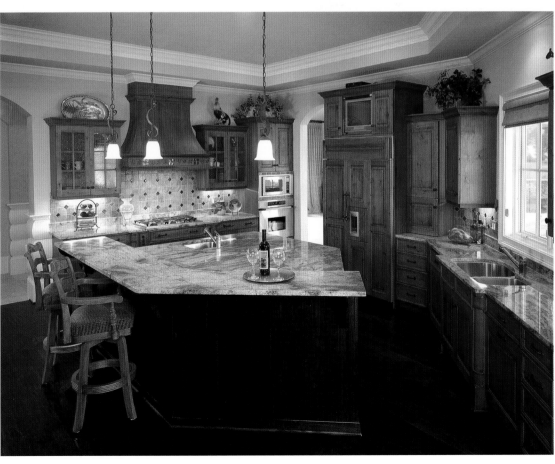

Q&A

more about Mike ...

WHAT'S THE BEST PART ABOUT BEING A BUILDER?

Having a sense of accomplishment once a home is complete.

WHAT DO YOU LIKE ABOUT DOING BUSINESS IN THE LOW COUNTRY?

What's not to like about being down here? It's beautiful. The environment is absolutely gorgeous, and the weather conditions allow us almost year-round access to the outdoors. Plus, I'm from here, and this is home. Everybody likes to be home.

WHAT'S THE MOST DIFFICULT PROJECT THAT YOU'VE WORKED ON?

We built an indoor elevated swimming pool with a two-story, poured-in-place concrete enclosure for a high-end custom home in Leamington. That was very challenging.

WHO HAS HAD THE BIGGEST INFLUENCE ON YOUR CAREER?

As a builder, Joe Harden. As a businessperson, Chuck Pigg. As a man, my father and grandfather.

Harden Tuten Custom Homes, Inc.

Mike Tuten
8 Arley Way
Bluffton, SC 29910
843.815.3700
800.544.8761
Fax: 843.815.3701
www.harden-tuten.com

Hubert Whitlock Builders, Inc.; *page 169*

Frank Harmon Architect; *page 127*

Architrave, Inc.; *page 137*

PIEDMONT & MIDLANDS

Debra Badalamenti
Jim Badalamenti
New Tradition Homes

Above: This vantage point gives a view from foyer to split-level stairway: half flight up to master bedroom area and half flight down to entertainment area.
Photograph by Michael Valentine

Facing Page: A front elevation beautifully illuminated in the evening.
Photograph by Michael Valentine

Debra and Jim Badalamenti take a lot of pride in focusing on the details of their homes. You will not find either of them sitting behind a desk because they personally supervise each project on a daily basis. Their on-site presence allows them to fine tune each home's details and personally monitor the quality of construction. Their subcontractors and suppliers are aware that they demand a higher level of quality, and it shows.

New Tradition's roots go back to Debra and Jim's college years. While Jim was studying engineering at North Carolina State University in Raleigh, Debra worked as the lone assistant to a local homebuilder. It was there that she discovered her love for home building. She eventually earned her own general contractor's license, and in 1997 founded New Tradition Homes in Weddington. Things went so well that four years later Jim joined her full time. Now New Tradition Homes is one of the area's premiere builders of luxury homes.

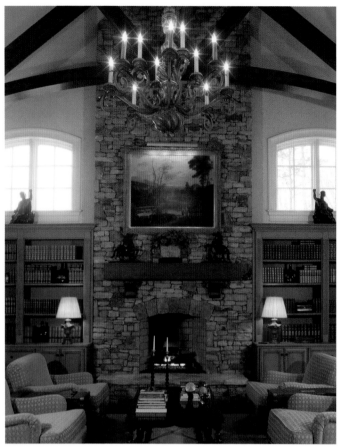

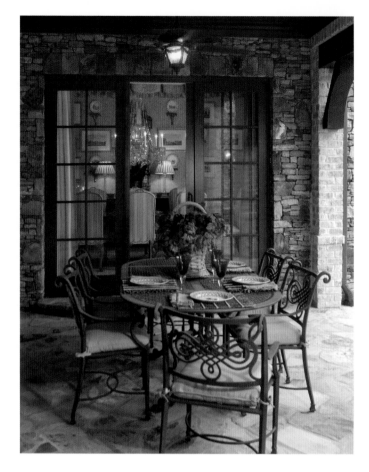

Together the couple builds a handful of homes each year, with their typical home being 7,000 to 9,000 square feet and priced between $1.5 million and $2.5 million. New Tradition's high-efficiency homes are built to stand the test of time. "We believe in quality from start to finish, both beneath the covers and what appears to the eye. We start by marrying the right home to the home site, so in the end the home and land flow naturally together like in a classic painting," explains Jim. "We like to incorporate natural stone, timber and brick to create European-styled homes that are timeless."

Detailed interior trim is an important component in a New Tradition home. "We believe in heavy wood mouldings, particularly in our studies and home theaters where fully stained

cherry panels are commonplace," explains Debra. "Trim complements our other fine finishes. Even the kids' bathrooms have granite countertops and picture-framed mirrors. We've forgotten how to cut corners."

One of the Badalamenti's favorite projects is a home they built near the entrance of Skyecroft, an Old World-themed community in Weddington. More than 9,000 square feet, the home has a traditional brick and stone exterior with French influences. Designed as a split-level, the home has six levels of luxurious appointments. The home also features mosaic tile flooring and a groin-vaulted ceiling that leads to an open gourmet kitchen. "It's a grand home, but it doesn't overwhelm," says Debra. "It's very dramatic, yet it's the perfect balance of luxury and size."

With every project, Debra and Jim strive to build one of the finest homes on the block, if not the finest. Says Debra, "We are building a new tradition of quality in distinctive homes. We won't build something that we're not comfortable with."

Above Left: An elegant yet inviting formal dining room.
Photograph by Michael Valentine

Above Middle: This vaulted family room features a stone fireplace, walnut floor and arched truss beams, which simply add to the charm of the space.
Photograph by Michael Valentine

Above Right: Gliding doors from the formal dining room lead to this rear covered veranda with flagstone floor.
Photograph by Michael Valentine

Facing Page Top: Seen at dusk, an outside entertaining space is created in this rear pool patio area with trellised terrace and covered terrace with barrel vault.
Photograph by Michael Valentine

Facing Page Bottom: A view from the family room through the casual dining area and into the kitchen features a large island, oversized refrigeration units, custom cabinetry and stone hood.
Photograph by Michael Valentine

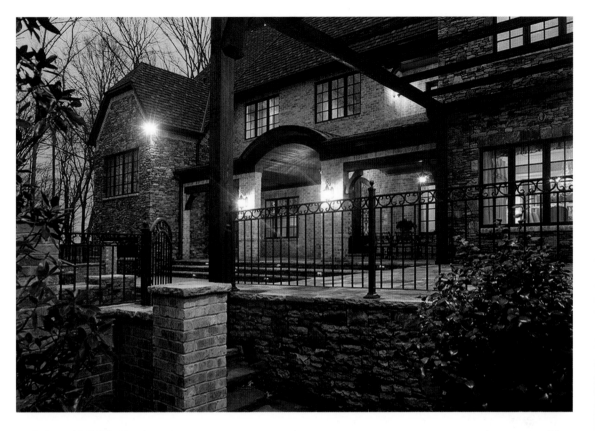

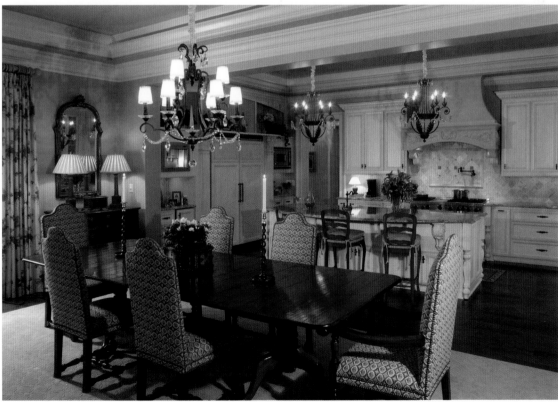

more about Debra and Jim ...

DO YOU ONLY BUILD CUSTOM HOMES?

Our business is 50 percent custom homes and 50 percent spec homes.

WHAT SEPARATES YOU FROM THE COMPETITION?

Our age-old attention to detail and the fact that we personally evaluate our sites daily.

WHAT DO YOU LIKE ABOUT DOING BUSINESS IN WEDDINGTON?

We fell in love with the area about 10 years ago and like it more every day. There are so many quality homes in this area so our homes fit right into the landscape.

WHAT NEIGHBORHOODS DO YOU BUILD IN?

Chatelaine, Firethorne Country Club and Skyecroft. We typically build within a five to six mile radius of our own home. That allows us to give our projects our full attention.

New Tradition Homes

Debra Badalamenti

Jim Badalamenti

1005 Woods Loop

Waxhaw, NC 28173

704.243.0149

www.nthomes.com

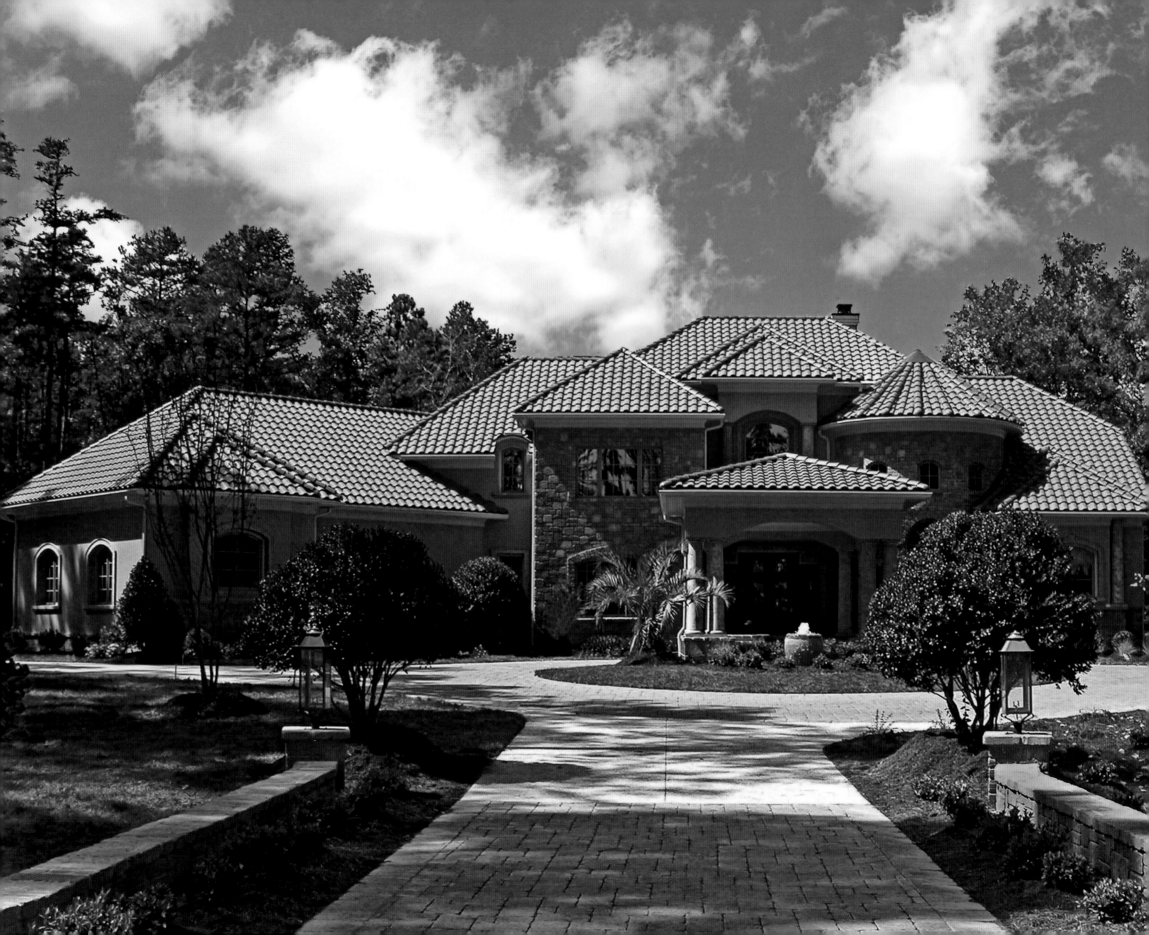

Rex Bost

Bost Custom Homes

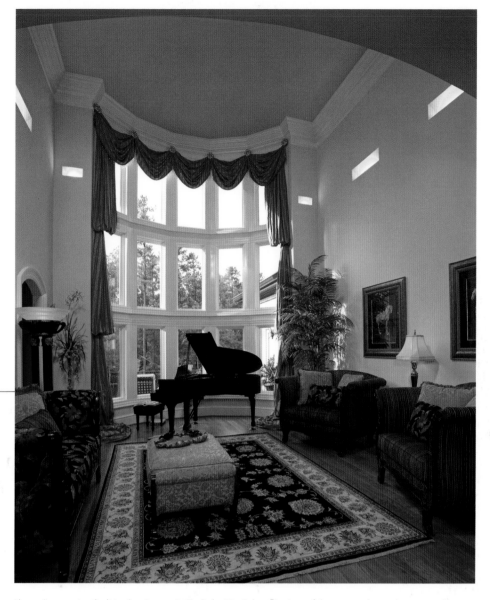

Above: As you enter the living/music room in "La Dolce Vita," dramatic views of the resort-style exterior emerge. The rows of windows and the concealed up-lighting add drama to the well-proportioned two-story space. "La Dolce Vita" was Bost Custom Homes' 2006 Parade entry, racking up the "Gold" and "Best of the Best" awards for the third year in a row.
Photograph by Strawbridge Photography

Facing Page: "The Bella Casa" earned Bost Custom Homes numerous awards and raised over $320,000 for the Eastern North Carolina Chapter of the Leukemia & Lymphoma Society.
Photograph by Bost Custom Homes and Strawbridge Photography

Rex Bost became intrigued with architecture while working as a stone masonry contractor in the early '80s. During that time he worked on many unique homes featuring contemporary and European architecture in the north Raleigh area. In 1986, he founded Bost Custom Homes and began designing and building.

"From the beginning, our reputation was built on unique design, craftsmanship, attention to detail, and structural integrity," explains Rex. "We have also constantly introduced new ideas, concepts and techniques, with practical applications."

Over the years, Rex has introduced masonry framing, safe rooms and free rain irrigation to the market. Masonry framing is a unique construction method utilizing concrete block construction, much like commercial building. This was a natural progression for Rex having learned masonry at a young age while working with his father and brother. Today many of his clients are choosing masonry framing

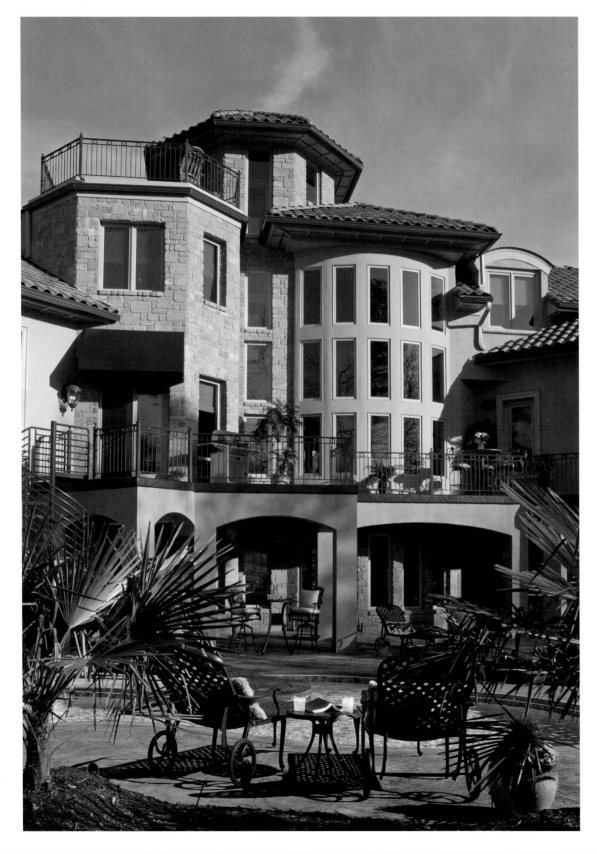

because of concrete's durability, energy efficiency, stability and environmental benefits. Rex says his company's end-of-year touch-ups and adjustments have been reduced significantly with masonry-framed homes.

Rex began researching safe rooms when hurricanes Floyd and Fran swept through the Triangle in the '90s. He discovered that FEMA had developed guidelines to build a room that would withstand an F 5 tornado. Since constructing his first safe room in his company's 2001 Parade of Homes, Rex has since incorporated safe rooms in many of his homes.

Utilizing "free rain" water harvesting systems is another way Rex practices environmentally friendly building methods. Based on Old World technology, he developed the system to collect rainwater from the roof and grounds in a large buried collection device. The water is then pumped from the tank and used for irrigation and other grey water needs. These systems also control runoff from the site, which is an important environmental issue in regard to protecting our drinking water supplies.

Architecturally, Rex has been innovative as well. In 1992, his company incorporated Mediterranean and Southwestern elements into one of its Parade of Homes entries. Although this architecture did not catch on at the time, it certainly enjoys popularity now.

In 2004, Bost Custom Homes built "The Bella Casa" in the Hills of Rosemont as a fundraiser for the Eastern North Carolina Chapter of the Leukemia & Lymphoma Society. The project raised over $320,000 for the organization and won three major marketing awards from the Triangle Sales & Marketing Council of the Home Builders Association of Raleigh-Wake County. It also won the Gold and "Best of the Best" awards in the Parade of Homes. Additionally, Bost Custom Homes was named "Building Company of the Year" for the second time (1-10 homes closed).

Left: Rear elevation of award-winning "Tuscan Sun." The see-through elevator provides a spectacular view of the guitar-shaped pool and golf course. It also provides exclusive access to the rooftop retreat with a patio and wet bar.
Photograph by Strawbridge Photography

Facing Page: The kitchen/morning area of "La Dolce Vita" features a curved wall with built-in fireplace and a hidden door to a secondary pantry. State-of-the-art appliances include a Sub-Zero refrigerator. The curved double trey ceiling up-lights the iridescent faux finish.
Photograph by Strawbridge Photography

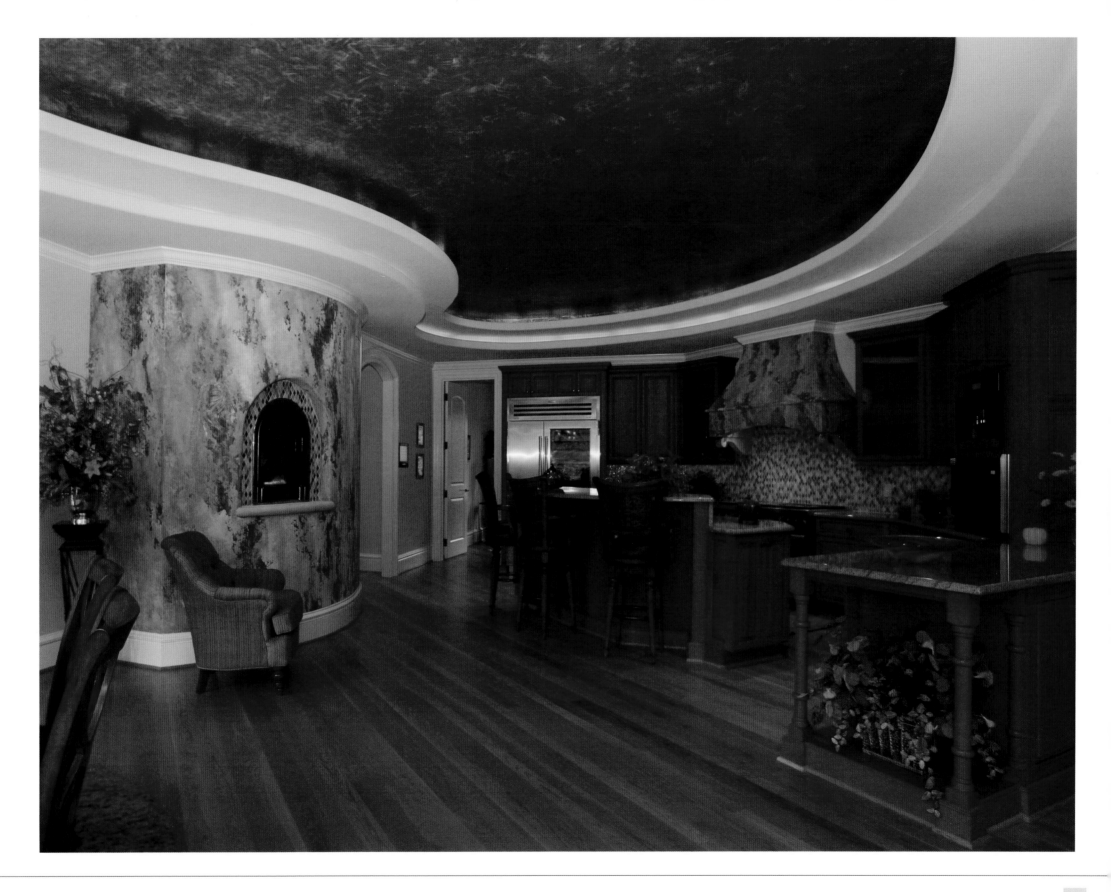

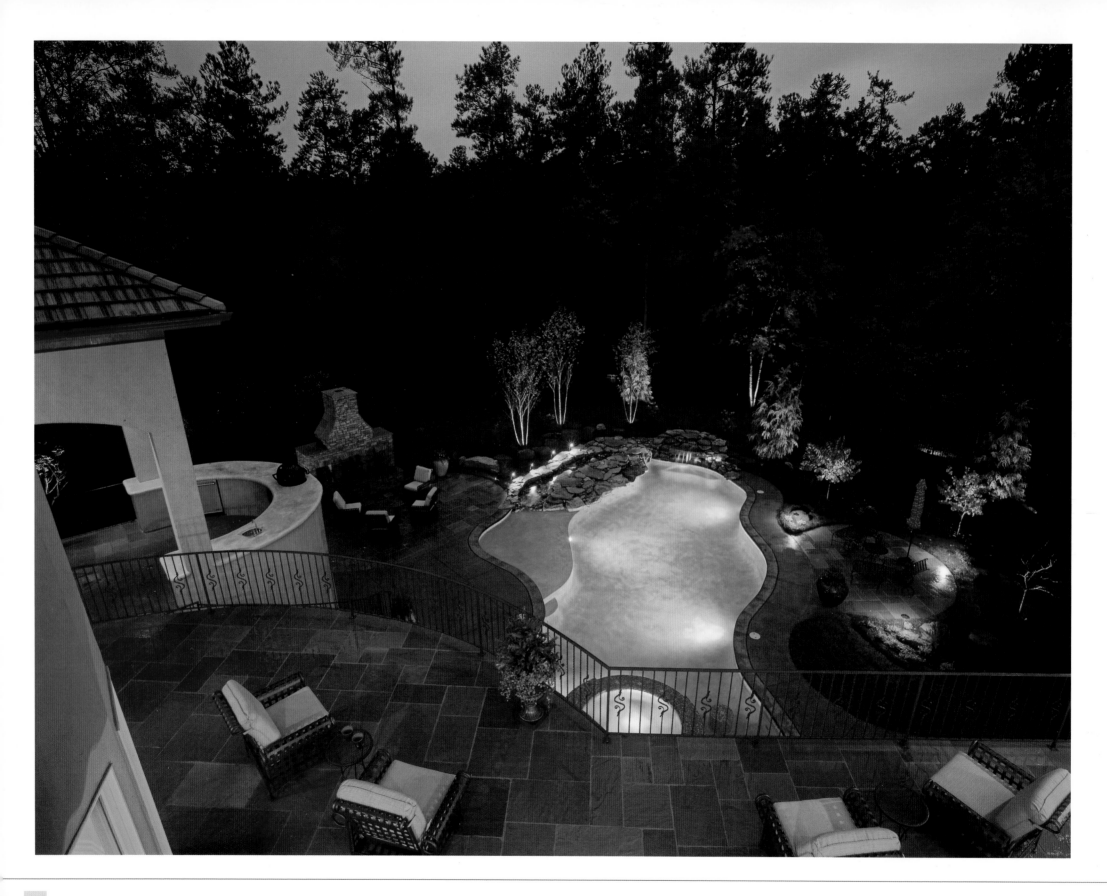

In 2005, the company's Parade entry was a redesigned and a more informal interpretation of "The Bella Casa." Named the "Tuscan Sun," the home features Mediterranean architecture with antique pieces and natural woods incorporated into the design. Located in Cary, the 7,400-square-foot home has five bedrooms, a finished basement, wine cellar, theater, safe room, music studio, rooftop patio and guitar-shaped pool. It was the recipient of the 2005 Parade of Homes Gold Award. Marketing awards included "Best Product Design," "Best Parade Entry" and "Best of the Best."

Rex admits that he has always been fond of European architecture. However, he is quick to point out that his company builds in a variety of styles such as Colonial, Contemporary, Southern, Low Country and Transitional. Most recently he has taken an interest in High Country and Craftsman architecture.

"We have a wonderful reputation of building unique projects. Each year our Parade of Homes attract thousands of visitors, including many that come every year to see what new ideas we may be unveiling," says Rex. "Beyond unique ideas, we pay particular attention to balance, flow, and efficient use of space of each custom home, inside and out."

Being a design/build firm, Bost Custom Homes is able to coordinate the building process so custom home clients are provided a plan that meets their needs, yet does not exceed their budget. "We provide basic design in-house and work with a number of talented designers and architects," says Rex. "Sometimes it's simply a matter of altering an existing plan to accommodate a client's needs, but many times we start from scratch."

For the past two years the average size of a Bost Custom Home has been approximately 7,500 square feet. The company builds about seven homes a year and is involved in the design process on most every project. Bost is currently the third largest custom homebuilder in the Triangle.

Top Right: The 2005 Parade Entry, "Tuscan Sun."
Photograph by Bost Custom Homes and Strawbridge Photography

Bottom Right: The owner's suite of "La Dolce Vita" features a sitting area with patio access and superior views. The space is defined by a three-sided fireplace and reading nook.
Photograph by Strawbridge Photography

Facing Page: Daybreak view from the second-story guest suite at "La Dolce Vita."
Photograph by Strawbridge Photography

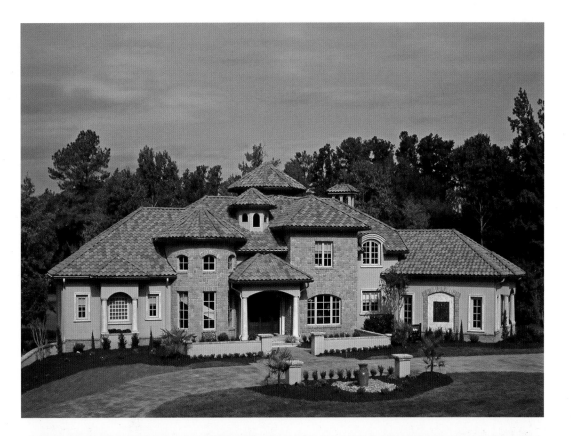

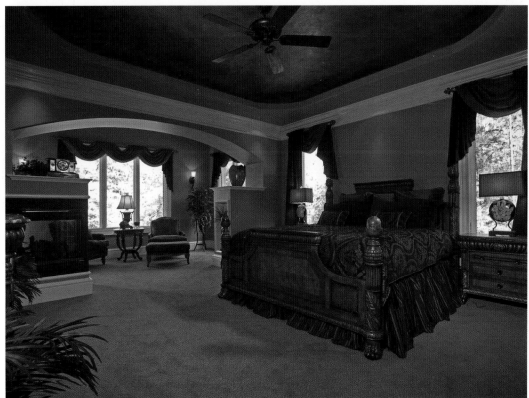

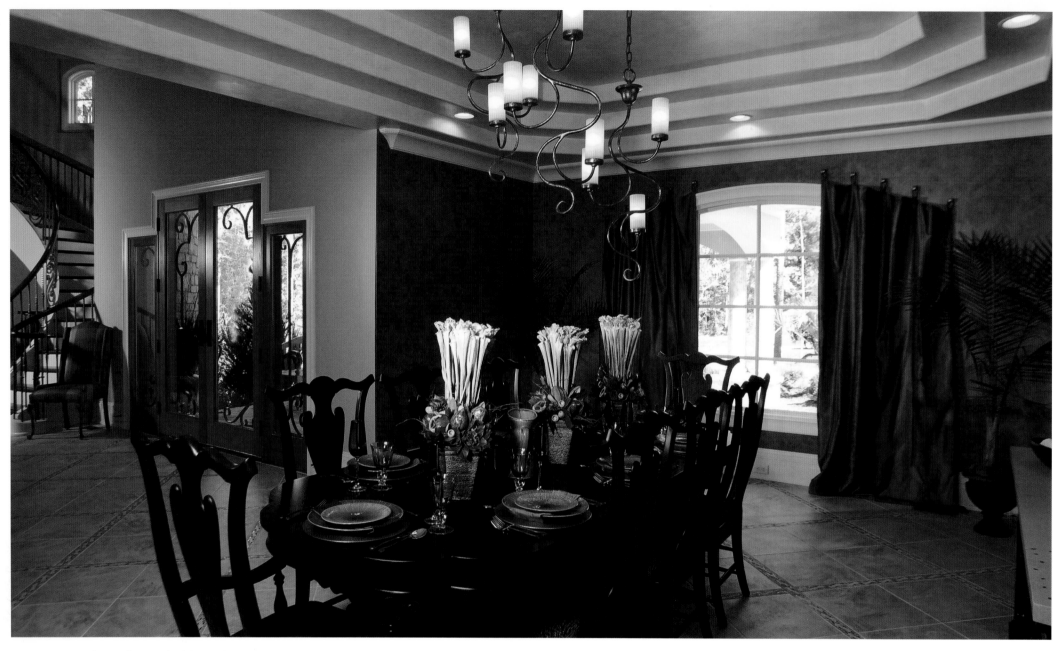

"We strive to be a better builder with each new home. We understand the products and materials we're using. We're building with more efficiency and with more environmentally friendly components," says Rex, who primarily builds in the Triangle area. "Moderate climate, easy access to the coast and mountains, a high concentration of universities, job opportunities, and the quality of life these accolades promote, are just some of the reasons people find this is a wonderful place to live and work." Although Bost Custom Homes' primary product is large estate homes, they are expanding into a smaller product line for the increasing demand of empty-nesters that are looking for simpler and smaller luxury housing. "I feel extremely blessed that I can do what I love and make others' dreams come true in the process," says Rex. "The ability to help a client visualize, design and build a home is priceless. It becomes not only their safest investment, but more importantly, it will house a lifetime of family memories."

Above: The formal dining area of "The Bella Casa" features Venetian plaster walls and ceilings.
Photograph by Strawbridge Photography

Facing Page: This Georgian-style home reveals the architectural diversity of Bost Custom Homes.
Photograph by Strawbridge Photography

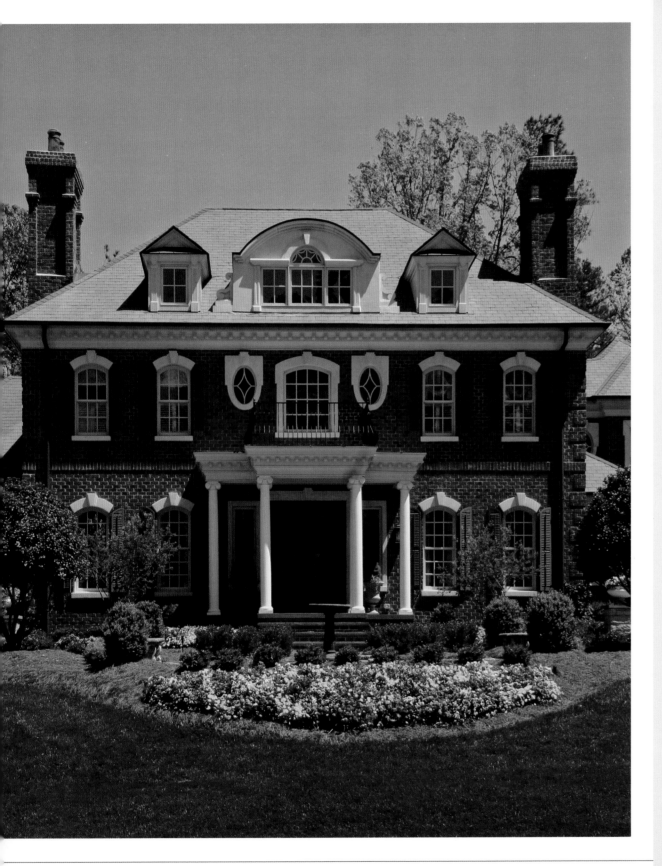

more about Rex ...

WHAT SEPARATES YOU FROM THE COMPETITION?

We have a wonderful reputation of doing really unique projects that people are attracted to. We pay close attention to balance and detail in every project we do. We introduce new building techniques based on Old World craftsmanship and cutting-edge technology.

WHERE DO YOU FIND INSPIRATION?

Everywhere, especially when I travel. I am constantly intrigued by architectural elements and unique building techniques that I observe from the most elaborate mansions and buildings, to a farmhouse in rural North Carolina.

WHAT IS YOUR FAVORITE PROJECT?

It's usually the last home we built.

IN WHAT NEIGHBORHOODS DO YOU BUILD?

The Hills of Rosemont, Linville, The Barony, Renaissance, Hasentree and Hidden Lake.

Bost Custom Homes

Rex Bost
219 East Chatham Street, Suite 205
Cary, NC 27511
919.460.1983
Fax: 919.460.1730
www.bostcustomhomes.com

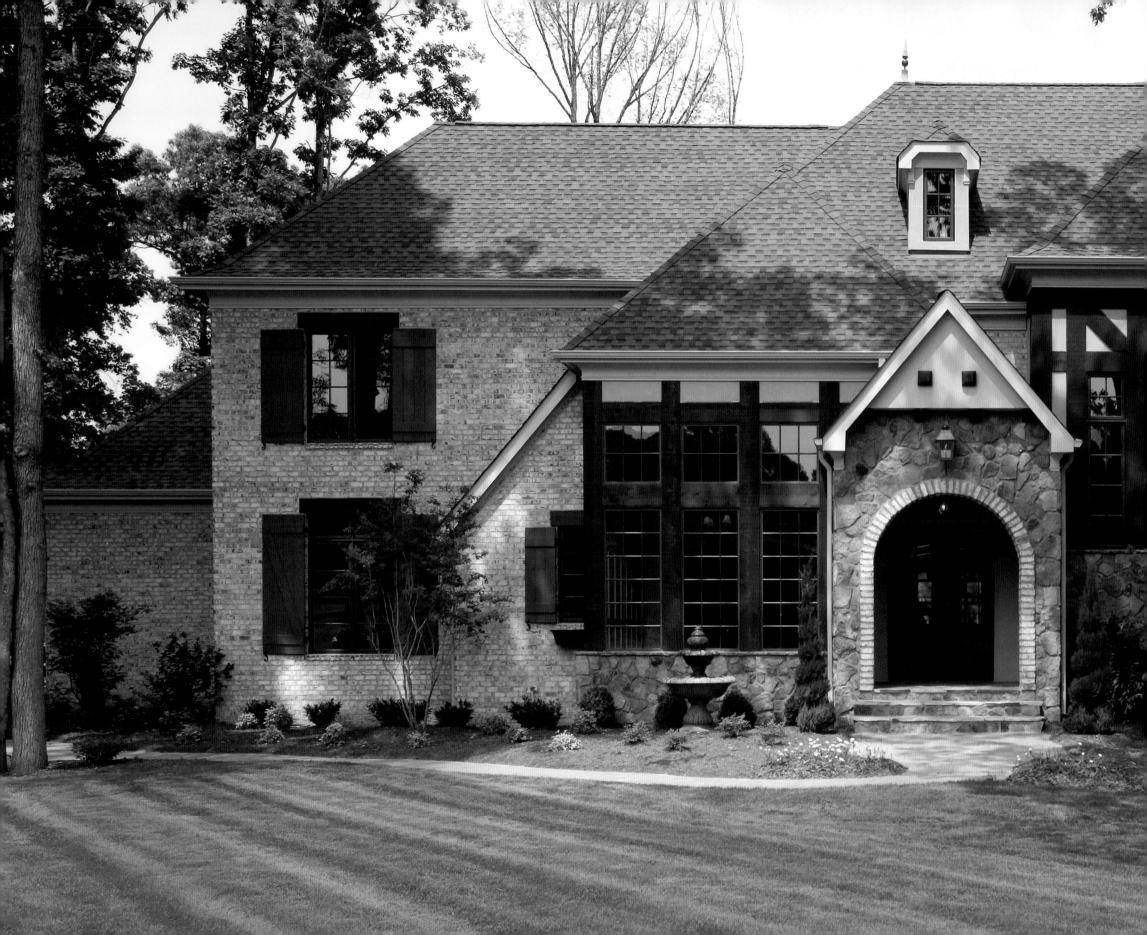

Jeff Conger

Conger Builders, Inc.

Conger Builders has experienced tremendous growth since it was established in 2001, yet the company still delivers the highest quality of craftsmanship and service to its clients. "We've successfully managed our growth. We're large enough to handle volume and small enough to maintain attention to detail and educate our customers," says president Jeff Conger. "We're a strong company, but we're also a family business."

Jeff's father, Fred, keeps things running smoothly behind the scenes, while his mother, Nancy, handles office management responsibilities. With a staff of six, Charlotte-based Conger Builders builds 12 to 15 high-end custom homes a year in the $1 million range.

Left: Conger Builders prides itself on its ability to build in a wide range of styles, from Traditional to Contemporary and Colonial to French Country.
Photograph by Matt Silk

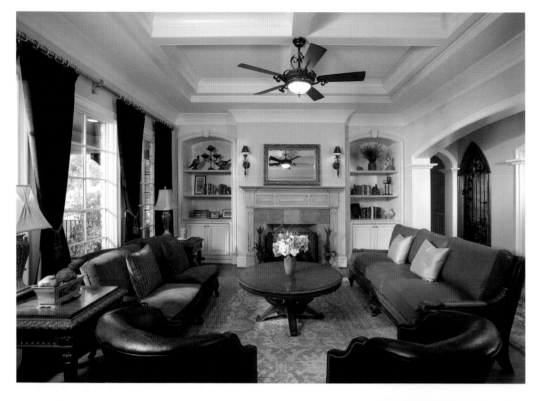

Jeff, who played professional baseball with the Pittsburgh Pirates for eight years, began his career in the construction field as a laborer in a high-end tile business. He started out making $8 an hour and within a year worked his way up to being a partner in the company. He later worked as a framer so he could understand construction from the ground up.

Although Jeff's schedule does not allow him time for framing these days, he still knows the details of every project the company is working on. "I have my hand in every job," he says. "Clients feel comfortable asking me questions because I am involved in all facets of their jobs, even though I have superintendents watching the sites."

Jeff is known for incorporating natural materials such as cedar and stone into elegant English Tudor and French Country designs. "We try to stay true to a guild craftsman level of building," says Jeff. His subcontractors have versatile skill sets in that they can handle any project that comes their way from fully custom wine cellars to beam detailing to ironwork to mantels. "With this level of talent, we can bring to life whatever clients can imagine for their homes. We pride ourselves in using subcontractors who have the ability to go the extra mile. Teamwork is the key to our success."

Conger Builders also prides itself in using all of the available space in its homes, which tend to be 4,000 square feet or larger. For a recent project, Jeff turned the loft area of an upstairs bedroom into a tree house for children. In another home he turned extra space into an upstairs kitchen between the bonus and media rooms. A premiere homebuilder in SkyeCroft, a European-themed community in Weddington, Conger Builders has also done a substantial amount of work on Charlotte's Providence Road corridor and in the Myers Park and Eastover neighborhoods. Says Jeff, "We love to make our customer's dreams a reality."

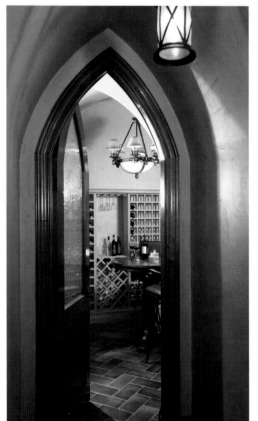

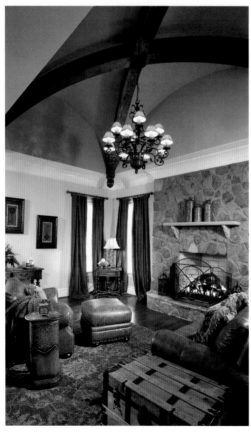

Top Left: Conger Builders focuses primarily on attention to detail. The detail in the millwork adds to the finished product.
Photograph by Matt Silk

Bottom Left: A dramatic gothic arch hallway descends to this expansive custom site-built wine cellar, which would make any connoisseur envious.
Photograph by Matt Silk

Bottom Right: A chandelier hanging from a fully suspended, beam-detailed groin vault, adorns the hearth room of a home located in an upscale south Charlotte neighborhood.
Photograph by Matt Silk

Facing Page Top: True raised panel wainscoting and bold custom dental moulding are a perfect complement to the arched cased openings of this elegant formal dining room.
Photograph by Pat Shanklin

Facing Page Bottom: Custom built, distressed kitchen cabinetry along with an impressive Viking appliance package embodies an Old World feel, in keeping with the home's English Tudor style.
Photograph by Matt Silk

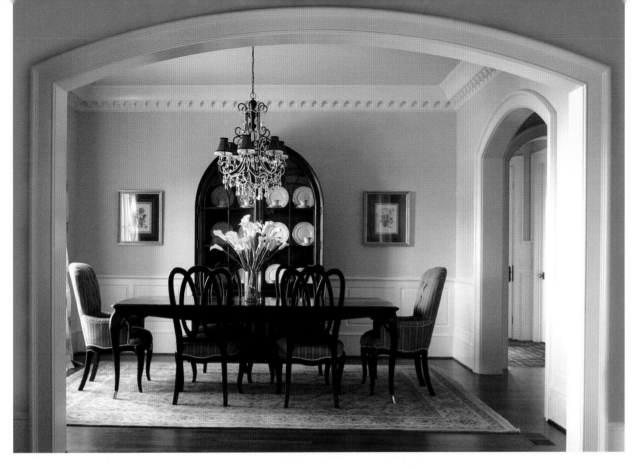

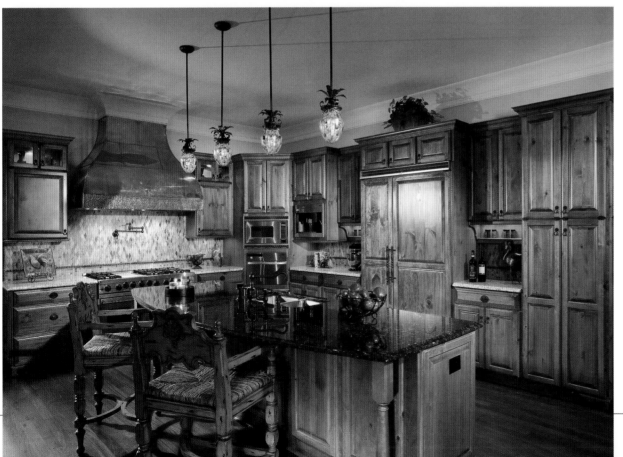

WHAT ONE ELEMENT OF STYLE OR PHILOSOPHY HAVE YOU STUCK WITH FOR YEARS THAT STILL WORKS FOR YOU TODAY?

Take care of the customer and everything else will fall into place.

WHAT IS THE HIGHEST COMPLIMENT YOU HAVE RECEIVED PROFESSIONALLY?

"Conger Builders, Inc. is the most honest builder around."

WHAT IS THE BEST PART OF BEING A BUILDER?

Creating the end product from the mind of the homeowner to paper and then to the site. You get to see a dream come true.

WHAT PERSONAL INDULGENCE DO YOU SPEND THE MOST MONEY ON?

Nice meals.

Conger Builders, Inc.

Jeff Conger

10612-D Providence Road, #490

Charlotte, NC 28277

704.321.0190

Fax: 704.841.9374

www.congerbuilders.com

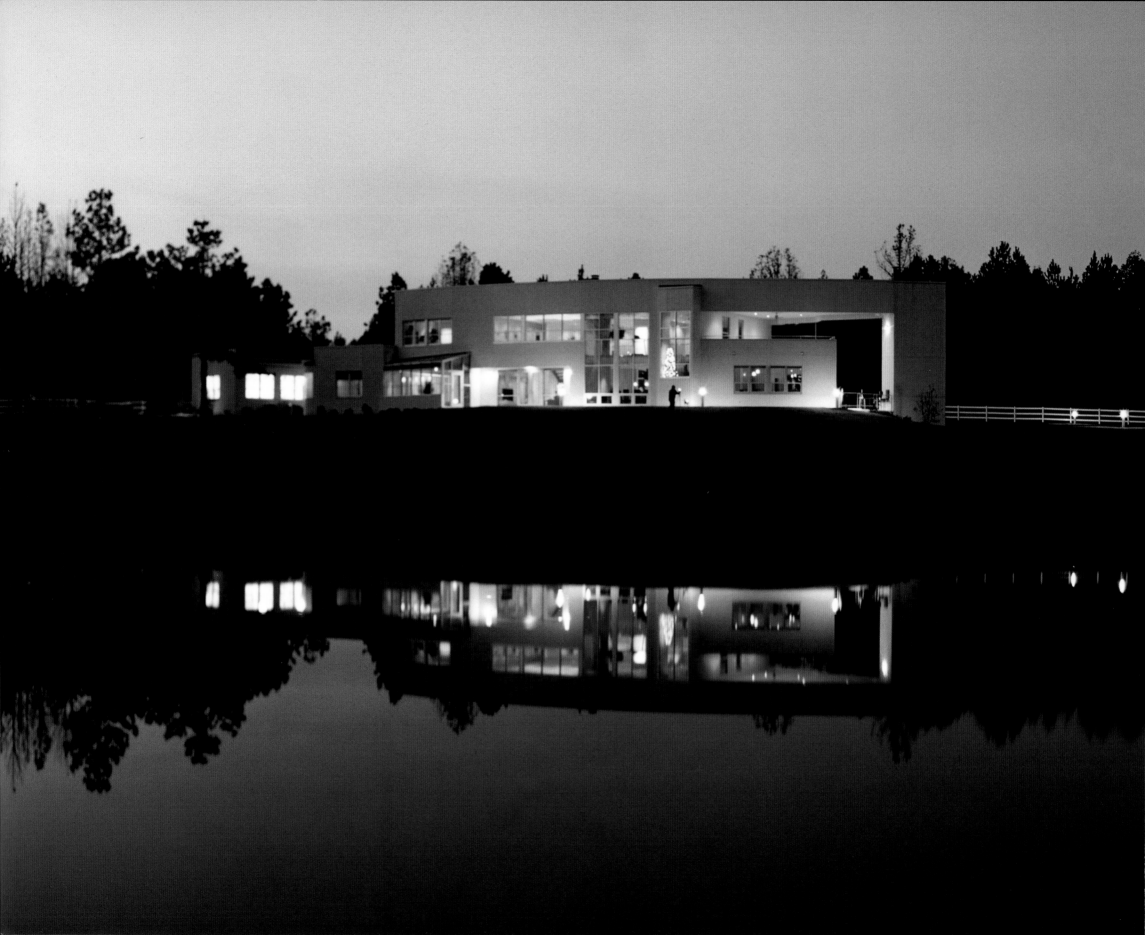

David Davenport
Davenport Architecture + Design, Inc.

Above: Interior kitchen view of the Thompson residence. The open space provides for exceptional entertaining.
Photograph by Jim Sink

Facing Page: Nightfall view of the Thompson residence, Raleigh, North Carolina.
Photograph by Jim Sink

Raised among the backdrop of Victorian homes in Cape May, New Jersey, David Davenport acquired a great appreciation for architecture at an early age. When his family relocated to Kitty Hawk, North Carolina in the 1970s, David worked as a carpenter prior to going to architecture school. "I felt like architecture was a good merger of my love of science and my desire to do something artistic," says David, who started Davenport Architecture + Design in 1997.

A custom residential design firm, Davenport Architecture + Design uses its creative vision and technical knowledge to provide architectural solutions that respond to the individual needs of each client. The firm is staffed with six employees, including two architects and a civil engineer, who happens to be David's wife, Shanda. She also has a degree in landscape architecture, which enables the firm to offer an integrated design approach from the conception of the site design through the building design process.

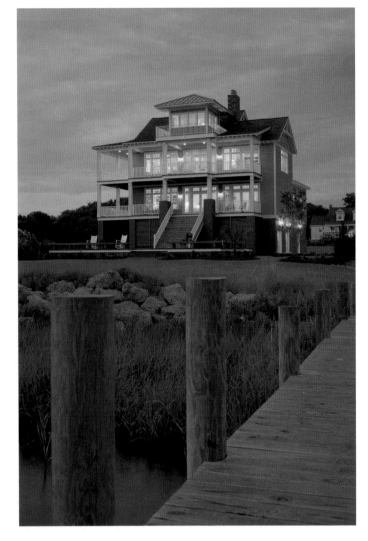

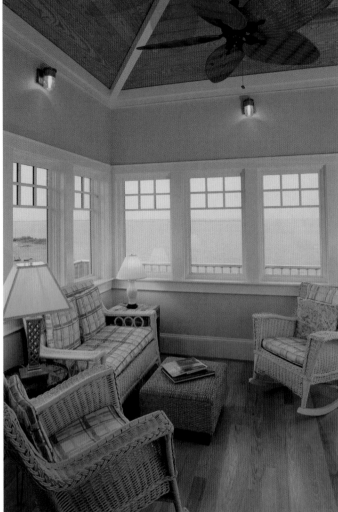

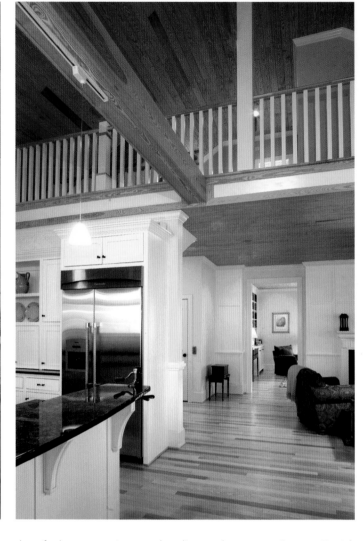

David designs a multitude of residential projects from small additions and remodels to luxurious homes in excess of 20,000 square feet. One of the firm's specialties is concrete homes, as David is a member of the Concrete Homes Council. Like European homes, concrete houses can have life spans of more than 200 years, but now offer clients durability and energy efficiency as well.

In the past three years he has designed six concrete homes ranging in price from $2.1 million to $2.7 million. A 17,000-square-foot hybrid home featuring concrete and wood—that David recently designed—is currently under construction in Cary, North Carolina. What David enjoys most about architecture is problem solving. Part of his methodology is turning the idiosyncratic desires of his clients into opportunities. One example is the Thompson residence in Raleigh, North Carolina. In this project the home responded to the site's land contours. Carved openings allow light to filter into the home, while the radius of the house responds to the shape of the manmade lake that fronts the home.

"Good architecture is about taking the time to make good decisions that are fresh and original. It's about creating a space that feels appropriate and enlivens the senses," says David. "That synthesis only comes from a lot of training and experience, and an understanding of the psychology of how space makes you feel."

Above Left: A water view of the Franklin residence, Harkers Island, North Carolina.
Photograph by Jim Sink

Above Middle: A spectacular view of the Shakleford banks from the watchtower in the Franklin residence.
Photograph by Jim Sink

Above Right: Interior shot of the detailed woodwork within the Franklin residence.
Photograph by Jim Sink

Facing Page Top: Entrance gate of the Lask residence, Treyburn, North Carolina.
Photograph by Jim Sink

Facing Page Bottom Left: Family room in Lask residence.
Photograph by Jim Sink

Facing Page Bottom Right: Second-floor view of the dining space in Lask residence.
Photograph by Jim Sink

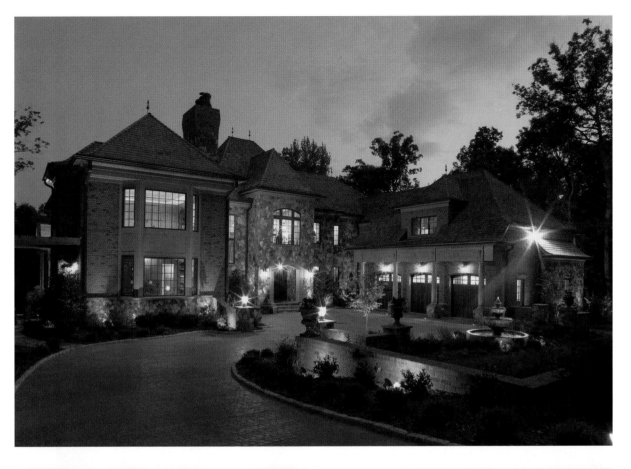

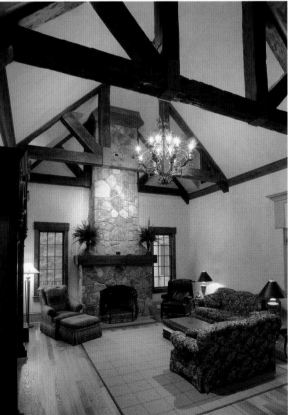

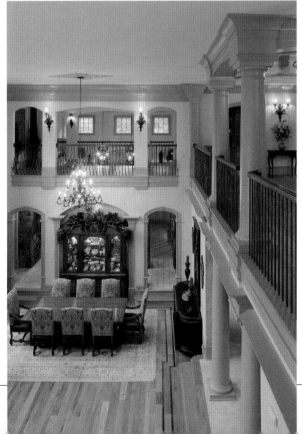

WHAT IS YOUR HIGHEST COMPLIMENT PROFESSIONALLY SO FAR?

Professionally, I don't look for compliments from my peers so much as I do from clients. Satisfied repeat customers who really enjoy their homes and who love living in the houses you've designed, that's the highest compliment that you can get.

WHO INFLUENCES YOU THE MOST?

There have been a handful of really spectacular architects in history and a lot of people hate them or like them. People like Frank Lloyd Wright; although I'm not a huge Wright fan, he's had a tremendous influence on architecture to this day. Some of my favorite architects are Alvar Alto, John Lautner and his work in southern California, and Tom Mayne of Morphosis. Another fabulous residential architect I like, but who is not as well known, is F.A. Voysey.

WHERE ARE YOU LICENSED?

North Carolina, South Carolina and Virginia. I'm kind of like the ACC of architects. We mainly work in the Southeast, mostly the Triangle to the coast. Although, I've also consulted on houses in Colorado and Florida.

WHAT'S THE BEST THING A CLIENT CAN SAY AT THE END OF A PROJECT?

We love our house, thank you.

Davenport Architecture + Design, Inc.

David Davenport
119 Salem Towne Court
Apex, NC 27502
919.362.3751

101 Sir Walter Raleigh Street, Suite 205
Manteo, NC 27954
252.473.5151

www.davenportarchitecture.com

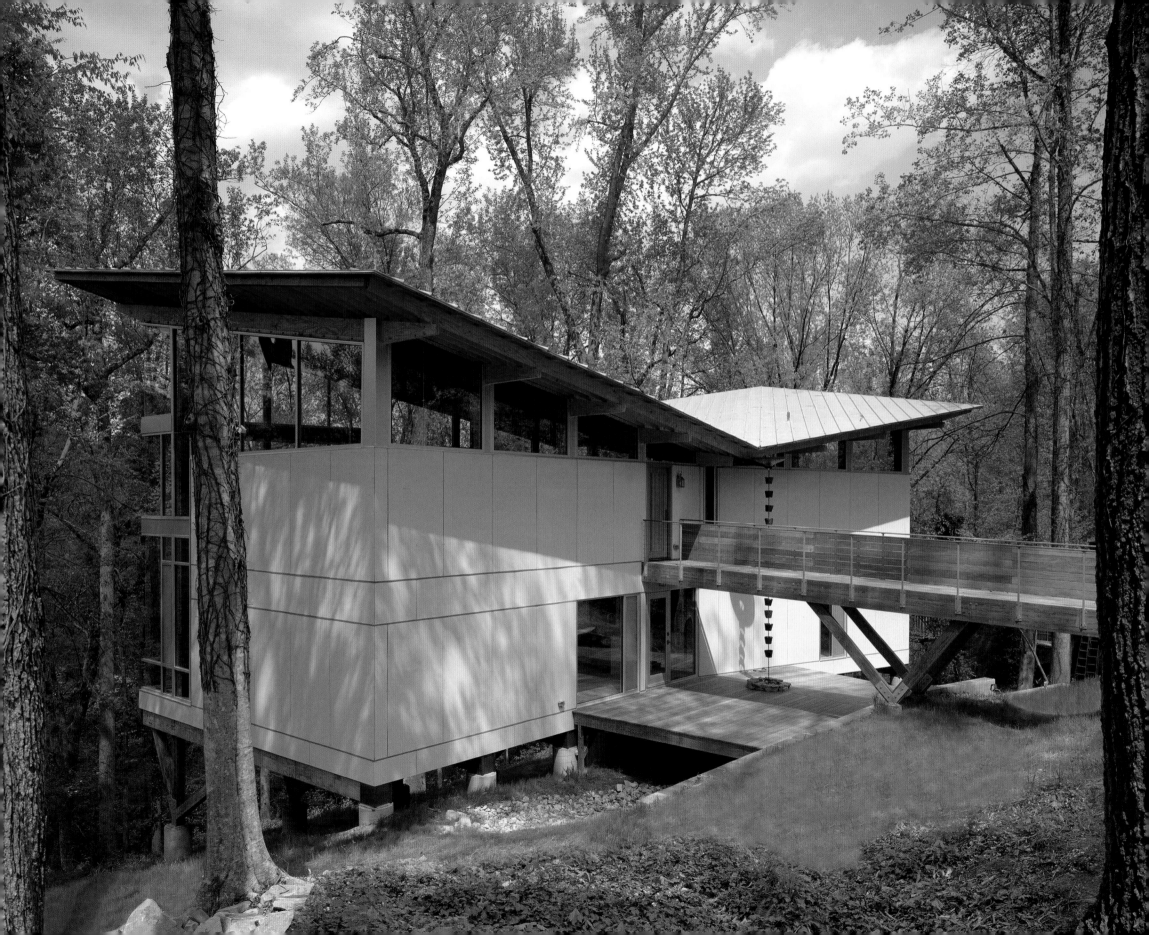

Frank Harmon

Frank Harmon Architect

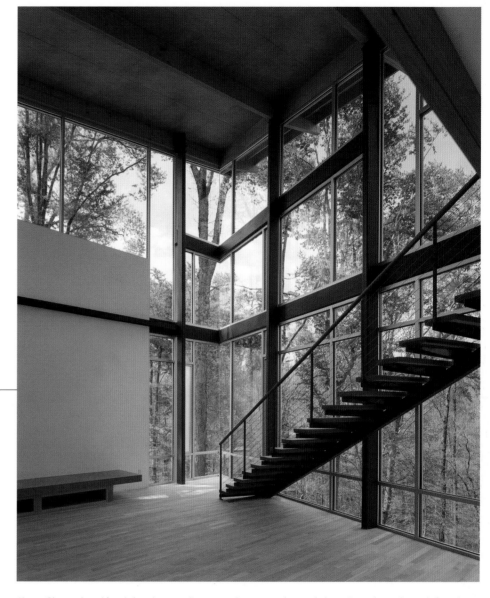

Above: Glass and steel façade lets the owner live among the trees on the wooded site. A metal stair descends from the entrance level to the main living room.
Photograph by Timothy Hursley

Facing Page: The Strickland-Ferris residence. The owner wanted "something dramatic" that would tread lightly on the hillside. The "butterfly" roof opens views to a creek and funnels rain into a collection system.
Photograph by Timothy Hursley

Creating a "sense of place" specific to one building, one landscape, one region, and one client is essential to Frank Harmon's design process. "Every building and every site is as individual as its client," says Frank, who is also an associate professor at North Carolina State University's College of Design, "which is why we are not compelled by any personal 'style' or 'signature.'" An architect for more than 35 years, Frank tells his clients that the single most important element in their home's design is its site because it will be there long after they will. "We involve ourselves on the building site from day one, and consider the site to be a partner in the design process. We believe that buildings should exist in harmony with their natural environments—that they should grow out of, rather than dominate, the site they inhabit."

Founded in 1985, Frank Harmon Architect is an award-winning design firm based in Raleigh, North Carolina. Since its inception the intentionally small firm has completed more than 200 architectural

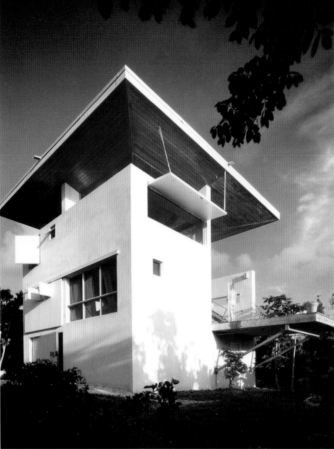
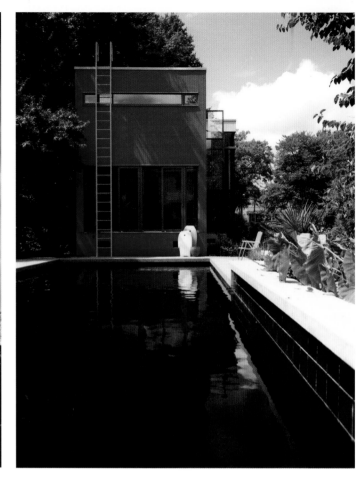

projects, has received more North Carolina design awards than any other firm in the state, and has been featured in *Architectural Design, Architectural Record* and *Time* magazine, among other publications.

Frank discovered, while he was an associate of Richard Meier Architect in New York City, that a small group of people who know each other well can accomplish just as much or more than a larger organization. Having a smaller project team also allows for each member to personally communicate with clients, which is imperative for good design. "We need to know what our clients' passions and inspirations are," says Frank, adding that he asks clients to fill out a questionnaire and often visits their current homes to study the patterns of their lives. "My goal in making houses and places for people is for them to live right now the best way they possibly can." Responding to climate, terrain, vegetation, and wildlife is significant in designing a sustainable environment where people feel genuinely connected. All of the firm's home designs involve a conscious orientation of the building to capture the sun in the winter and block it in the summer. "Whenever we can, we design the building while we're on the site," explains Frank. "That's a way to actually experience what we're thinking about."

The majority of Frank Harmon Architect's projects are Green structures, rooted in the honesty of Modernism, that incorporate sustainable design principles, including the use of non-toxic materials. Part of the firm's design ethic is that architecture, in addition to making a physical contribution to the community, should also make a didactic one. For that reason, the firm uses local materials, such as Atlantic white cedar grown on the North Carolina coast, whenever possible. "If possible, we're going to use local stone and brick as well," says Frank. "We like to explore the nature of familiar materials because they are comfortable, tactile and friendly." When a project is completed, Frank wants the client to be happy, of course. But "we also want to know that we have created something that is well-crafted, innovative and aesthetically inspiring," he adds.

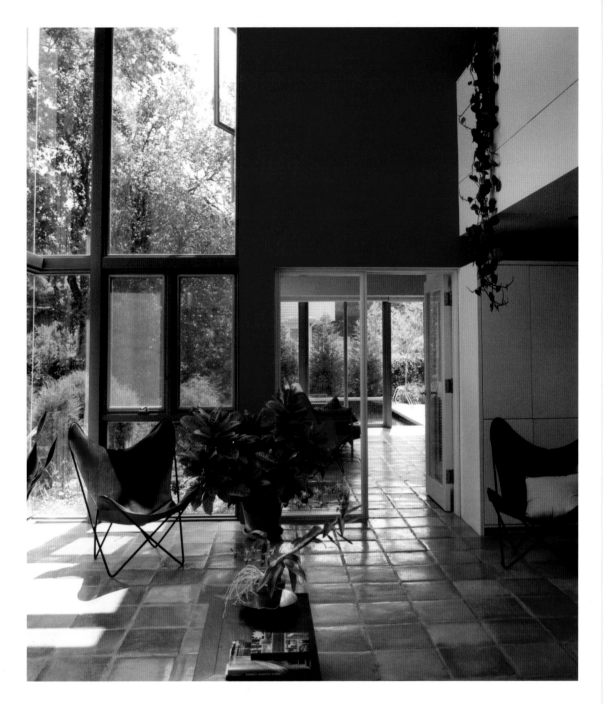

Above: Earth, sky and water form the backdrop for the Harmon residence, which is an oasis within a busy university neighborhood.
Photograph by Tom Aldi

Facing Page Left: Simple materials and a modern vocabulary combine to create a studio for two artists that evokes the grace of traditional farm buildings in the area.
Photograph by Brian Hoffman

Facing Page Middle: The Taylor vacation house in the Bahamas is a modern Green house that is both striking in appearance and at ease in its environment.
Photograph by James West

Facing Page Right: The architect's own home is a modern, compact house and garden that effectively blurs the line between indoors and out.
Photograph by Tom Aldi

DID YOU ALWAYS KNOW THAT YOU WANTED TO BE AN ARCHITECT?

I discovered it when I was in the eighth grade. I was sitting in Mrs. Dickinson's English class in Greensboro, North Carolina, looking out the window, which I usually did. I was not a great student. I began to notice this older house across the street with porches. I thought it was amazing. I realized that somebody had to think about this to make it. One thing led to another, and I decided that architecture would be my path.

WHAT DO YOU TEACH AT NORTH CAROLINA STATE UNIVERSITY?

I'm currently teaching design studio for graduate students. It's a comprehensive class that goes through all the analysis, methods, and techniques of design. I've also taught structures, which I enjoy very much, and the history of architecture.

WHO ARE SOME OF YOUR FAVORITE ARCHITECTS AND WHY?

I like Glenn Murcutt in Australia, Rick Joy in Tucson, Arizona, and Brian MacKay-Lyons in Nova Scotia. Their work is very connected to its place. It's innovative and is made with a wonderful sense of design. By that I mean the organization of space and the integration of materials and structure are such a way that the building seems as naturally suited to its place as a pine tree.

WHAT DO YOU ENJOY ABOUT BEING AN ARCHITECT?

It allows me to be a free and creative person. Secondly, it allows me to do that in the service of others. Thirdly, it's terribly thrilling to see the results of a structure, something no one has ever seen before actually being built. Lastly it provides decent income that allows me to support my children and family in addition to doing other wonderful and creative things.

Frank Harmon Architect

Frank Harmon

706 Mountford Street
Raleigh, NC 27603

919.829.9464

www.frankharmon.com

Bernard Malloy
Judy Malloy

Brightleaf Development Company, LLC

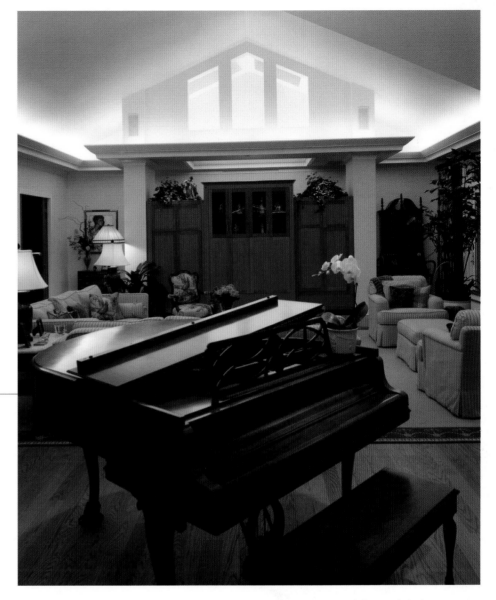

Above: A skylight shaft strategically placed behind built-in cabinets illuminates a private hallway to the bedroom area. It also becomes a dramatic focal point to the room.
Photograph by Seth Tice-Lewis

Facing Page: This truly custom design brings nature inside and creates a living room outdoors.
Photograph by Seth Tice-Lewis

Cary's Brightleaf Development Co. is a generation-spanning family business. As husband and wife, Bern and Judy Malloy have been building custom homes for more than 30 years. Their son, Cory, cut his teeth in construction as a boy, working summers for the family business. He joined Brightleaf after college and has spent the last eight years in the field. Cory plans to continue with Brightleaf as a partner when he earns his Graduate Master Builder designation from the National Association of Home Builders.

In addition to its familial ties, the company thrives on its long-term relationships with employees and tradespeople. Brightleaf's journeyman carpenter/supervisor Mike Cook adds age-old experience to the mix, incorporating proven building methods to balance modern materials.

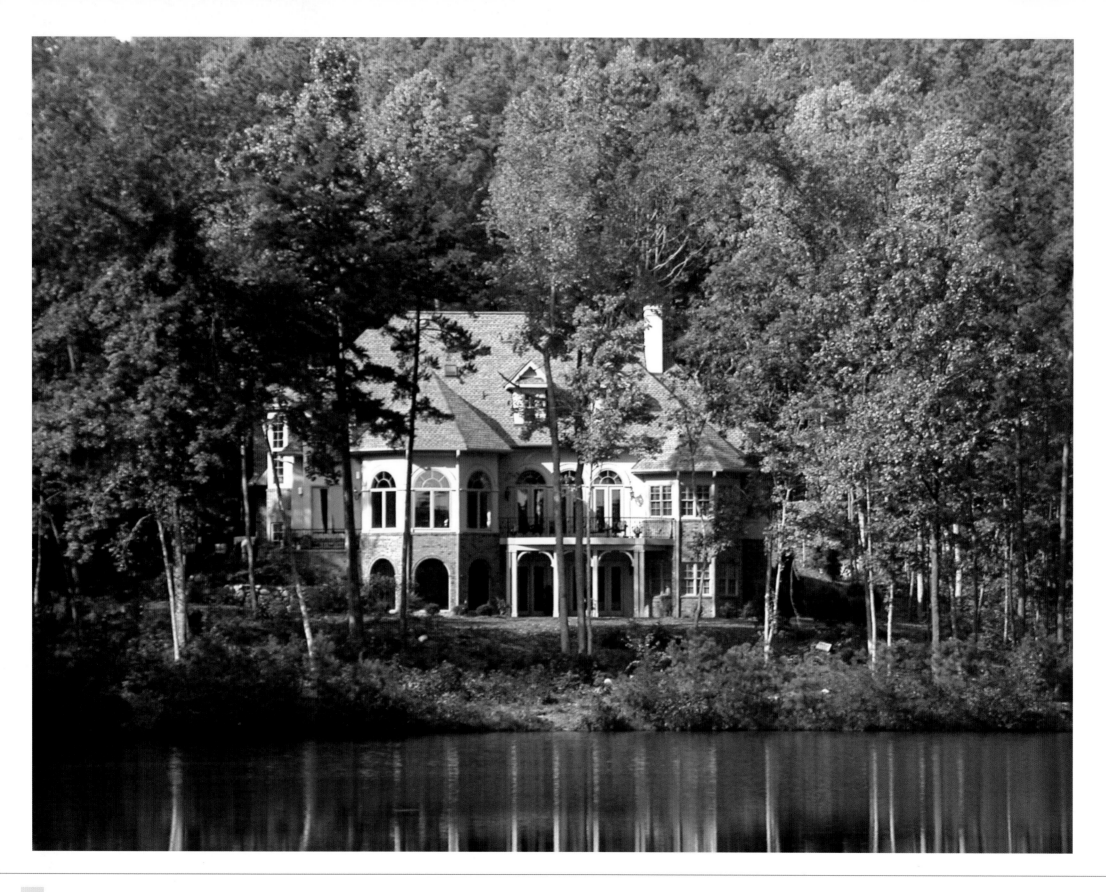

It was decided early on that the principals would be personally involved with each project, therefore only four to six homes are built each year. They believe that building a custom home is a cooperative endeavor and can only be successful through clear communication and teamwork. Brightleaf prides itself on its ability to sort out the details as it smoothly guides its clients through every step of the building process

The company doesn't focus on one style of architecture. For instance, one project might feature an Old World French Country design while another has more of a soft contemporary feel. The home site drives many design features, and Bern enjoys the challenge of adapting the design to each site.

Brightleaf homes range from 4,000 to 9,800 square feet and feature intricate detail and complex designs. A recent project involved building a truly proportioned lighthouse attached to a sprawling Prairie-style lake house. The lighthouse features elevator access and an exterior balcony surround.

Judy says the construction industry has progressed light years from where it was 30 years ago. "It's more complicated these days," she says. "That's why you need a builder who is up to date on the latest technologies and who is not afraid to incorporate experts in those areas as members of the team."

Bern explains, "Construction today concentrates on how a house performs: using efficient heating and cooling technologies along with insulation and building envelope systems. We also employ the use of engineered lumber as much as possible to give greater strength and stability to the structure."

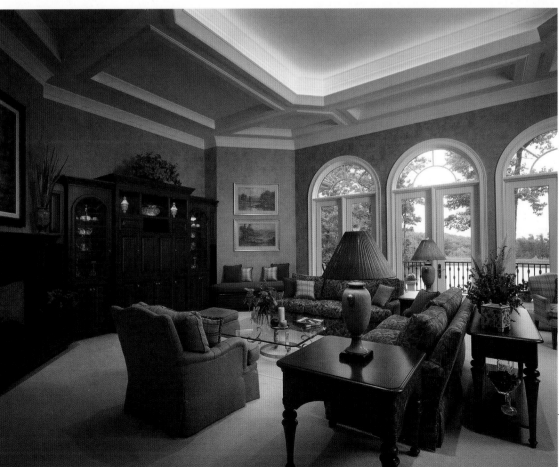

Top Right: A cathedral dome, arches and attention to detail create a haven of serenity in the master bath.
Photograph by Jerry Blow

Bottom Right: The grandeur of the architectural design and superb trim detail create the backdrop for this gracious and cozy room.
Photograph by Jerry Blow

Facing Page: The view from across the lake enhances this grand home with the natural beauty of its setting.
Photograph by Debby Temmermand

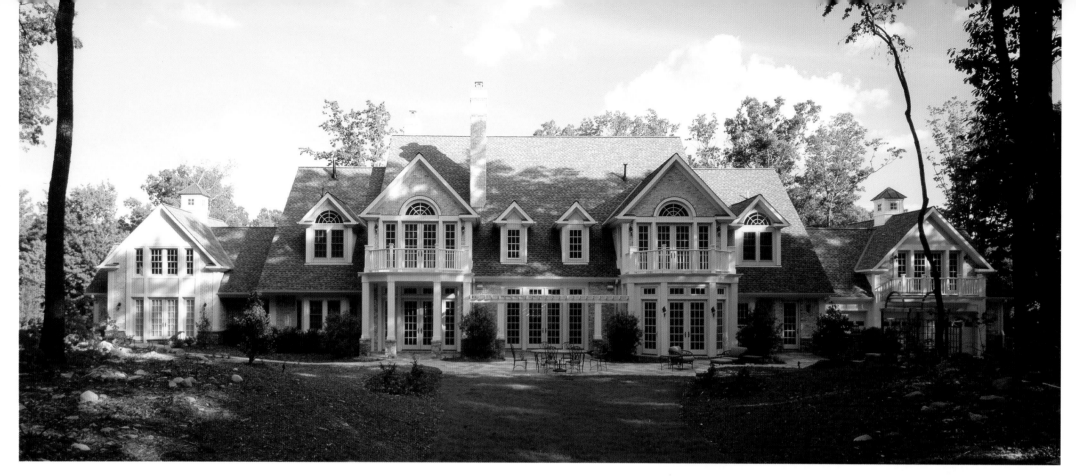

When asked what their favorite project is, they simply can't say because they've enjoyed all of them. Being one of the builders for Chapel Hill's prestigious Governors Club is certainly exciting for them. The couple estimates that they have built 30 to 40 homes for the 1,600-acre private golf community. Governors Club honored Brightleaf with awards for "Builder of the Year," "Customer Satisfaction" and "Outstanding Building Quality." The company also won the community's Team Project Award two years in a row.

Bern finds that one of his favorite aspects about the business is client interaction. He enjoys involving the clients in the building process of their new home. With the challenge of each new custom home, every day is different for the Malloys. Says Judy, "We find the uniqueness of each home a rejuvenating experience."

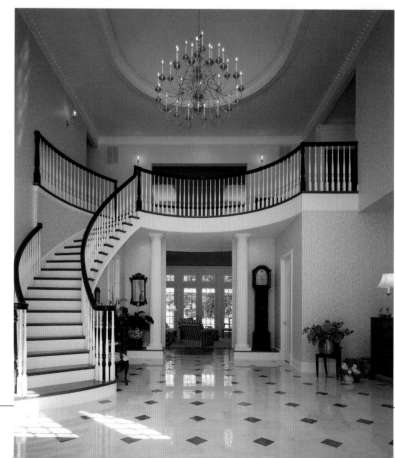

Above: This elegant French Country-inspired home shows off its graceful appeal.
Photograph by Philip Jensen-Carter

Right: A touch of Southern charm welcomes you to this grand foyer.
Photograph by Philip Jensen-Carter

Facing Page Top: The cedar shakes and stone give a rustic feel to this classic farm-style home, supported by a separate guest house to the right.
Photograph by Philip Jensen-Carter

Facing Page Bottom: The country kitchen adjoins an English conservatory bringing to view the gardens beyond.
Photograph by Philip Jensen-Carter

Facing Page Far Right: A family that works together ... Judy, Bernard and Cory Malloy.
Photograph by Monica Mauch

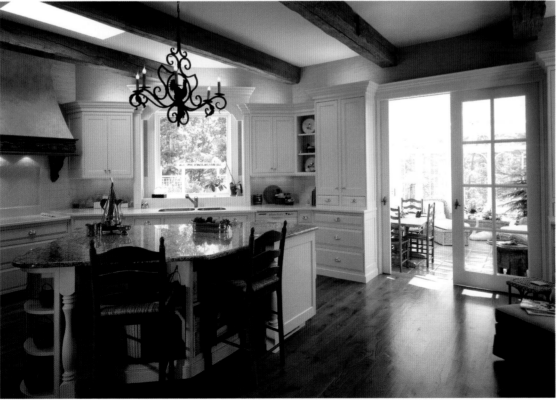

more about Bernard and Judy ...

WHO HAS HAD THE BIGGEST INFLUENCE ON YOUR CAREER?

Our clients. We have met and worked with many talented people who have helped us shape our business.

WHAT IS THE SINGLE THING YOU WOULD DO TO BRING A DULL HOUSE TO LIFE?

Open it up, bring in more light and add soft colors.

WHAT SEPARATES YOU FROM YOUR COMPETITION?

Customer satisfaction. We have clients who have called us many years after moving in to say hello and to tell us that they still love their homes.

WHAT IS THE HIGHEST COMPLIMENT YOU HAVE RECEIVED PROFESSIONALLY?

Brightleaf is very good at empowering people to be and do their best.

Brightleaf Development Company, LLC

Bernard Malloy

Judy Malloy

110 Lochwood West Drive

Cary, NC 27511

919.816.0099

Fax: 919.858.9785

www.BrightleafCo.com

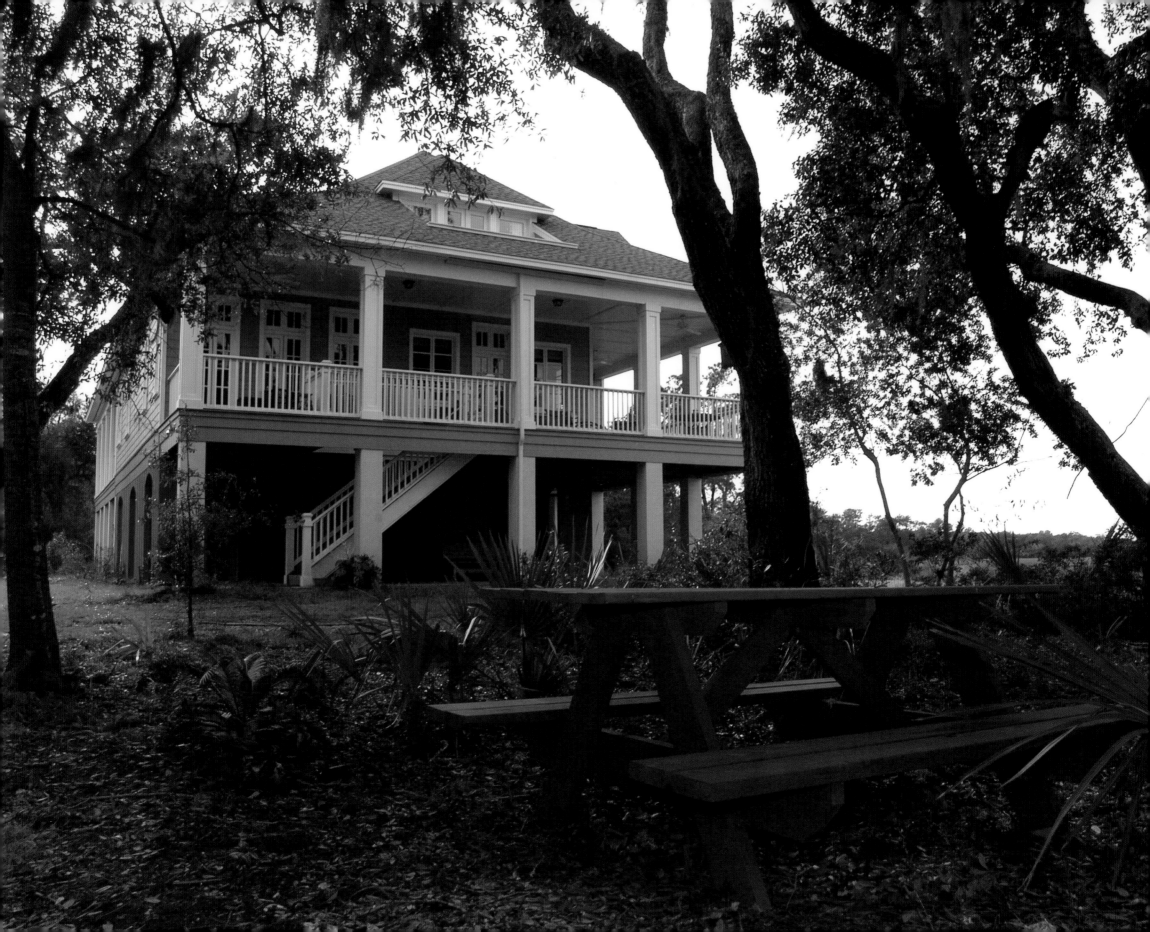

Allen Marshall
Dale Marshall

Architrave, Inc.

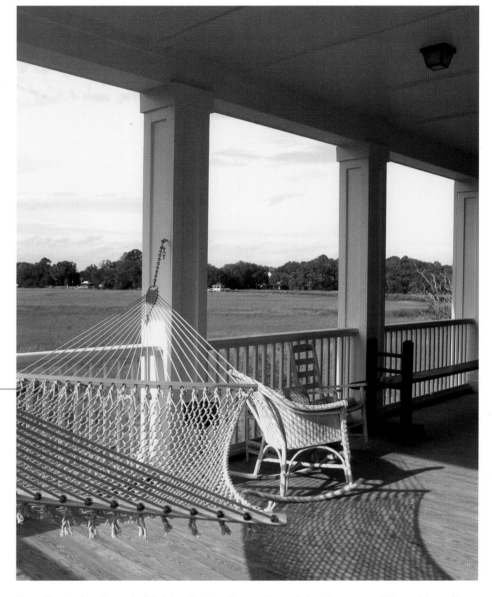

Above: The view from the porch of the home (shown on the opposite page) shows the expanse of the marsh beyond in this home designed for relaxed living.
Photograph by Sam Holland

Facing Page: A serene view from a marsh near Edisto Island captures the relaxed spirit of this home, owned by an interior designer and her husband.
Photograph by Sam Holland

Allen Marshall has designed houses for four generations of one family. His goal is to continue working until he designs a home for the family's fifth generation, and that young fellow is currently nine years old.

Although many of Allen's friends have retired, he has no plans to put his pencil down. "I just love what I do, and I think it comes out in what we produce," says Allen, who is a principal of Architrave, Inc. in Columbia, South Carolina with his nephew, Dale Marshall.

An established design-oriented practice, Architrave is known for integrating traditional and historical Carolina styles with modern sensibilities and smart design. "Basically I like to keep design simple. I don't like for architecture to look like a patchwork quilt," explains Allen. "I like for it to flow. It should be simplistic but thorough."

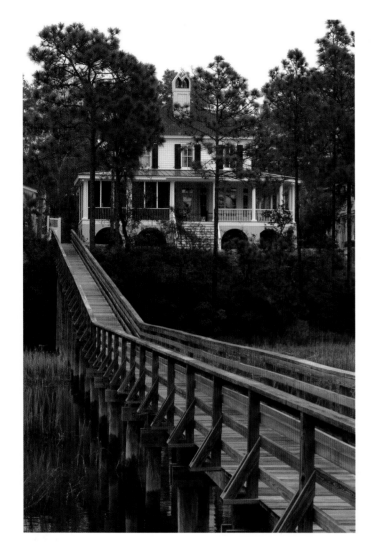

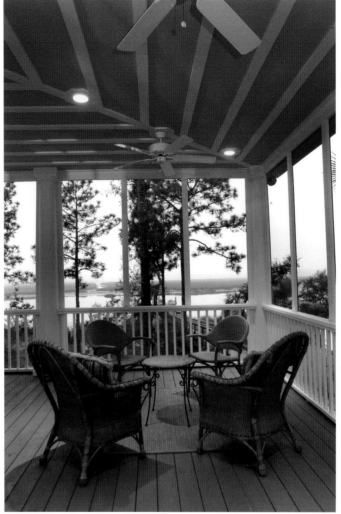

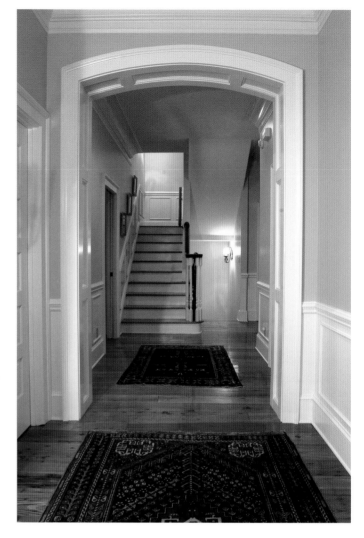

All of Architrave's projects are different because the firm designs in a contextual sense. Allen and Dale look at what is appropriate for the site and for the client. "If a design doesn't accommodate a client's lifestyle and furniture, then it doesn't really matter how great it looks," says Dale, who is also a licensed attorney. "For us, design is not about trends. It's more about creating something that's unified and that will be a home you'll be comfortable living in for 20 years."

Allen and Dale work hard to forge relationships with their clients so that they are able to provide homes that exceed expectations and dreams. 90 percent of Architrave's work comes from referrals. "We've built our reputation around being personal with our clients. We take their ideas and mold them into the whole item so it becomes them and not us," says Allen. "They always have a party for us when we finish a house."

Experience has also been essential to Architrave's success. Allen has easily designed more than 1,000 homes since he began his career over 40 years ago. "You can't drive for a half a mile in Lexington and Richland counties where you don't see a commercial building or residential building or entrance gate or club house that I haven't been involved with," he says. Dale has also created a substantial amount of work, as he has designed several hundred homes.

Above Left: Looking up from the dock toward this family home near Beaufort shows off the traditional southern details that won this home a Robert Mills award from AIA, South Carolina for vernacular architecture.
Photograph by Sam Holland

Above Middle: The porch of this home is designed for gracious and relaxed entertaining overlooking the river and marsh beyond.
Photograph by Sam Holland

Above Right: This foyer highlights the classic and traditional details that made this home an award winner.
Photograph by Sam Holland

Facing Page Left: Looking back from the tidal marsh toward the expansive outdoor living areas of this oceanfront home on Seabrook Island, it is easy to see how this home feels anchored to its site.
Photograph by Tripp Smith

Facing Page Right: The details on this screened porch show off the exquisite craftsmanship of its builder, Hidden Oaks Properties.
Photograph by Tripp Smith

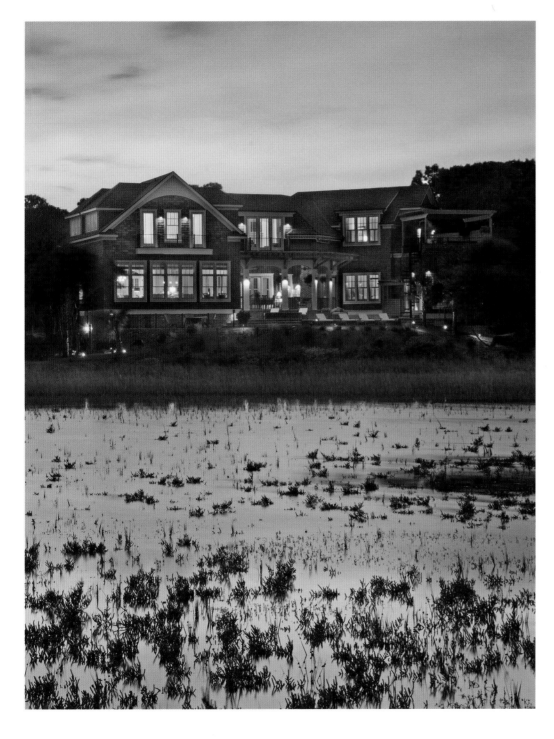
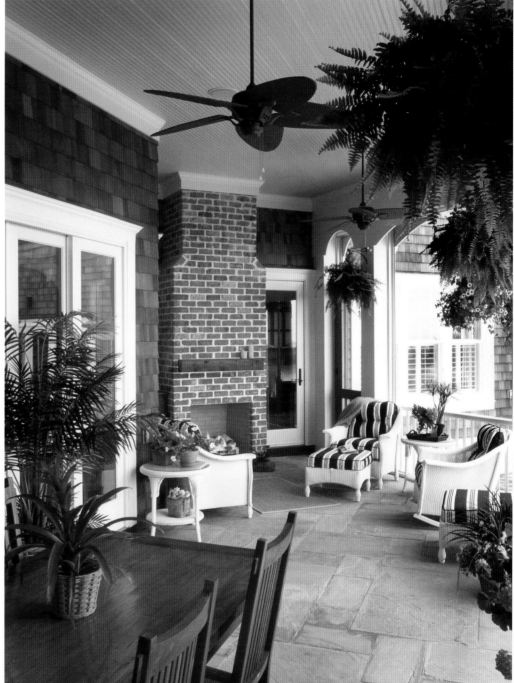

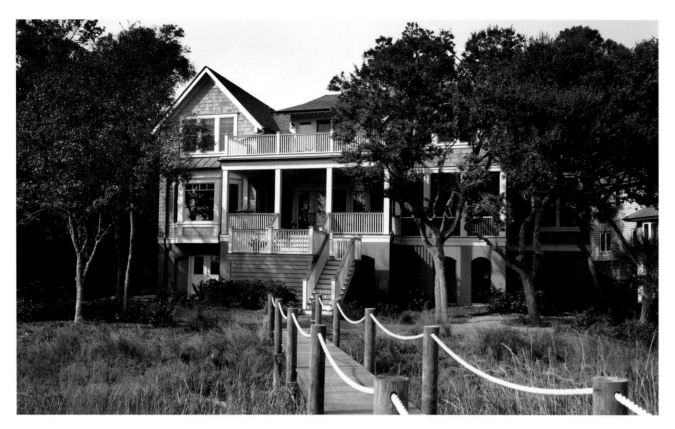

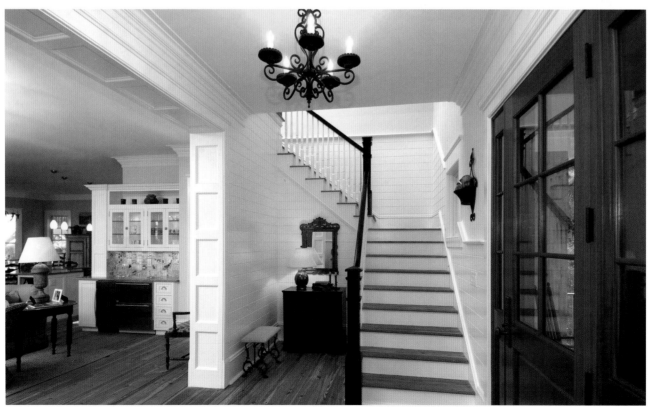

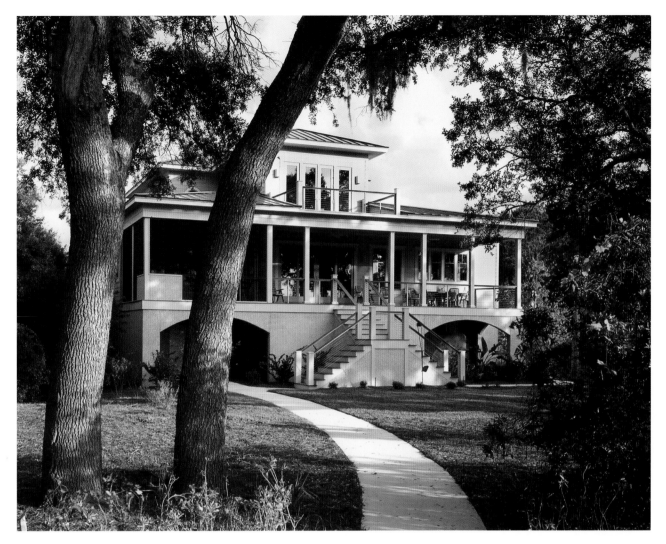

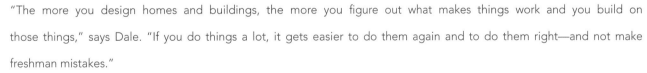

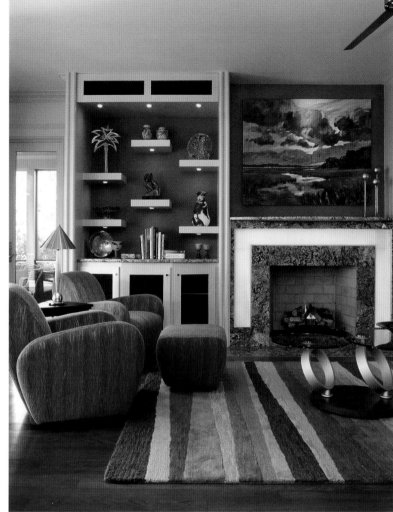

"The more you design homes and buildings, the more you figure out what makes things work and you build on those things," says Dale. "If you do things a lot, it gets easier to do them again and to do them right—and not make freshman mistakes."

Together the Marshalls design approximately 20 houses a year across South Carolina and have been featured in *South Carolina Homes & Gardens* magazine. With a satellite office in Charleston, they have designed more than 100 residential projects for Daniel, Kiawah, and Seabrook Islands. Though they design new homes for clients in Columbia, their work there is more focused on renovations and additions.

Dale recently worked on a project where he converted an 1890s' Richardsonian building into two high-end condos. In its inception, the building was a bank and later became a drugstore in the 1930s. "We designed condos in something that had never been housing before," explains Dale. "We were able to preserve the character of the original space and respect the original building." The project, known as 1520 Main Street, won an AIA Columbia Award in addition to a Historic Columbia Design Award.

Above Left: This modern take on a traditional Low Country raised cottage has a wealth of contemporary details in a traditional package.
Photograph by Tripp Smith

Above Right: The interior detail captures the sophisticated contemporary taste of its owners, along with the carpentry skills of its master builders.
Photograph by Tripp Smith

Facing Page Top: This creekfront home on Seabrook Island was designed to nestle within the island's live oak canopy.
Photograph by Sam Holland

Facing Page Bottom: The foyer highlights the cottage-like detail of this intriguing home. The old heart pine floors were hand-finished to retain their antique character.
Photograph by Sam Holland

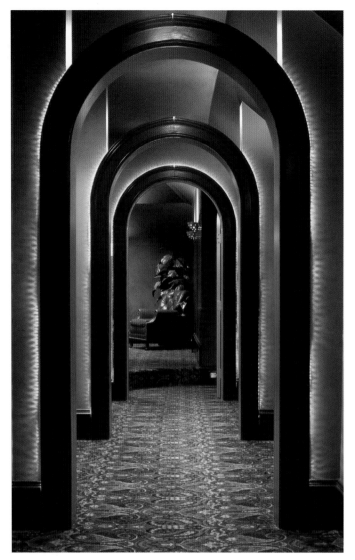

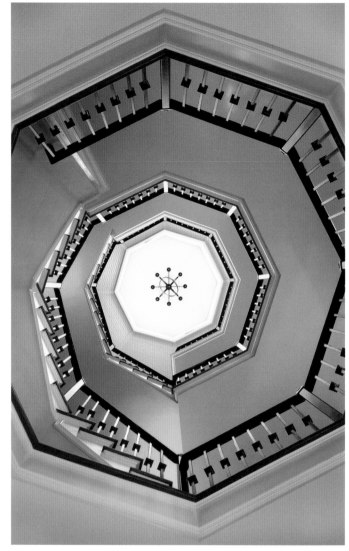

Architrave also won a Robert Mills award from AIA South Carolina for its renovation of a ranch house near Lake Katherine in Columbia. "From the outside it was a tasteful ranch house. We didn't try to invent it as something else, but we were able to double its size through careful manipulation," says Dale. "On those types of projects we try to make the house look like as if it has not been added on to. We figure out what the best style elements and features of the house are and highlight those while taking away the things that were extraneous and didn't work." The firm received another Robert Mills award for vernacular

architecture for a new home it designed outside Beaufort, South Carolina.

Whether they are designing a new house or renovating a historic structure, Allen and Dale work hard to deliver solutions that work. "I view architecture as an art and also as a client service industry. We want to create homes that are beautiful, yet functional. That's always been our philosophy," says Dale. "We're able to design homes that work for our clients by listening carefully to what they want and need. In the end if the client isn't happy with their

home, it's not a successful project no matter how many awards it wins."

Above Left: The entry court of this large home on Wadmalaw Island provides a serene space for the owners to display their gardening skills.
Photograph by Tripp Smith

Above Middle: The entry to this home theater is a whimsical recreation of a traditional Art Deco movie palace lobby.
Photograph by Tripp Smith

Above Right: Looking up three levels to the cupola, the central hall floods the center of the home with light while providing access to an exterior ship's watch with views out the adjacent waterway.
Photograph by Tripp Smith

Facing Page Top: This contemporary home in Columbia's Gregg Park community captures the sophisticated elegance of its owners.
Photograph by Sam Holland

Facing Page Bottom: The interior provides a gallery-like setting for their collection of contemporary art along with an open plan that allows them to entertain extensively.
Photograph by Sam Holland

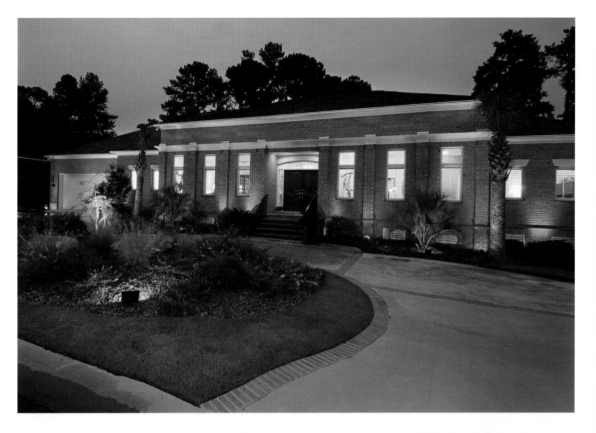

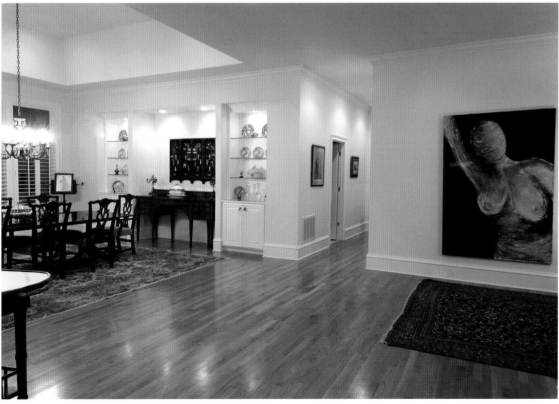

more about Allen and Dale ...

WHAT IS THE AVERAGE SIZE OF ONE OF YOUR DESIGNS?

A fairly typical house for us is 4,000 square feet. We don't believe in making things bigger than they have to be. We'd much rather build something smaller with better quality materials.

WHAT KINDS OF THINGS DO YOU LIKE TO DISCOVER ABOUT A CLIENT BEFORE DESIGNING THEIR HOME?

We like to get personal. We find out where a client stores everything and what items they have to store. We like to find out what kinds of clothes they wear and what they cook with. We ask about all sorts of details so we can design a home that works for the client.

WHAT DO YOU LIKE ABOUT DOING BUSINESS IN COLUMBIA?

It's a great place to live. Many of the families who live in Columbia have been here for several generations. It's still very much a small town. Geographically it's close to Charleston, which makes it easy for us to work on projects on the coast. It's also close to the mountains. We truly have the best of both worlds.

WHAT'S THE BEST PART ABOUT BEING AN ARCHITECT?

Watching projects come to fruition and having clients tell us that they still love their home after living in it for a year. We also enjoy doing multiple projects for clients.

Architrave, Inc.

Allen Marshall
Dale Marshall
730 Blanding Street
Columbia, SC 29201
803.252.6636
Fax: 803.779.1739
Charleston: 843.768.2004
www.architraveonline.com

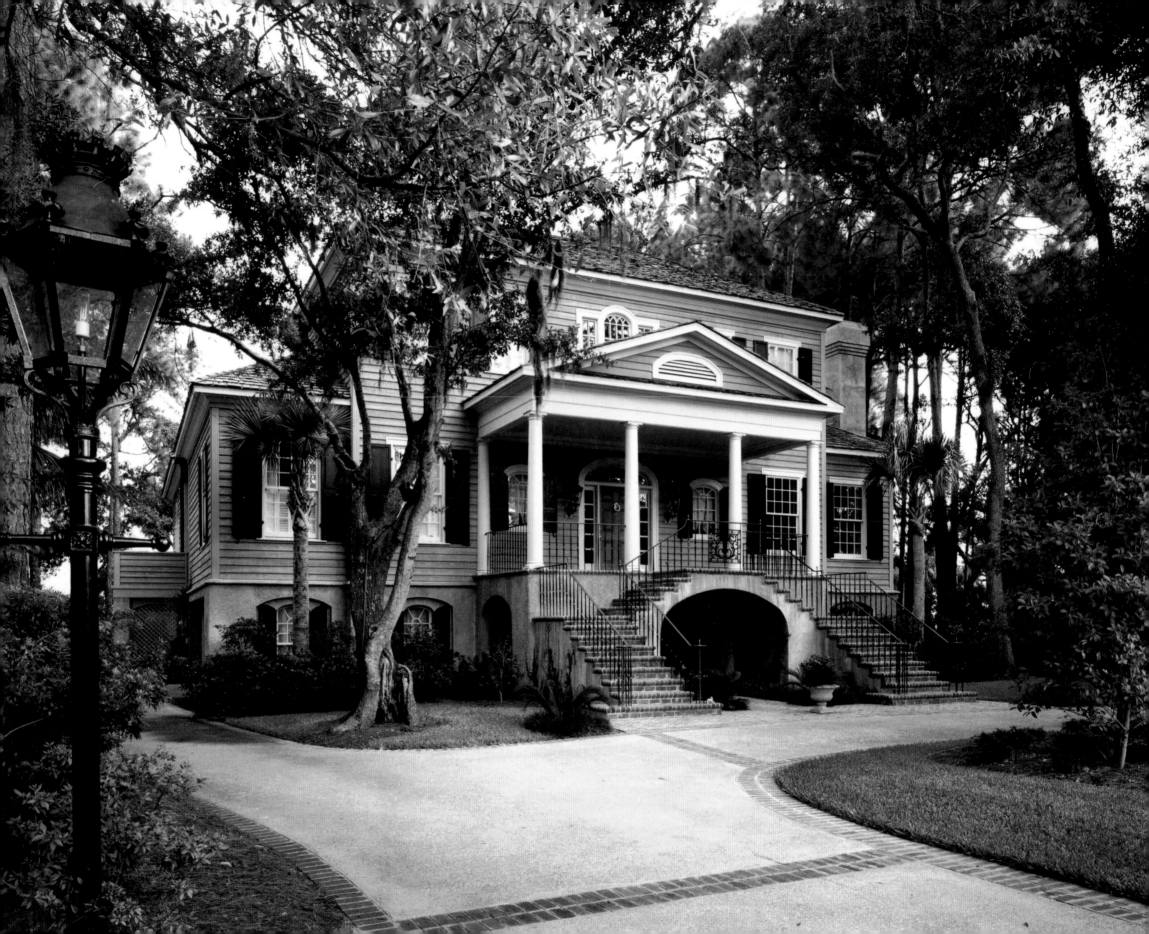

Jim Meyer
Sam Greeson
Mark Paullin

Meyer • Greeson • Paullin Architecture/Interior Design PA

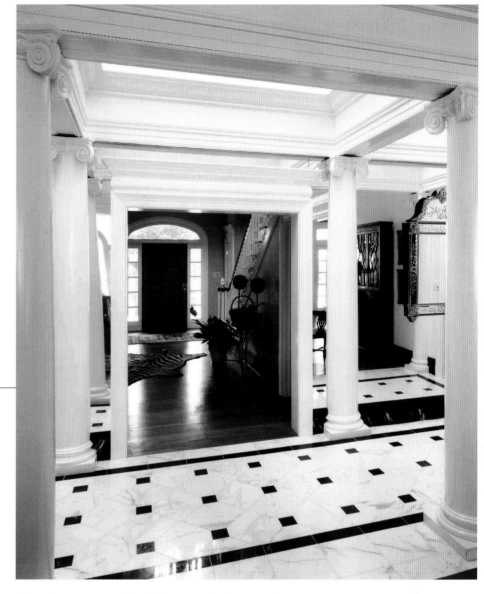

Above: The interior marries classical detailing and skylights in a bright central gallery.
Photograph by JoAnn Sieburg-Baker

Facing Page: The design of this home on Hilton Head Island draws on the architecture of historic Low Country plantations.
Photograph by JoAnn Sieburg-Baker

In fourth grade Jim Meyer and Sam Greeson knew they wanted to become architects. It was that year that Jim's parents hired an architect to design the family's home, and Greeson became fascinated with the construction of a neighbor's house. Classmates at the North Carolina State University School of Design, Jim and Sam became friends. They graduated in 1971 and opened an architectural office in 1979, which became Meyer•Greeson•Paullin, Architecture/Interior Design PA when Mark Paullin was made a partner in 1997.

Ever since the first client walked through the door, effective communication has been the most important part of design to this full-service architectural and interior design firm. Meyer•Greeson•Paullin takes pride in hiring architects who communicate effectively with everyone involved in the creation of a custom home. Paullin says the firm's specialty is simply doing things the right way by offering clients the highest level of detail and service. "Styles of architecture are like languages," says Mark. "We train

people at this office to understand how to speak the languages and understand the vocabulary." When clients first meet with an architect at Meyer•Greeson•Paullin, discussions center around how the house will be used as opposed to the size of the house. "The more you can interact with clients and talk about their habits, the faster you get on the same page in the design," says Mark.

The Charlotte-based firm, which employs 22 people, including seven registered architects and two ASID member interior designers, focuses on designing custom primary and secondary residences in addition to custom renovations. Meyer•Greeson•Paullin has mastered the art of renovations in such historic Charlotte neighborhoods as Dilworth, Eastover and Myers Park by making additions look as if they were part of the home's original design. While Meyer•Greeson•Paullin does not focus on a particular type of architecture, the highest quality of materials coupled with good craftsmanship

is incorporated into every design. The eclectic nature of the firm's portfolio illustrates how different each client and project is. The practice focuses primarily on the Southeast with a substantial amount of homes in the resort towns of the North Carolina mountains as well as Florida and South Carolina. However, Meyer•Greeson•Paullin has also designed projects for sites as far away as Hawaii.

The firm's designs have been featured in such national and international publications as *Better Homes and Gardens Decorating*, *British House & Garden*, *Southern Accents*, *Southern Living* and *Trend*.

Above: This home, in Davidson, was influenced by traditional French Country houses.
Photograph by JoAnn Sieburg-Baker

Facing Page Top: Casual living defines this lakeside retreat near Charlotte.
Photograph by Leslie Wright Dow

Facing Page Bottom: The interior reflects the owners' love of sailing and the simple life.
Photograph by Leslie Wright Dow

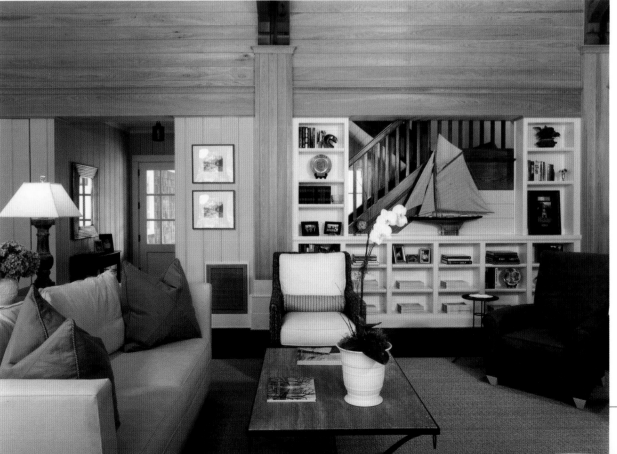

more about Jim, Sam and Mark ...

WHERE DO YOU TRAVEL FOR INSPIRATION?

Charleston, Italy, San Francisco—anywhere where there are classic neighborhoods with classic architecture. Jim has an affinity for Cincinnati's older neighborhoods. Sam admires England's architecture, and Mark is in love with Italy.

WHAT IS THE AVERAGE TIME IT TAKES TO DESIGN A HOME?

Four to six months.

WHAT IS THE BEST PART OF BEING AN ARCHITECT?

Jim likes it because every project is different, and there is no monotony to it at all.

WHAT SEPARATES YOU FROM THE COMPETITION?

Our level of detail and service.

Meyer•Greeson•Paullin Architecture/Interior Design PA

Jim Meyer

Sam Greeson

Mark Paullin

320 South Tryon Street, Suite 222

Charlotte, NC 28202

704.375.1001

Fax: 704.333.3620

www.mgparchitects.com

Tony F. Miller
Miller Architecture

Known for his national award-winning millwork designs, Tony Miller believes in spending money only where it shows. An architect for 15 years, Tony has designed more than 400 custom structures with all levels of specialty detail. With every project he strives to design a picturesque edifice with sufficient styling to remain timeless.

Each project is different as the architectural style is driven by the client. "I try not to have preferences to a particular architectural style so I can be open to different things," says Tony. "There are plenty of styles out there that haven't been explored." Tony finds inspiration through travel and is an avid photographer. He keeps at least 200,000 digital images in his office for clients to browse in addition to more than 2,000 architectural books. Tony also collects historical detailing books from the 1920s and 1930s.

Tony's aptitude toward visualizing details three dimensionally helps him create compositionally interesting and well-crafted designs for clients who are looking for something out of the ordinary. As for size, Miller Architecture's designs range from a four-square-foot cat porch addition to a 14,000-square-foot custom home. One current project involves a 10,000-square-foot Craftsman stone-and-timber farmhouse and coordinating indoor riding arena. The house has secret passages and a dry moat with a drawbridge leading to the children's play loft. It should be fun.

Above Left: Tony F, Miller, AIA (pictured on the Piazza) designed this home outside Charlotte with the latest technologies and a kinetic exuberance not common in Classical Revival.
Photograph by Tim Buchman, Charlotte

Above Right: Adirondack-style cottage, in a North Carolina mountain resort, features rustic materials including mountain laurel handrails and tree stump newel posts.
Photograph by Donna Bise, Charlotte

Facing Page: The counter balance in the secret passage of this whimsical gothic estate allows it to be pulled open with just a fingernail and disappear into perfect alignment.
Photograph by John Martinelli, Philadelphia

Miller Architecture

Tony F. Miller, AIA
715 North Church Street, Suite 140
Charlotte, NC 28202-2217
704.377.8500
www.millerarchitecture.com

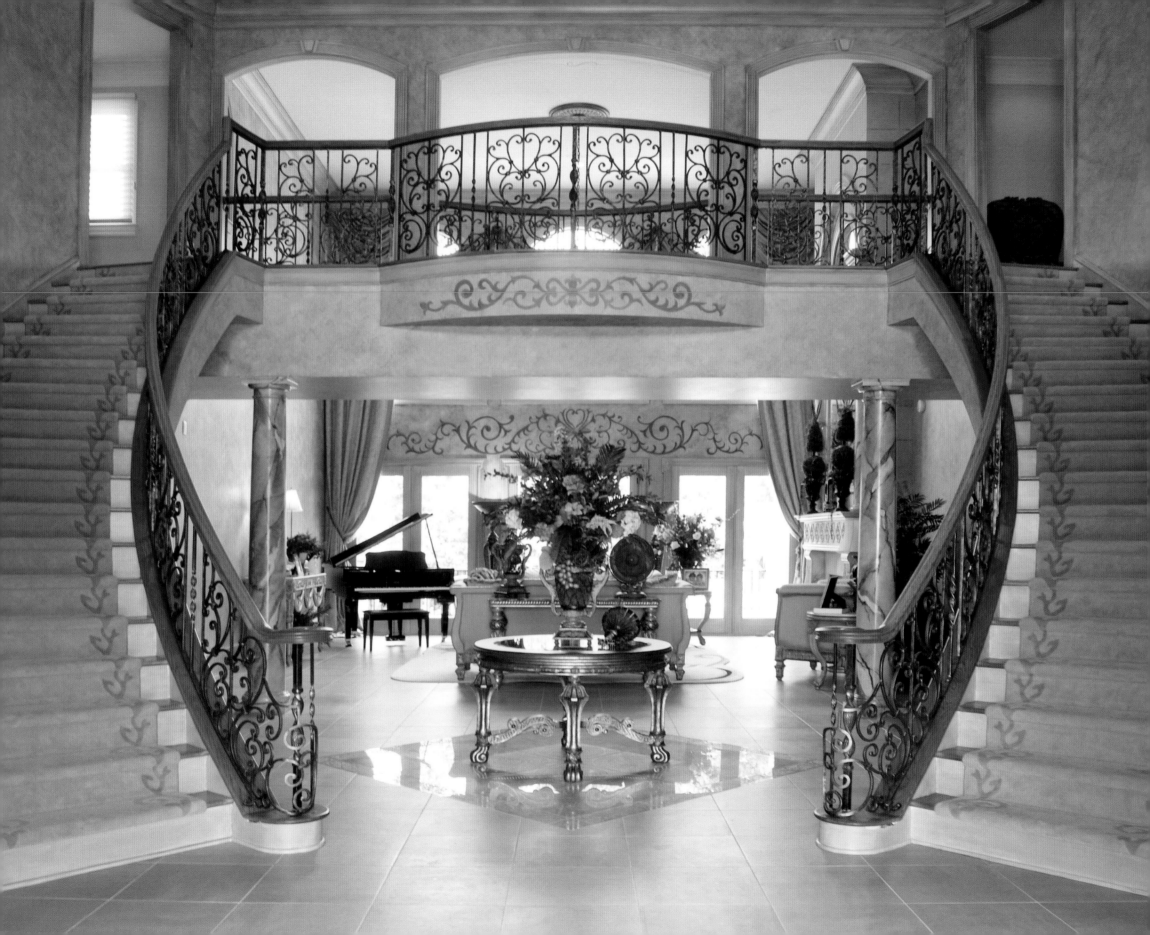

David O'Bryan

David O'Bryan

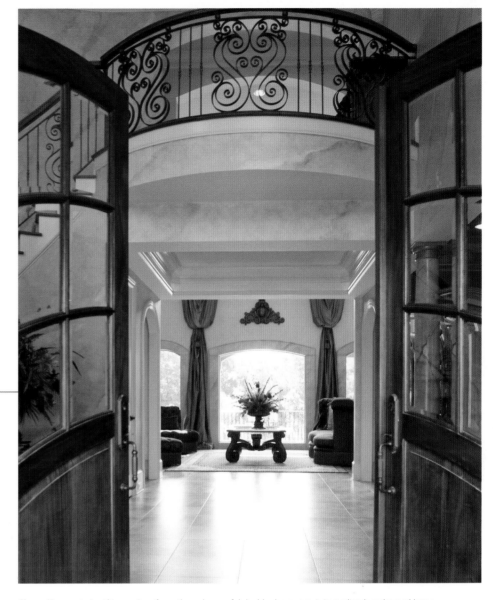

Above: Upon entering this spacious foyer through graceful double doors, one is immediately welcomed home.
Photograph by www.valentinedesign.com

Facing Page: Elegance greets you in this dual staircase, two-story foyer.
Photograph by www.valentinedesign.com

Designing homes for 19 years, David O'Bryan has kept his practice small on purpose. "It's just me. My biggest struggle has been staying small. Not only do I meet with my clients personally, I design their homes personally. I enjoying going out on the job site," explains David, who has been a licensed architect in New York since 1994 and a residential designer in North Carolina. He works from his home in Kannapolis, which is north of Charlotte, North Carolina. "I'm involved with a client's house through every phase of the design. Clients don't meet with me once and get handed to someone else."

Being a team player and giving his clients personal attention is paramount to David when designing a home. "In the process of developing property or designing a home, being a team player means you listen to everybody, and you don't think you know it all," he says. David understood early on that it takes a team of professionals to build a quality project and has a unique personality that works well with interior designers, engineers, builders and sub-contractors.

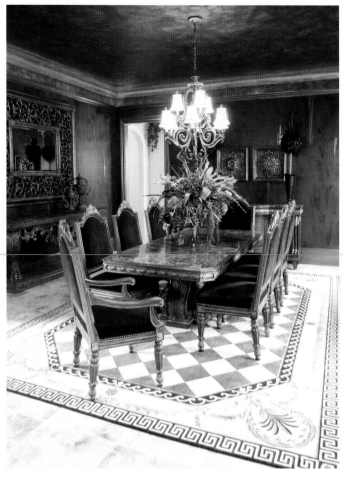

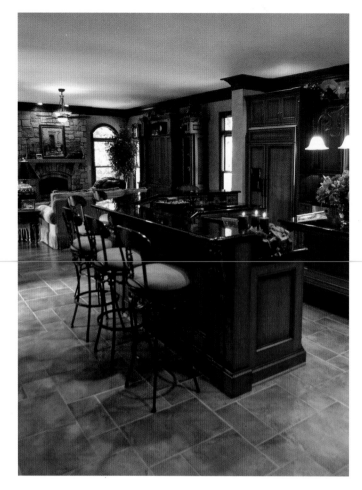

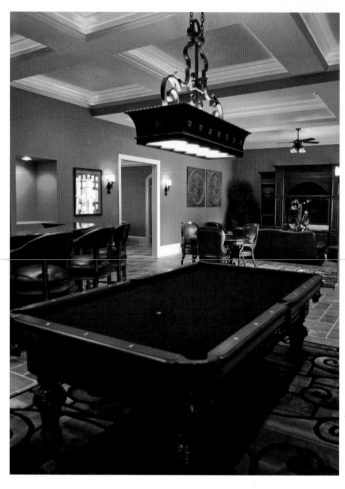

"The first thing I do with a client is I make a friend," he says. "I talk with them about their lifestyle. I ask what they do in the morning, what they do on the weekends, how they raise their kids, what's important to them. Some elements of that will start to design the home, and then I incorporate that into the project. I also involve my clients in the design process. We will actually have work sessions together which allows the client to see a part of the project evolve."

Not limited to one style or one clientele, David uses his creativity to clearly express the dreams of his clients. In 2006, he designed around 50 homes with the average price of about $1.7 million without repeating a design. "I've never limited myself to a

certain style or price range. Everyone is entitled to good design no matter the project design or cost.

"All my projects are custom designed and to me, that's the most important thing because if you're going to make a large investment in your home, why have someone else's dream?" he asks. "Your home is an expression of who you are, and it can create an experience for you, your family and your friends."

David finds a tremendous amount of enjoyment in the design process because he is so creative and can come up with designs quickly. Clients are attracted to his creativity, as he has been known to design while he talks with them. "I try to read what

they're saying to me. I try to put myself in their shoes," he says. "I find out what their dream is and then I take on that dream. I've actually dreamed of many homes and woke up the next morning and sketched them out." Sketchbooks full of thoughts can be found throughout his office.

Above Left: Dinner is served in this casual yet elegant dining room. The ceiling and jewel tones of the room create quite a dramatic setting for any meal.
Photograph by www.valentinedesign.com

Above Middle: This open kitchen and family room creates a warm, functional space great for family gatherings.
Photograph by www.valentinedesign.com

Above Right: Adult-style game room with 11-foot-high coffered ceiling, sunken sitting room and bar.
Photograph by www.valentinedesign.com

Facing Page: This Old World-style stucco and stone exterior home creates a beautiful drive up.
Photograph by www.valentinedesign.com

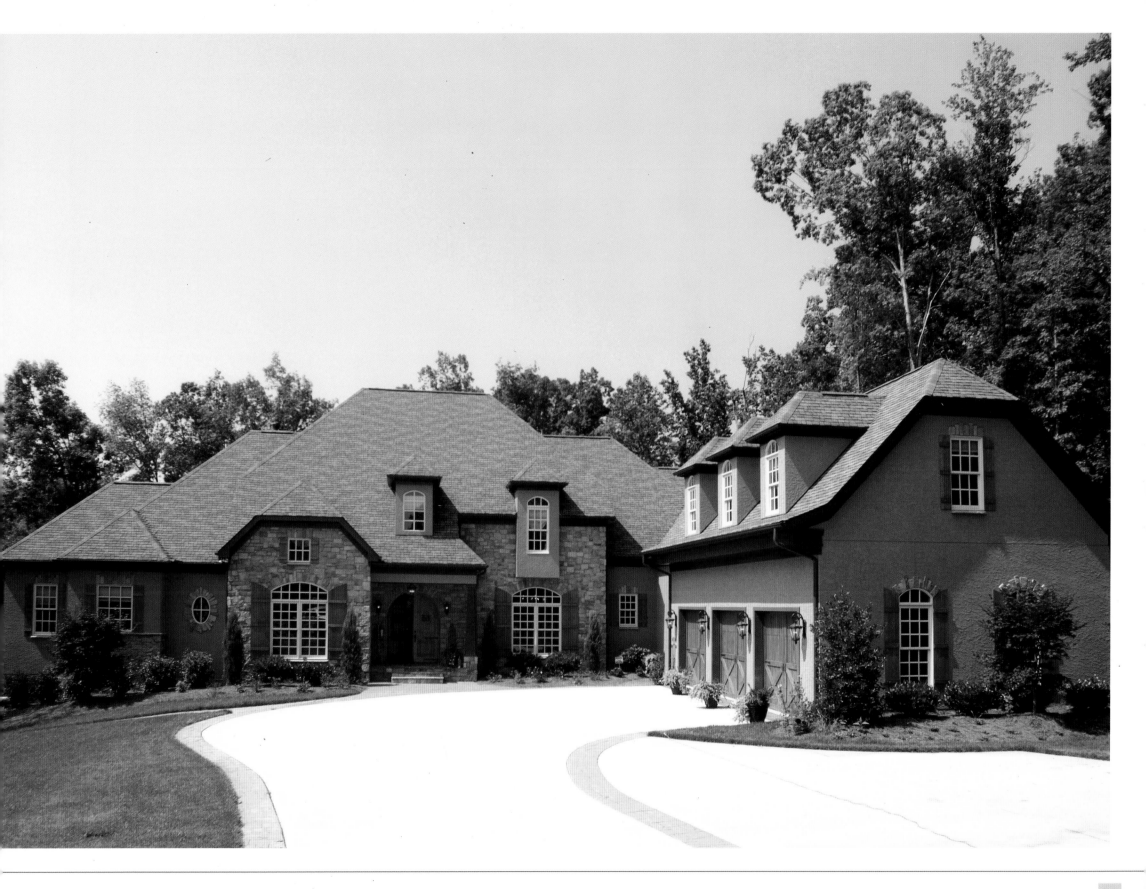

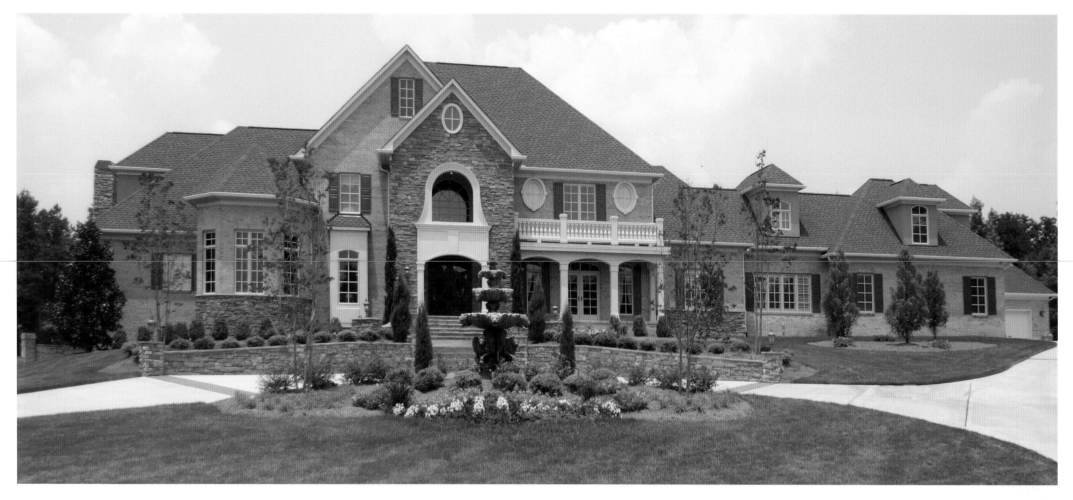

David built his home in The Vineyards at Pine Creek, a gated community he designed and developed as a business partner with Ken Lingafelt and Mike Minter of Southeast Developers. Initially they designed the development and then the lots, which are approximately one acre or larger. David has designed most of the homes for the development. "I create my own work by developing property as well," he says. "The challenge is always to meet the design criteria and design a house that looks like it belongs there."

In addition to New York and North Carolina, David has also designed homes in Florida and South Carolina. In the Charlotte area you will find his designs in many prestigious communities.

Above: This traditional-style exterior home boasts a circular drive and an evening porch with a lovely view of the grand fountain.
Photograph by www.valentinedesign.com

Right: This resort-style backyard is located directly off the veranda.
Photograph by www.valentinedesign.com

Facing Page Top: A two-story fireplace and antique mantel backdrop this gracious and cozy room.
Photograph by www.valentinedesign.com

Facing Page Bottom: With seating for 10, this formal dining room can accommodate intimate gatherings for family and friends.
Photograph by www.valentinedesign.com

more about David ...

DID YOU ALWAYS KNOW YOU WANTED TO DESIGN HOMES?

I knew I wanted to be an architect when I was in high school. I went to a vocational school to study rough carpentry. I was a junior in high school when the teacher there noticed that I had the ability to draw and build. When he explained something that needed to be built he would ask me to draw it first. I thought I was going to be a contractor and build houses. This teacher taught me how to visualize what I was drawing, and I had the ability to explain it to the class. I always loved building models and sketching. I didn't even know what an architect was, to be honest. I just knew that I had this teacher who was a mentor, and he would send me home with little drawing projects. My senior year of high school I actually got to design the house the school auctioned off.

WHAT INSPIRES YOU?

People, places, and I love to read. I enjoy books on cities, architecture, new books, and old books in general. Sometimes a paragraph can inspire a design thought. Even a piece of art has captured my imagination. My wife and I travel quite a bit. We have been to Europe, Central America, Canada, and many inspiring locations in the United States. Every year we go to Nicaragua on a mission trip. I got the opportunity to design a mission house and an orphanage there. It is inspiring to see how people all over the world live and enjoy life.

WHAT DO YOU ENJOY ABOUT BEING AN ARCHITECT AND RESIDENTIAL DESIGNER?

Seeing a blank piece of paper become reality. With every project it is exciting to see where the inspiration will come from, you never know. That to me is fascinating.

David O'Bryan

David O'Bryan
6018 Chardonnay Circle
Kannapolis, NC 28081
704.786.0298
www.davidobryan.com

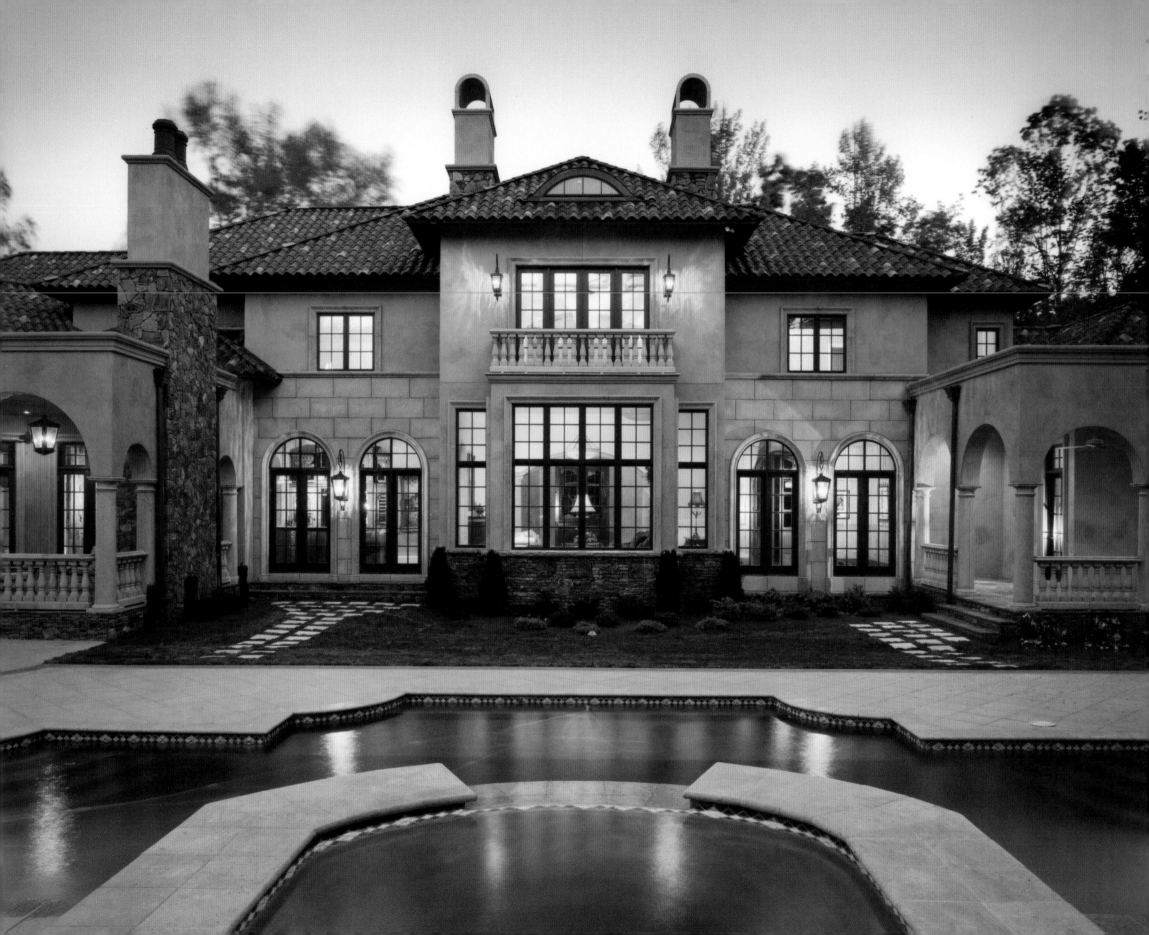

Christopher Phelps
Christopher Phelps & Associates

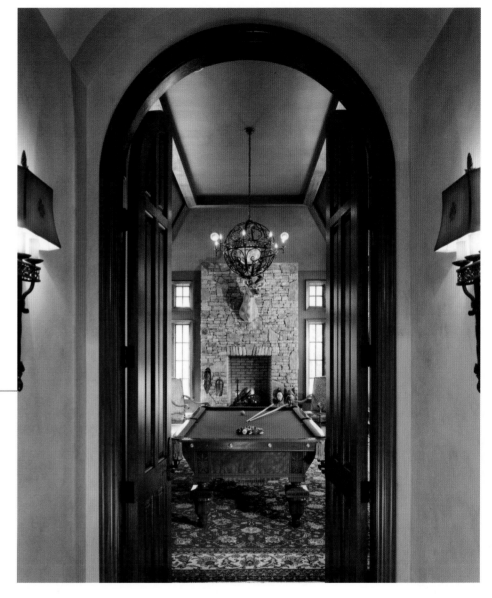

Above: This vibrant hallway leads into a handsome billiard room.
Photograph courtesy of Christopher Phelps & Associates

Facing Page: The back elevation of a Mediterranean-style home lit at dusk.
Photograph courtesy of Christopher Phelps & Associates

As a child growing up in Norwich, New York, Christopher Phelps would sketch the Victorian homes on Main Street relentlessly. His love for sketching has not wavered as the residential designer still draws all of his designs by hand and finds inspiration from blank sheets of paper.

The owner of Christopher Phelps & Associates in Charlotte, Christopher has designed homes in some of the area's most prestigious communities including Ballantyne Country Club, Longview, The Palisades, The Peninsula, The Point, The Sanctuary and Skyecroft. He has also done extensive work in communities in Charleston, South Carolina such as Daniel Island, Isle of Palms and Kiawah Island.

"I think our firm has been successful because we are a firm that meets the client's needs. We approach every project with a team effort, meaning the builder, the interior designer and us. We found this niche

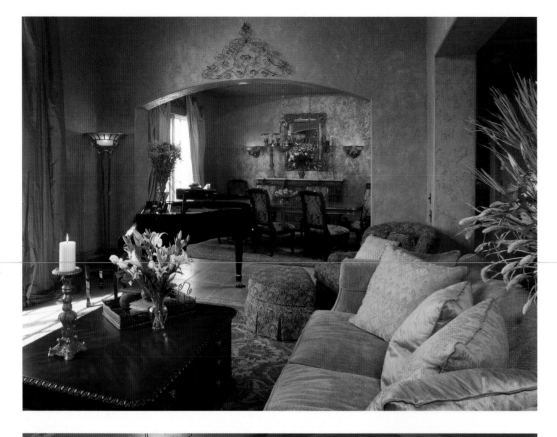

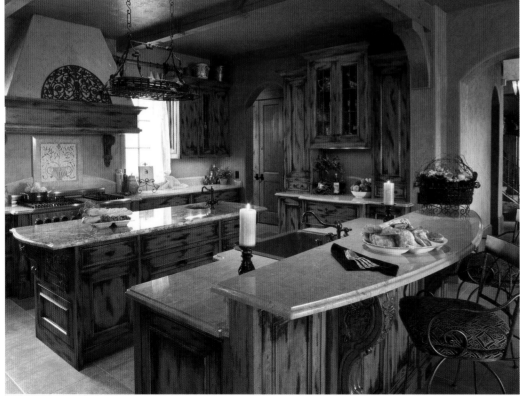

early on, and it really serves our clients well," says Christopher, who founded his 20-person firm in 1989. "We're called upon to do different kinds of projects in a variety of geographic areas so we have to be versatile."

Christopher is known for developing innovative designs in a variety of architectural styles from European to Contemporary to Georgian to Low Country. Regardless of what style he is designing, his design philosophy dictates that it be authentic. "If someone asks me to design a Craftsman-oriented home for them, I take that very seriously and strive to be as authentic as I can be with the design while taking into consideration the homeowner's lifestyle and desires," explains Christopher, whose designs range in size from 3,500 to 25,000 square feet.

Christopher began his career working as a draftsman for various architectural firms. Later on he worked for local homebuilders and eventually had his own construction firm. "I am a little bit unusual in that I've spent as much of my career building as I have drawing," he says. In 2005 he started a construction company based in Charlotte called Origin. One of the first projects of his new venture was a $3.9 million spec house on Queens Road West in Charlotte's Myers Park neighborhood.

One of the things that separates Christopher Phelps & Associates from its competition is its ability to take clients through the design process with efficiency. "We've been extremely successful in moving the client through the design process at a comfortable momentum where we draw and they react," Christopher says. "We've learned that there is an enormous amount of clientele who want to sit down and go through the process of producing their own home, but they really don't want to spend the next two or three years doing it."

On average Christopher's firm develops custom plans for clients in two to three months. "We don't by any means compromise the product in any way. Our first priority is to always provide

Top Left: A view of the living room which looks into a formal dining room.
Photograph courtesy of Christopher Phelps & Associates

Bottom Left: This traditional kitchen features beautiful custom millwork.
Photograph courtesy of Christopher Phelps & Associates

Facing Page: Natural stone accents the façade of this exquisite country estate.
Photograph courtesy of Christopher Phelps & Associates

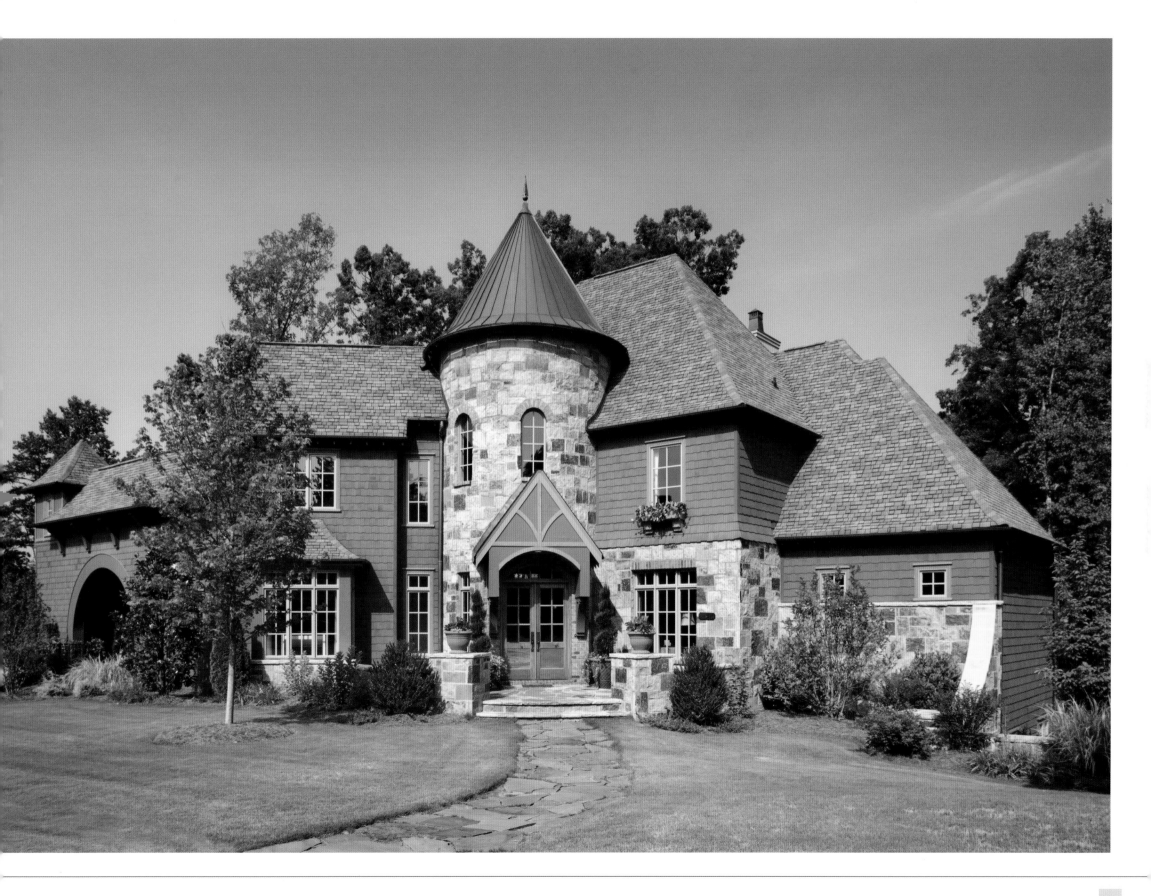

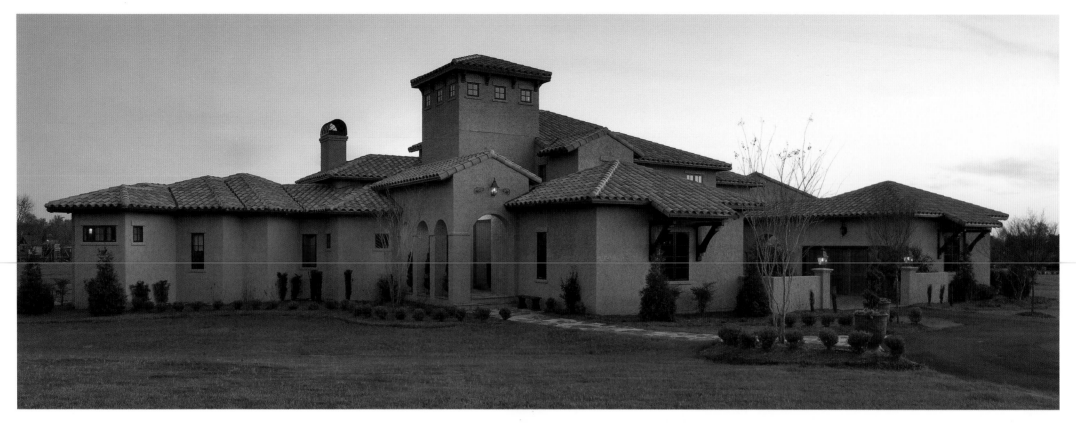

extraordinary service and quality to our clients, " he says. "We create innovative designs for our clients and then we work directly with the builder. If anyone needs us, we're right there. Our clients appreciate that." Featured in publications such as *Today's Custom Home* and the *Charlotte Business Journal*'s "Luxury Living" section, Christopher's work has won numerous accolades at HomeArama, including five gold and three silver awards at the 2006 HomeArama at The Sanctuary.

"All of our relationships, whether they be with our clients or the builders that we work with, are based on trust," says Christopher. "We want to have mutually satisfying relationships with everyone who is involved in one of our projects. That's the only way to be successful."

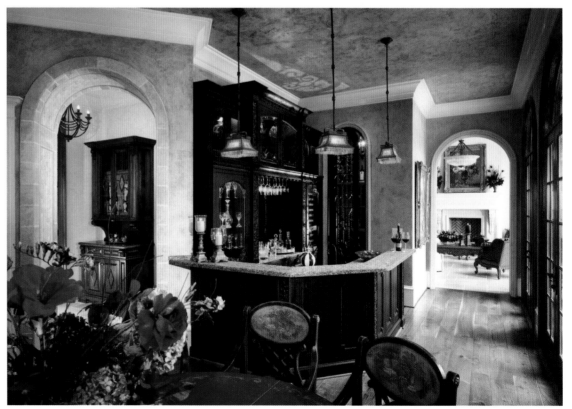

Above: The flavor is decidedly Mediterranean in this sprawling residence.
Photograph courtesy of Christopher Phelps & Associates

Right: The perfect area to offer a charming built-in bar with casual seating.
Photograph courtesy of Christopher Phelps & Associates

Facing Page Top: This Shingle-style home is featured in a lush, tranquil setting.
Photograph courtesy of Christopher Phelps & Associates

Facing Page Bottom: A welcoming view from an expansive marble entryway into a bright formal living room.
Photograph courtesy of Christopher Phelps & Associates

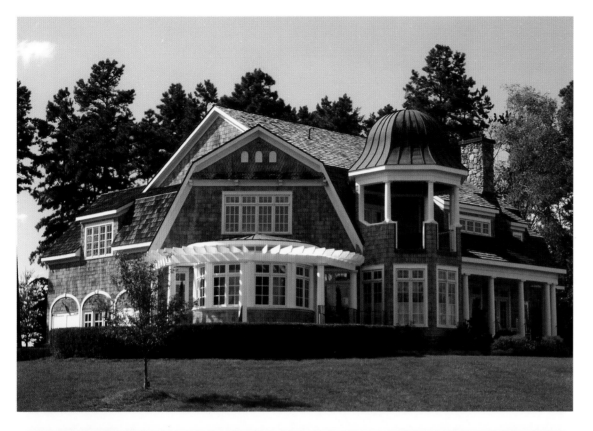

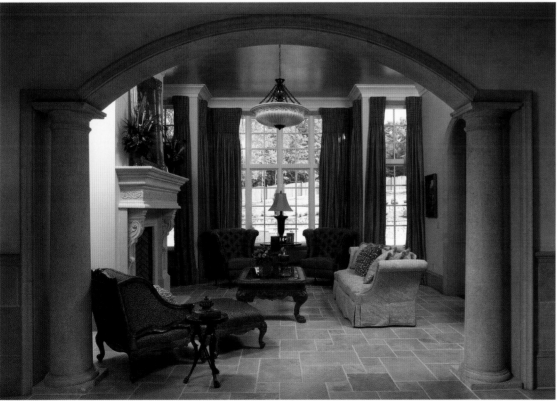

more about Christopher ...

WHAT DO YOU LIKE ABOUT DOING BUSINESS IN CHARLOTTE?

Ever since I've lived here, Charlotte has been a city receptive to my business, meaning that it is a city marked for growth. There is a positive attitude coupled with an entrepreneurial feeling here that allows you to really step up and do some things that you might not be able to do in other cities that are not quite as progressive. It's a great city to watch grow, and I'm glad I'm part of that growth.

DO YOU HAVE A FAVORITE PROJECT?

They're all favorites until the next one comes along. Probably one of my favorites is a 10,000-square-foot residence I designed in Seven Eagles for a local businessman almost 10 years ago. It was one of the first opportunities I had to do a home of that size and caliber. It was great fun.

WHAT INSPIRES YOU?

I'm inspired by having a clear understanding of a project and knowing that someone trusts me so that I can have full reign with it and create something wonderful for the client.

DO YOU EVER USE A COMPUTER WHEN YOU DESIGN HOMES?

No, I think God wants people to sketch with their hands. I sketch on everything. My list to go to the grocery store has got sketches on it. I even sketch in church. It's an art that if you don't do it, I don't know how you build.

Christopher Phelps & Associates

Christopher Phelps
225 East Worthington Avenue, Suite 200
Charlotte, NC 28203
704.377.5569
Fax: 704.377.6909
www.christopherphelps.com

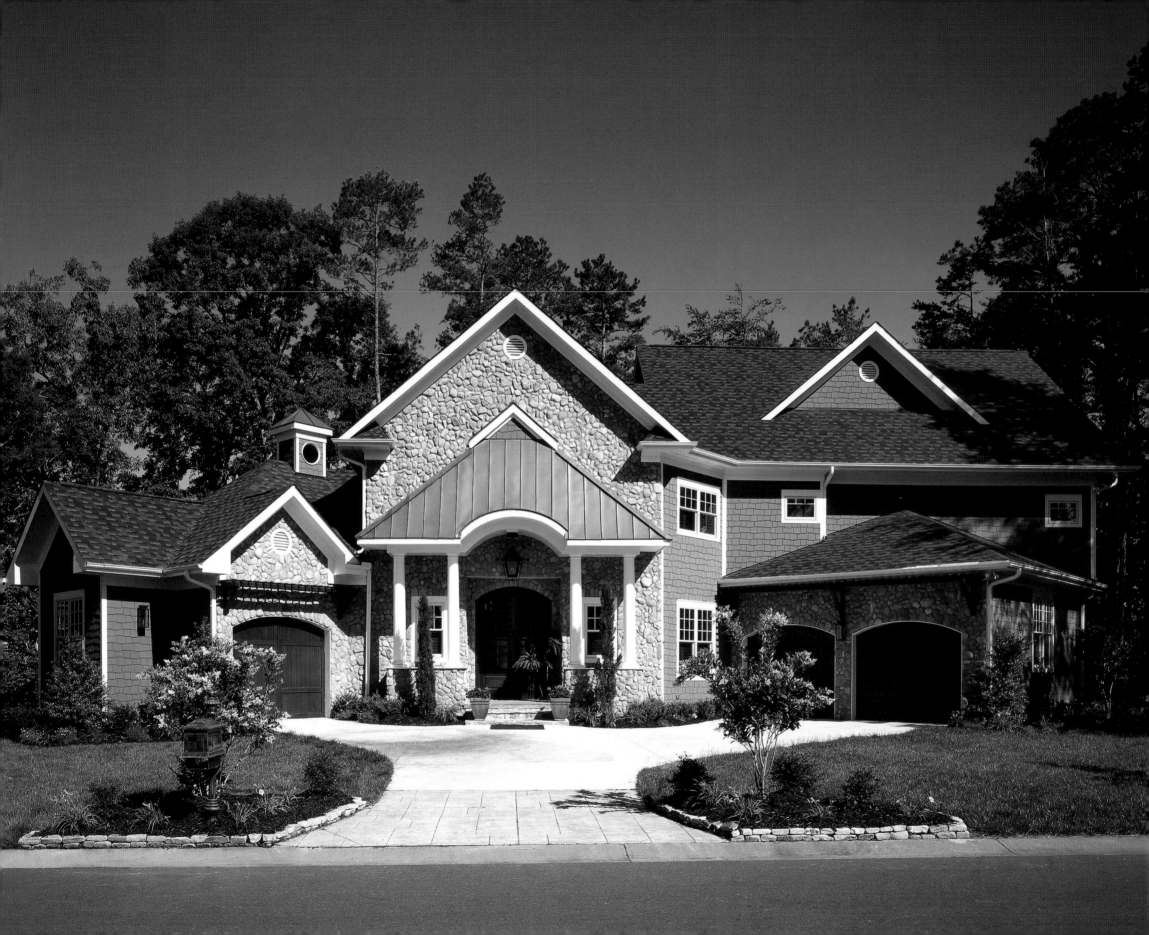

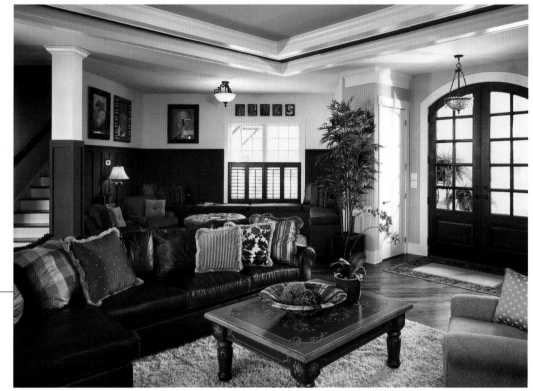

Jennifer B. Pippin
Pippin Home Designs, Inc.

A native of North Carolina, Jennifer B. Pippin has always had a strong appreciation for the environment. A residential design specialist in Cornelius, Pippin has taken many classes in energy efficiency and indoor air quality issues, and frequently works with renewable and sustainable products. Although her custom homes and renovations pepper the East Coast, the majority of them can be seen on Lake Norman, as showcasing waterfront views is one of her specialties.

"I like to bring the outdoor view in," says Pippin, who lives in one of her renovation designs on Lake Norman. "I use a lot of windows in all of my designs. One of my current projects features curved glass in a circular great room overlooking the water."

Pippin designs 50 to 60 homes per year ranging in size from 2,500 to 17,000 square feet; the average being 4,000 to 5,000 square feet. Regardless of how many projects she's working on, she always takes time to listen to her clients and her intuition. "I think it's very important that you feel good in your home," she says. "If it doesn't feel good on paper to us, we know it's not going to feel good once it's constructed."

Pippin Home Designs, Inc.

Jennifer B. Pippin
21016 Catawba Avenue
Cornelius, NC 28031
704.895.0000
Fax: 704.895.0066
www.PippinHomeDesigns.com

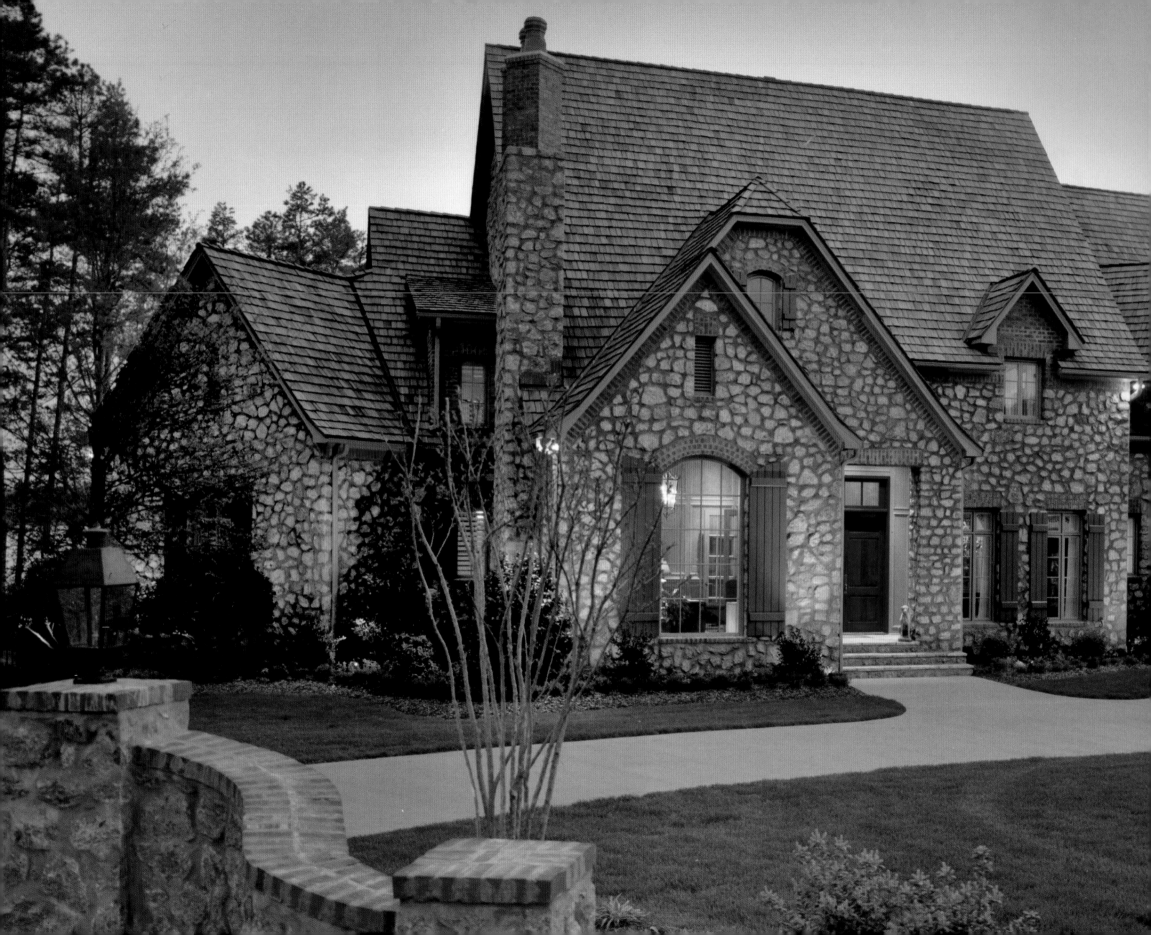

Alan Simonini
Ray Killian Jr.
Simonini Builders, Inc.

When asked what makes them most proud as custom-home builders, Alan Simonini and Ray Killian Jr. have a fast answer. And it might not be what you expect. Sure, their company, Simonini Builders, constructs lavish residences that are delightful to look at and live in. And, yes, those homes are sought-after masterpieces with livable floor plans, intricate crown mouldings, outdoor fireplaces, courtyards with fountains, and hand-painted accents. But what really brings a smile to Alan's and Ray's faces is their firm's customer satisfaction record. However spectacular their homes are—and they are dazzling—their service is unrivaled in the industry.

Alan and Ray are 50-50 partners in the company Alan's father started in 1973. Since taking control of the firm in 1994, they have increased production by nearly 700 percent, from

Left: This Oklahoma limestone 7,500-square-foot residence, on the shores of Lake Norman, typifies the attention to detail Simonini Builders employs in all homes, from the coast of South Carolina, to the lakes surrounding Charlotte, North Carolina.
Photograph by Pat Shanklin Photography

20 homes per year to about 115 in 2005, with an average price tag of just under $1 million, in both the Carolinas. But, as Alan stresses, they have not grown the company by themselves, and their success has not been perpetuated on a reputation for fine custom construction alone. A culture of hiring the right people, empowering them to do their jobs, and giving them the task of ensuring customer satisfaction is the basis by which they operate—and it is the foundation for an impressive portfolio of achievements.

The philosophy is the opposite of that of a small company, in which an employee could be expected to wear a lot of hats. "When you are introduced to our company, and establish a relationship, you find a lot of specialists: financial specialists, estimators, superintendents, marketing professionals, IT administrators, etc." Ray explains. "We hire the most incredible talent we can find, and we have a support system within SBI that allows those people to excel at what they do—with the overriding mission of putting the client first."

Pleasing the customer is an attitude that permeates every aspect of the business, from Alan and Ray right down to the frontline receptionists. It is a goal that is continuously

monitored and evaluated throughout every step of the process, from the initial contact to the tiniest customer service claim. And it is the reason Simonini Builders was the first custom builder in the country to win the National Housing Quality Gold Award from the National Association of Home Builders. It is also why it was named "America's Best Builder" in 2002 and "National Builder of the Year" in 2006 by *Professional Builder* magazine, another first for a custom builder.

In fact, SBI boasts a dizzying list of awards, which prompts great expectations from the customer who sees them. "And that is not a problem at all," Ray says. Managing and exceeding expectations is what his company is all about.

Above: Timeless beauty, personalized service and enduring value are the overarching goals of Simonini Builders in all their endeavors, from custom home building and renovations to neighborhood building. This residence in Heydon Hall embodies all these commitments in a single example of uncompromised beauty.
Photograph by Michael LoBiondo Photographic

Facing Page Top: Lakeside Village at Oldfield, a Simonini Builders exclusive community near Hilton Head, is an example of an architecturally congruent neighborhood. Special emphasis is placed on the complementary architecture throughout, in addition to the well-manicured parks and recreation areas, typical of a Simonini-exclusive community.
Photograph by Gary Kufner Photography, Courtesy of Oldfield, LLC

Facing Page Bottom: Simonini Builders expansion to South Carolina began in Daniel Island Park, an island community near Charleston, South Carolina. Simonini Builders embraces the Low Country architecture found in this region, as evidenced by these homes, overlooking a serene pond. The views and interaction with water found in the coastal regions of South Carolina is a hallmark of Simonini homes.
Photograph by Louis Joyner Photography

Q&A
more about Simonini ...

WHAT STYLE OF HOMES DOES THE COMPANY BUILD?

The diversity of architectural styles is across the board—inspired by everything from Georgian to Mediterranean, Gothic Tudor to Italianate. Similarly, very few builders have the range of price points that SBI does.

WHAT ARE SOME OF THE BIGGEST INFLUENCES ON THE WAY THE COMPANY DOES BUSINESS?

With regard to customer service, The Ritz-Carlton is a good model, Ray says. Instead of pointing someone in the direction of their room, a member of The Ritz-Carlton staff will walk a guest there. With regard to the way they build houses, the luxury car industry shaped their thinking. "When you buy a Lexus, you're buying quality, dependability, service and integrity—everything you would expect in a luxury automobile. This is what our customers come to expect and experience at Simonini Builders."

WHAT IS THE COMPANY'S VISION?

We want to create a business that is built to last, Alan says. That means having a team capable of delivering on any project regardless of size or complexity. It means being one of the nation's most respected and desirable custom-home builders. And it means having a company that attracts and keeps the best people.

Simonini Builders, Inc.

Alan Simonini
Ray Killian Jr.
1910 South Boulevard, Suite 200
Charlotte, NC 28203
704.358.9940
www.simonini.com

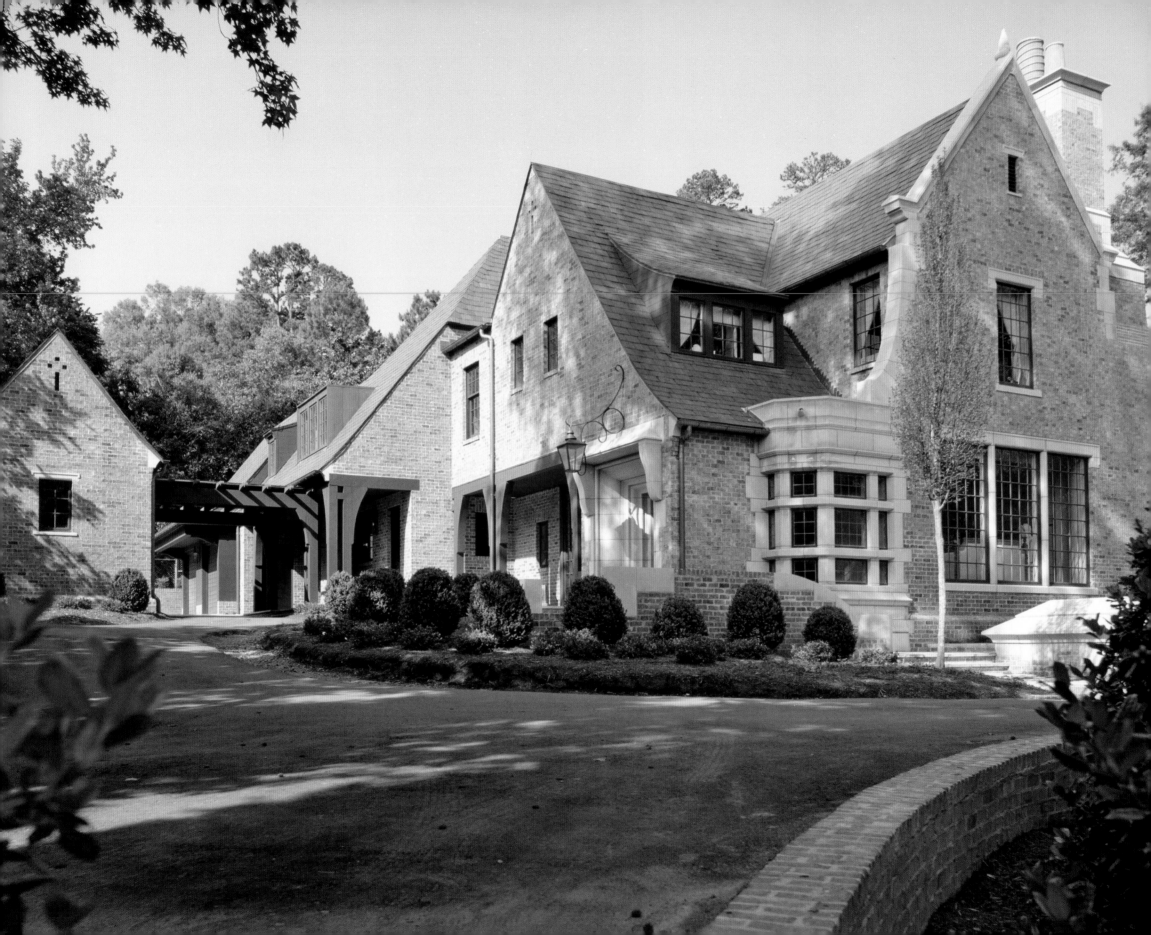

Scott Whitlock
Stephanie Whitlock Hazard
Steven Whitlock
Tyler Mahan

Hubert Whitlock Builders, Inc.

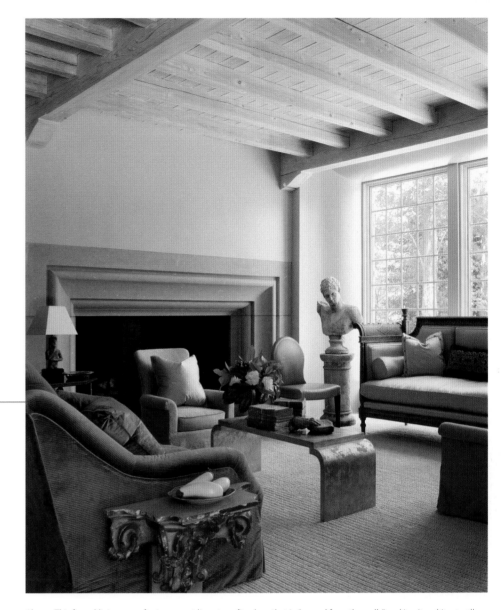

Above: This formal living room features a cut limestone fireplace that is "carved from the wall," making it architecturally structural. Ruard Veltman Architecture.
Photograph by William Waldron Southern Accents © 2007

Facing Page: This new Jacobean Tudor-inspired home is composed of brick, limestone and dark timbers, which all combine to conjure a romantic appearance. Ruard Veltman Architecture.
Photograph by William Waldron Southern Accents © 2007

For 50 years the name Hubert Whitlock has been synonymous with quality construction in Charlotte, North Carolina. Hubert Whitlock founded Hubert Whitlock Builders in 1957 after studying design at Harvard University. Today three of Hubert's four children work together to uphold the company's stellar reputation for fine craftsmanship, integrity and respect for its clients and employees.

"My father gave me the unique opportunity to experience all phases of the business beginning in high school," says Scott Whitlock, who earned a degree in business at East Carolina University before returning to the family business in 1982. Scott is now president of the company. "There were days when I was a carpenter's helper and others when I worked with the brick mason or the roofer."

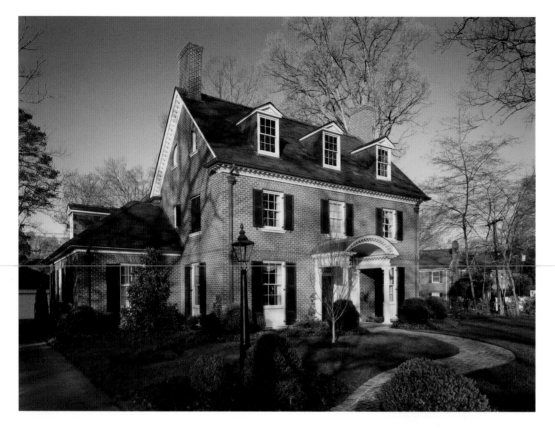

Scott's father also taught him other duties involved with the business, including payroll, estimating and sales. "The most valuable lessons came from observing and listening to my father. I believe the most important thing I learned from him was his compassion for everyone he worked with. I watched all kinds of people—clients, employees, associates, subcontractors and vendors—respond to his wisdom and humor," he recalls. "He made people feel special, and he was laying the foundation for a wonderful company that I'm proud to be a part of today."

Tyler Mahan joined Hubert Whitlock Builders as a carpenter in 1989. Tyler's commitment to quality and his strong managerial skills were immediately evident, and he soon became vice president of production. Around the same time Stephanie Whitlock Hazard, now vice president of finance and administration, joined the company, and a few years later, Steven Whitlock, now vice president of human resources and marketing, joined the team.

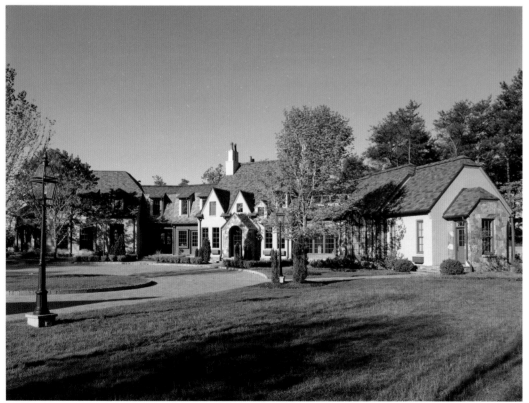

Top Left: This new Georgian home blends well with the existing neighborhood and expresses the owner's love of Williamsburg, as well as classical architecture. Every detail was designed and executed with great care. Don Duffy Architecture.
Photograph by Tim Buchman

Bottom Left: An English village inspired this new lake house: traveling down a narrow winding drive—under an archway between two-story towers with dovecotes—one arrives at the village square. Don Duffy Architecture.
Photograph by Michael Valentine

Facing Page Top: The modifications on this renovated home included a new porte cochere (left), entry portico (center), and master bath wing (right), as well as a restyling of the existing structure. A new English Tudor clay tile roof system required additional roof bracing throughout. Project Architects: Ken Pursley and Ruard Veltman.
Photograph by Tim Buchman

Facing Page Bottom Left: Within this kitchen and family room, pecky cypress paneling and coffered ceilings create a library-like space of beauty and comfortable intimacy. Project Architects: Ken Pursley and Ruard Veltman.
Photograph by Tim Buchman

Facing Page Bottom Right: Gracefully leaded and antiqued mirror panels overlook a beautiful carved-marble tub. Project Architects: Ken Pursley and Ruard Veltman.
Photograph by Tim Buchman

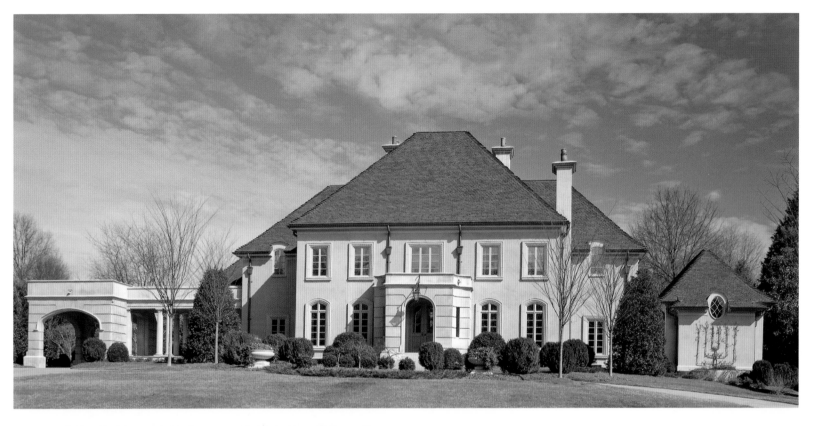

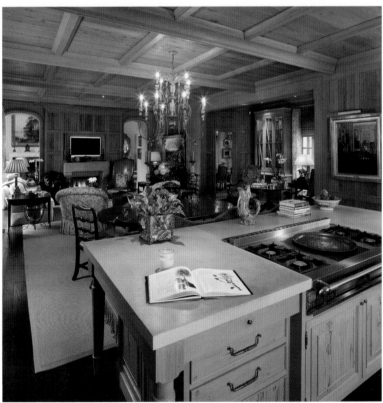

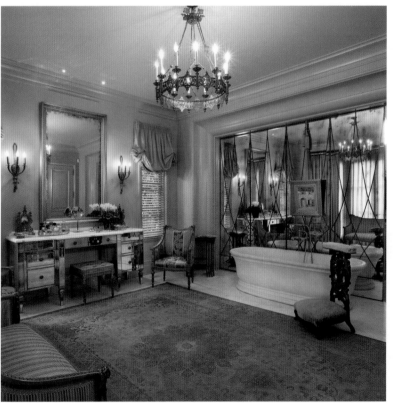

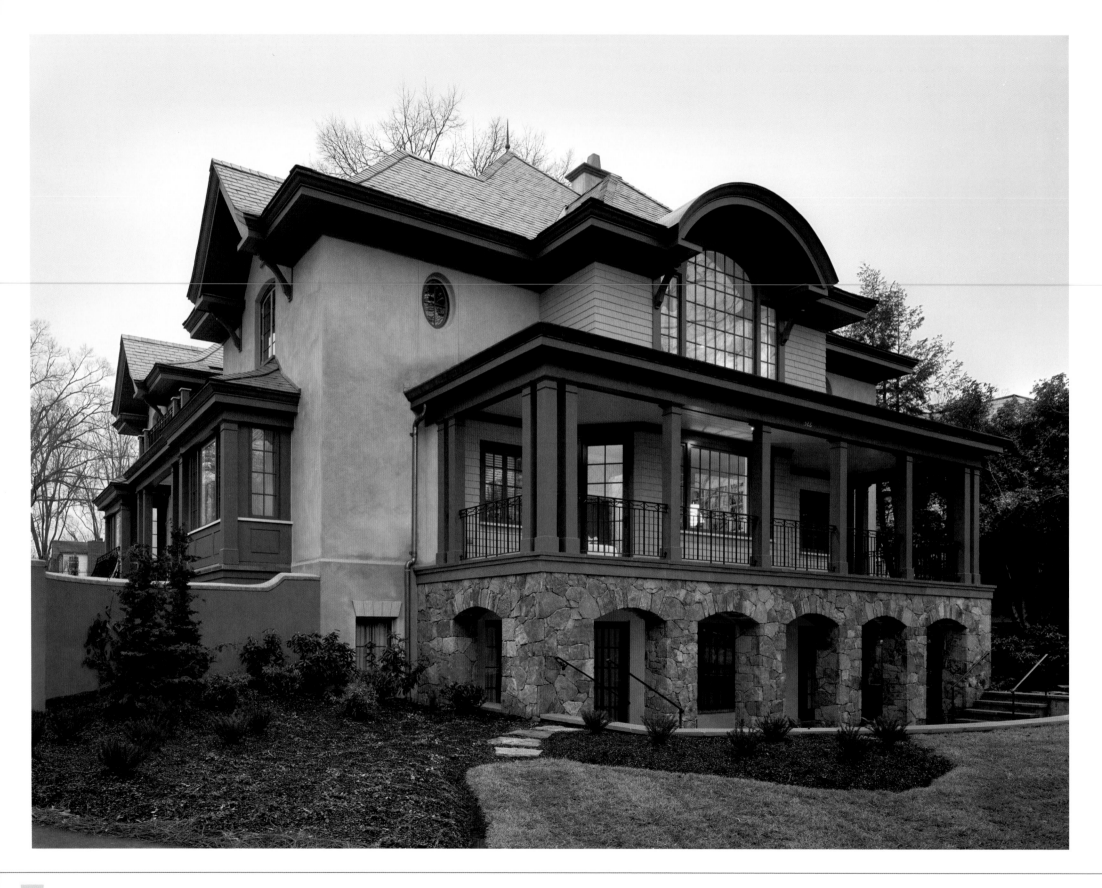

Today, Hubert Whitlock Builders handles 25 to 30 projects a year, including remodeling, historic renovations and custom homes for some of the Charlotte area's most discerning homeowners. New homes range in size from 4,500 to 12,000 square feet. The company recently renovated the Morrocroft mansion, which was built by Governor Cameron Morrison in 1927, in addition to constructing the chancellor's home on the University of North Carolina at Charlotte campus.

"While our work is concentrated in the finer neighborhoods of Charlotte, we occasionally branch out beyond Charlotte, and we are licensed in North and South Carolina," explains Steven. "We aim to have clients for life. Over 90 percent of our business comes from referrals, which we believe validates making quality and trust our main objectives. Our father was completely focused on doing things right."

"Our passion for perfection at Whitlock is shared by the artisans and tradespeople who work with us," says Stephanie, "and it drives us to understand and execute the details of fine homebuilding. We find personal satisfaction in the whole process, such as starting with the hidden beauty of specialty wood, milling it and bringing it through a unique staining process, and achieving the touch of silky smoothness found in a superbly crafted banister. Our clients and their architects enjoy working with us because they trust us to facilitate an environment in which a home of extraordinary beauty and quality will be built."

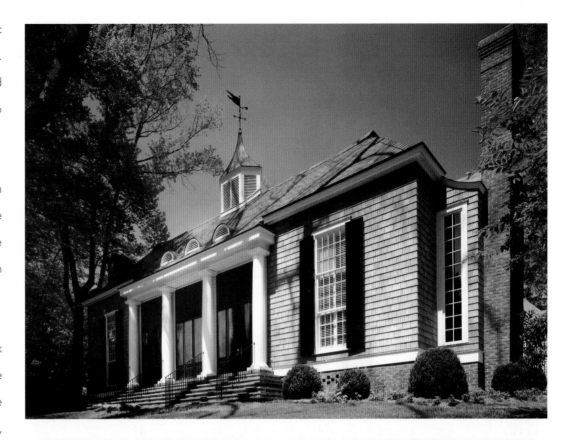

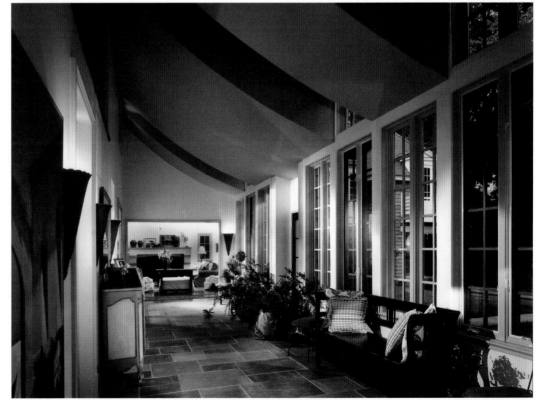

Top Right: Centered on the lot, a robust louvered and screened summer house becomes the key street element of this rambling new Shingle-style house. McAlpine Tankersley Architecture.
Photograph by Stanley Capps

Bottom Right: A normally mundane service gallery is made soaringly dramatic by the interior curvature of the roof above. Tall dormers rhythmically puncture the ceiling. McAlpine Tankersley Architecture.
Photograph by Stanley Capps

Facing Page: A streetside view of this new home offers a unique side entry, which creates a level forecourt access on a steep site. Wide overhangs and porches afford shelter for the generously sized porches. Architect: Jay Dalgliesh, Dalgliesh, Gilpin & Paxton P.L.L.C.
Photograph by Stanley Capps

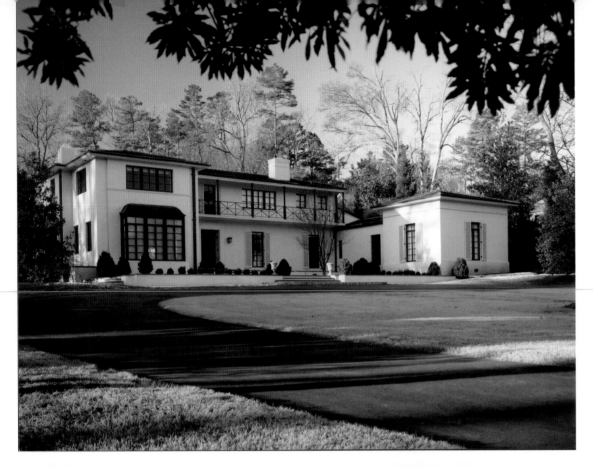

"When you combine our extraordinary staff with processes and technology that work, we're able to deliver unparalleled detail work," says Steven. "Our clients rely on us to execute well—whatever design, details, innovation or technology their project demands. We're continuing to build a history. These fine homes are going to be around for a long time."

Hubert Whitlock's clients share in that vision. "Our clients want to create a home with personal meaning and value for their families," explains Stephanie. "Many also recognize their position in the community gives them a unique opportunity and responsibility to build a home that will represent the highest quality in home building in Charlotte. They turn to Whitlock to make sure they get the quality consistent with these goals for their family—and the community."

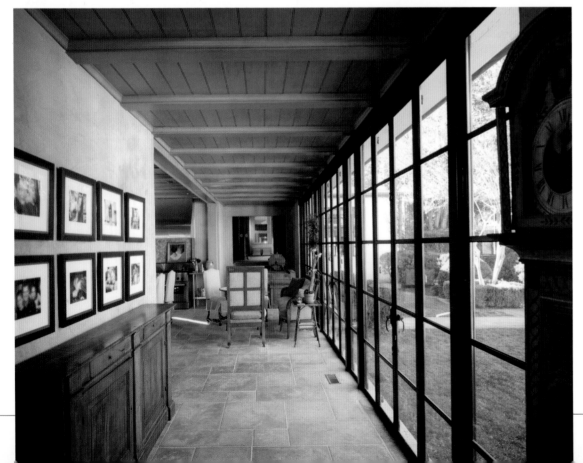

Top Left: Exterior modifications on this renovated home included a new master bedroom wing (right) and a complete restyling of the exterior façade. McAlpine Tankersley Architecture.
Photograph by Tim Buchman.

Bottom Left: This glass curtain wall was added as part of the kitchen addition to capture the light and view from the existing courtyard space. McAlpine Tankersley Architecture.
Photograph by Tim Buchman.

Facing Page Top: A new footprint and taller ceilings allow light to pour into the center of this renovated home. The resulting space is light, airy, and comfortable with a soft palette of materials and colors (limestone mantel/painted concrete floor). Kent Lineberger Architecture.
Photograph by Tim Buchman.

Facing Page Bottom: A new kitchen takes the place of an unheated loggia. Clean lines with subtle architectural details and trim, along with more minimalist materials like stainless steel, a butcher block and painted concrete create a functional, warm and inviting space. Kent Lineberger Architecture.
Photograph by Tim Buchman.

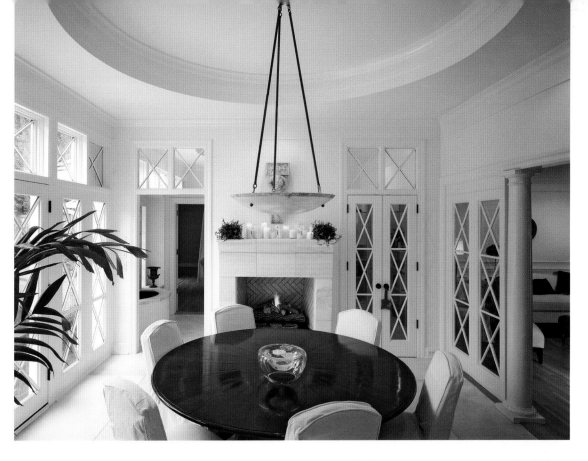

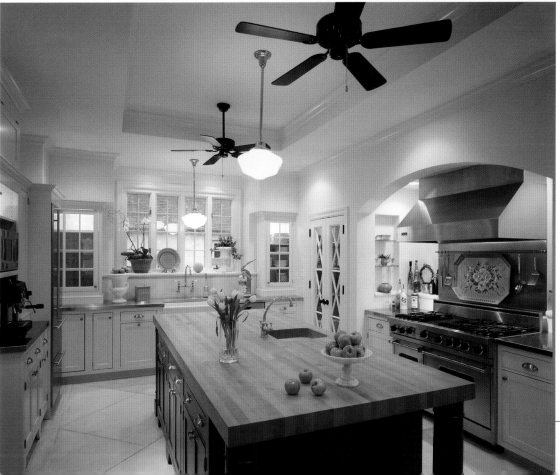

more about Scott, Steven and Stephanie ...

WHO HAS HAD THE MOST INFLUENCE ON YOU?

Our father, Hubert Whitlock. Because he was a perfectionist, he instilled in us how important quality is in the construction business.

WHAT ARE SOME OTHER INFLUENCES?

Another important attribute we've carried on is our father's emphasis on continuing to learn and grow as a company. Therefore we take advantage of opportunities each year as members of the National Association of Home Builders (NAHB) and the Remodelers Council, the Remodelers Executive Roundtable and The Institute of Classical Architecture & Classical America. Scott recently attended the National Green Building Conference of the NAHB. All of our field staff recently attended classes at the North Carolina 21st Century Building Conference.

WHAT AWARDS HAS HUBERT WHITLOCK BUILDERS WON?

Professional Builder and *Professional Remodeler* listed us at as one of the "101 Best Companies to Work for in the Residential Construction Industry." We've also won the national Chrysalis Award for Remodeling Excellence, in addition to numerous remodeling awards from the Home Builders Association of Charlotte.

DO YOU SPECIALIZE IN A PARTICULAR STYLE?

All of our work is driven by the client, so we build in a variety of styles.

Hubert Whitlock Builders, Inc.

Scott Whitlock
Stephanie Whitlock Hazard
Steven Whitlock
Tyler Mahan
8101 Tower Point Drive, Suite 100
Charlotte, NC 28227
704.364.9577
Fax: 704.364.9579
www.whitlockbuilders.com

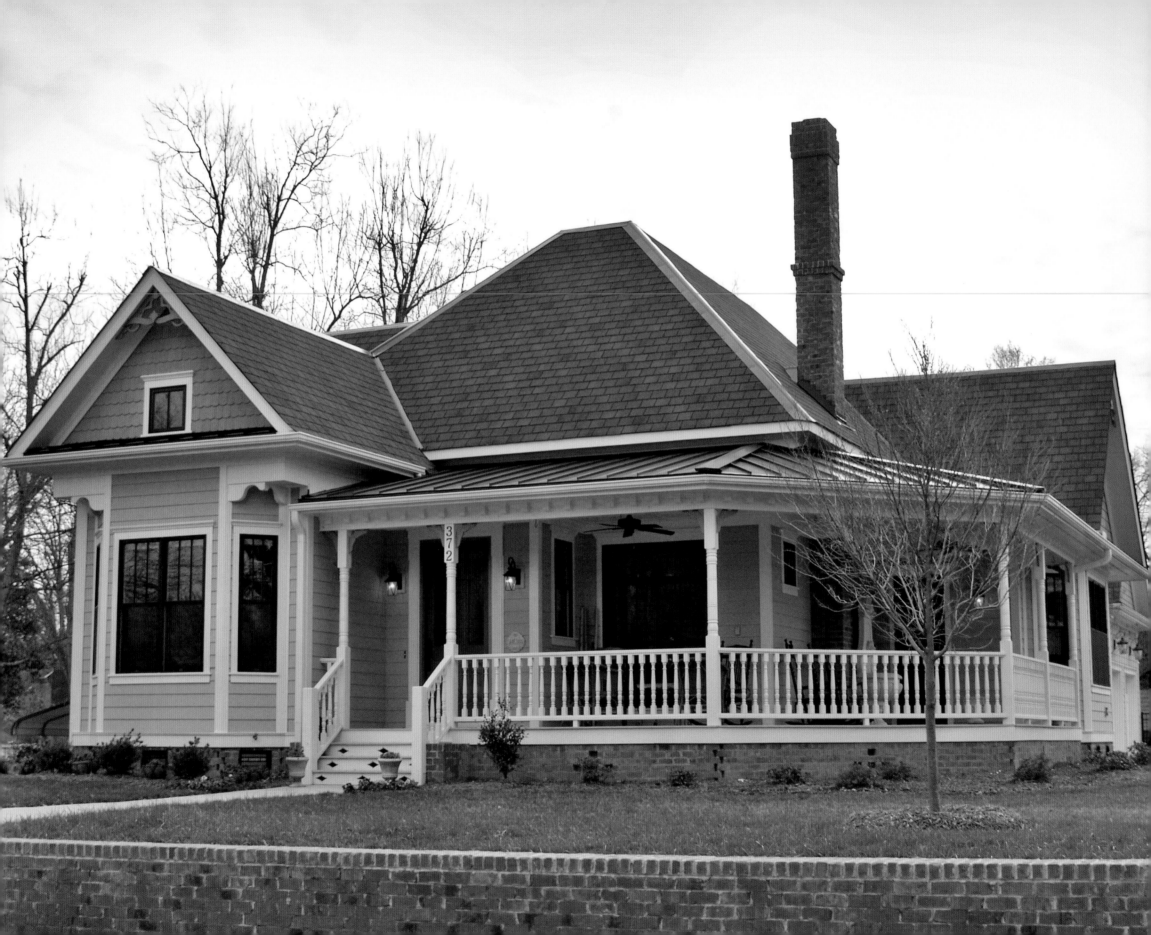

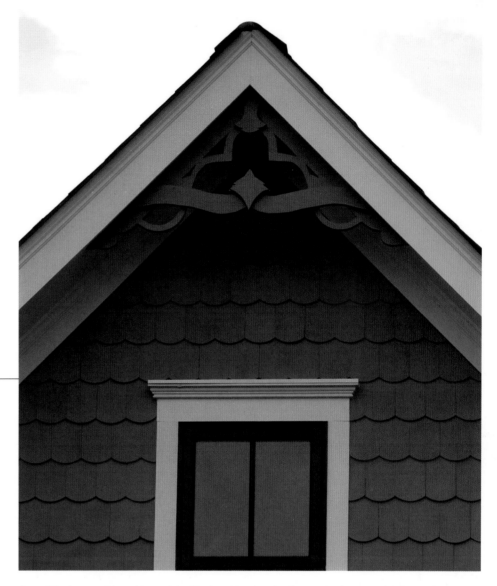

Brent Zande
Zande Homes, Inc.

Above: This close-up of the architectural detail in the gables shows just how precise they are to their historical ancestors.
Photograph by Ashley Meyfohrt

Facing Page: This home is a modern interpretation of the Victorian style. Details like the front porch brick and column brackets were interpreted directly from nearby historical homes.
Photograph by Ashley Meyfohrt

Brent Zande believes that less is more and has built a construction company based on that philosophy. Located in Mooresville, North Carolina, Zande Homes, Inc. focuses on building premiere homes on a smaller scale with 3,000 square feet being the average size.

"As Americans age, they don't want a huge home that requires a tremendous amount of maintenance, but they still want a home with high-end qualities," explains Brent. "We're able to offer the same level of finish and products that you would see in a 12,000-square-foot house, but we're doing it on a smaller scale. You're getting every bit of the quality and a better design because more thought is put into how the home will function. Instead of having twice the home you would actually live in, you have the exact right amount of home to live in all of it."

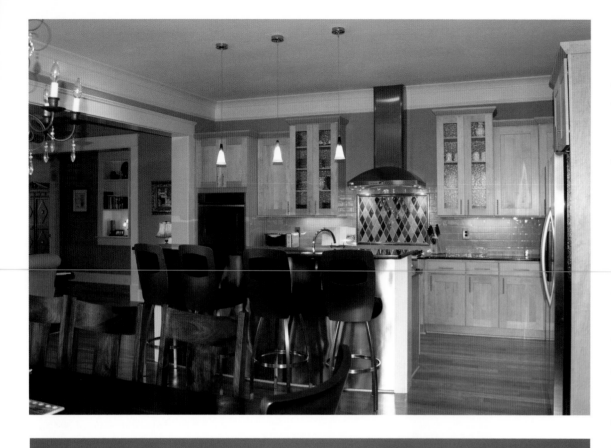

Brent and his family live in a 2,000-square-foot Victorian home he built on Center Street in Mooresville. "We found a small lot with all the older homes in Mooresville and built just what I'm talking about," says the Ohio native. "If I can't live in it then I shouldn't be talking about it."

A 10-year-old company, Zande Homes concentrates on building custom and spec homes in Cornelius, Belmont, Davidson, Huntersville, Kannapolis, Mooresville and Statesville. "Everything about our company is different by design," says Brent, who is an honors graduate from Michigan State University with a B.S. in construction management. "There are six members of our team and half of them are female. I think that makes us far more attentive to our customers' needs. We hear them a lot better, and we act on that."

The building process that Zande Homes incorporates into its projects makes it easy for clients to become involved. "When we build for a client, the steps are clear, and the client knows when and how we need them to be involved," explains Brent. "We're a very fast company, and the idea behind that is the quicker that we can build your home, the happier you'll be with it, and the less it will cost you for us to construct it." He has an individual in his office dedicated to keeping clients on track by making sure that they have enough time to make good decisions in a timely manner. Thus construction is not delayed.

Brent says that quality issues are minimized by a rapid flow of communication and construction. Everyone is on the same page which saves effort, time and money. "We think through the details," he says. "We want our clients to get caught up in the enthusiasm of building a home."

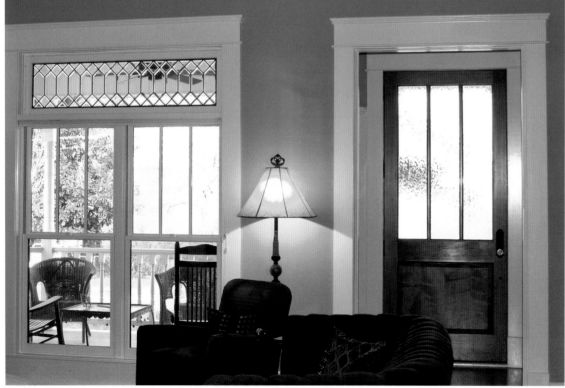

Top Left: The kitchen is a perfect example of mixing modern and classic elements. It demonstrates how to combine the luxuries of today's lifestyle with the essence of antique furnishings and materials.
Photograph by Ashley Meyfohrt

Bottom Left: The living room shows off the use of a leaded glass window that was salvaged from an old bar. It was placed strategically in the front of the home to allow light to reflect and distort throughout the porch and the living space.
Photograph by Ashley Meyfohrt

Facing Page Top: The master bedroom shows the use of the classic style of interior trim in black, which is reminiscent of the Victorian period.
Photograph by Ashley Meyfohrt

Facing Page Bottom: Intricate tilework creates the perfect backdrop for this vintage-style claw-foot tub. Simplicity at its best.
Photograph by Ashley Meyfohrt

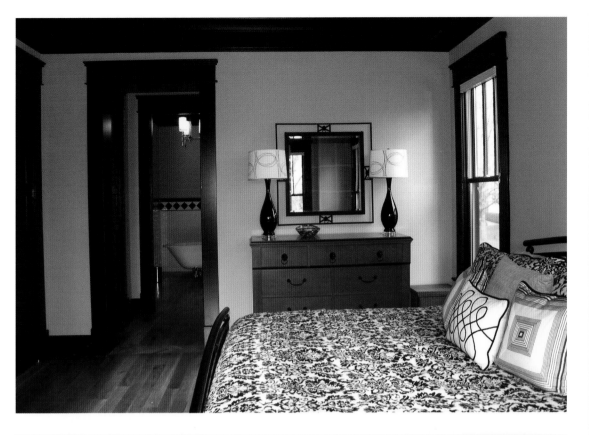

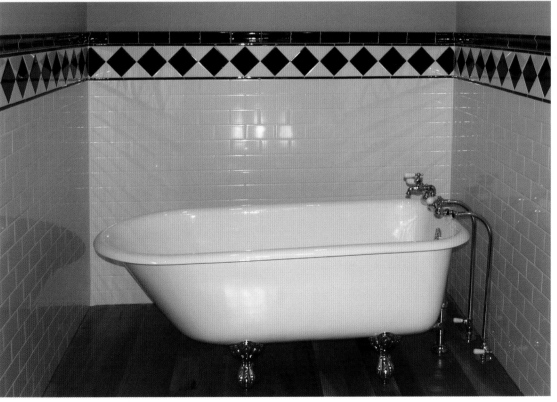

Q&A

more about Brent ...

HOW MANY HOMES DO YOU BUILD A YEAR?

We close on 16 to 17 homes a year. 30 to 40 percent of our work is custom homes.

DO YOU HAVE A FAVORITE PROJECT?

Yes and no. I really enjoyed building my own home, but each home and each client bring new and exciting ideas and challenges that make this a great job.

WHAT DO YOU LIKE ABOUT DOING BUSINESS IN THE MOORESVILLE AREA?

It's near Lake Norman, and many of the clients we've attracted in the lake area have a mindset that really goes well with our philosophy. We enjoy building projects that have more of a casual feel and that give people the opportunity to interact outside of the home. We like large covered porches and great landscapes. I really appreciate that our clients are enthusiastic. They feel like it's new territory so we're able to do some things that are outside of the box.

WHO HAS HAD THE MOST INFLUENCE ON YOUR CAREER?

Richard Zande, my father. He came from a working-class family, went to Michigan State, and eventually owned the largest civil engineering firm in Ohio. I certainly got my drive from him.

Zande Homes Inc.

Brent Zande
107 North Main Street
Mooresville, NC 28115
www.zandehomes.com

Platt Architecture, PA; *page 221*

Bronco Construction; *page 201*

Cornerstone Builders; *page 205*

MOUNTAINS & UPSTATE

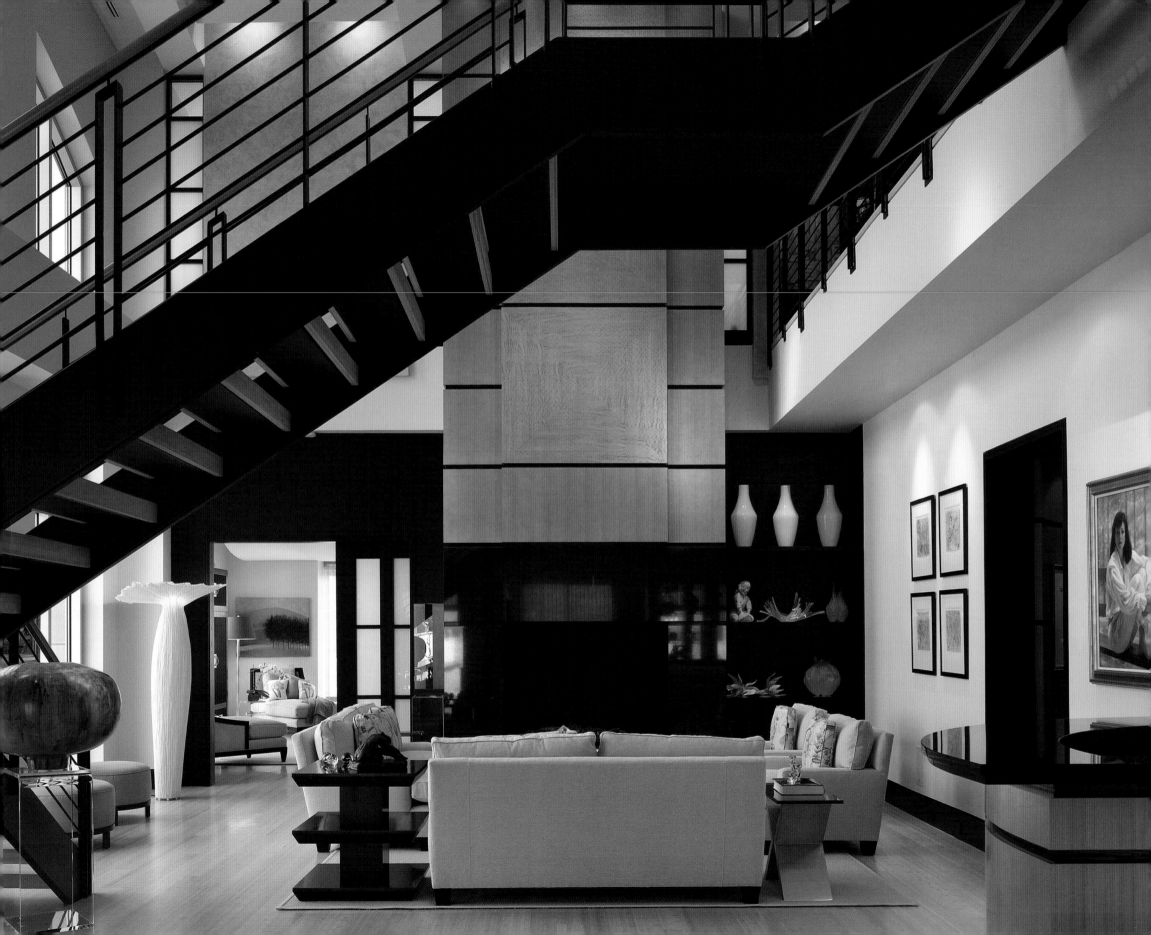

Frank Bain
Neal Prince + Partners Architects

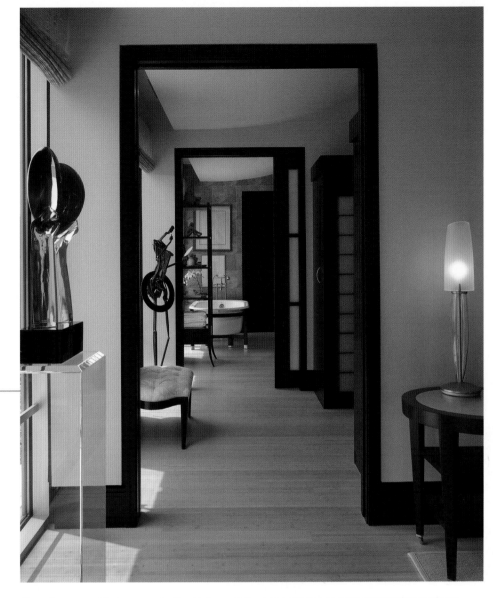

Above: Japanese architecture was a significant influence in the design of Heiwa, an award-winning urban penthouse. Through the gallery into the master suite, a wide range of materials such as bamboo, granite, marble and ebonized oak were used.
Photograph by Gary Knight Photography

Facing Page: Main-level living room of Heiwa, an Art Deco-inspired high-rise in Greenville, South Carolina. The 26-foot tall ceiling and a floating stair defines the space of the open floor plan. Anigre black paneling and black granite are consistently used throughout the home. Architects: Joel Van Dyke and Mike Martinez.
Photograph by Gary Knight Photography

When Jim Neal founded his firm as a sole proprietorship almost 40 years ago, he set his focus, energy and talent on designing some of the most innovative homes in the Greenville area. As the firm flourished, so too did its list of achievements including commercial, educational and religious structures (among them the Billy Graham Chapel in Asheville, North Carolina)—not to mention the addition of Robin Prince, who initially joined the firm in 1973 and became Partner in 1981.

"Sometimes our clients bridge into one or more of these project types," says Frank Bain, associate principal and director of the Neal Prince + Partners Architects residential studio. "It is a direct result of our residential work that we receive many of our commissions in other areas. Residential has always been a thread in this company."

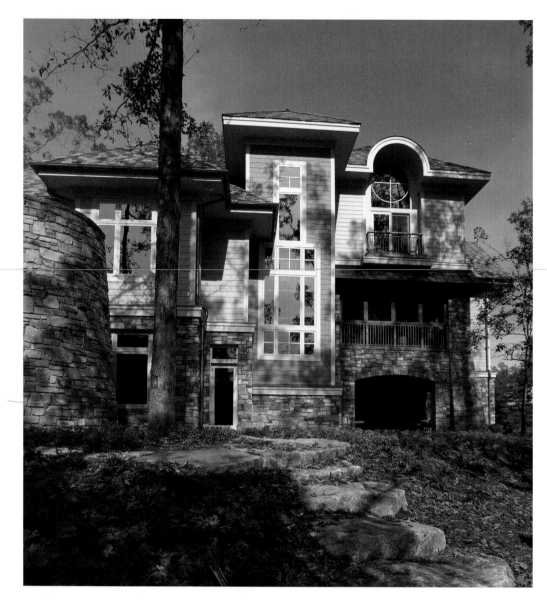

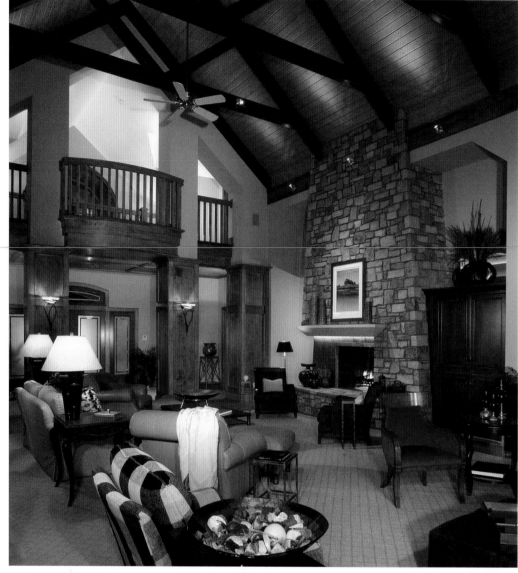

With more than 30 staff members, including licensed architects and interior designers, Neal Prince + Partners Architects continues to create stunning examples of residential architecture. Many of the firm's homes lean toward a more contemporary feel.

"We believe that for a house to become a home, it must fully capture the dreams of its users and the unique attributes of its setting," explains Frank. "From the outset we strive to promote a collaborative approach to design by fostering the client's participation in the process. From modest rural cottages to sophisticated urban penthouses, we prize each and every project that we undertake and take great pride in doing so."

Much of the firm's residential work is found in some of the most prestigious private communities in the western Carolinas from mountaintop developments in Brevard and Highlands, North Carolina to the shores of Lake Keowee in South Carolina. On average the firm designs three to five new

Above Left: The architect used varied exterior architectural forms to diminish the impact of the almost 10,000-square-foot home on Lake Keowee in South Carolina. Breathtaking views were created in multiple directions from every space in the home. Architects: Joel Van Dyke and Tommy Manual.
Photograph by Fred Martin Photography

Above Right: The great room features an open two-sided fieldstone fireplace, exposed roof beams, 180-degree views, plush furnishings and a concealed wet bar.
Photograph by Fred Martin Photography

Facing Page: Guests arrive into an enclosed courtyard. This intimate entrance provides a buffer between the motorcourt and foyer, creating a dramatic transition into the two-story great room.
Photograph by Fred Martin Photography

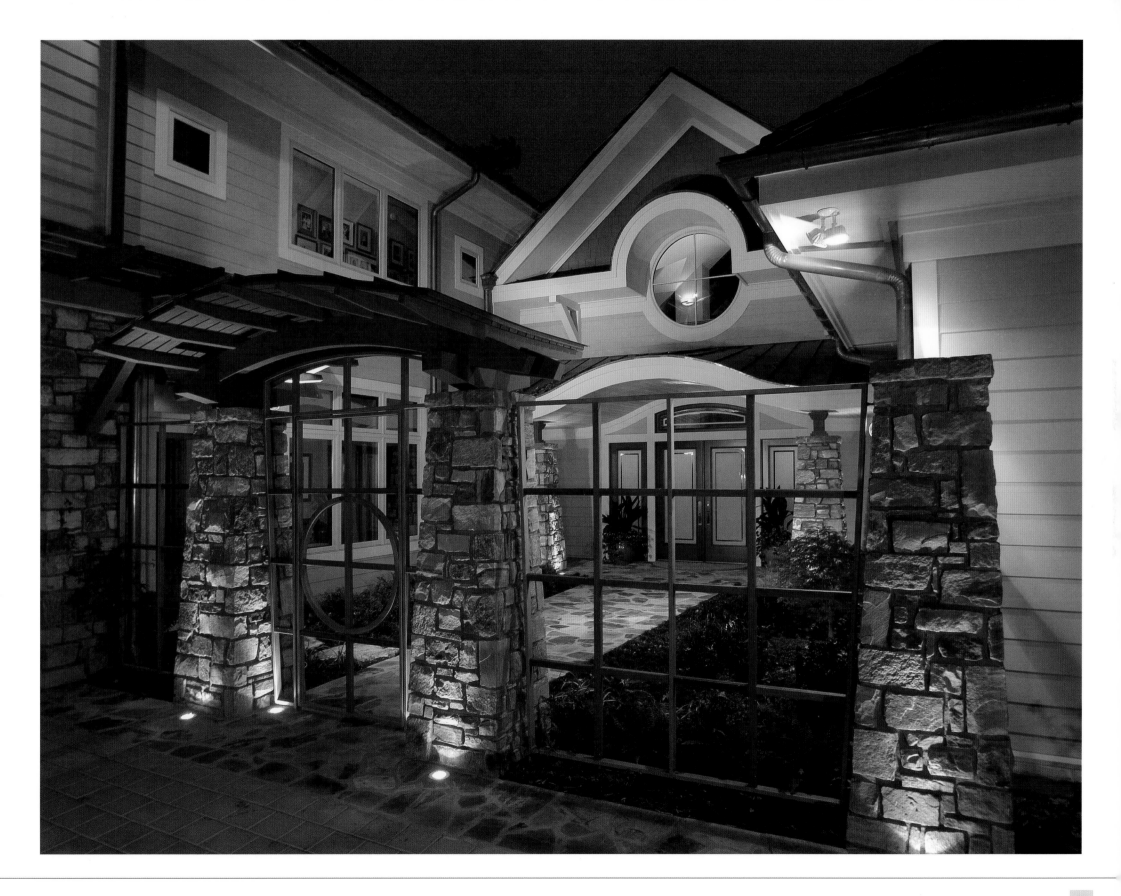

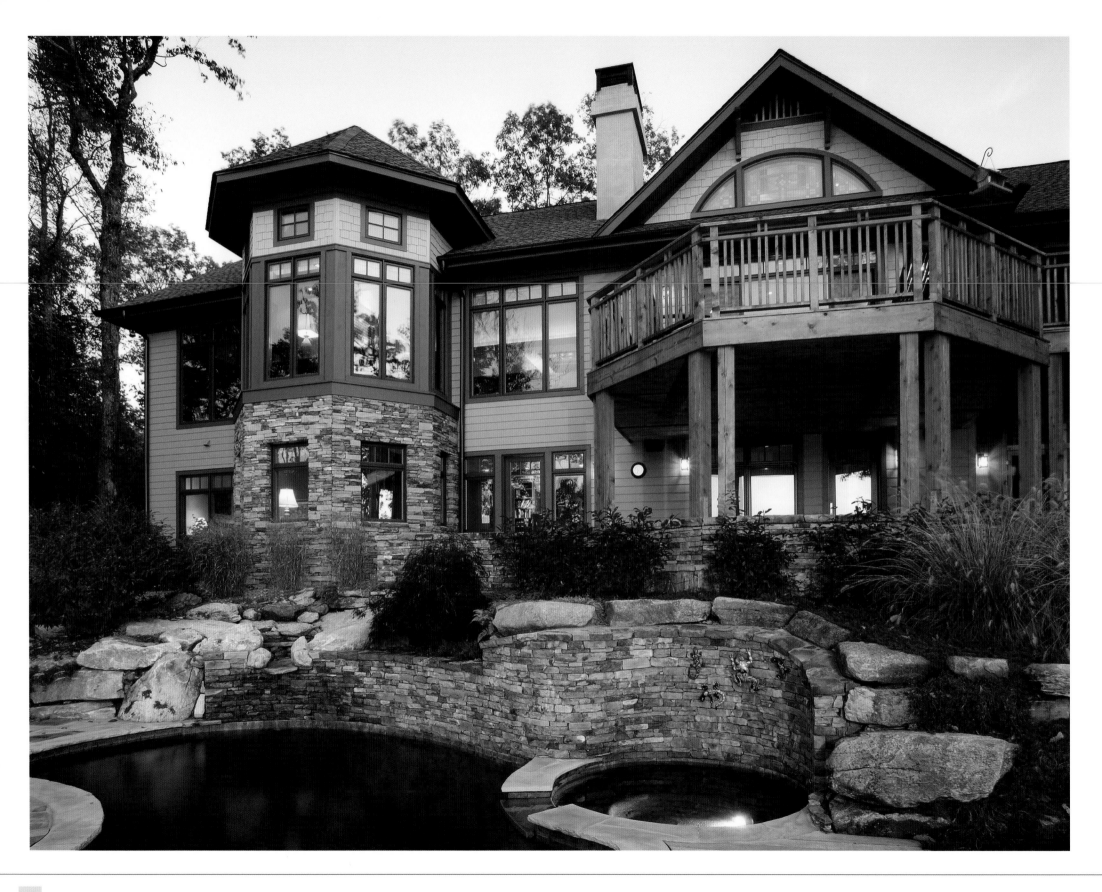

large-scale luxury homes a year. Neal Prince + Partners Architects' work is also in Greenville, of course, where the firm designs new homes as well as numerous renovations for some of the wonderful older homes in the downtown area.

"One of the things that I really enjoy about residential architecture is that you really form a remarkable bond and a relationship with the client that you simply can't do with any other project type," says Frank, who earned his bachelor's and master's degrees in architecture at Clemson University. "When we take a project on we really strive to get inside the client's head and figure out the most intimate details so that when the house is finished it's a part of them, and it speaks to them. I really enjoy working with individuals, figuring out how their family works and their daily routine—what they like and dislike. Many of our clients end up becoming friends once their home is complete."

Frank says the architects at Neal Prince + Partners Architects avoid designing in a particular style. "I think good design really transcends style. That's evident when you look at classic works of architecture that are timeless. When you get down to the root of those buildings, they're simply excellent designs," he says. "Design is much more important than style because good design is everlasting. It really is the design that drives a successful building."

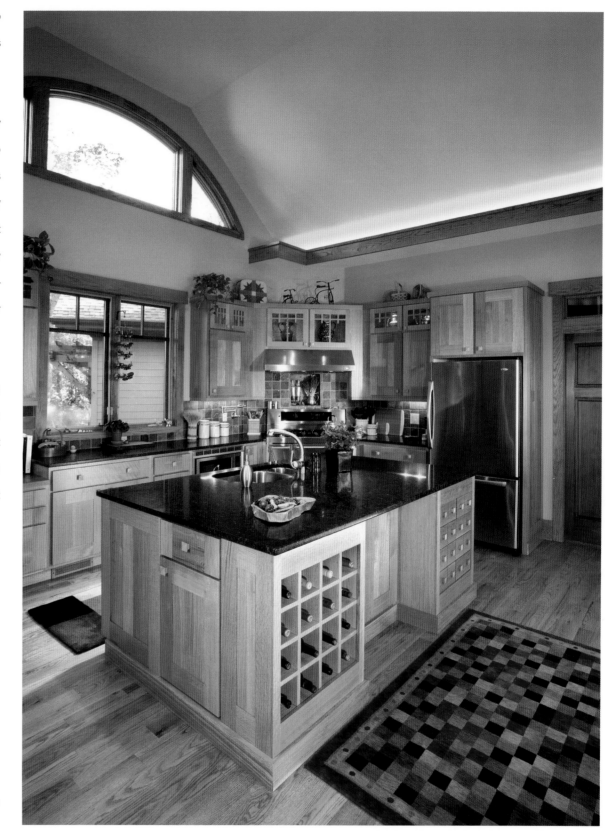

Right: The kitchen of this mountain retreat in Brevard, North Carolina features Arts-and-Crafts-style cabinetry integrated with solid granite counter workspaces and modern appliances. Architect: Chris Stone.
Photograph by Marc Lamkin

Facing Page: The viewside elevation allows the owners to see expansive views of the Blue Ridge Mountains not only from within the home but from large outdoor spaces as well.
Photograph by Marc Lamkin

One of the ways the firm resists imposing a strict architectural style is by making every home a collaborative project. Every home that Neal Prince + Partners Architects designs is a collaboration of several talented designers working together. It is not uncommon during a project to have open "pin-up" presentations where the client is very involved and participates in the expression of ideas. "This allows the design to be something the clients can take ownership of because they are so involved," explains Frank. "Our task is to help them make wise decisions."

Another way is by drawing inspiration from the physical landscape that surrounds the home. "Reconciling all these diverse elements often leads us off the beaten path to a road less taken, the exact place where our clients feel at home," explains Frank.

Incorporating a home into its site involves a deep respect for the environment—one that Neal Prince + Partners Architects takes seriously. "As architects in this day and age it can be very difficult to provide a successful solution for a project because the sites that we work with are already so beautiful. Our work alters the environment," says Frank. "To do that responsibly and as delicately as possible while still meeting the needs of the client and creating pleasing architecture that fits the land is challenging, but it's a challenge that we enjoy."

Featured in *Carolina Architecture & Design, Luxury Golf, Pinnacle Living,* and *South Carolina Homes & Gardens* magazines, the firm's work has also received numerous awards. In 1997, Neal Prince + Partners Architects was awarded the Twenty-Five Year Firm Award for "Notable Work" by the South

Carolina Chapter of the American Institute of Architects. The firm also won the 2007 Robert Mills Award, an Honor Award from the South Carolina Chapter of the American Institute of Architects, for the design of Heiwa, a private residence in Greenville.

When asked what his favorite project is, Frank cannot narrow it down to one. "Every project that you're working on becomes your favorite at the moment," he says. "I tell potential clients that when you're designing a home it's basically a prototype. You're designing prototype after prototype after prototype. There's nothing that's perfect about it, but you're always trying new things and experimenting, maybe trying to stretch the envelope a little bit to give them something that's unique, but most importantly, speaks to them personally."

Above: The central courtyard and elevated master bedroom deck afford the owner direct exterior access, light and views as well as opportunities for outdoor living, dining, entertaining or just relaxing.
Photograph by Fred Martin Photography

Facing Page: The design for this two-story, four-bedroom Adirondack-style mountain home balances comfort and elegance with natural materials to create a ruggedly sophisticated residence. Architect: Frank Bain and Tommy Manual.
Photograph by Fred Martin Photography

Q&A
more about Frank ...

DID YOU ALWAYS KNOW YOU WANTED TO BE AN ARCHITECT?
Growing up I was always interested in how things worked. I liked drawing very much as a child, and I liked to build so it just seemed to go hand in hand. I've never wavered from wanting to be an architect. I've wanted to be an architect ever since I can remember.

WHAT DO YOU ENJOY MOST ABOUT BEING AN ARCHITECT?
I enjoy the relationships that I build with our clients. They become more than clients; they become friends.

ARE YOU MECHANICALLY MINDED?
Yes, I'm curious about how all things work mechanically. I like to take things apart and put them back together so I can understand the components and how they work. It actually helps me as an architect. I've also renovated two older homes and have done a good portion of the work myself. That's helped me learn a lot, and I have an appreciation for the value of craftsmanship in construction.

WHAT DO YOU LIKE ABOUT DOING BUSINESS IN GREENVILLE?
It's just a very unique and thriving city. It's not as big as Atlanta and Charlotte, of course, but it has enough influence from other areas. It's got a cosmopolitan feel in some areas, but it also still has some very old traditional southern charm in certain ways.

Neal Prince + Partners Architects

Frank Bain, AIA
110 West North Street, Suite 300
Greenville, SC 29601
864.235.0405
Fax: 864.233.4027
www.neal-prince.com

Mark W. Barker
MWB Construction & Development

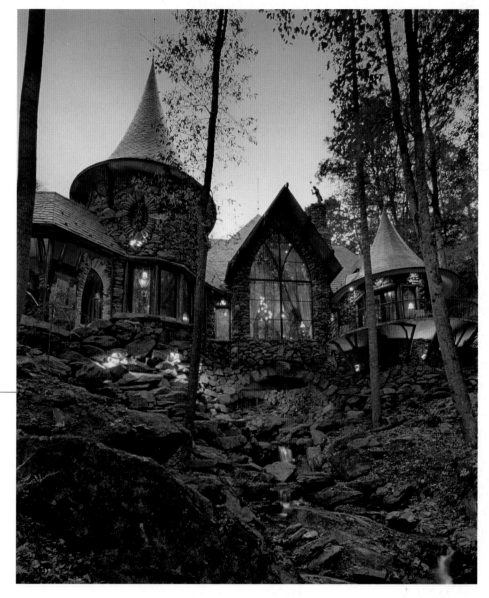

Above: This mountain home grows out of the natural setting creating a metamorphosis-like appearance.
Photograph by J. Weiland

Facing Page: This unique mountain home boasts an observatory at its top. A tower goes up through the stairwell without anything touching it so that nothing shakes the scope while an observer is looking through it.
Photograph by J. Weiland

Mark W. Barker started his construction and development business more than 20 years ago and looks at the custom homes he builds a little differently than most builders do. "We're not just building houses, we're building large pieces of art," says the Montreat native, who is known for his laid-back demeanor. "We're building sculptures that people can live in."

Based in Black Mountain, MWB Construction & Development is known for building unique custom homes on some of the most challenging sites in Western North Carolina. "Most people prefer to have a flat, square lot. I like to fit a home into the site instead of going in and grading the site. Integrating a home to a unique site is very important to me," explains Mark. "I'd rather have a hillside or a stream or some natural features to work with. Our goal is always to preserve and enhance the natural beauty of the site."

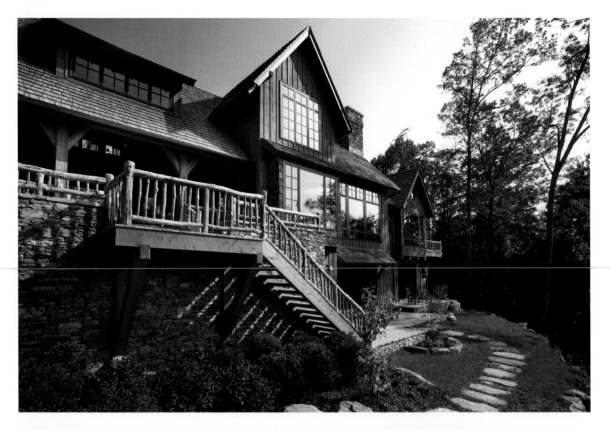

The average size of an MWB home is 4,000 to 5,000 square feet, although Mark has built homes as large as 18,000 square feet. In 2005, he built the *Southern Accents* Showcase Home in Madison County. The next year he built the HGTV 2006 Dream Home near Lake Lure. "That was a great experience and a lot of fun. The biggest challenge was the time frame," he says. "We only had seven months to construct a home that would normally take a year and a half."

A recent project involved a magnificent home in Biltmore Forest constructed with limestone and granite. Featuring terraces and a two-story grand hall, this structure exudes European charm. "This was a fun project because the owner was such a pleasure to work with," Mark says.

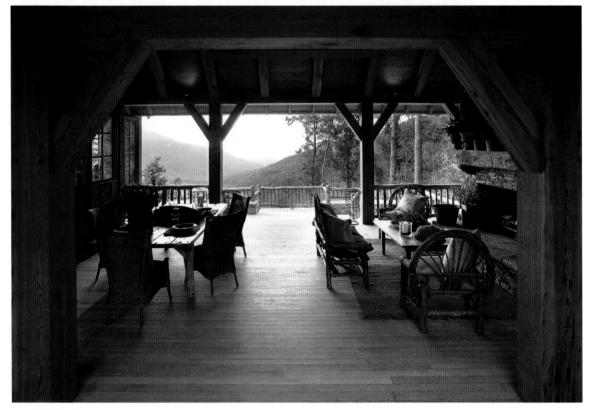

Top Left: The backyard of a mountain dream house reveals expansive windows to experience the breathtaking views.
Photograph by Eric Perry, Mid-Coast Studios

Bottom Left: This outdoor living space offers all the comfort of the indoors with amazing views.
Photograph by Eric Perry, Mid-Coast Studios

Facing Page Top: The rear façade of this home looks out onto the backyard with the valley beyond.
Photograph by Tim Burleson, Frontier Group

Facing Page Bottom: European elegance translates well in the mountains.
Photograph by Tim Burleson, Frontier Group

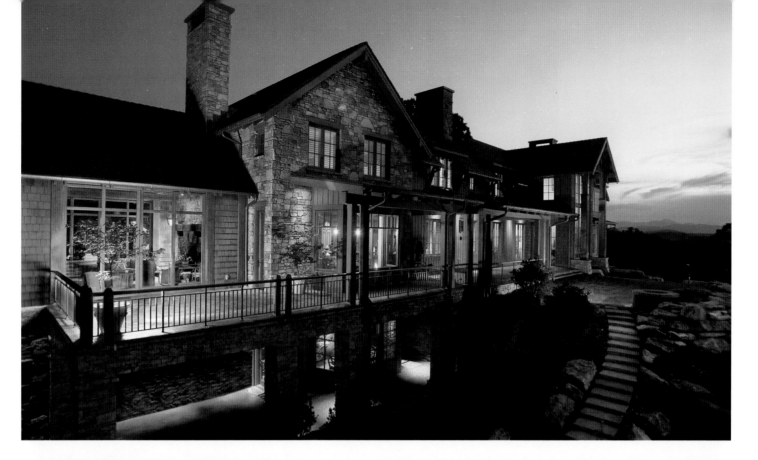

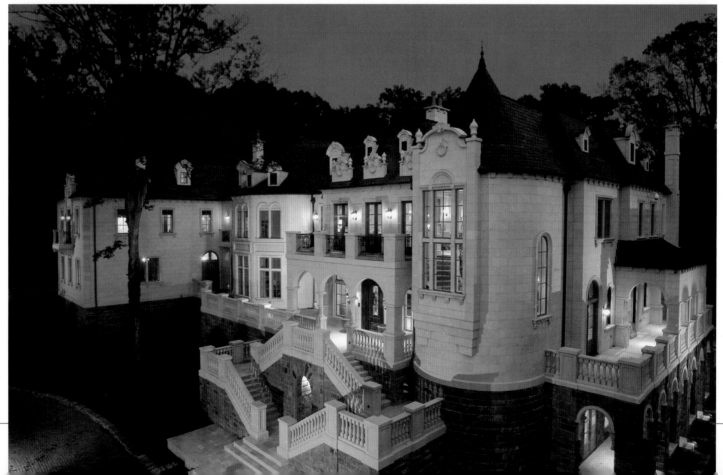

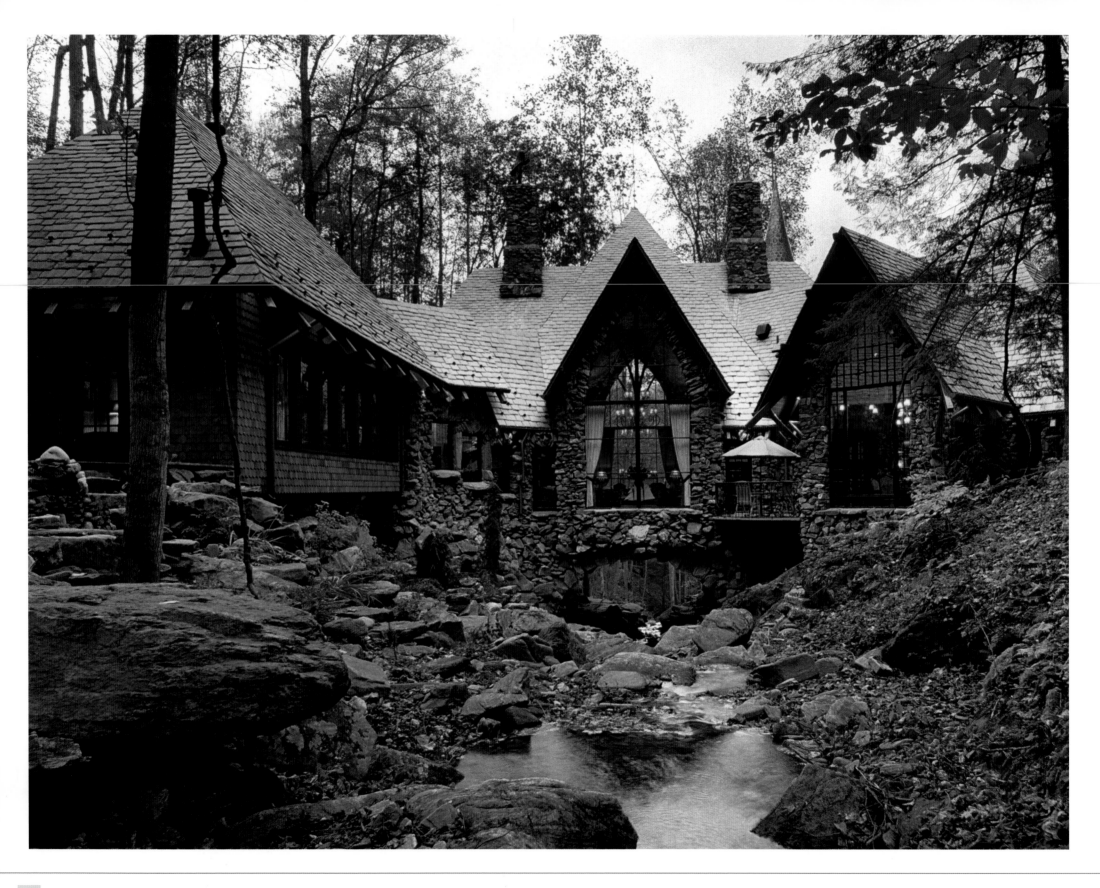

One of his favorite projects is "castle over the creek," a home he built for a couple in Yancey County with 1,000 tons of boulders culled from the home's 400 acres. The focal architectural point of the house is a 22-foot arch that spans a cascading stream. Featuring turrets, circular overhangs, irregular copper roof detailing, and gothic windows, the home looks as if it emerged from the earth naturally.

"Most of the detailing and finishes were designed on site. In addition to that, it was challenging to work across the creek and not disturb it. We had to build temporary bridges. We also couldn't get around the house so we had to be extremely creative in how we planned it," recalls Mark. "This house was a team effort, but the couple we built it for deserves all of the credit for the home's special design. They had the vision."

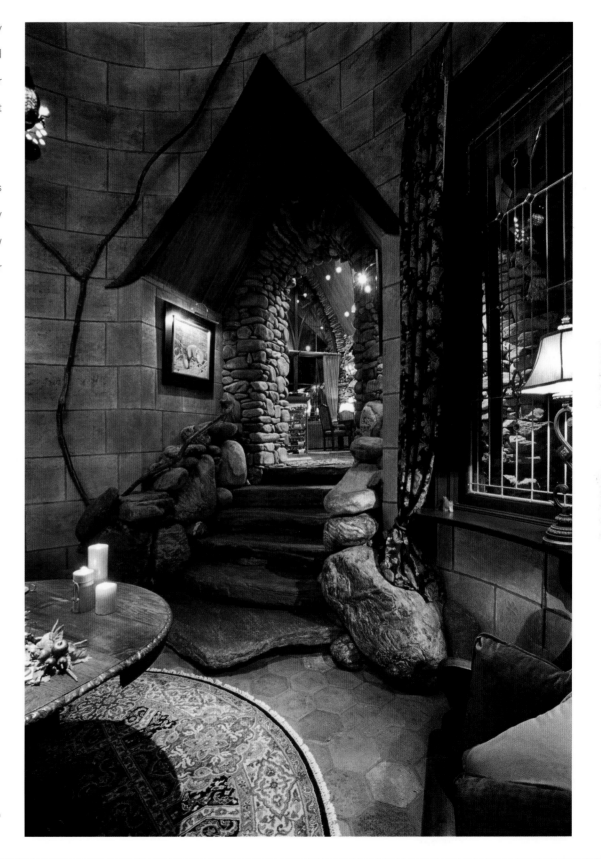

Right: Authentic stone stairs leading "to heaven."
Photograph by J. Weiland

Facing Page: This picturesque mountain home is actually built to incorporate the creek as a significant design element, with a lovely window placed perfectly to offer observers a stunning view.
Photograph by J. Weiland

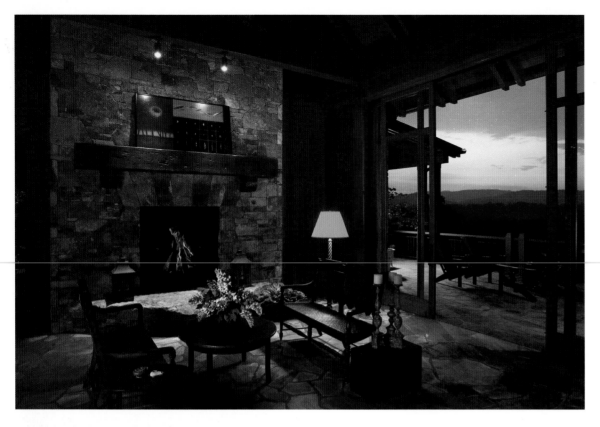

Working with a team of approximately 30 employees and many subs, Mark is involved with every project. Throughout the year he has six or seven custom projects going on simultaneously. Most of them span more than a year. "I work well with architects and clients, and I get really involved in the creative and technical end of it," he says. "It's just fun to do something different and something challenging. I never say no to what people want. Our motto is, 'If you can dream it, we can build it.'"

Mark also enjoys working on the physical aspects of a home and tries to incorporate environmentally sound materials into his projects. In 1995, he founded R-PRO, an insulation company in Fletcher, North Carolina that focuses on cellulose insulation. Made from recycled materials, this non-toxic insulation won't burn and contains no fiberglass or asbestos. R-PRO also sprays high thermal foam where it is best.

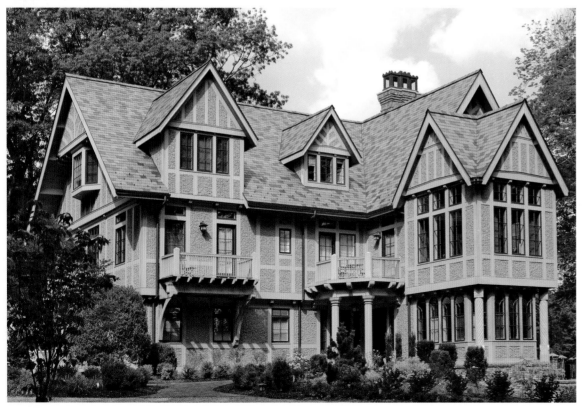

Top Left: This living area features glass pocket doors which transform the area into one large indoor/outdoor living space.
Photography by Tim Burleson

Bottom Left: This stunning home recalls storybook magic; it was designed by architect Robert Griffin.
Photograph by Mark W. Barker

Facing Page: This mountain Tudor home refines the ruggedness of its setting merely by its presence.
Photograph by J. Weiland

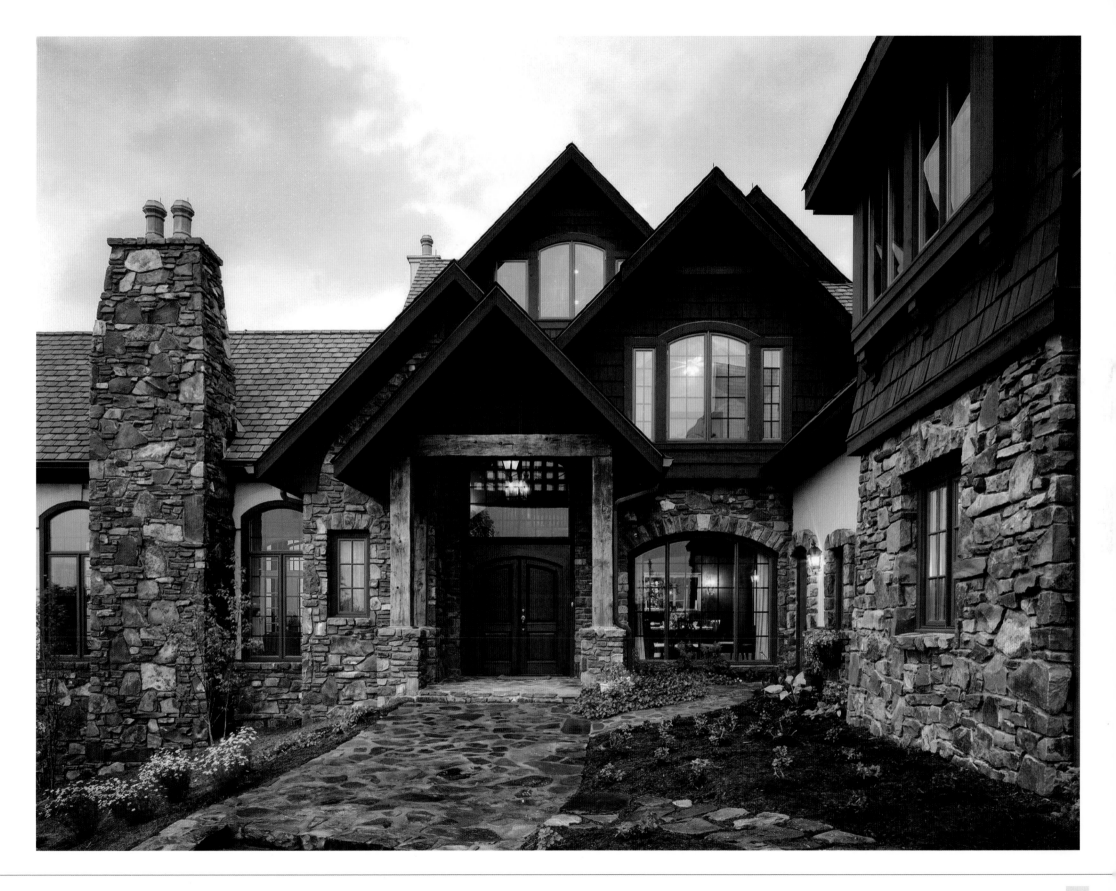

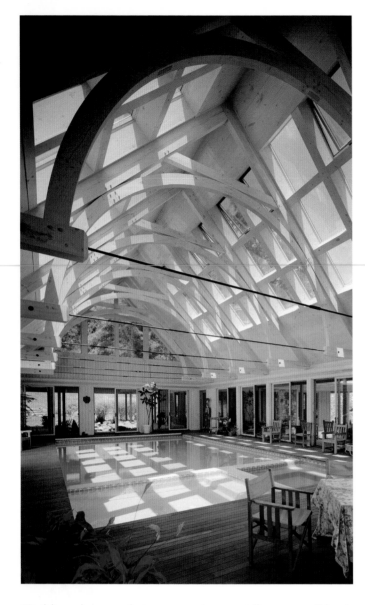

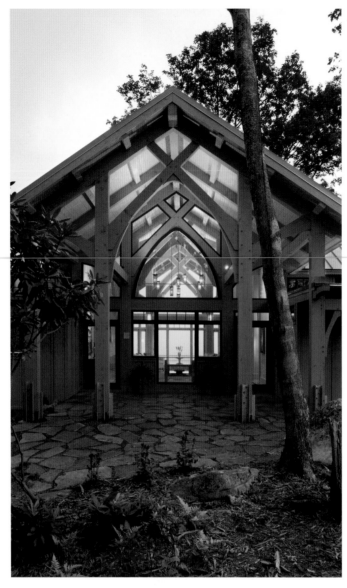

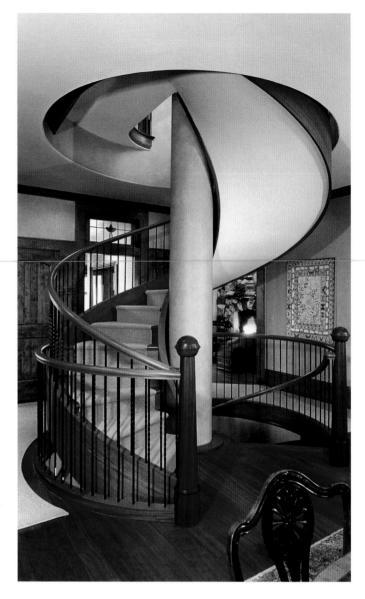

"Building homes that are environmentally responsible is important. Using this type of insulation is one way to do that. Using reclaimed materials is another way," explains Mark, who is an avid antiques collector. "I like to incorporate established pieces into a home such as old timbers, doors and mantel pieces. That's fun for me."

Having fun and keeping everyone happy is Mark's building philosophy, and it shows through in the relationships he has

with clients during the home-building process and after. "I never planned to be a builder," says Mark, who has a business degree from Tennessee's Covenant College. He considered law school and seminary school after graduation.

"While I was looking for a job, I got a job with a contractor. Then someone talked me into remodeling their bathroom. When it got to the point where the jobs were larger, business was good and I really enjoyed what I was doing, it just hit me. The happiest

day of my life was when I decided I was just going to build and never go back to school."

Above Left: Forty-eight skylights bathe this pool in natural light and warmth.
Photograph by J. Weiland

Above Middle: The Southern Showhouse complete with Jeld-wen custom wood windows and patio doors.
Photograph by Philip Beaurline

Above Right: This amazing winding stairwell leads to this mountain home's 42-foot rooftop observatory.
Photograph by J. Weiland

Facing Page: A view of North Carolina Craftsman home at dusk.
Photograph by J. Weiland

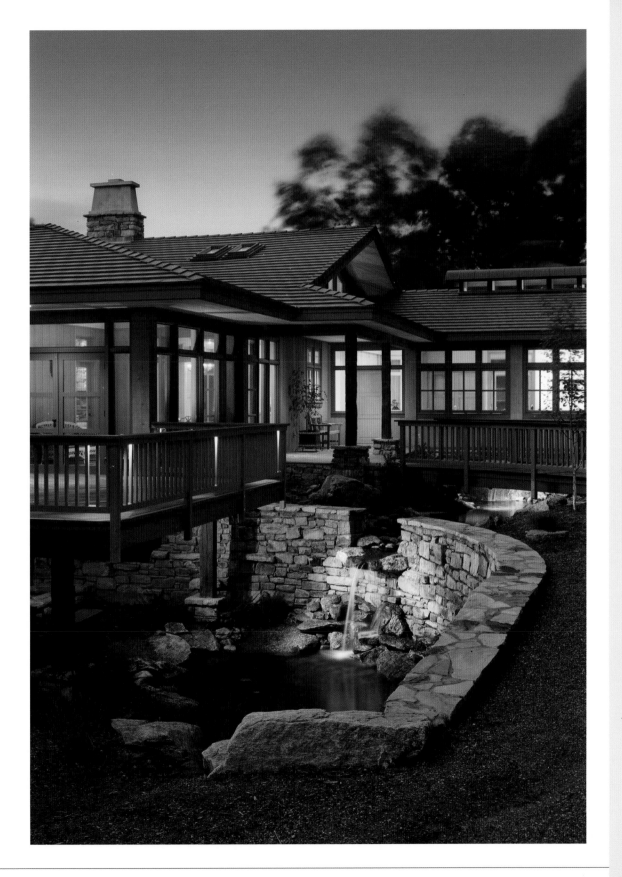

Q&A
more about Mark ...

ARE YOU AN ARTIST?

No, I'm not an artist although a friend recently called me an artist when he saw the carport I did on my home. Seriously, one day I'd like to paint pictures. I know that I'd like it.

WHAT DO YOU LIKE ABOUT DOING BUSINESS IN THE MOUNTAINS?

I guess the main thing I like about it is that it's my native place. It's where I grew up. I've always loved hiking and all the natural elements that are here.

WHAT DO YOU ENJOY ABOUT BEING A BUILDER?

The creative part of it. I get extremely involved in the creative process and the design of a home. I work very well with architects and their ideas and the owners and their ideas to make their dreams come true.

CAN YOU IMAGINE DOING ANYTHING ELSE?

No way.

Photograph by Michael Valentine

MWB Construction & Development

Mark W. Barker
PO Box 1228
Black Mountain, NC 28711
828.669.4525
Fax: 828.669.0134

www.mwbconstruction.com

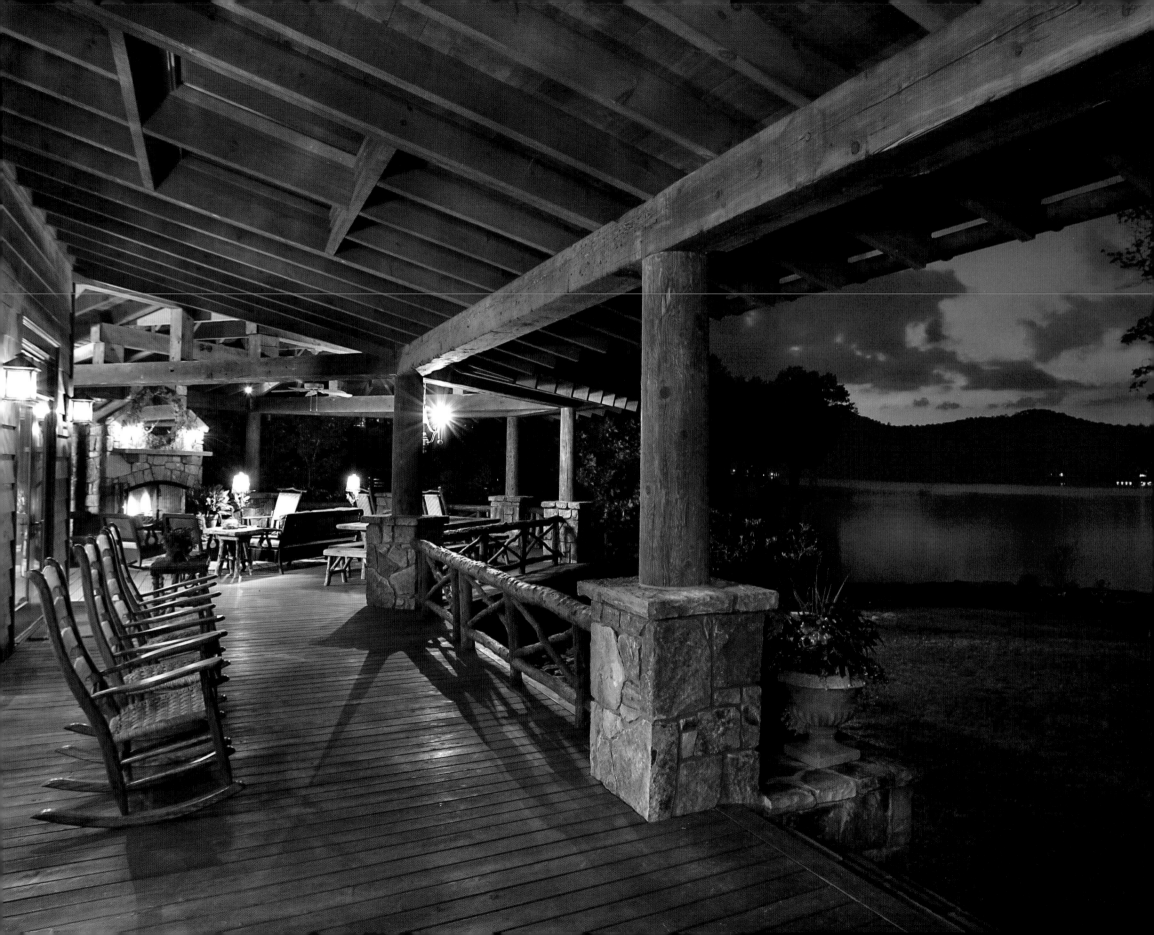

Bob Dylewski
Bronco Construction

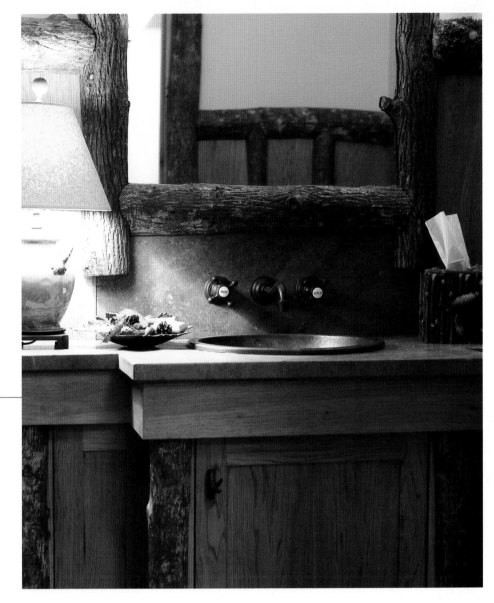

Above: Local hickory split logs frame the mirror, vanity and wainscot panels of this rustic powder room. Bronco Construction uses natural, local materials whenever possible.
Photograph by Tim Burleson

Facing Page: This expansive and inviting wood deck creates a spectacular outdoor living area in a Lake Toxaway residence. The intricate roof is framed with reclaimed beams which are supported by standing dead cedar posts.
Photograph by Tim Burleson

Bob Dylewski moved Bronco Construction from Florida to the North Carolina Mountains in 1998 so he and his family could enjoy the beautiful outdoors and lifestyle that the area offers. Since then he has earned the reputation for building custom homes of the highest quality. "I tell my clients that I'm going to build their house the way I would build my own," says Bob. "I want to build a home that has long-term value."

Located in Mills River between Asheville and Hendersonville, Bronco Construction typically builds homes from 3,000 to 12,000 square feet. They can be found in such places as Lake Toxaway and Balsam Mountain Preserve in Waynesville. With experienced management and a team of highly skilled mechanics and craftsmen, Bob builds both primary and secondary homes for families. In many cases clients want a legacy home that can be passed down and enjoyed for generations.

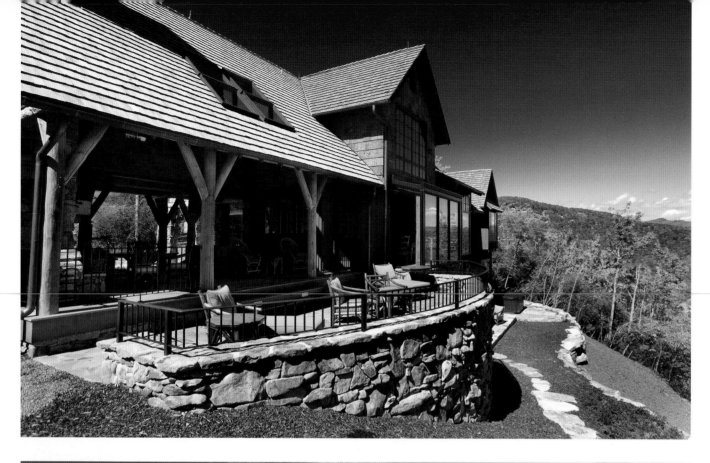

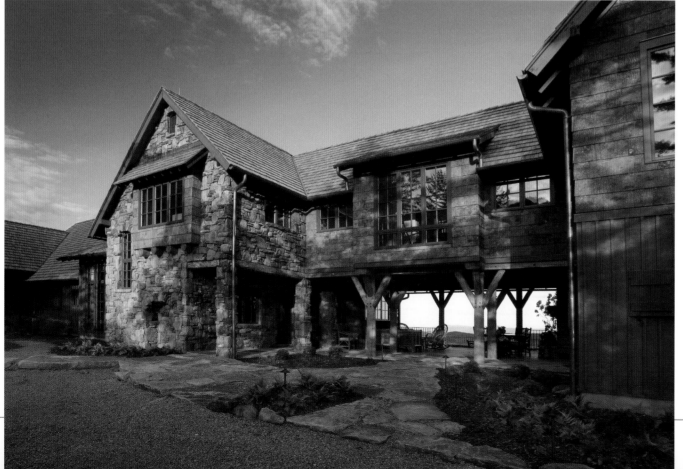

"When people build a custom home, they want the home to say something about them personally," says Bob. "We work closely with the architect and interior designer to help the owner create something that is uniquely theirs."

Bob enjoys incorporating reclaimed materials from local old barns and buildings into his projects. "It gives the home a connection to the history of our area that people can relate to," says the Pennsylvania native. "Many of our clients come from other parts of the country, and they want their home in the mountains to have a connection to the local materials and craftsmen."

By becoming personally involved in the building process, Bob and his team build relationships with their clients. "It is important to be a good listener, and to understand what a client's tastes and priorities are," says Bob. "We try to pay very close attention to the smallest details of all our projects."

With every project Bob's goal is to exceed his client's expectations. "Clients put a tremendous amount of trust in us, and we take that very seriously," says Bob. "Integrity is so important in this business. We make every effort to take our clients by the hand and lead them through the building process so that we can build something special and unique. We want it to be an enjoyable, rewarding process."

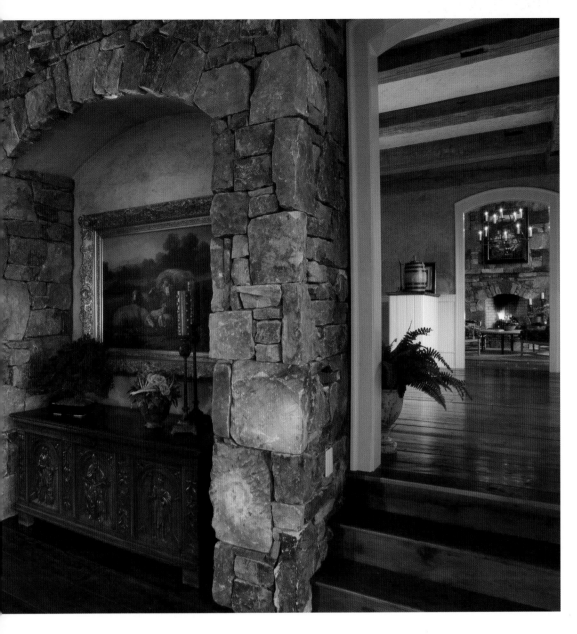

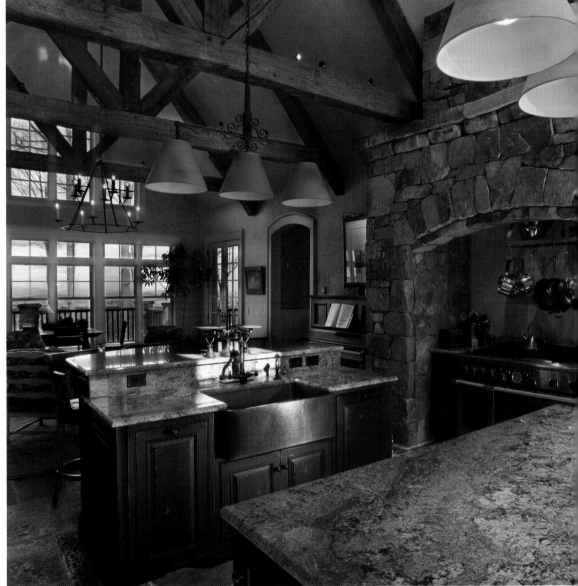

Above Left: Old original face pine flooring, Venetian plaster and antique hand-hewn beams create the Old World décor of this home in Flat Rock, North Carolina.
Photograph by Tim Burleson

Above Right: The reclaimed hand-hewn timber frame trusses are fashioned together utilizing true mortise and tennon joinery with wooden pegs. Bronco Construction uses original old materials and building techniques whenever the opportunity presents itself.
Photograph by Tim Burleson

Facing Page Top: As seen in this residence, placement and site/landscape design are critical when building on the challenging sloped sites of western North Carolina.
Photograph by Tim Burleson

Facing Page Bottom: Local North Carolina fieldstone and poplar bark siding were blended together to create a rustic exterior and define the strong architectural elements of this home on Toxaway Mountain.
Photograph by Tim Burleson

Bronco Construction

Bob Dylewski

4669 Boylston Highway
Mills River, NC 28759

828.891.2782

Fax: 828.891.2783

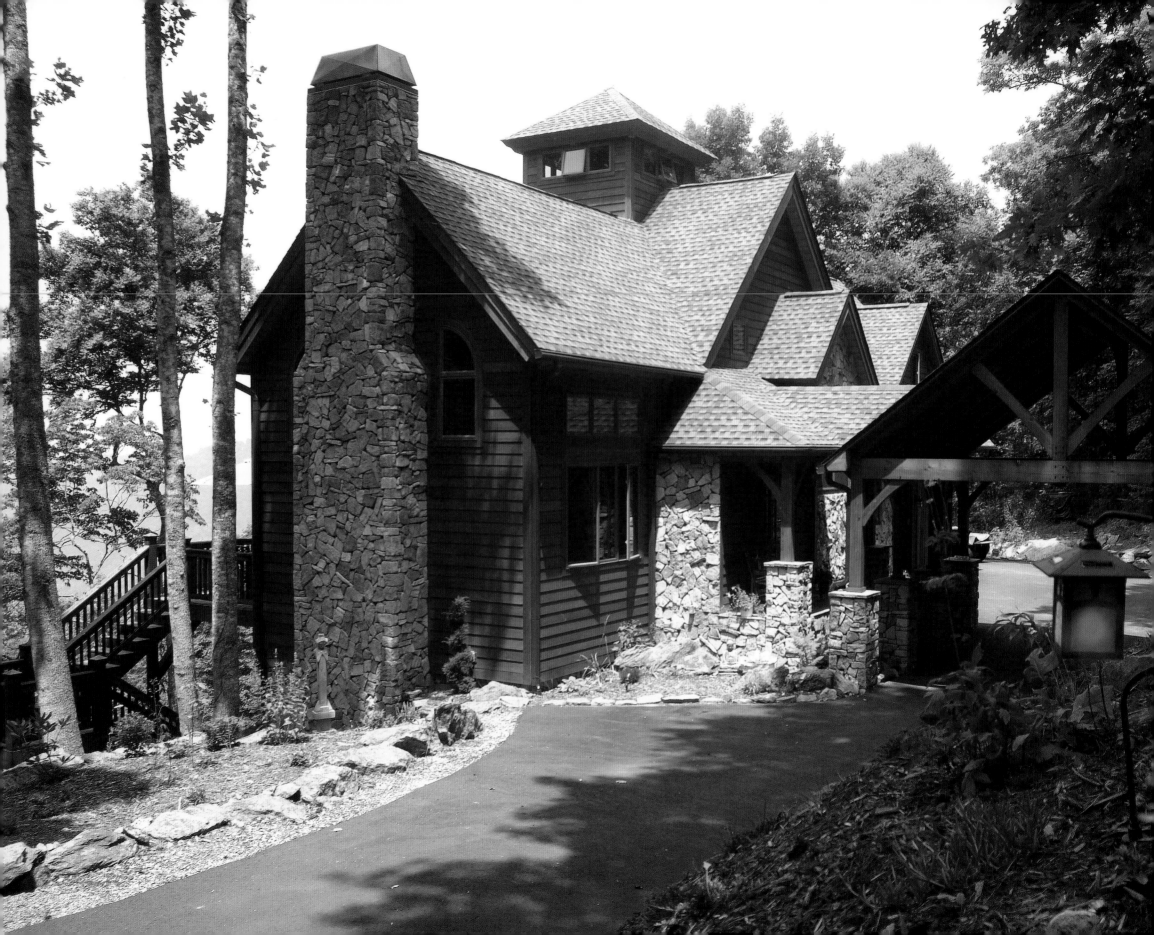

Steve Frellick
Cornerstone Builders

Above: A graciously sized porch captures the serenity and beauty of the mountains.
Photograph by Michael Valentine, Valentine Design

Facing Page: The Martin/Korp residence is beautifully integrated with its steeply sloping site.
Photograph by Michael Valentine, Valentine Design

After a year of law school, Steve Frellick decided that was not the career path he wanted to take. Instead he began working in a field he had always enjoyed—construction. "Deep down I think I always knew I wanted to be a builder," recalls Steve. "My grandfather renovated and built homes, and he taught me about woodworking and craftsmanship. When I was in school I worked in construction during the summer so I was introduced to the industry at a young age and have always gravitated towards it."

After learning about the building process by working for various construction companies, Steve founded Cornerstone Builders in Chicago in 1995. Three years later he moved his business to the Asheville area. Now, with a team of 12, including his brothers Brian and Dean, Steve has quickly become one of the premiere custom homebuilders in Western North Carolina.

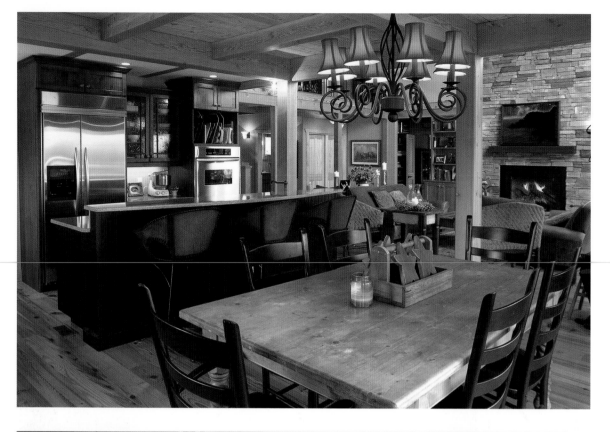

"We're a family business that specializes in custom Timberpeg timber-frame homes," explains the Michigan native. "These high-end homes blend well into the environment here. Our clientele is mainly comprised of people who are looking to retire or settle in the mountains, and they want a home that really fits in with the area."

Framed with either white eastern pine or Douglas fir, Timberpeg homes feature post-and-beam construction coupled with uncompromised quality. Ken Wertheim, an architect who is also the independent representative for Timberpeg in Asheville, designs most of the homes Frellick and his team build.

A member of Asheville's Green Building Council and the North Carolina HealthyBuilt Homes Program, Steve incorporates environmentally friendly building methods into all of his projects. Cornerstone is the exclusive builder for both The Crossings at Cane Creek, a new 54-acre development in Asheville where all the houses will be certified North Carolina HealthyBuilt Homes, and The Falls at Edenderry. Both developments will incorporate Timberpeg designs.

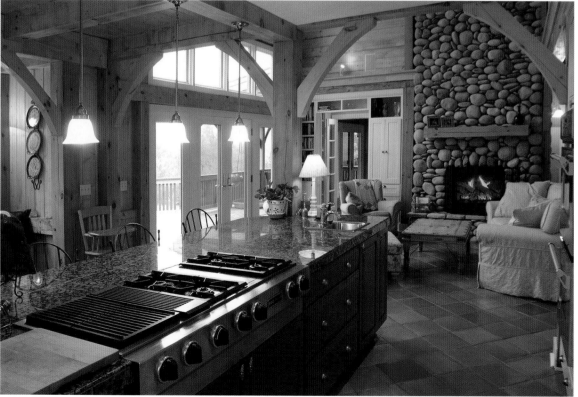

Top Left: Changes in ceiling height and detailing distinguish the Hosey residence's adjoining great room and cozy mountain kitchen.
Photograph by Michael Valentine, Valentine Design

Bottom Left: Wood paneling and natural stone create a relaxing ambience within this home located in The Falls at Edenderry.
Photograph by Michael Valentine, Valentine Design

Facing Page: Outdoor living at its best, the deck overlooks Lake Lure and the Great Smoky Mountains in the distance.
Photograph by Michael Valentine, Valentine Design

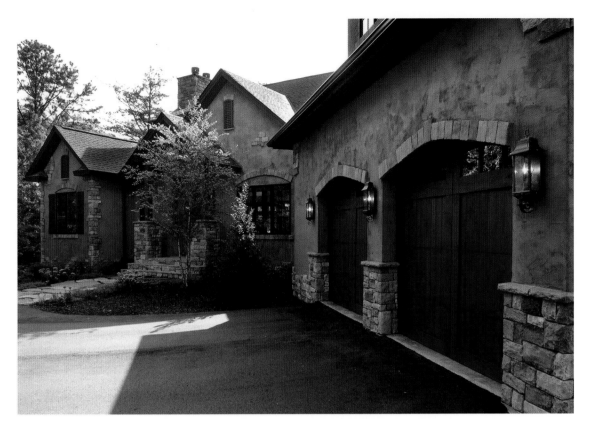

Steve believes in staying personally connected to all of Cornerstone's projects and has assembled a team of subcontractors and suppliers who are just as dedicated. "We're very closely involved with our projects and our clients, and we also pay close attention to the quality of our homes, making sure that we deliver the best product possible," says Steve, adding that his company builds four to six homes a year. "We're a small, hands-on company, and we want to stay that way. We've created a niche while building our name on quality and caring about each project individually. Whether it's a $500,000 home or a $5 million home, we're closely involved with our clients throughout the entire process."

Above: Thoughtful design, earthen materials and fine craftsmanship combine in this Knob Hill residence.
Photograph by Michael Valentine, Valentine Design

Facing Page Left: Natural light cascades through the carefully positioned windows of the Martin/Korp residence.
Photograph by Michael Valentine, Valentine Design

Facing Page Right: Located in Lake Lure, North Carolina, the Timberpeg-constructed home boasts beautifully vaulted ceilings and a profusion of natural materials.
Photograph by Michael Valentine, Valentine Design

Q&A
more about Steve ...

WHAT BROUGHT YOU TO THE ASHEVILLE AREA?

We vacationed here and really liked the people. We simply loved the area. When we were in Chicago my brother Brian and I were more focused on "This Old House" type home renovations. Moving down here afforded us the opportunity to get into new, custom home construction.

WHAT SIZE HOMES DO YOU BUILD?

We've built homes as small as 1,600 square feet and as large as 9,000 square feet, but the true character of a home is not in its size, but rather in the quality and craftsmanship represented.

WHAT IS YOUR BUILDING PHILOSOPHY?

For me, this business is about building something that matters to someone. The most important thing is the people involved.

WHO HAS INFLUENCED YOU THE MOST?

As a builder it would be Bob Schultz, my mentor in Chicago. In my life it would be my entire family.

Cornerstone Builders

Steve Frellick, Builder

Brian Frellick, Project Manager

Dean Frellick, CFO

170 Old Fort Road

Fairview, NC 28730

828.628.0669

Fax: 828.628.4212

www.buildcornerstone.com

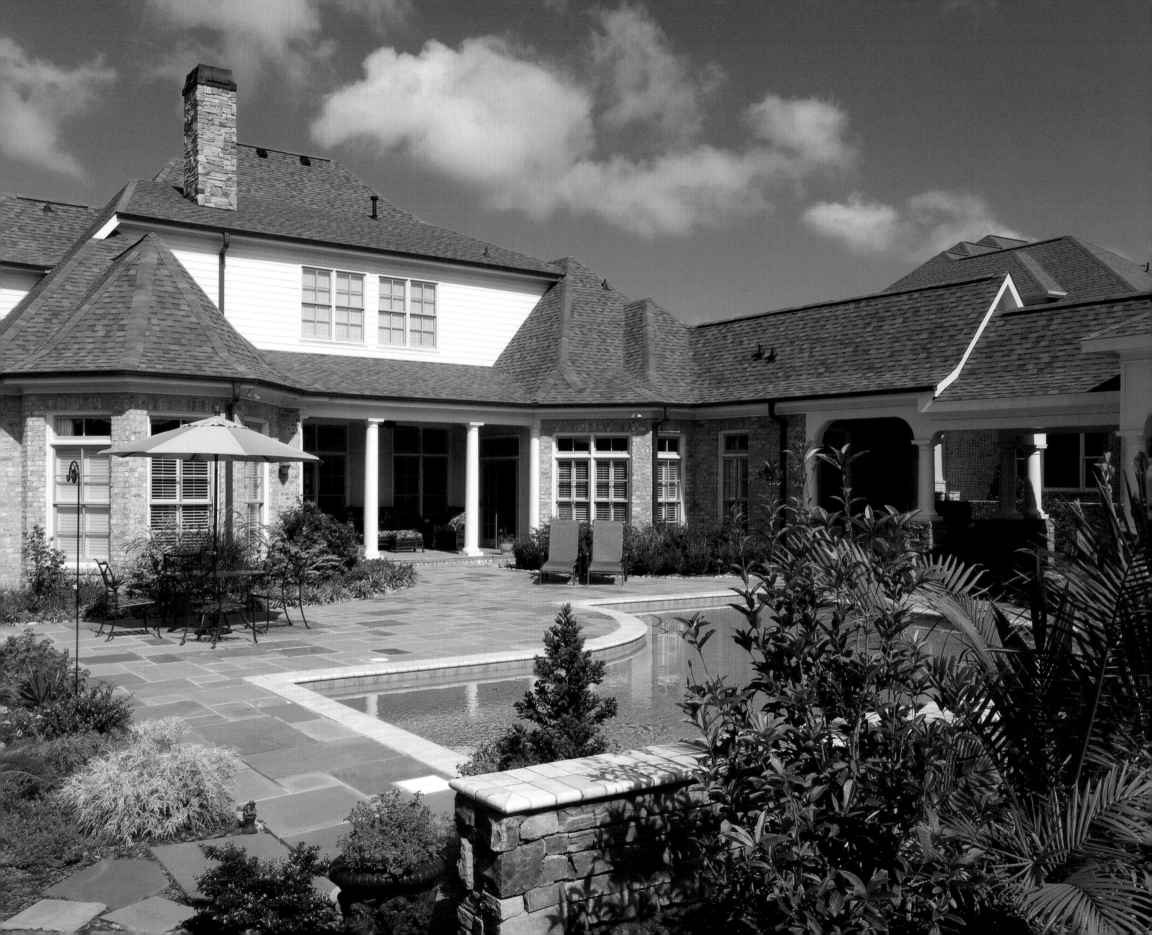

Mark Galloway
Michael Galloway
Galloway Custom Homes

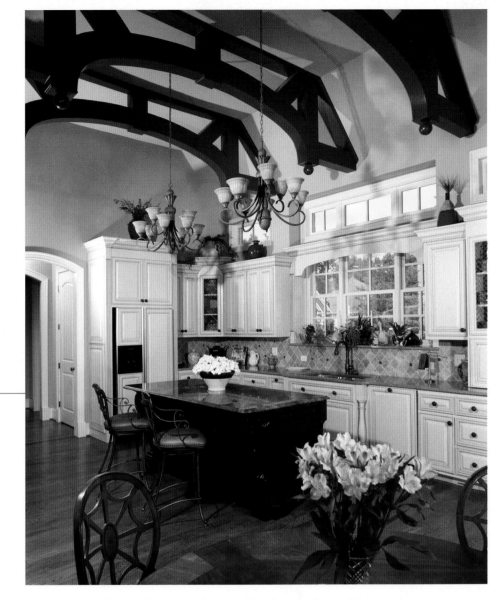

Above: Handcrafted decorative beams accent the ceiling of this elegant but functional kitchen.
Photograph by Stephen Stinson, Fisheye Studios

Facing Page: A sun-drenched poolside patio with a covered porch and breezeway are the focal point of this home's backyard.
Photograph by Stephen Stinson, Fisheye Studios

Whether they are meeting with a client on site or selecting nails for Trex decking, brothers Mark and Michael Galloway focus on client satisfaction when they build a home. Tutored by their father, R. C. Galloway, who has over 40 years of experience in the building industry, Mark and Michael started Galloway Custom Homes in 1989 and build 10 to 12 custom and spec homes a year in some of Greenville, South Carolina's most exclusive neighborhoods, including: Chanticleer, Claremont, Hammett's Creek, Kilgore Plantation, Kingsbridge and Thornblade.

"We've basically drawn a 30-mile radius around our office. If a project is outside of that radius, we simply won't take it on unless we are personally able to stop at our sites at least once a day to make sure that everything is going well," explains Michael, adding that their company does not employ superintendents. "We have a set of subcontractors that have taken us years to develop. From brick masons to interior designers, we partner with the most innovative, seasoned professionals to provide the best in craftsmanship and services for our clients."

Predominantly builders of traditional architecture, most notably French Country, the Galloway brothers work with local architects to bring a client's vision to life. They also work with clients who bring their own architects into the process. "Through meetings, e-mails and phone calls, we have excellent one-on-one communication with our customers," says Michael. "That's important because we want to make sure they know that we're truly building a custom home and not just another spec house."

A Galloway home ranges in size from 3,600 square feet to 10,000 square feet with a price range of $450,000 to $1.75 million. "Our best selling point is to take a prospective customer into one of our homes when it's completed," says Michael. "People instantly see our attention to detail through the moulding we use and just our finish work in general."

Featured in *South Carolina Homes & Gardens* magazine and *Builder/ Architect* magazine, Galloway Custom Homes is known for building a quality product. "We take pride in customer satisfaction," says Michael. "If a client comes to us with a legitimate problem with their home even years after we've built it, we'll usually take care of it just to maintain goodwill. It doesn't make sense to jeopardize that trust and relationship over minor issues even after the standard warranty period. Open and honest communication is the foundation of our company."

Left: A simple yet inviting formal dining room.
Photograph by Stephen Stinson, Fisheye Studios

Facing Page Top: A view into the great room showing custom handcrafted fluted columns along with a coffered ceiling.
Photograph by Stephen Stinson, Fisheye Studios

Facing Page Bottom: Mahogany cabinetry accented with a black glazing adds a personal touch to this kitchen.
Photograph by Stephen Stinson, Fisheye Studios

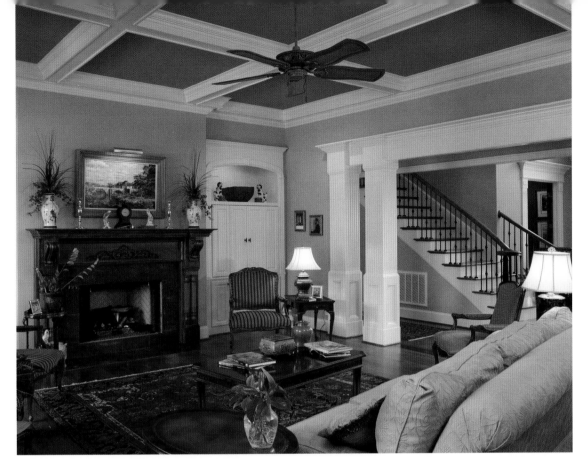

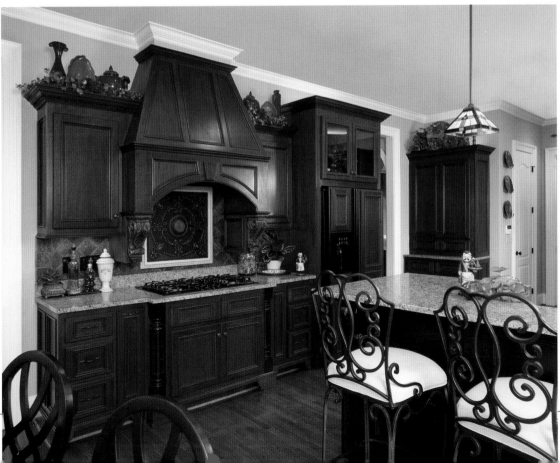

more about Mark and Michael ...

WHAT WOULD YOU SAY IS THE BEST COMPLIMENT YOU HAVE RECEIVED PROFESSIONALLY?

We've been told by several homeowners we have built for that the next time they build a home they would not even bother with a quote from other builders. That to me is the best compliment a builder can receive.

WHAT IS THE MOST CHALLENGING PROJECT THAT YOU HAVE DONE?

Projects outside the Greenville area are the most challenging because it stretches us thin when we have to go out of our normal area. We try to stay close to home.

WHO HAS HAD THE BIGGEST INFLUENCE ON YOUR CAREER?

Our father, R. C. Galloway. You can imagine how easy the transformation was for us in starting our own company after learning from him. We automatically cut out years of miscues by having his expertise to guide us. He is now semi-retired and is a consultant for us.

WHAT DO YOU LIKE BEST ABOUT BUILDING HOMES?

It's very rewarding, not only for us but for the homeowner too, after months of meetings with architects, interior designers and contractors to see the final product. When you have a good team and everybody's input is taken into consideration during the construction process, you can count on the final product being outstanding.

Galloway Custom Homes

Mark Galloway
Michael Galloway
129 Woodruff Place, Suite A
Simpsonville, SC 29681
864.289.9994
Fax: 864.289.9978
www.gallowaycustomhomessc.com

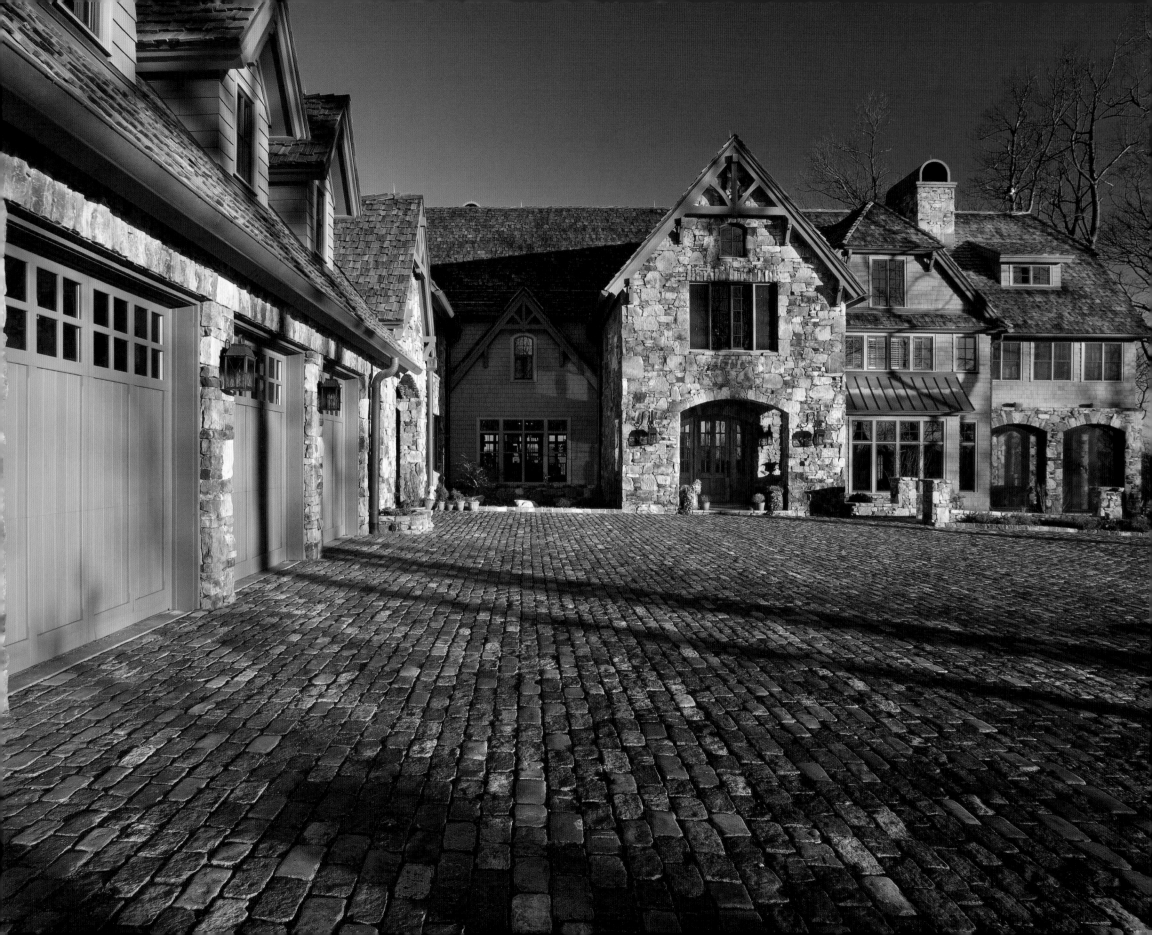

Tim Greene

Tim Greene and Associates

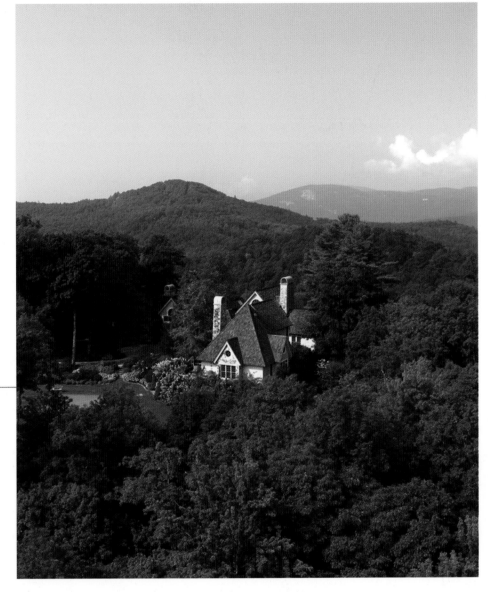

Above: A custom mountaintop home with view overlooking the beautiful Smoky Mountains. Homes designed by Tim Greene and Associates reflect the character and taste of each client.
Photograph by Gil Stose

Facing Page: Native stone, metal and cedar shingles are combined to create the façade on this elegant 11,000-square-foot home and carriage house garage.
Photograph by Tim Burleson, Frontier Group, Inc.

Tim Greene and Associates is housed in an office complex made of reclaimed materials from barns, mills and warehouse structures. Greene designed and built the complex in much the same way he designs and builds custom homes. "By using native materials such as stone, bark and reclaimed barns, paneling and hardwood flooring we have come up with a unique style indigenous to the area. We try to use proven techniques and materials in our designs," explains Tim.

Like most folks who move to Cashiers, Greene was lured to the area 30 years ago by its casual mountain lifestyle. At an almost 4,000-foot elevation, Cashiers offers some of the freshest air in the state, not to mention some of North Carolina's most breathtaking views. Greene's team takes all of that into account during the design process. Every site is topographically surveyed so that they know where each and every tree is located.

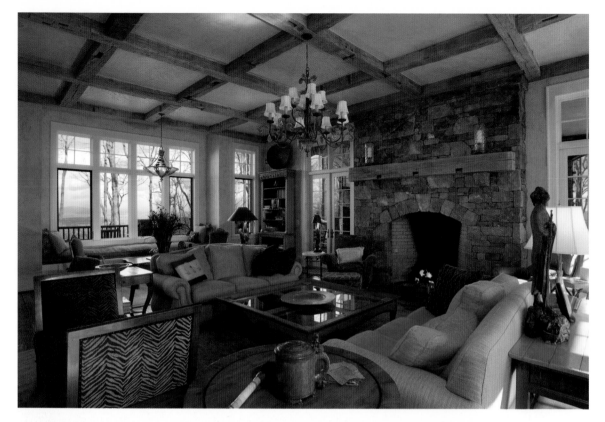

"It's important to take into consideration the site's conditions. We try to save every tree we possibly can," says Tim. "We designed a house around a hemlock tree that held the state record. Eighteen years later the hemlock is still there, and it's still healthy."

Tim views designing and building homes as a service business. "You've got to be attentive and listen to what the client wants. Hopefully, we interpret the client's wishes in a unique way," he says. "We want to create a structure that functions around the client's lifestyle."

Because of Cashiers' natural beauty, it is essential that Tim's designs bring the outdoors into the interior of the home. One way he brings more natural light into a home is by incorporating lots of glass and windows into his designs. "If you have French doors that are protected, you can leave them open, and it brings the smells and the sounds of the outdoors in," says Tim. "It really makes a big difference. That's what most people are up here for."

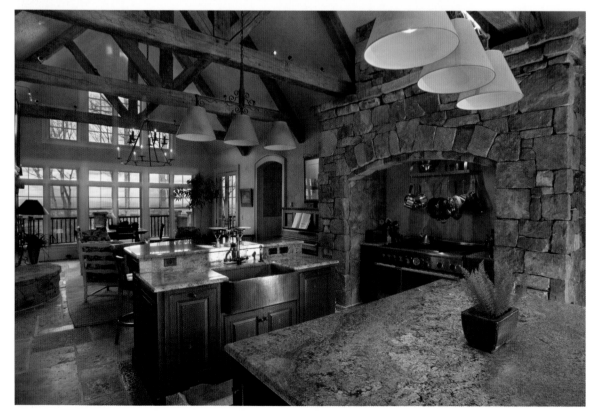

Outdoor rooms are another way for clients to enjoy the area's natural environment. Tim says his firm was one of the first to introduce the outdoor living concept by featuring outdoor fireplaces and kitchens in addition to screened enclosures into its designs.

Not only has Tim incorporated outdoor rooms into his mountain homes, but he has also included them in homes he's designed for Kiawah Island in South Carolina, as his firm's work spans across the Southeast from Florida to Virginia. The firm has also done work in Colorado.

Top Left: The coffered ceiling and stone fireplace with old beam mantel invites warmth and coziness into the living room.
Photograph by Tim Burleson, Frontier Group, Inc.

Bottom Left: Interesting truss work throughout the kitchen and a unique arched cooking center adds to the functionality as well as to the beauty of this inviting space.
Photograph by Tim Burleson, Frontier Group, Inc.

Facing Page: The grand entry foyer and staircase, with a handmade staircase lead to the second floor with sweeping mountain views.
Photograph by Tim Burleson, Frontier Group, Inc.

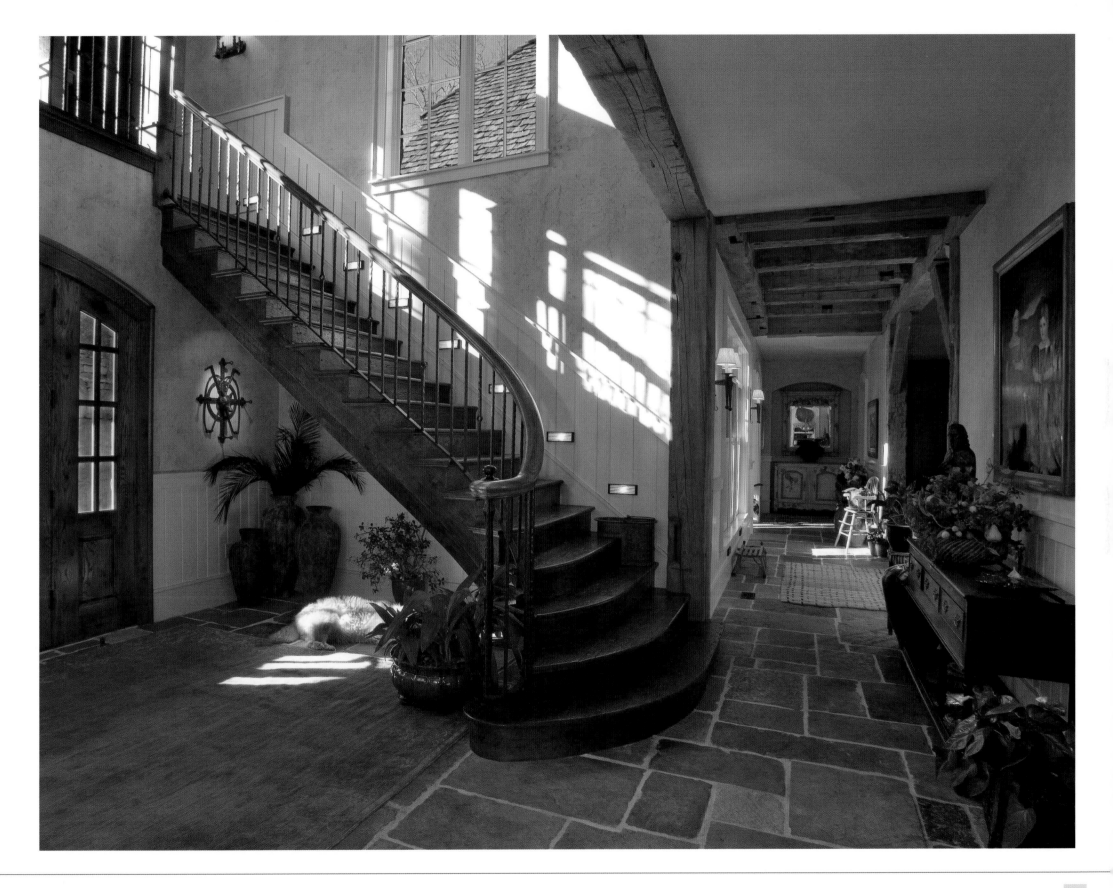

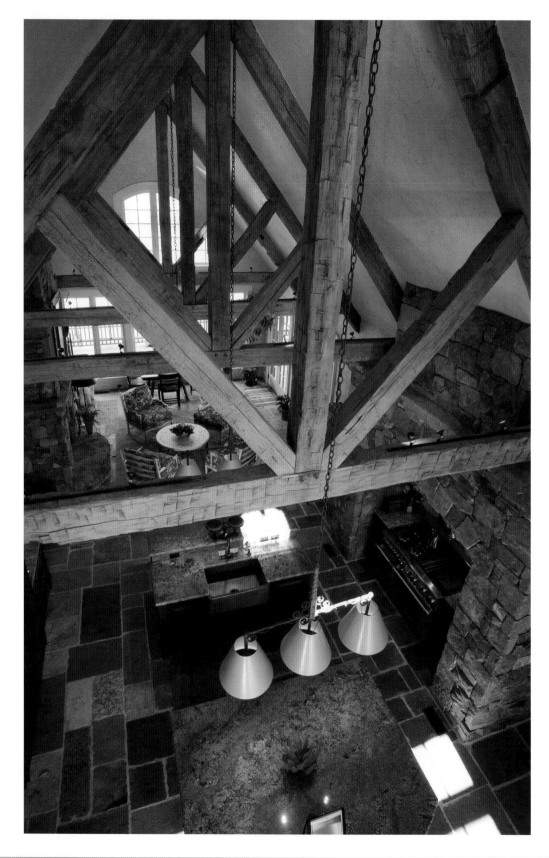
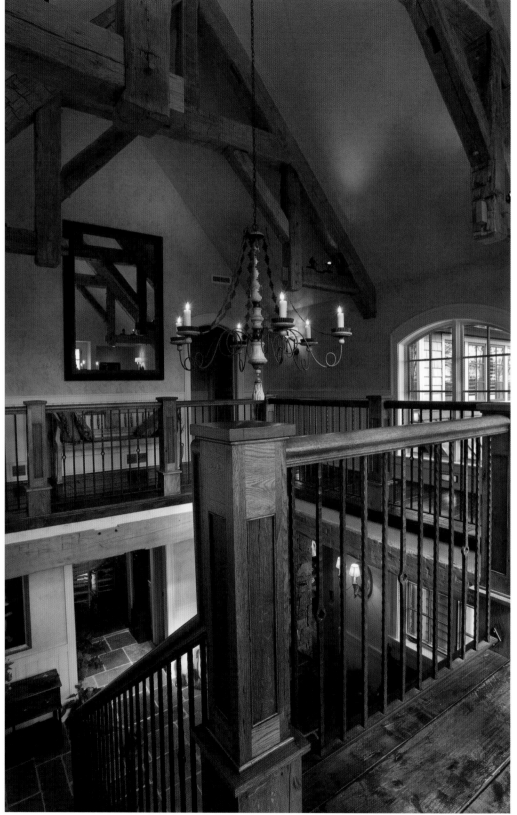

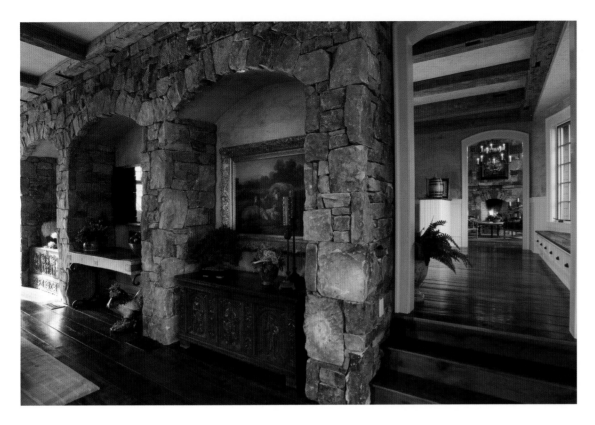

Tim Greene and Associates designs six to eight homes a year ranging from quaint cottages to mountain mansions. The firm generally builds two to three of its designs each year. "Our primary business is design, but once we establish a relationship with our clients and they realize we can build, they'll go ahead and ask us to do the construction," explains Tim.

"We're a very hands-on firm. We never seem to end relationships with our clients," he says. "Because Cashiers is a seasonal area, one of the first things our clients do when they get into town is stop in to say, 'Hi.'"

Q&A
more about Tim ...

WHAT IS THE MOST CHALLENGING PROJECT YOU'VE BEEN INVOLVED WITH?
They're all challenging. We deal with so many difficult sites, slopes, water streams, wet-weather streams, mountain brooks, and all those kinds of things. My whole effort is about making as little impact on the site as possible and still accomplishing the owner's wishes.

WHAT IS YOUR FAVORITE PROJECT?
I try to make all of them special and unique.

DID YOU ALWAYS KNOW YOU WANTED TO DESIGN HOMES?
I started out as a commercial pilot, and that wasn't fulfilling to me. I always had an interest in construction. I enjoy that part of the process, and I loved the artistic and creative part. Designing homes was a natural fit for me.

WHAT DO YOU ENJOY MOST ABOUT WHAT YOU DO?
The creativity of it and having something happen for all of your effort, which will hopefully outlive me. It's great to have happy clients come back and ask us to design second or third homes for them. That's really the most gratifying thing.

Tim Greene and Associates

Tim Greene
24 Canoe Point
Cashiers, NC 28717
828.743.2968
Fax: 828.743.2969

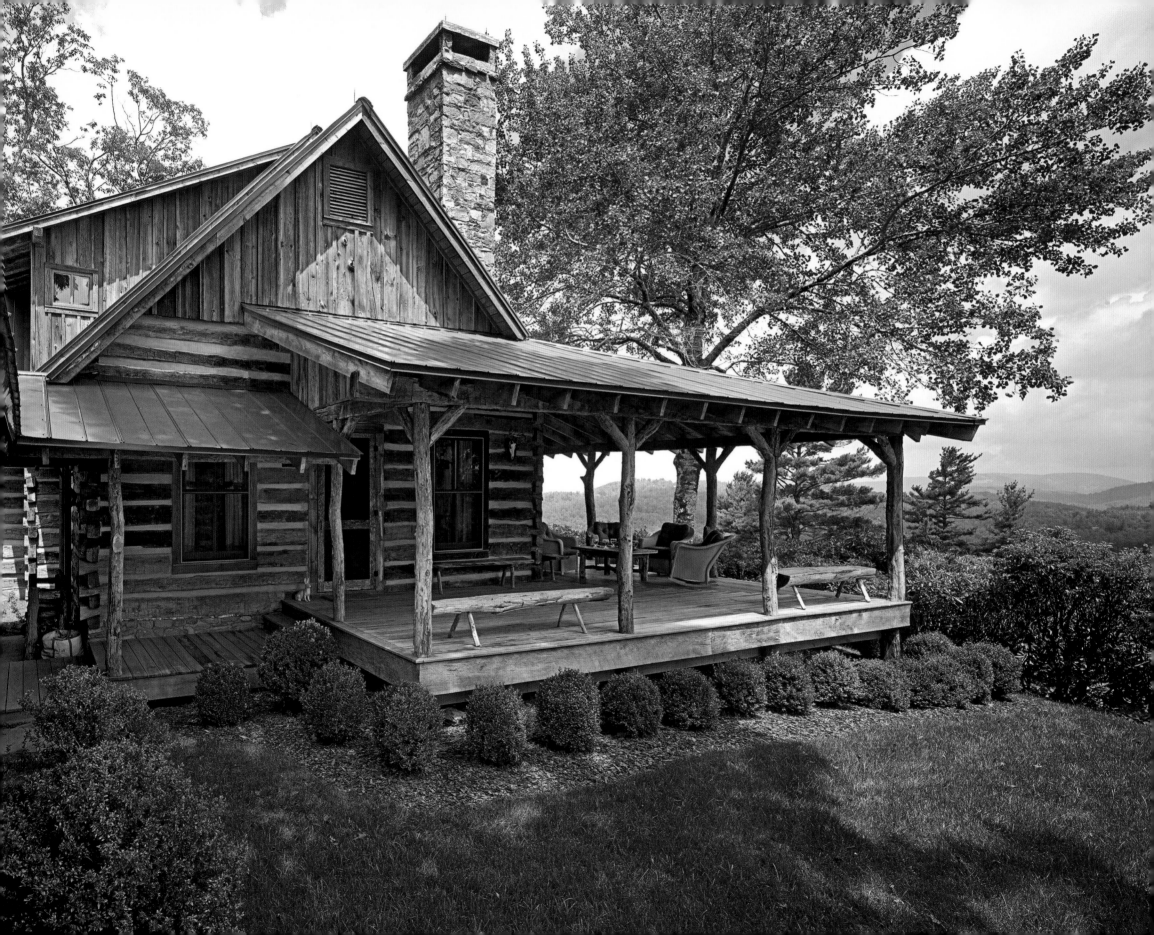

Al Platt
Parker Platt

Platt Architecture, PA

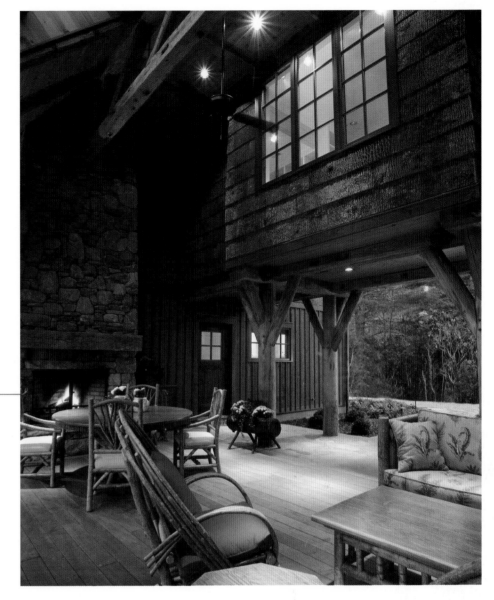

Above: Atop Toxaway Mountain, this bridge provides entry to the guest quarters above an outdoor living room. True to its surrounding context, bark siding, antique logs and timbers, and local stone can be seen in this Lake Toxaway, North Carolina home.
Photograph by Tim Burleson, Frontier Group, Inc.

Facing Page: This rustic cabin and porch, overlooking the Cashiers Valley, boasts antique hewn logs and lumber, locust posts and recycled stone in Highlands, North Carolina.
Photograph by Jerry Markatos

A central open dogtrot serves as the entryway of the HGTV 2006 Dream Home that architects Al and Parker Platt designed. Sparkling in a distant valley like a sapphire, Western North Carolina's Lake Lure serves as the focal point of the space as it reminds visitors of what a mountain home should be about.

"It's a pretty powerful message about what's important," says Al, who founded Platt Architecture, PA in 1982 and now has a team of 14, including his son, Parker. "What we do with our architecture is try to make as many connections as possible between the people who live in the house and the area where the house is located. We do this through materials, shapes, and forms, and by making other visual and functional connections to the landscape. This gives our clients the opportunity to feel like they live in the atmosphere and climate of the mountains."

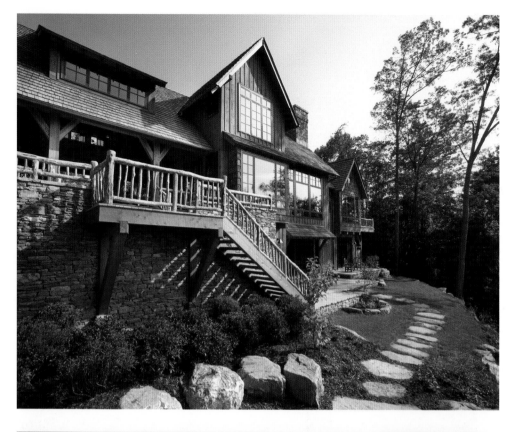

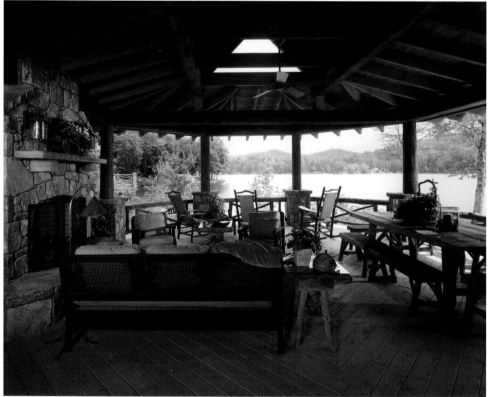

Whether the Platts are designing homes on a lake, as they have many times at Lake Toxaway, or on the side of a mountain, their homes are consistently about being in the mountains and experiencing the environment. "Our homes are places that we hope enhance the experience of living in the mountains in a casual way," explains Parker. "Our houses become secondary to the environment and are designed to be comfortable and durable. These are places where you can enjoy big meals as grandchildren and dogs run around. They're places where you can store your hiking gear after a day of exploring or come dry off after a day on the lake."

Al takes an organizational approach to designing a mountain home as he carefully considers what a family would need to share and experience the space successfully. He thinks about where they'll cook meals, where they'll sleep, where they'll work on jigsaw puzzles. He then incorporates forms and shapes that are familiar to the setting with materials that appear to be derived from the site to create a home. "By these simple practices, you may be able to create something that's deeply satisfying," he says.

Working from their spacious offices and design studio in downtown Brevard, Platt Architecture has designed homes in Brevard, Highlands, Cashiers, Lake Toxaway, Waynesville, Burnsville, and many other locations in Western North Carolina and the upstate of South Carolina. Al and Parker prefer to remain geographically close to their projects so they can be completely involved throughout the entire process.

"We're drawn to clients who come to us for what we consider to be the right reasons, couples and individuals who want and understand what we are able to offer," says Al. "We hope they see their house as a means to an end, as a means of fulfillment and not as an end in itself. They are people who want to spend time in the mountains and are very active. They're excited about the climate, the scenery, the crafts, the culture and the people indigenous to this area, and they want to express that in their home."

Top Left: The side view offers a look at the porches, decks, terraces and principal rooms of the HGTV 2006 Dream Home. Lake Lure, North Carolina.
Photograph by Eric Perry, Mid Coast Studio

Bottom Left: A stunning view of the lake from this porch is enjoyed by all. Authenticity is reached through the choice of materials including antique timbers, log columns, exposed roof framing and locust rails. Lake Toxaway, North Carolina.
Photograph by Jerry Markatos

Facing Page: An inside view of the HGTV 2006 Dream Home living room reveals heart pine beams, pine paneling and a barn board ceiling. Lake Lure, North Carolina.
Photograph by Eric Perry, Mid Coast Studio

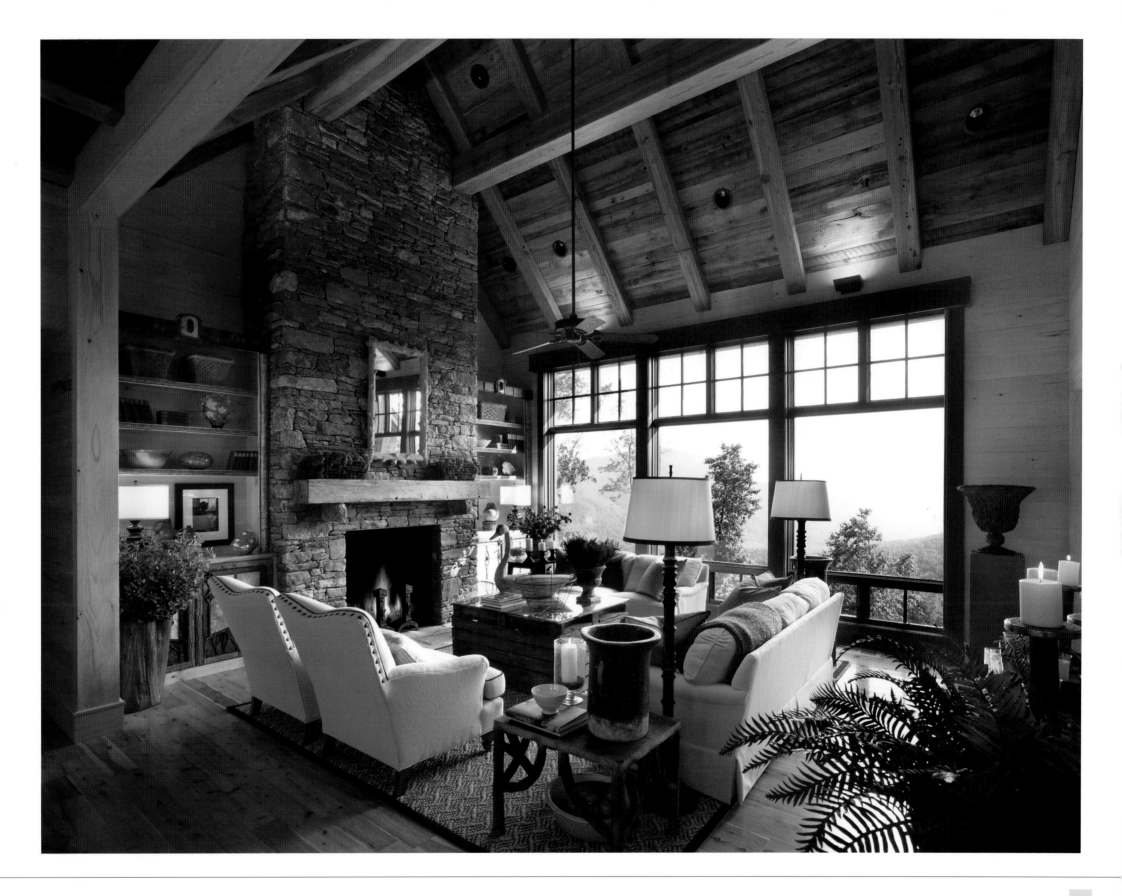

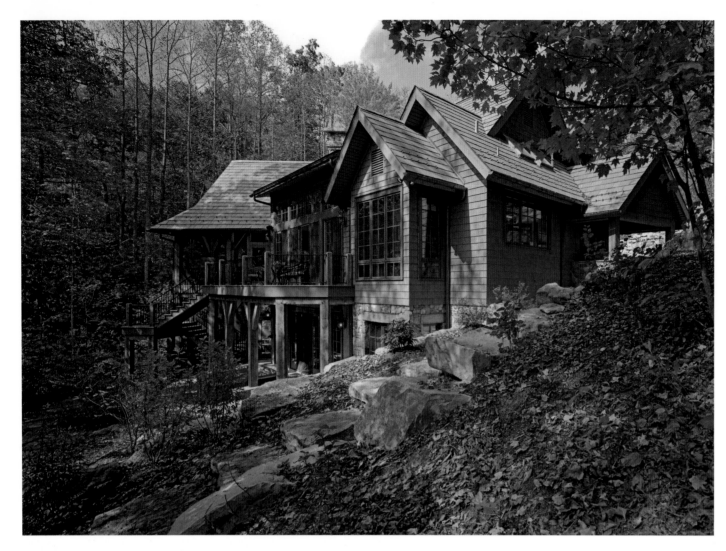

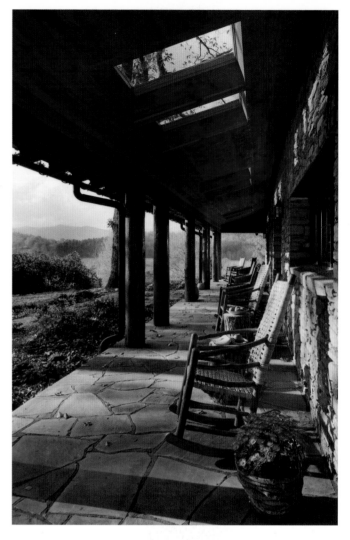

Al and Parker take architecture seriously. They realize that they are creating homes that will outlive them and their clients. They know that these homes will have an impact on people's lives. That respect for their craft, coupled with their respect for the environment, has resulted in an affiliate company called Conservation Advisors, which Al and Parker own with John Witherspoon.

The consulting company began in 1997 when the Platts began developing Richland Ridge, which has grown to 450 acres in rural Transylvania County. Today, the development is comprised of 24 two- to three-acre home sites and 375 acres of permanently conserved mountain land. By assisting other landowners and developers with conservation strategies, Conservation Advisors has helped protect more than 6,000 acres of land in Western North Carolina.

"It's a different approach to development. Like our architectural work, our conservation work is straightforward and has the ultimate goal to protect land," says Al. "We try to create architecture that preserves and respects the natural areas, habitat and environment,"

adds Parker. "Even when we work in already developed places, we try to make our houses look like they pre-existed the development. We know they'll exist longer than we will."

Above Left: Private faces of a house in a wooded site. Shingles, slate, antique timbers and iron rails all add charm and innovation to the rustic façade. Hendersonville, North Carolina.
Photograph by Jerry Markatos

Above Right: This entry porch is situated to enjoy the French Broad River Valley beyond. The stone terrace and walls, pine timbers and beams and skylights bring an element of the indoors to the outdoors in Brevard, North Carolina.
Photograph by Jerry Markatos

Facing Page Top: This garden side elevation allows one to appreciate the attention to detail down to the shingles, shakes and local stone. Highlands, North Carolina.
Photograph by Jerry Markatos

Facing Page Bottom: This cozy living room and loft includes antique timbers, textured plaster and local stone. Highlands, North Carolina.
Photograph by Jerry Markatos

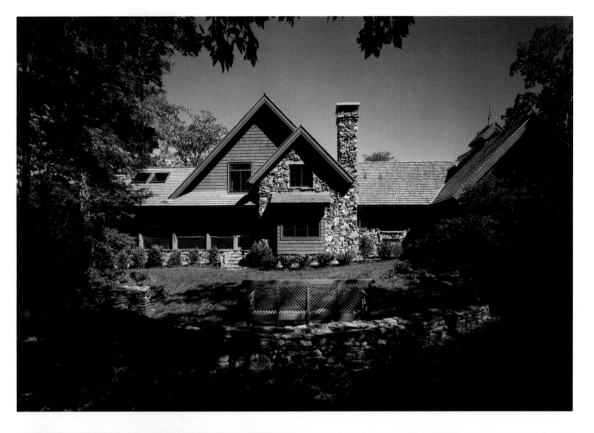

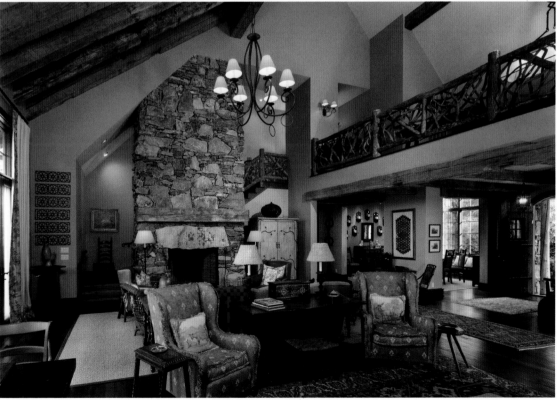

more about Al and Parker ...

WHAT DO YOU NEED TO CONSIDER WHEN DESIGNING A LAKE HOME?

Sometimes lake sites are as steep as mountain sites. Sometimes you get lucky and they're gentle, and you can actually use and enjoy the area between the house and the water. The house plan is developed with boating and bathing in mind, organized so that it's easy to use the water and all that it implies: wet feet, towels, coolers, dogs, etc.

HOW MANY HOMES DO YOU DESIGN A YEAR AND WHAT IS THE AVERAGE SIZE?

We design eight to 10 homes a year. The average size of one of our designs is approximately 4,500 square feet. A new, very limited program of "stock plans" has enabled us to offer fully developed and detailed designs in a friendly, "ready to wear" format.

WHAT WOULD YOU SAY ONE OF YOUR FAVORITE PROJECTS IS?

We have a saying around here, "If something looks like we've been messing with it, then we keep messing with it until it doesn't look like we've been messing with it." That's how we feel about design. If it's really successful it ends up with a kind of anonymous look that makes you believe that you are part of a settled, established culture of people who know how to live together in a certain place. For us, that makes the best architecture. Clients who resonate with that are our favorite clients, and we get the best results with them.

Platt Architecture, PA

Al Platt

Parker Platt

33 West Main Street

Brevard, NC 28712

828.884.2393

Fax: 828.885.8398

www.plattarchitecture.com

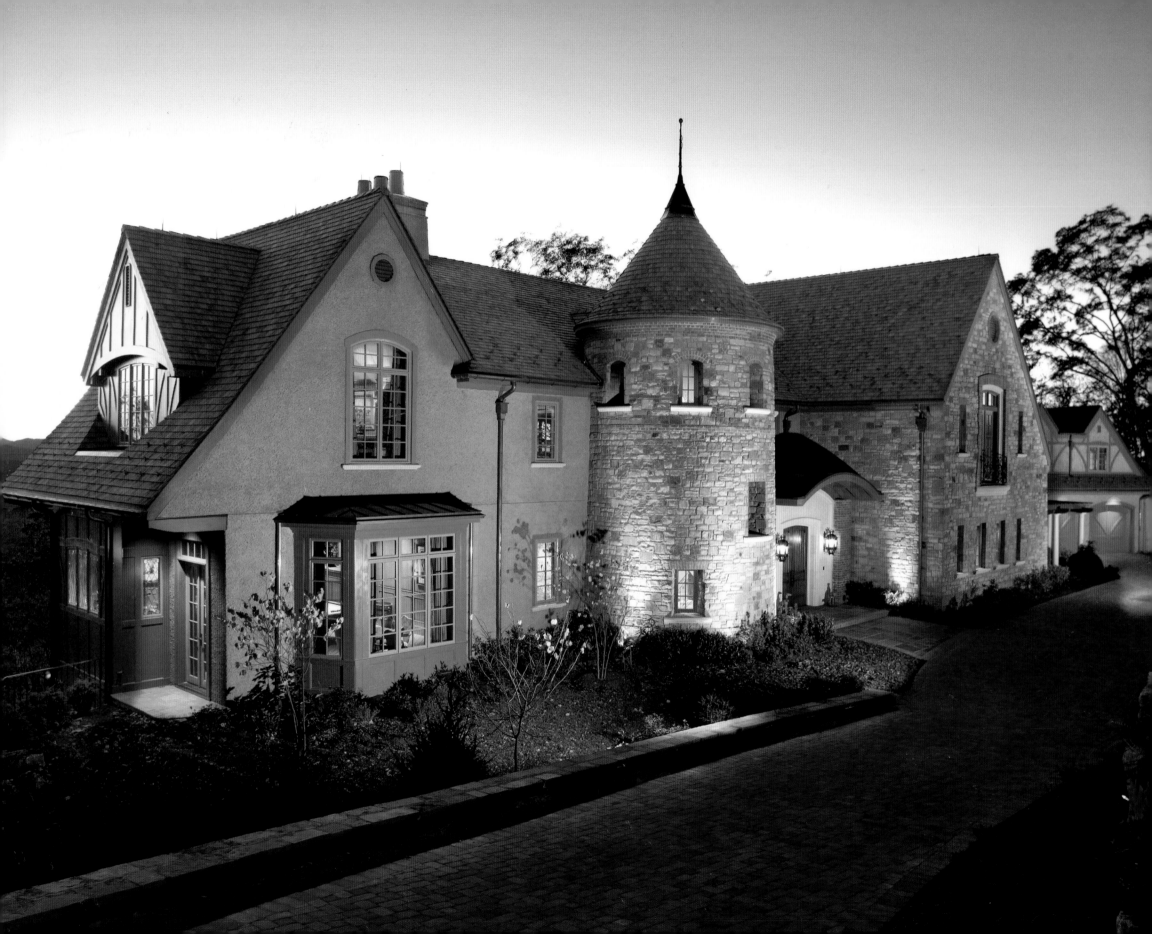

Jim Samsel
Samsel Architects

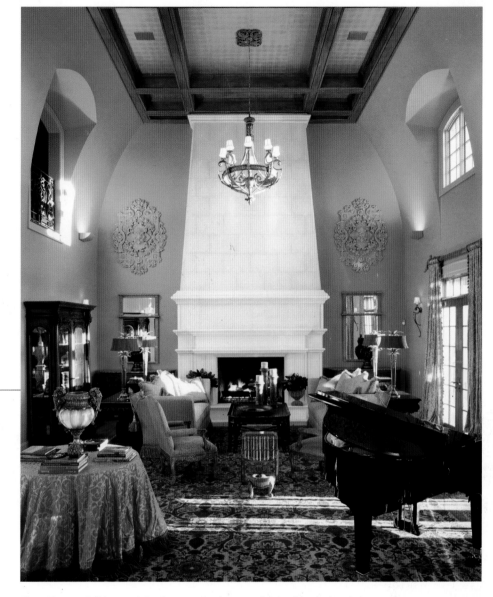

Above: The great hall features Italian limestone fireplaces as well as locally crafted iron balcony railings.
Photograph by David Dietrich

Facing Page: At 3,000 feet above sea level, residents of this European-inspired chateau enjoy views of both Asheville and the Blue Ridge Mountains.
Photograph by John Warner, Warner Photography

Jim Samsel discovered the natural beauty of Asheville, North Carolina more than 20 years ago and its inspiration has been reflected in his firm's award-winning design work ever since. Jim was drawn to the Blue Ridge Mountains as well as this town's historic architecture and unique culture. He became fascinated with the area's building traditions and how Biltmore Estate influenced generations of craftspeople, and decided to stay. The Maryland native graduated from the University of Arizona architecture program and went on to receive a master's degree in design and development from Massachusetts Institute of Technology. He founded Samsel Architects in 1985.

"For more than a century, Asheville's style has been a wonderful combination of fine craftsmanship and simple elegance—all set amid the mountain landscape," says Jim, who leads a staff of 14. "There are great design precedents that have their roots in different time periods from this region. We find inspiration from those precedents, and carry a lot of those principles forward as we interpret them for today."

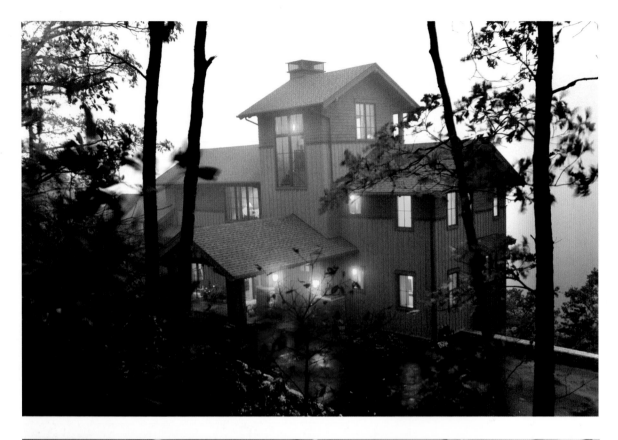

Samsel Architects draws from the character of the region and the surrounding environment for its designs. "We're really blessed to live in a beautiful environment. It's a fragile landscape, and we have to be very respectful of how we treat it," says Jim. "Our approach is to keep the site disturbance as minimal as possible and, if needed, we work with landscapers to reintroduce native foliage."

As a member of the U.S. Green Building Council and a founding supporter of the Western North Carolina Green Building Council, Jim also incorporates natural and regional materials in designs. "In many cases we use Appalachian woods," explains Jim. "In addition, there are a lot of great recycled materials on the market now such as reclaimed flooring, timber and trim. Those products add a tremendous visual interest and character to the interior finish. We also try to use materials that don't have toxic manufacturing or indoor air quality effects, including paints and finishes that are environmentally sensitive."

Samsel Architects' respect for nature and commitment to sustainability is one of the factors that sets the firm apart. Another is the Samsel design team's ability to listen and its attention to detail. "We're real sticklers on the full integration of the design concept. We want our finished projects to appear timeless and in keeping with nature," Jim says. "Our attention to detail is something that both the contractors and clients appreciate."

The firm designs approximately a dozen homes a year in North Carolina, South Carolina, Tennessee and Virginia. Its work has been featured in *Southern Accents* and *Southern Living* as well as recognized with several North Carolina AIA Design Awards.

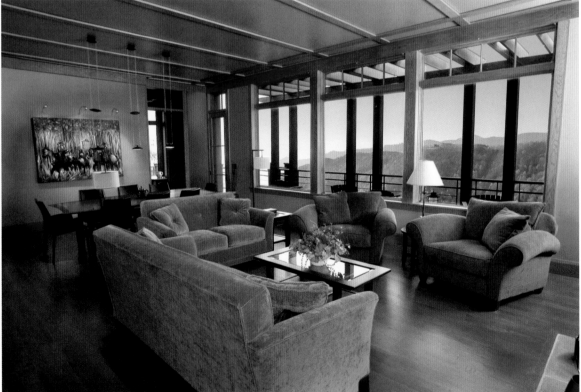

Top Left: Perched atop a slender mountain ridge, this home provides expansive views and withstands high elevation weather through site-responsive design.
Photograph by Laura Mueller

Bottom Left: The home's understated interior provides a welcome vantage point to appreciate the distant mountainside beyond.
Photograph by Laura Mueller

Facing Page: This country house nestles into its meadow setting at the base of a mountain.
Photograph by Frontier Group, Inc.

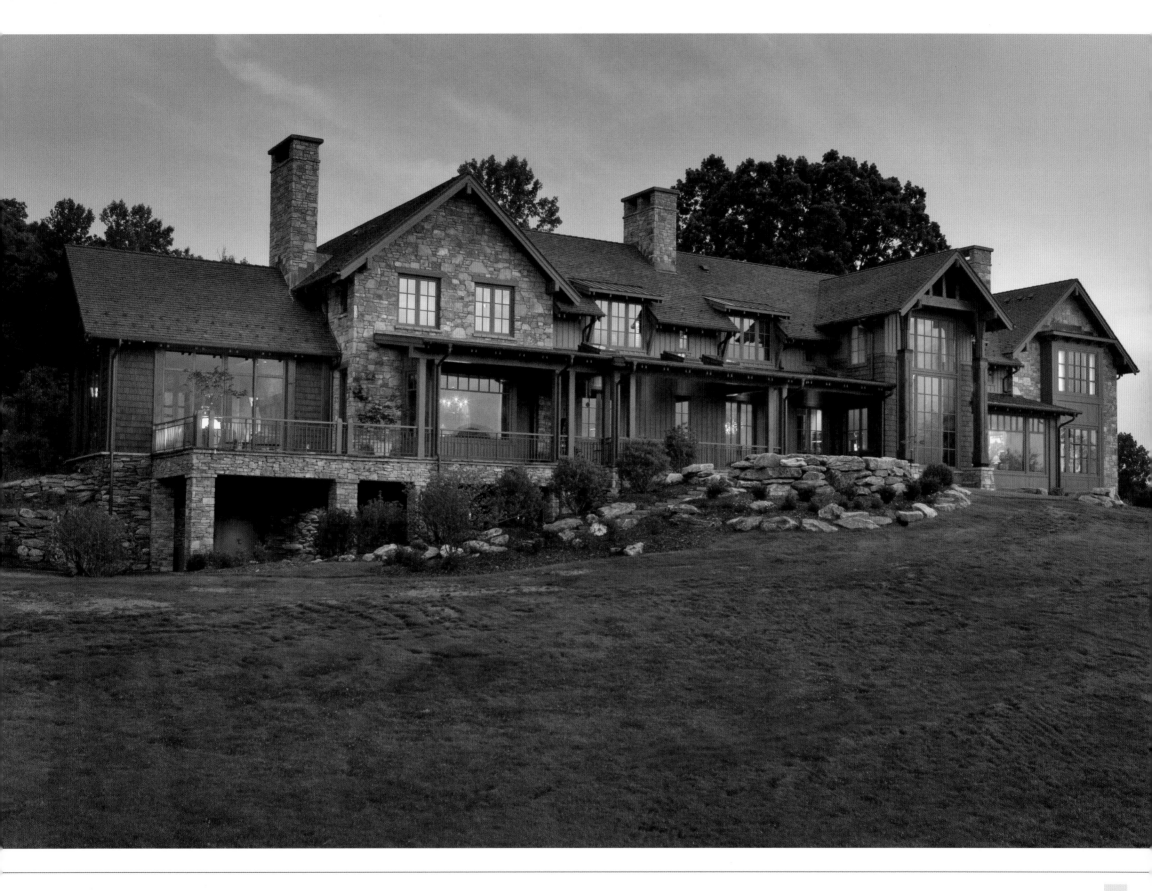

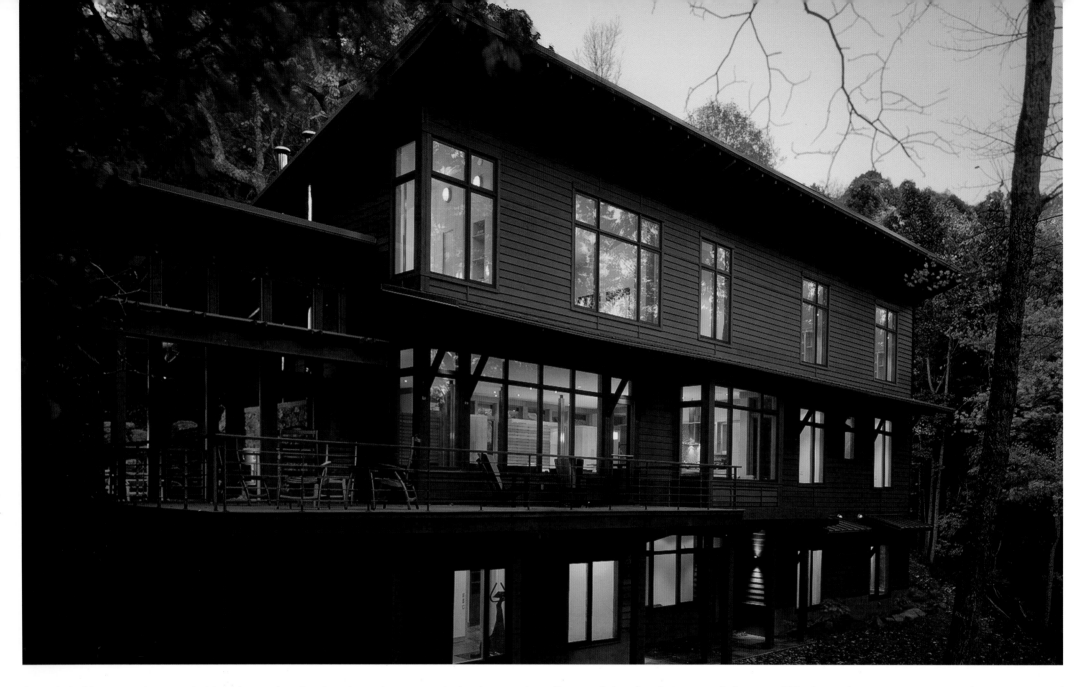

Samsel Architects explores varied architectural styles but has taken a particular interest in contemporary interpretations of Arts-and-Crafts and Asian designs. "There's a real simplicity and elegance in these styles' combination of materials," Jim says. "That works well for today's open floor plans that offer more windows and light."

Samsel Architects especially appreciates clients who have flexible expectations in terms of style. "We take a collaborative approach to design with each project. It's important that we listen to the client, and that they listen to us," Jim says. "We design homes to incorporate their interests and come up with color palettes that reflect who they are. In every project, we strive for sustainable design and superior performance."

Above: High-efficiency systems, low-VOC finishes and FSC-certified materials make this Energy Star™ rated home an exemplary model of contemporary, sustainable design.
Photograph by Paul Jeremias

Facing Page Top: This British Arts-and-Crafts-style home reflects the heritage of its forested, early 20th-century "park" neighborhood.
Photograph by Samsel Architects Archive

Facing Page Bottom: The piano bay provides an anchor to the carefully detailed living room.
Photograph by Paul Jeremias

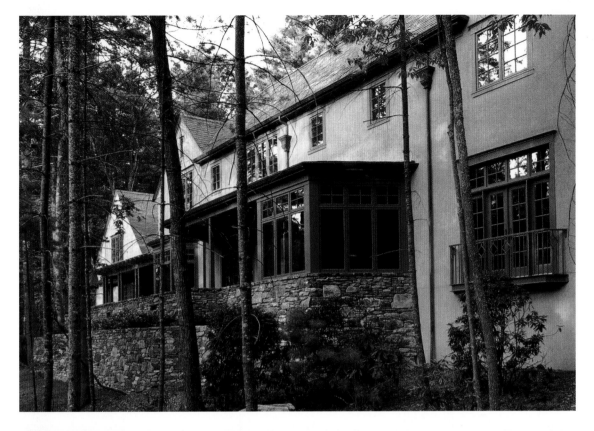

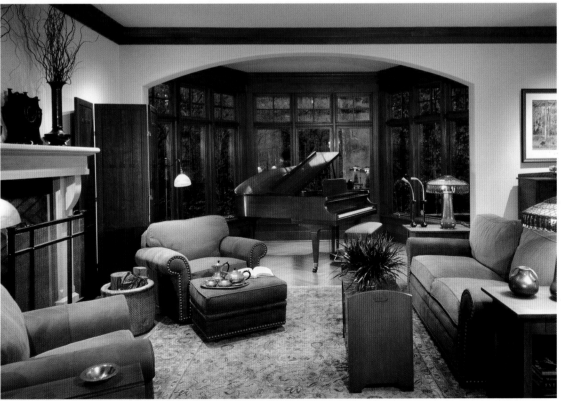

WHAT DO YOU LIKE ABOUT DOING BUSINESS IN ASHEVILLE?

There is a wonderful group of craftspeople here—from cabinetmakers to ironworkers. It's really an emerging community so we are able to get details executed and a certain quality of installation that makes for a satisfying collaborative experience. The artisans here really take pride in their work.

WHAT BRINGS A DULL HOUSE TO LIFE?

Color, art and light.

WHAT ONE ELEMENT OR PHILOSOPHY HAVE YOU STUCK WITH THAT STILL WORKS FOR YOU TODAY?

Timeless design and thoughtful dialogue with nature.

WHAT DO YOU LIKE ABOUT BEING AN ARCHITECT?

Creating beautiful things. We like working with people, and we feel that we're good listeners. We like to satisfy and exceed folks' expectations for what a home can be. I also like to think we are leaving a positive legacy in the built environment. Our hope is that someone in the future will appreciate the lasting beauty and quality of our work.

Samsel Architects

Jim Samsel, AIA
60 Biltmore Avenue
Asheville, NC 28801

828.253.1124
Fax: 828.254.7316

www.samselarchitects.com

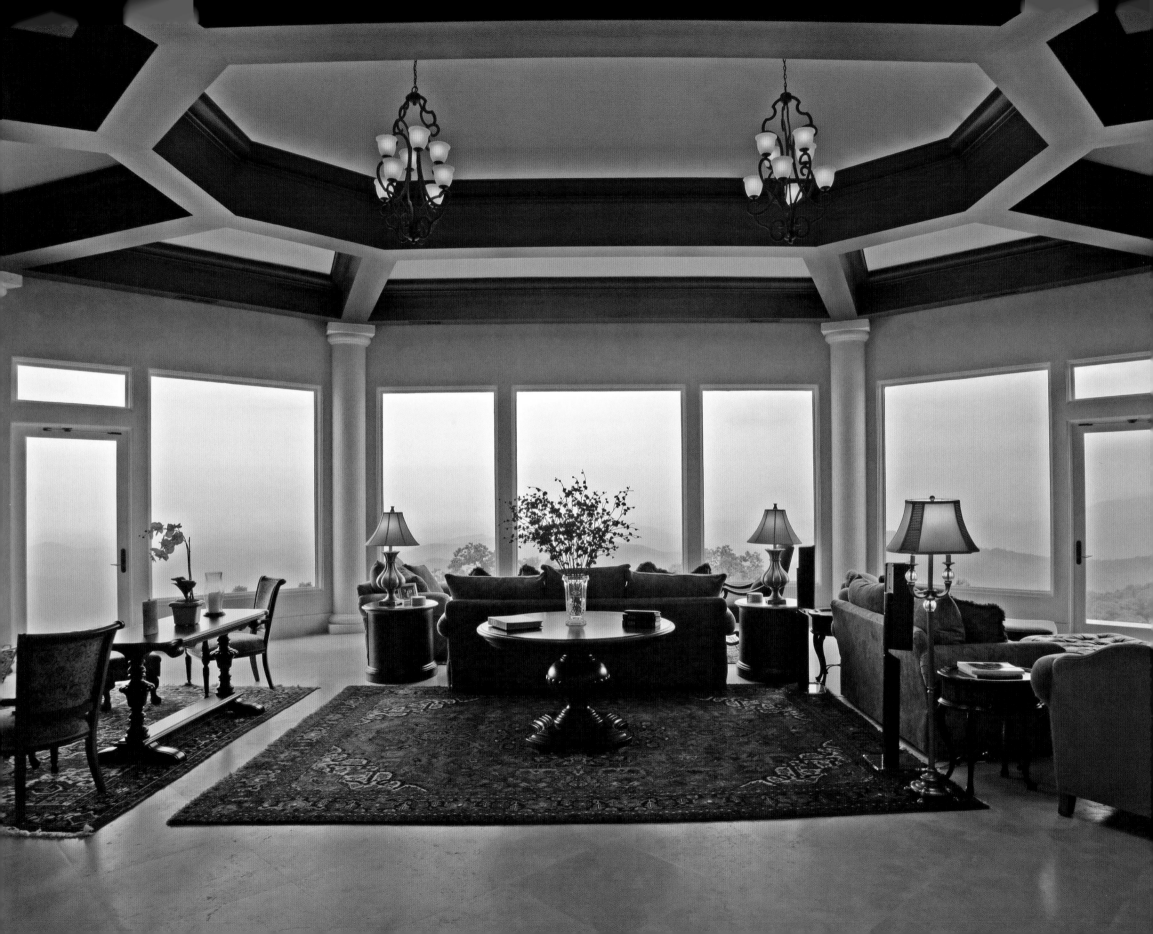

Mark Searcy
Searcy Custom Homes

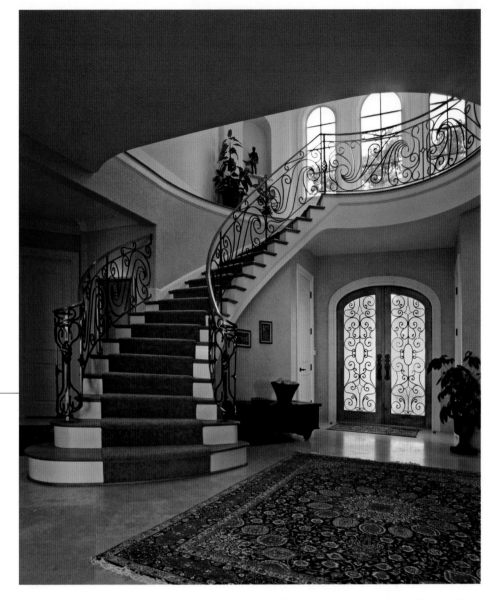

Above: An inviting foyer bids visitors to enter. An open arrangement of the forward rooms permits natural light and views to penetrate the formal core of the plan. The one-of-a-kind wrought-iron staircase railing, the unique, graceful arched entrance doors, and the breathtaking domed ceiling establish a sense of grandeur.
Photograph by Corey Cagle Photography

Facing Page: Upon entering, guests are treated to a view of the grand room with its soaring ceiling, and comfortable seating groups. Faux-finished walls, elegant columns, the detail in the ceiling, and three layers of crown moulding emphasize the dramatic scheme of the home. Expansive windows fill the room with light and visually extend the exterior views beyond. This room takes advantage of the unique piece of land chosen and defines how family and friends experience it.
Photograph by Corey Cagle Photography

Twenty-five years ago Mark Searcy began his building career remodeling homes in Western North Carolina. In a short time, his work evolved into new entry-level homes. And that quickly grew into mid-level luxury timber frame and log homes. A native of Hendersonville, Mark soon earned the reputation of being one of the best homebuilders in the area. Over the next decade, the evolution was complete, and today, Searcy Custom Homes builds some of the finest custom homes in Western North Carolina and the upstate of South Carolina.

"My affinity has always been to push for quality," says Mark. "As a company, our background is probably one of the most unique things about us. I think it gives us some exceptional cross-training abilities. We've learned to customize homes within a budget structure." Mark has distinguished himself as a highly respected custom homebuilder by his meticulous attention to detail, dedication to the highest

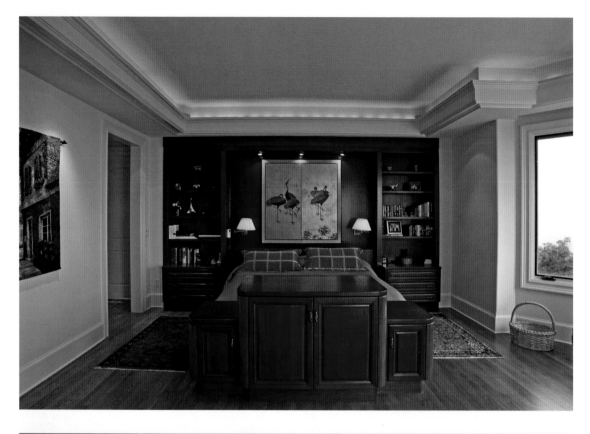

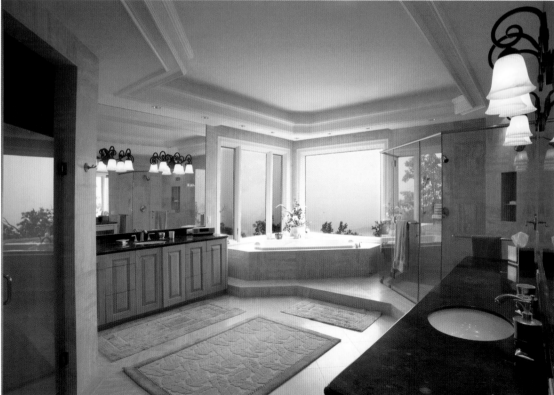

standard of quality, and excellence built on experience. Yet, his dynamic company is so innovative that his projects stay way ahead of the curve. They afford special attention to land clearing and site preparation, incorporating the natural environment, to create a home that harmonizes with the scenic beauty of the surrounding landscape.

Searcy Custom Homes has a truly remarkable commitment to buyer satisfaction. Mark says he focuses on building to the client's specific desire and taste so that every project is unique. When someone wants something original and a little out of the ordinary, Searcy Custom Homes is the right company. Mark has built every architectural style from homes resembling ski lodges incorporating full-size logs, to French country houses, to neo-modern designs. "I think our specialty is to zero in on what the client wants and build a one-of-a-kind home exactly the way they want it," he says.

Turning dreams into reality requires experience, passion, and creativity. Searcy Custom Homes has the experience to make that happen. In this day and age of instant gratification, it is refreshing to find someone dedicated to old-fashioned quality, meticulous detailing, and distinctive elegance. Other builders may build nice houses, but Mark listens carefully to ensure that he can build the house that will be their home. Modifications are made along the way so that the finished home is truly a dream realized.

After about 15 years of maintaining several active projects, Mark began to make the transition to one very special project at a time. "I began to realize that it was always that challenging or unique project that had my attention," Mark says. "I simply enjoy my job more that way. Now our goal is to find that one dream home to focus all of our energies on."

Top Left: The bedroom offers a quiet sanctuary for the owners. Part of the Wennerstrom's home theater includes a 60-inch plasma screen smartly concealed in the cabinet at the foot of the bed.
Photograph by Corey Cagle Photography

Bottom Left: The master retreat area is rounded out by a master bath—including heated tiled floors, a spa-style tub surrounded by marble and harbored by giant windows, a walk-in shower and a massive walk-in closet. The glaze applied to the cabinets in the spacious master bathroom coordinates with the subtle coloring in the floors.
Photograph by Corey Cagle Photography

Facing Page: The elaborate covered entry sets off a dramatic tile roof. The rusticated surround enriches authentic details such as carved corbels and curved walls. At the front of the courtyard, natural landscaping blends effortlessly with nature establishing an impressive entry.
Photograph by Corey Cagle Photography

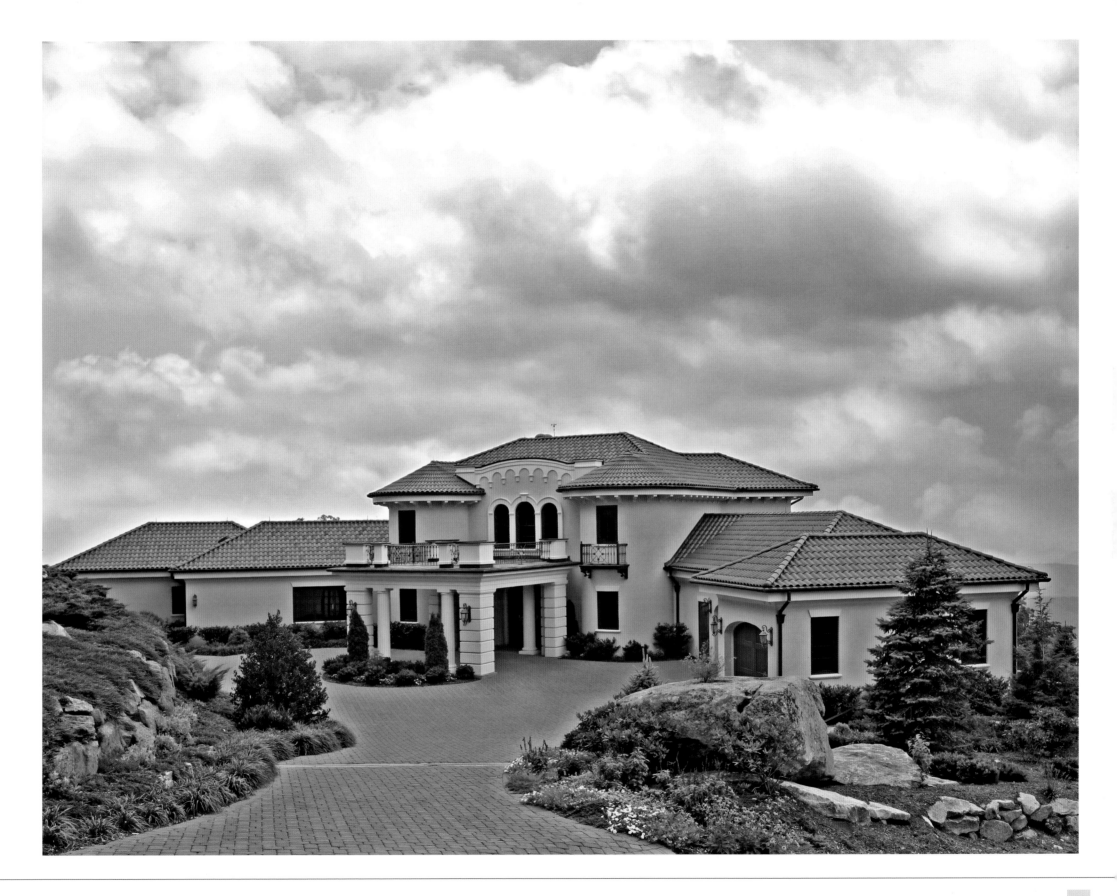

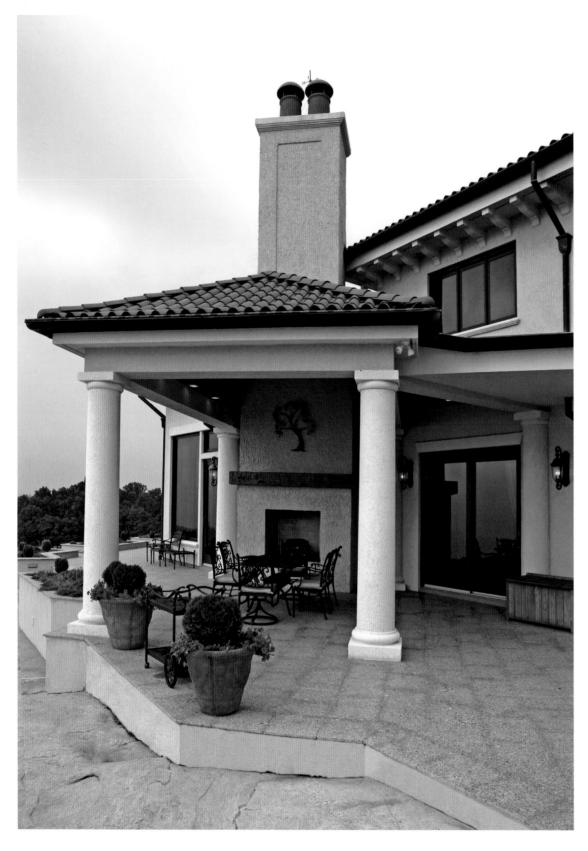

With a small number of employees, Searcy Custom Homes believes that quality work is far more important than quantity. Mark says this approach allows him to deliver seamless transitions between the various phases of the building process. "Building one home at a time allows me to give it my full attention. Clients don't have to share me with 10 other custom projects," he says. "We take into consideration the client and the location when selecting the right project for us."

When Mark founded his business in 1981, he decided that he was either going to have clients he could be friends with after the home was complete, or he was going to choose another line of work. That philosophy has paid off in full for him as his homes can be found throughout some of the area's most prestigious neighborhoods such as The Cliffs Communities, Kenmure, Carriage Park and Thrashing Rock. "Nobody knows us better than our previous customers, and most of Searcy Custom Homes' clients are referrals," says Mark.

The amount of personal attention put into each home is unprecedented. Says Mark, "We just don't stop until our clients are happy—whether that means finding another technique, locating an alternate product, or redoing a finish." His focus goes far beyond the bottom line. Searcy is genuinely concerned about each project and is determined to maintain trust, honesty and communication at the highest level.

Left: A patio table is set for the owners to enjoy another lovely day on the mountainside. The veranda adds large outdoor living and entertaining spaces from which the owners can take advantage of the beautiful Carolina weather and enjoy the panoramic view of the valley below or chat with friends. Soaking in the Jacuzzi is a favorite pastime, particularly when the vistas are so pleasing.
Photograph by Corey Cagle Photography

Facing Page Top: A tour of the spacious kitchen says this is the territory of a very serious and talented cook. Smartly styled cream-colored cabinetry, topped by granite, gives the kitchen a sense of sophistication.
Photograph by Corey Cagle Photography

Facing Page Bottom: The leathery faux-finish on the walls offers warmth and elegance to the dining room. The interior palette of sunshine-bright yellows creates a cheery atmosphere. An area rug defines and anchors the space.
Photograph by Corey Cagle Photography

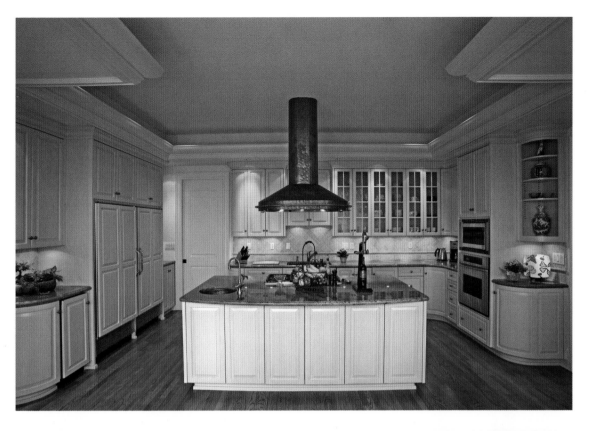

more about Mark ...

WHAT HAVE YOU AND YOUR COMPANY ACHIEVED THAT MAKES YOU MOST PROUD?

It is a rare accomplishment for a builder when his name becomes synonymous with quality and integrity. In the Carolinas, the Searcy Custom Homes signature on a custom home has just that kind of meaning.

TO WHAT WOULD YOU ATTRIBUTE YOUR UNPRECEDENTED SUCCESS?

There are many reasons for our success, but I would say that my staff is central. They realize that pleasing the homeowner requires more than simply building a comfortable home. It requires delivering that home on time and on budget. I have some of the best craftsmen in the region working with me. Their talents remain one of the distinguishing characteristics of a Searcy Custom Home. My team is hard working, excited and passionate about quality.

HOW DO FORMER CLIENTS FEEL ABOUT THE BUILDING PROCESS?

Former clients speak in the most glowing terms of our sense of commitment and reliability. We often hear that their home is everything they hoped for and that they were delighted with how much fun they had building it with Searcy Custom Homes. We make clients feel a part of the project by encouraging them to be on the jobsite regularly.

Searcy Custom Homes

Mark Searcy
2526 Bobs Creek Road
Zirconia, NC 28790
828.697.0603
Fax: 828.692.3172
www.searcycustomhomes.com

PUBLISHING TEAM

Brian G. Carabet, Publisher
John A. Shand, Publisher
Phil Reavis, Executive Publisher
Kara Price, Associate Publisher
Beth Benton, Director of Development & Design
Julia Hoover, Director of Book Marketing & Distribution

Michele Cunningham-Scott, Art Director
Mary Elizabeth Acree, Graphic Designer
Emily Kattan, Graphic Designer
Ben Quintanilla, Graphic Designer

Elizabeth Gionta, Managing Editor
Lauren Castelli, Editor
Anita Kasmar, Editor
Rosalie Z. Wilson, Editor

Kristy Randall, Senior Production Coordinator
Laura Greenwood, Production Coordinator
Jennifer Lenhart, Production Coordinator
Jessica Garrison, Traffic Coordinator

Carol Kendall, Project Manager
Beverly Smith, Project Manager

PANACHE PARTNERS, LLC
CORPORATE OFFICE
13747 Montfort Drive, Suite 100
Dallas, TX 75240
972.661.9884
www.panache.com

THE CAROLINAS OFFICE
704.608.4947

Michael Moorefield Architects; *page 57*

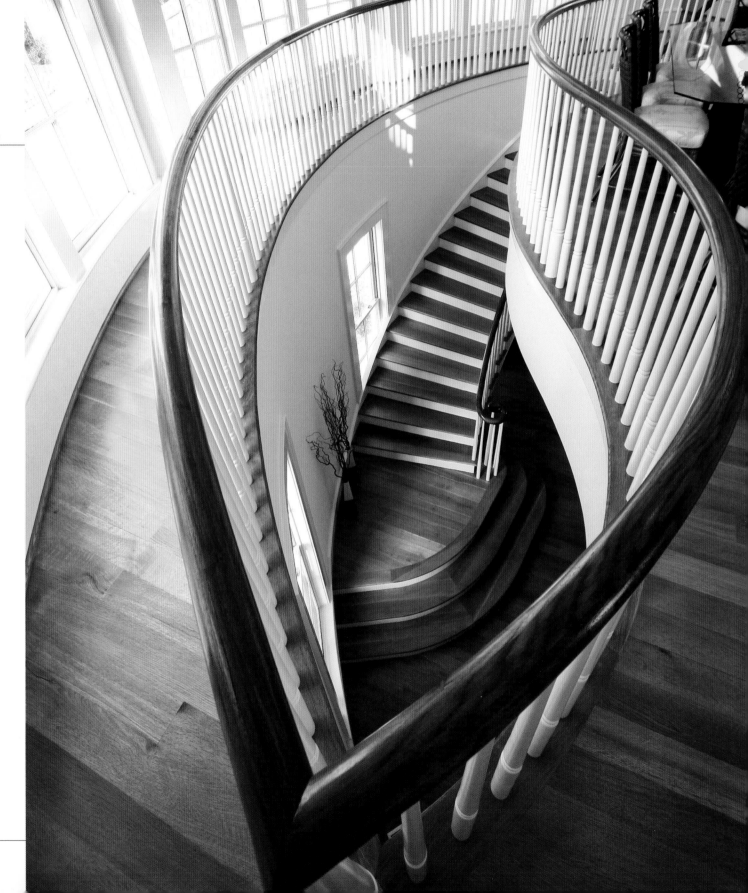

Dream Homes Series

Dream Homes of Texas
Dream Homes South Florida
Dream Homes Colorado
Dream Homes Metro New York
Dream Homes Greater Philadelphia
Dream Homes New Jersey
Dream Homes Florida
Dream Homes Southwest
Dream Homes Northern California
Dream Homes the Carolinas
Dream Homes Georgia
Dream Homes Chicago
Dream Homes San Diego & Orange County
Dream Homes Washington, D.C.
Dream Homes the Western Deserts
Dream Homes Pacific Northwest
Dream Homes Minnesota
Dream Homes Ohio & Pennsylvania
Dream Homes California Central Coast
Dream Homes Connecticut
Dream Homes Los Angeles
Dream Homes Michigan
Dream Homes Tennessee
Dream Homes Greater Boston

Additional Titles

Spectacular Hotels
Spectacular Golf of Texas
Spectacular Golf of Colorado
Spectacular Restaurants of Texas
Elite Portfolios
Spectacular Wineries of Napa Valley

City by Design Series

City by Design Dallas
City by Design Atlanta
City by Design San Francisco Bay Area
City by Design Pittsburgh
City by Design Chicago
City by Design Charlotte
City by Design Phoenix, Tucson & Albuquerque
City by Design Denver

Perspectives on Design Series

Perspectives on Design Florida

Spectacular Homes Series

Spectacular Homes of Texas
Spectacular Homes of Georgia
Spectacular Homes of South Florida
Spectacular Homes of Tennessee
Spectacular Homes of the Pacific Northwest
Spectacular Homes of Greater Philadelphia
Spectacular Homes of the Southwest
Spectacular Homes of Colorado
Spectacular Homes of the Carolinas
Spectacular Homes of Florida
Spectacular Homes of California
Spectacular Homes of Michigan
Spectacular Homes of the Heartland
Spectacular Homes of Chicago
Spectacular Homes of Washington, D.C.
Spectacular Homes of Ohio & Pennsylvania
Spectacular Homes of Minnesota
Spectacular Homes of New England
Spectacular Homes of New York

Visit www.panache.com or call
972.661.9884

PANACHE PARTNERS, LLC

Creators of Spectacular Publications for
Discerning Readers

INDEX